A Guide to Drawing

reproduced on the cover
Wayne Thiebaud
(b. 1920; American).
Pastel Scatter, 1972.
Pastel on paper,
26 × 20⅛″ (66 × 51 cm).
Private collection.

To Daniel Mendelowitz
Painter and Teacher
A Gentle and Honest Man

Acquiring Editor *Karen Dubno*
Special Projects Editor *Jeanette Ninas Johnson*
Picture Coordinator *Elsa Peterson*
Senior Production Manager *Nancy Myers*
Art Director *Louis Scardino*

Photographic sources appear on page viii.

Printed in the United States of America

Library of Congress Cataloging-in-Publication Data
Mendelowitz, Daniel Marcus.
 A guide to drawing.

 Rev. ed. of: Mendelowitz's guide to drawing. 3rd ed. c1982.
 Includes index.
 1. Drawing—Technique. I. Wakeham, Duane A., 1931– . II. Title.
 NC730.M396 1988 741.2 87-3466

ISBN 0-03-007312-X

Address correspondence to:
111 Fifth Avenue
New York, N.Y. 10003
8 9 0 1 039 9 8 7 6 5 4 3 2 1

Holt, Rinehart and Winston, Inc.
The Dryden Press
Saunders College Publishing

Fourth Edition

A Guide
to Drawing

Daniel M. Mendelowitz
Late of Stanford University

Duane A. Wakeham
College of San Mateo

Holt, Rinehart and Winston, Inc.
*New York Chicago San Francisco Philadelphia
Montreal Toronto London Sydney Tokyo*

Preface

The basic concept of *A Guide to Drawing*, as stated in the preface to the third edition, is to provide "a comprehensive and systematic introduction to the art of drawing, focusing on the mastery of traditional skills as the basis for expressive drawing."

The book, designed to be used for both beginning and advanced drawing classes, as well as for specialized advanced courses such as life drawing, offers an introduction to the breadth and range of subjects, media, and techniques that provide a framework for developing individual ideas and approaches, with *expression* as the goal. Because it is meant to be comprehensive, *A Guide to Drawing* includes much more material than can be covered in any one course, and it is unlikely that anyone—student or instructor—will choose to adhere strictly to the sequence as presented. Instead, all are encouraged to dip in and help themselves to that which interests them or seems appropriate to their needs. Each topic is accompanied by a rich selection of master drawings as well as by a progression of studio projects designed both to allow beginning students, working alone or under the direction of a teacher, to master basic skills, and to encourage advanced students to use those skills creatively and expressively. The assignments have been made as flexible as possible so that they will serve the needs of many situations. While not intended as a history of drawing, the inclusion of such references reflects the shared desire of the original author, Daniel M. Mendelowitz, and the present revision author to arouse in students both curiosity and awareness about the ancestry of drawing.

The basic organization of *A Guide to Drawing*, as with the previous edition, remains consistent with the late Professor Mendelowitz's

original concept. There has been, however, substantial rewriting in almost every chapter, partly necessitated by the deletion and addition of drawings, but also from the desire to insure clarity, as well as to introduce new ideas. Whenever possible, at least two or three drawings, related in subject but different in technique or expression, have been selected to accompany the discussion of each topic so that students begin to develop an awareness of some of the various approaches to drawing that are available to them. Approximately 40 percent of the drawings are new to this edition; over 60 percent of the drawings reproduced are 20th-century examples.

Chapter 4, Copying and Sketching, is new to this fourth edition; its purpose is to reveal how both activities of long-established tradition are of particular benefit to the student. A discussion of color has been added both to Chapter 6, Value, and Chapter 8, Composition, and the coverage of colored media in Chapter 10, Dry Media, has been expanded. Greater emphasis is devoted to gesture and gesture drawing in Chapter 14, Figure Drawing.

While the content of Chapter 9, Perspective, remains relatively unchanged from the previous edition, the projects have been simplified, the instructions rewritten, and supplementary diagrams added. Beyond basic one- and two-point perspective, the chapter focuses on the perspective of inclined planes, figures in space, cast shadows, and reflections, all challenging problems for pictorial artists. The various topics are presented both as observable phenomena, *empirical perspective,* and theoretically as *linear perspective.* While the information and projects might seem too complex to some, they are offered for those students and instructors interested in the subject and willing to work through the material.

Chapter 16, Illustration, has been condensed for this edition and is presented as an introductory survey to acquaint students with various types of illustration, the purpose and requirements of each, and to suggest how *A Guide to Drawing* provides an appropriate and necessary basic course for aspiring illustrators.

Chapter 17, Expressive Drawing, also new, is intended to make students aware that expressive drawing, whether representational or abstract, is a matter of personal expression, not only about emotions and attitudes toward subject matter and media, but also about how one approaches the act of drawing and the choices one must make.

The drawings throughout the book, although varied in style, technique, and purpose, are largely representational. In the June 1985 issue of *Art in America* Stephen Westfall interviewed Norman Bluhm as an important participant in the abstract expressionist movement in New York in the 1950s. Looking at the contemporary scene, Bluhm lamented that "None of the current expressionists draws well," a criticism echoed by a number of reputable national art critics. Bluhm stated emphatically, "To be an artist, you have to have certain essential skills and talents. One of them is to be able to draw." His expression of doubt as to whether one prominent painter "can draw so much as a cup" suggests that even as an artist primarily associated with abstract art, Bluhm views the ability to draw representationally as the requisite basic vocabulary for the artist. The premise of *A Guide to Drawing* is that having acquired that vocabulary, creative people are freed by that knowledge and, like Picasso, can then choose to draw in whatever style is pleasing and seems appropriate to that which is to be expressed.

I want to express my appreciation to a number of people who have made significant contributions to this project. Mrs. Daniel Mendelowitz, in addition to expressing support and confidence, offered valuable suggestions in terms of picture selection. Richard Sutherland of Foothill College, as he did in the previous edition, provided continuing organizational assistance with the illustration program, manuscript preparation, and indexing. I want to acknowledge my colleagues and students in the art department at College of San Mateo for helping me focus my thinking.

My thanks to my reviewers for all of their thoughtful comments, many of which have been incorporated into the book in its final form. Those who offered suggestions at the outset of the revision project were: Greg Constantine, Andrews University; Craig Marshall Smith, Metro State College; Marc Wurmbrand, Crafton Hills College; Dan Ziembo, College of Lake County; and Harold Zinsla, Indiana University, South Bend. Those who reviewed the preliminary manuscript were: Marcia Goldenstein, University of Tennessee; C. J. Kavanaugh, Tyler Junior College; Paul Lamal, Central Piedmont Community College; Alice McConnell, Southern Connecticut State University; Ellen Meissinger, Oklahoma State University; and Jim Murray, Lincoln Land Community College.

I am particularly grateful to the many artists, collectors, and institutions for allowing their drawings to be reproduced.

To the staff at Holt, Rinehart, and Winston, my special thanks and appreciation: Editor Karen Dubno, who provided perceptive and understanding guidance throughout; picture researchers Elsa Peterson and Susan Chevlowe; manuscript editor Barbara Curialle Gerr; and project editor Jeanette Ninas Johnson.

D.A.W.

Photographic Sources

References are to figure numbers unless indicated Pl. (plate).

Chapter 1 7: Eeva-inkeri, New York.

Chapter 2 24: (c) The Art Institute of Chicago. All rights reserved. 38: (c) The Art Institute of Chicago. All rights reserved. 39: GCB/Bernardo Chaves, Paris.

Chapter 3 47: Lichtbildwerkstatte "Alpenland," Vienna. (c) Dr. R. Handl.

Chapter 4 53: RMN. 62: Otto E. Nelson, New York. 66: RMN. 68: RMN. 69: (c) 1986 Founders Society, Detroit Institute of Arts.

Chapter 5 76: William Ryan.

Chapter 6 99: Knoedler Gallery, New York/Frank J. Thomas, Los Angeles. 102: Copyright (c) M. C. Escher Heirs, c/o Cordon Art, Baarn, Netherlands. 106: Howard Wilson. 108: Gretchen Tatge, Riverside, CT.

Chapter 7 114: Robert E. Mates, New York. 117: Yasuhiro Esaki. 123: Geoffrey Clements, Staten Island, NY. 125: (c) The Art Institute of Chicago. All rights reserved. 126: (c) The Art Institute of Chicago. All rights reserved.

Chapter 8 140: Al Mozell, New York. 142: Knoedler Gallery, New York. 143: Geoffrey Clements, Staten Island, NY. 144: (c) The Art Institute of Chicago. All rights reserved. 147: Bevan Davis, New York.

Chapter 9 153: Fototeca Unione at the American Academy, Rome. 155: Robert C. Dawson. 166: Brian Forrest, Santa Monica, CA. 178: Copyright (c) M. C. Escher Heirs, c/o Cordon Art, Baarn, Netherlands.

Chaper 10 179: Bo-ling Cheng, New York. 181: Allen Mewbourn, Houston. 182: Allport Associates Gallery, San Francisco. 184: RMN. 192: (c) The Art Institute of Chicago. All rights reserved. 193: Alan Zindman, New York.

Chapter 11 199: Berggruen Gallery, San Francisco. 205: Stein-Mason Studio, Boston. 209: (c) The Art Institute of Chicago. All rights reserved. 214: Trahan-Brocato Photo, New Orleans. 215: Sun Photo, Ann Arbor, MI.

Chapter 12 223: Bruce C. Jones, Centerport, NY. 238: Allport Associates Gallery, San Francisco.

Chapter 13 243: Tom Scott, Edinburgh. 248: Art Resource. 250: RMN. 258: Greg Heins, Newton Center, MA. 259: Robert E. Mates, New York. 263: Adam Reich.

Chapter 14 265: Hirmer Fotoarchiv. 267: RMN. 268: Alinari/Art Resource. 271: Otto E. Nelson, New York/Midtown Galleries. 274: Otto E. Nelson, New York/Midtown Galleries. 283: RMN. 292: RMN.

Chapter 15 299: (c) The Art Institute of Chicago. All rights reserved. 300: RMN. 302: (c) 1986 Sotheby's Inc. 308: Al Mozell, New York. 315: Bruce C. Jones, Centerport, NY. 317: (c) The Art Institute of Chicago. All rights reserved.

Chapter 16 332: Ted Adams, Inc. 335: Hellman Associates, Inc., Waterloo, IA.

Chapter 17 347: (c) The Art Institute of Chicago. All rights reserved. 350: (c) 1986 Founders Society, Detroit Institute of Arts.

Color Plates Pl. 6: Brian Forrest, Santa Monica, CA. Pl. 8: Allan Stone Gallery, New York. Pl. 9: Paula Cooper, Inc., New York. Pl. 10: Lee Fatheree. Pl. 12: Prudence Cuming Associates, London.

Contents

Introduction

The Nature of Drawing

Drawing . . . is the necessary beginning of everything [in art], and not having it, one has nothing.
—Giorgio Vasari

"Intimate," "delightful," "spontaneous," "direct," "unlabored"—these adjectives carry special implications of the affection that many critics and connoisseurs feel for that particular form of artistic expression known as *drawing*. Part of the reason for this fondness must certainly reside in the very informal and personal nature of the body of master drawings that comprise our legacy from the past. Unlike more elaborately finished works, drawings offer an intimate contact with the act of creation and thereby permit the viewer insights into the artist's personality. Like notes in a diary, drawings often present direct notation made by artists for themselves alone, free of artificial elaboration or excess finish.

If we compare a master painting with one of its preliminary sketches, we see not only the different approach and manner of execution characteristic of the two processes, but we also find hints of the artist's progress in conceptualization (Figs. 1, 2). In the drawing, we can sense the impulses that formed the final work. An exciting empathy occurs as we recognize the artist's enthusiasm, the sense of discovery, the lively interplay of hand, eye, mind, brush, pen, or pencil, and paper—all intensely human aspects of the creative art.

Another factor also helps to explain the appeal and power of drawing. The incomplete or fragmentary work, precisely because it does not provide a fully developed statement, may evoke a greater play of the observer's imagination than does a more finished expression. A sketchy work can be interpreted and becomes meaningful in terms of the viewer's individual experience. Our minds can readily supply the unspecified details in Edouard Vuillard's sketch of his mother reading (Fig. 3). By contrast, the closure of a carefully finished, fully detailed work such as Andrew Wyeth's *Beckie King* (Fig. 4) largely excludes such imaginative wanderings on the part of the viewer.

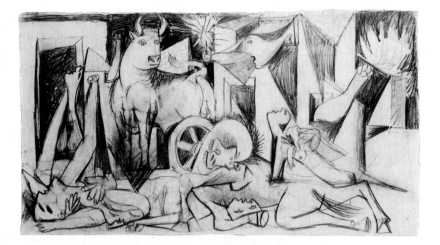

right: 1. Pablo Picasso
(1881–1973; Spanish–French).
Composition study for *Guernica*.
May 9, 1937. Pencil on white paper,
9½ × 17⅞″ (24 × 45 cm).
Prado, Madrid.

below: 2. Pablo Picasso
(1881–1973; Spanish–French).
Guernica. 1937. Oil on canvas,
11′5½″ × 25′5¾″ (3.49 × 7.77 m).
Prado, Madrid.

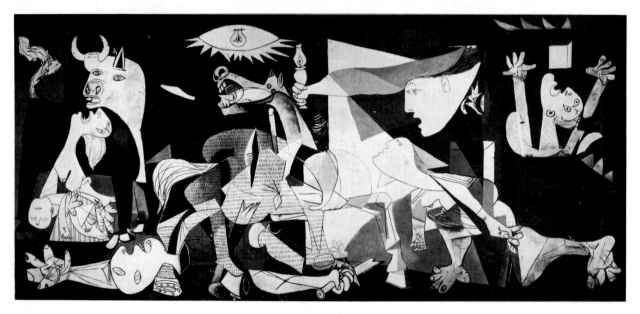

What Is Drawing?

The word **drawing,** used today almost exclusively in relation to the visual arts, implies making a mark by pulling or dragging a tool across a receptive background, usually a piece of paper. Drawing, however, goes beyond the act of simply making marks; it is making marks to communicate and share visually by the most immediate means responses to perceptions and experiences. The process of drawing, as will be stressed throughout the book, cannot be separated from the act of seeing. Additionally, thought, feeling, and judgment are essential to the process if drawing is to be more than mere representation.

A quick glance through the illustrations in this book will reveal that drawing encompasses a potentially endless variety of media and techniques. While it is perhaps more common to think of drawing in terms of black marks on white paper, many drawings include color, even a full spectrum of colors. Contemporary drawing exhibitions have come to include almost any works done on paper, with the result

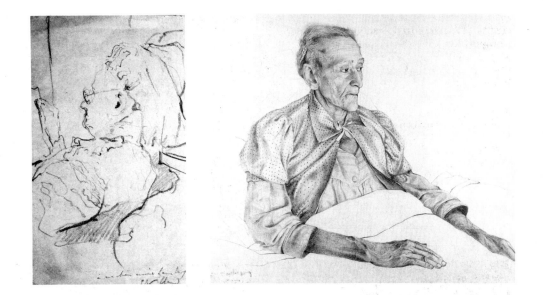

that it is sometimes impossible to separate drawing from painting. Categorization has become increasingly less important; the lines separating one area of creative endeavor from another have blurred, with some artists evidencing more concern about achieving a desired effect than about the process used.

Drawings are no longer limited in size, as they were for centuries, by the dimensions of sheets of handmade paper. Good drawing paper is now available in rolls that make possible drawings on a scale previously associated with works on canvas. A photograph of artist Chuck Levitan standing before his drawing *Lincoln Split* (Fig. 5) clearly establishes the monumental size of his images. Without such reference, it is only by reading captions and taking note of dimensions that we can begin to fathom the scale of individual works, which in a book such as this are all reduced to images of much the same size.

Referring to drawing as a "graphic art" creates a certain confusion. Technically, that term should be reserved for print processes such as etching, engraving, lithography, and serigraphy, in which **multiple** images are transferred to paper from a master plate, block,

left: 3. Edouard Vuillard (1868–1940; French). *Portrait of Madame Vuillard.* Pencil, 8⅛ × 4⅝″ (20 × 12 cm). Yale University Art Gallery, New Haven, Conn. (Edward B. Greene Fund).

right: 4. Andrew Wyeth (b. 1917; American). *Beckie King.* 1946. Pencil, 28½ × 34″ (72 × 86 cm). Dallas Museum of Fine Arts (gift of Everett L. DeGolyer).

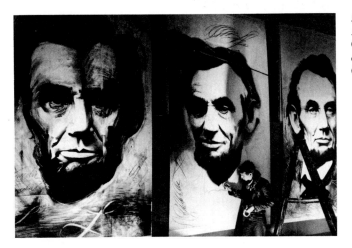

5. Charles Levitan (b. 1942; American). *Lincoln Split.* 1976. Charcoal pencil on paper, each 6 × 10′ (1.83 × 3.05 m). Courtesy the artist.

or silkscreen. A drawing is unique, calling for the initial and direct application of image to ground. It is appropriate, however, to include in an analysis of drawing those prints for which the original images were drawn on master plates.

Types of Drawings

For an introduction to the art of drawing we should briefly touch upon the various types of drawings and the functions they can perform. We might identify three broad categories—drawings that **describe** what is seen, that **visualize** what is imagined, and that **symbolize** ideas and concepts.

To many people, drawing means recording that which is before the eyes. This may entail a quick linear sketch executed in a personal shorthand that demonstrates the unique traits of an artist such as Rembrandt, an unequalled observer of the human condition (Fig. 6),

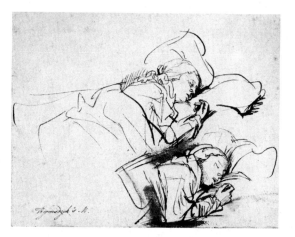

6. Rembrandt (1606–1669; Dutch). *Two Studies of Saskia Asleep.* c. 1635–37. Pen and brown ink, brown wash; 5⅛ × 6¾″ (13 × 17 cm). Pierpont Morgan Library, New York.

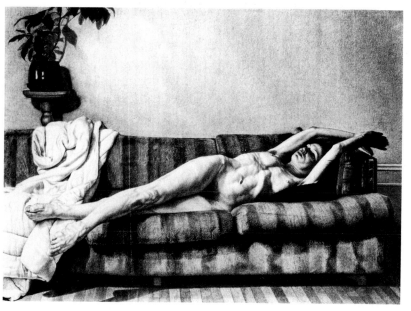

7. James Valerio (b. 1938; American). *Female Model on Sofa.* 1979. Charcoal, 30¼ × 42¼″ (77 × 107 cm). Courtesy Allan Frumkin Gallery, New York.

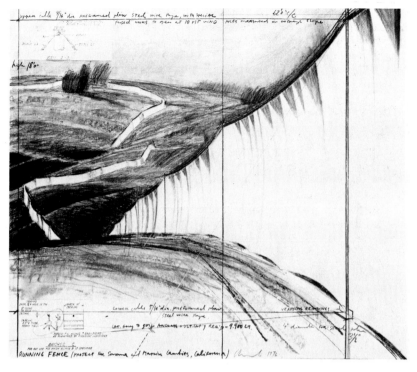

8. Christo (b. 1935; Bulgarian–American). *Running Fence*. 1973–76. Preparatory work. Fabric, pastel, charcoal, pencil and engineering drawings; 22 × 28″ (56 × 71 cm). Courtesy the artist.

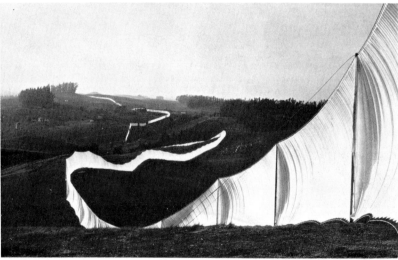

9. Christo (b. 1935; Bulgarian–American). *Running Fence* installed in Sonoma and Marin counties, California, for two weeks. 1976. Height 18′ (5.49 m), length 24½ miles (39.43 km).

or a carefully observed study, greatly detailed and nearly photographic in its accuracy as in James Valerio's *Female Nude on Sofa* (Fig. 7).

Drawing can also visualize a nonexistent situation or an object conceived in the imagination of the artist (Fig. 8). In 1972 Christo proposed extending an 18-foot-high cloth fence across 24½ miles (39 kilometers) of rolling hills in northern California, the fence eventually to disappear into the Pacific Ocean. Having conceived of the *Running Fence,* Christo was able to visualize what the effect would be before the actual construction took place three and a half years later (Fig. 9).

Visualization is not limited to representational images. It can be an abstract vision, such as Philip Guston's *Ink Drawing* (Fig. 10), which gives few clues to its figurative origins—if indeed these exist—but with its lines and shapes offering an expressive character of its own.

The third category of drawings is based upon the use of symbols as a convenient shorthand for nonverbal communication. Objects, ideas, and qualities can be represented as symbols that may or may not resemble the symbolized subject. In *Explosion Sketch* (Fig. 11) Roy Lichtenstein choses a familiar comic strip device to symbolize the radiating waves of energy, matter, and sound typically associated with an explosion. The imaginary sound it generates is of much greater intensity than the delightfully jarring jangle of Matt Kahn's *Doorbell* (Fig. 12).

10. Philip Guston (1913–1980; Canadian–American). *Ink Drawing*. 1952. Ink on paper, 18⅝ × 23⅝" (47 × 60 cm). Whitney Museum of American Art, New York.

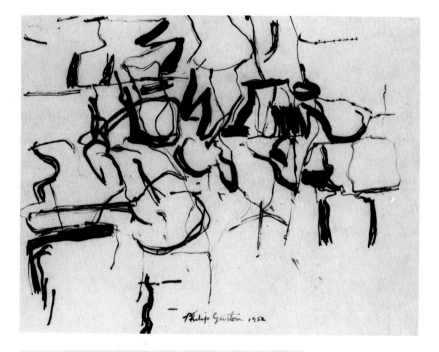

11. Roy Lichtenstein (b. 1923; American). *Explosion Sketch*. c. 1965. Colored pencil and ink, 5½ × 6½" (14 × 17 cm). Collection Mr. and Mrs. Horace Solomon, New York.

12. Matt Kahn (b. 1928; American). *The Doorbell*. 1955. Ink and charcoal, 23 × 14″ (58 × 36 cm). Private collection.

Claes Oldenburg utilizes each of the three categories in his drawings of a drum pedal (Figs. 13–15). Figure 13 represents the drum pedal as most people might expect to see such an object. In Figure 14, Oldenburg has imaginatively visualized the assembly in two different states of collapse, while the *Schematic Rendering* (Fig. 15) is a diagram that explains how the mechanism is assembled. All three drawings depict the same object, yet each drawing serves a separate function and provides the viewer with different information.

The three categories need not be treated independently. The drawing of the collapsed drum pedal, for example, incorporates both visualization and description. In each category, drawings can range from simplified, preliminary indications of form and ideas to intricately detailed, finished drawings. The effectiveness and completeness of any drawing depends not so much on elaborate development as on the degree to which it conveys the artist's intent.

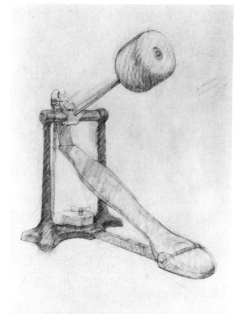

left: 13. Claes Oldenburg (b. 1929; Swedish–American). *Drum Pedal Study.* 1967. Pencil, 30 × 22″ (76 × 56 cm). Collection Kimiko and John Powers.

below left: 14. Claes Oldenburg (b. 1929; Swedish–American). *Drum Pedal Study—Visualization of Collapsed Version.* 1967. Pencil, 29 × 25½″ (74 × 65 cm). Collection Kimiko and John Powers.

below: 15. Claes Oldenburg (b. 1929; Swedish–American). *Drum Pedal Study—Schematic Rendering from Back.* 1967. Pencil and wash, 30 × 22″ (76 × 56 cm). Collection Kimiko and John Powers.

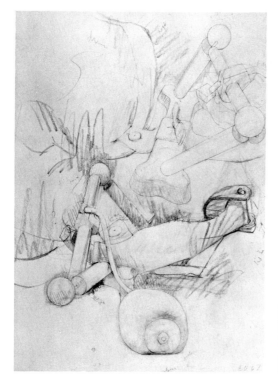

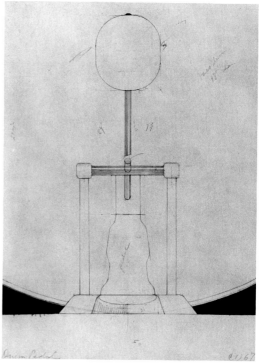

Expressive Drawing

It has been said that Pablo Picasso was born knowing everything there was to know about drawing. In contrast, Vincent van Gogh is described as a person with no natural talent who became an artist through sheer determination. Persons with an interest in learning to draw, plus the willingness and persistence to master some basic skills, can develop the ability to record with a certain degree of accuracy objects that are placed before them. Such drawing depends to a large degree upon learning to see. Drawing, however, as suggested by the examples reproduced in this book, involves more than making an accurate rendering of a subject, just as it requires more than the skillful manipulation of media and technique. Drawing is about content; it presents a point of view, interpretation, and expression unique to the individual artist.

As viewers we respond to those works that not only draw us closest to the artist by allowing us to share an interest, emotion, or insight, but also allow us to project our own experience and feelings. We find most appealing drawings that offer more than an ordinary depiction of a subject, drawings that reveal qualities about the artist as well as the subject. In *Studies of Manet* (Fig. 16), Edgar Degas depicts his model with great sensitivity, creating from direct observation an image that is both literal and poetic. Less literal, though nonetheless

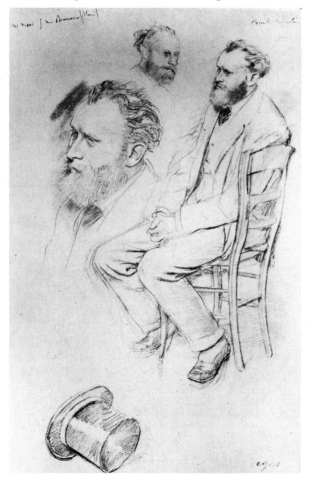

16. Edgar Degas (1834–1917; French). *Studies of Manet.* c. 1864–65. Pencil on pink paper, 16 × 11″ (41 × 28 cm). Louvre, Paris.

compelling, is Larry Rivers' *Portrait of Edwin Denby III* (Fig. 17), which combines vigorous drawing with a keen sense of selectivity. Equally effective in conveying a strong feeling of humanity, in spite of the deceptively childlike quality of the drawing, is Paul Klee's *A Trio Conversing* (Fig. 18). Comparing the three works, each done in pencil, we can see that while the choice of medium and technique contributes significantly to the effectiveness of the drawings, it is the individual sensitivity, character, and intention of the artist that gives expressive character to each of the works.

17. Larry Rivers (b. 1923; American). *Portrait of Edwin Denby III*. 1953. Pencil, 16⅜ × 19¾″ (42 × 50 cm). Museum of Modern Art, New York (given anonymously).

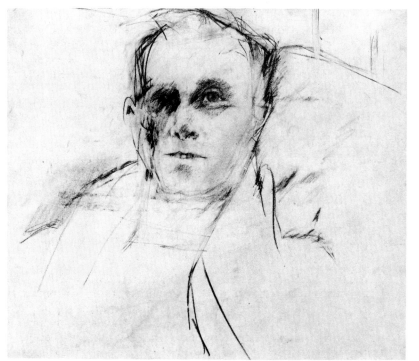

18. Paul Klee (1879–1940; Swiss–German). *Trio Conversing*. 1939. Pencil, 8½ × 11½″ (21 × 29 cm). Collection Felix Klee, Bern.

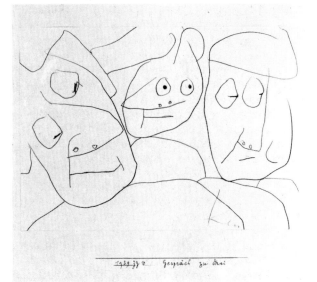

The Role of Drawing Today

Like much else in our artistic heritage, our conceptions about the role of drawing in the arts come to us largely from the Renaissance. During the early years of that period, drawing as we now practice it became established as the foundation of training in the arts. A long-term academic apprenticeship, which called for drawing from nature as well as copying studies executed by master artists, prepared students for their profession. In later centuries this system, with only slight alteration, continued as the accepted means of artistic training.

In the 20th century this procedure has been seriously challenged. The impact of abstract painting and other contemporary movements tended to make the arduous disciplines of earlier times seem irrelevant to the needs of the contemporary student. Many teachers and students believed that highly structured training inhibited the development of original and innovative forms of expression by encouraging students to depend upon trite and outworn formulas, rather than allowing their inner resources free play.

The early training of artists as diverse as Pablo Picasso, Henri Matisse, Paul Klee, Josef Albers, and Joseph Stella—all schooled in the conventional regimen—would seem to contradict that attitude. In addition to the early academic *Standing Male Nude* by Picasso (Fig. 19), included in the illustrations for this book are some rather surprising early drawings by Albers and Stella that are very different from the images with which they are so closely identified.

In a 1948 letter, Matisse wrote:

> . . . I am afraid the young, seeing in my work only the apparent facility and negligence in the drawing, will use this as an excuse for dispensing with certain efforts I believe necessary.

While academic procedures of the rigidity maintained in the ateliers of past masters no longer seem appropriate, a program of introducing guidance and instruction remains vital to artistic development. The initial experiences of the beginner leave an indelible imprint upon subsequent development. Although making accurate descriptive drawings need not be the ultimate goal, learning to *see* size, shape, and space relationships, and developing the discipline and control to translate convincingly what is seen onto a sheet of paper, provide a basic and essential vocabulary for the artist (Fig. 19). Having acquired that vocabulary, the artist is then free to choose to draw in whatever style is pleasing and seems appropriate to that which is to be expressed (Fig. 20). Picasso is reported to have commented that if he could draw as well as Raphael, as some observers suggested, he should be allowed the right to draw as he chose.

Rather than abandoning the discipline of drawing as irrelevant to contemporary art, we can choose to reinterpret the craft in terms of today's standards, which accept an increased variety of styles and a much wider range of expression than in the past. Abstraction (Fig. 10) flourishes side by side with the most disciplined realism (Fig. 7) or with exuberant whimsy (Fig. 18). Our increased catholicity of taste is, to an equal extent, the result of psychological understanding of the nature of human beings, with a consequent sympathy toward a broader range of expression.

Having the freedom to mix and manipulate media in whatever manner they choose, many artists, representing all levels of artistic maturity, now feel challenged to work with media in more tradition-

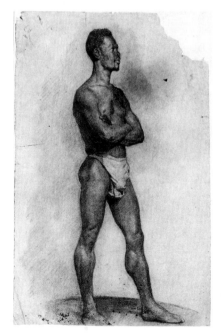

19. Pablo Picasso (1881–1973; Spanish–French). *Standing Male Nude*. 1896–97. Charcoal and crayon on light tan paper, 18⅝ × 12½″ (47 × 32 cm). Museo Picasso, Barcelona.

20. Pablo Picasso (1881–1973; Spanish–French). *Standing Female Nude*. 1910. Charcoal on white paper, 19 × 12¼″ (48 × 31 cm). Metropolitan Museum of Art, New York (Alfred Stieglitz Collection).

ally disciplined ways. For some who came of age during the heyday of abstract expressionism, using traditional, even "academic," drawing techniques in the pursuit of naturalistic imagery, sometimes in the monumental scale characteristic of other contemporary styles, is a novel experience.

Drawing has an essential role to play in our world, both as a means to an end—in the development or conceptualization of other expressions—and as an end in itself. The revived interest in representational styles and the figurative tradition testifies to a felt need for draftsmanly qualities in art. Most important, however, is the immediacy of drawing—a quality perfectly in tune with the spontaneity and free expression so greatly prized in contemporary society. Drawing is very much an art of today.

Initial Experiences

The basic concept of *Guide to Drawing* is contained in Camille Pissarro's instruction to his son Lucien, in a letter from 1883.

> . . . it is essential for both eye and hand to grasp the form, and it is only by much drawing, drawing everything, drawing unceasingly that one fine day one is very surprised to find it possible to express something in its true spirit . . .

Drawing is a matter of training the eye as well as training the hand—the hand responds to what the eye sees. While learning to see is a major topic of Chapter 3, the essential relationship between observation and representation will be a recurring theme throughout the book.

The subject chapters that follow have been structured around a series of projects with specific instructions for novice artists. Generally speaking, the exercises increase in difficulty throughout the book, although there is no rigid adherence to this scale. Even if all the projects are not executed, students are encouraged to read each one carefully to understand the concept presented.

Making Drawings

The purpose of the assignments is not to make beautiful drawings, nor even necessarily to make successful drawings. The purpose is to

learn to draw by making drawings—many drawings. Michelangelo is supposed to have said that his work contained 99 percent hard work and one percent genius. The value to be derived from the individual assignments can be only that value that the student is willing to give to them.

Beginners can expect to make some awful drawings. Mistakes will be frequent, but they can be corrected and changed. Success cannot be determined on the basis of just one experience, one drawing. If a first attempt is not satisfying, perhaps a second or third will be. Anything, whether it be playing a musical instrument, meditating, or drawing, becomes easier and more effective with continued practice. Practice contributes to increased technical competence and control.

Most drawings fail, not from lack of skill, but from lack of planning. Many artists and students mistakenly believe that planning automatically destroys freshness and spontaneity. The contrary is more often true, since knowing what one intends to do allows one to enter into the drawing process directly and spontaneously. The uncertainty and confusion that accompany lack of planning frequently result in overworking a drawing. In such instances, once the drawing problems have been solved, it can be advantageous to redo the drawing to achieve the desired freshness. Students are urged not to discard any of their drawings since development and improvement become most apparent when later works are compared to early efforts.

With increasing development of skills and confidence, the student may wish to concentrate on one type of drawing, one medium, or one variety of subject. This natural tendency should be exploited, since growth in **depth** is more important to artistic maturity than growth in **breadth.** Breadth of experience serves the primary function of helping individuals to find themselves. It is true, however, that any serious and intensive activity eventually demands an expansion of horizons. The beginner must constantly guard against the tendency to buttress an emerging artistic ego by repeating minor successes, thus neglecting the possible discovery of full strengths and capacities.

The work of most mature artists reveals periods of intensive concentration within a narrow framework of special problems alternating with periods of exploration and experimentation. It is not only wise, but essential, for the beginner to travel a similar path, concentrating on areas of particular interest as long as they remain challenging but, when success comes too easily, moving on to something else. It is true that without experience any new medium, technique, or subject may seem difficult, yet serious students soon discover that the understanding, discipline, and proficiency developed in one area is directly applicable to another. Although success is not always immediate nor ensured, each project, each new experience, contributes to creative growth. Exploration in breadth combined with concentration in depth requires the unique discipline that characterizes the artist—an inner control in which deep satisfactions and dynamic dissatisfactions alternate to stimulate continued growth. Through such discipline the art student discovers and reveals personal abilities, establishing the basis for mature artistic expression.

Looking at Drawings

Students should be aware that we also learn to draw by studying the works of other artists. This book is richly illustrated with master drawings, both past and present, selected to acquaint you with creative uses of media and techniques, and to introduce you to different approaches to handling form, composition, and subject matter. Understanding the way master artists see will expand your own ability to see. You are not encouraged to attempt to copy any of the drawings line for line to produce a facsimile of the original. That has little value. (The tradition of copying is discussed in Chapter 4.)

Presentation of Drawings

Drawings done as learning exercises are not necessarily intended to be exhibition pieces. There will be occasions, however, when more finished drawings will be exhibited, if only for classroom critique, at which time it will be appropriate to consider how the work is presented. Smudged, torn, wrinkled drawings pinned to a wall make much less of an impression than clean, neatly matted drawings. Mats that are clean, well cut, and as unobtrusive as possible focus attention on drawings by isolating them from whatever surrounds them. White or off-white mats are recommended over colored mats, which tend to draw more attention to themselves than to the artwork.

Mat knives or X-acto knives are satisfactory for cutting simple mats; beveled cuts require a mat cutter that holds a cutting blade securely at an angle. Razor blades are not recommended. A metal straightedge or T-square offers the best cutting edge. It helps if two people work as a team, one person holding down the straightedge with both hands to prevent slippage. Always position the straightedge so that if the knife slips it cuts into the part of the board to be discarded rather than into the mat.

Four strips of paper or cardboard are useful in determining the size of the opening to be cut. The mat should overlap the edges of the paper by at least three-eights of an inch (about 1 centimeter). The top and sides of a mat are always the same dimension; the bottom is one-half to one inch (1.25 to 2.5 centimeters) wider. Using paper tape hinges along one edge, attach the mat to a piece of backing board of the same outer dimensions. Position the drawing and attach to the backing with gummed paper tape—three or four small pieces of tape along the upper edge will be sufficient. (Pure-rag, acid-free board for both the mat and backing and linen tape are recommended for permanent matting projects.)

Students who develop the habit of doing full-sheet drawings can prepare two standard mats—one vertical, one horizontal—for classroom presentation. Portfolio preparation is discussed at the end of Chapter 16, Illustration.

Beginners' Media

*. . . but first you must learn
how to hold a crayon . . .*
—Adolphe William Bouguereau (to Matisse)

Beginners are urged to concentrate on the drawing media that are least demanding. The important thing is to draw as freely and uninhibitedly as possible, so that the transmission of impressions, ideas, and impulses will be direct and unself-conscious. Pencil, charcoal, ball-point pen, felt-tip pen, and brush and ink should meet initial needs and provide ample possibilities for expression. The following equipment and materials are generally standard and suffice to commence working. Other materials and tools can be added later.

drawing board (basswood or Masonite), 20 by 26 inches (51 × 76 cm)
thumbtacks (to use with basswood board)
masking tape (to hold sheets of paper to Masonite board)
newsprint pad, 18 by 24 inches (46 × 61 cm)
heavy clips (to hold newsprint pad to the drawing board)
4B or 6B graphite drawing pencil
large, soft pencil eraser
stick charcoal (soft) and compressed charcoal (0 or 00)
kneaded eraser
chamois
fixative (and fixative blower if fixative is not available pressurized cans)
ball-point and felt-tip pens (medium and wide)
India ink
medium-size pointed brush (No. 10), of the best quality you can afford
 (*not* an oil painting brush)

Charcoal

Charcoal, which is easy to apply and equally easy to remove, provides a rich and versatile medium for the beginner. At the outset, one should not overvalue expertise. Timidity most often inhibits development, while a relaxed use of charcoal encourages the direct expression of perceptions. Depending on the angle of the stick and the pressure exerted upon it, charcoal lines can be pale or dark, even in width or of varying widths, creating a repertoire for line drawings as well as for value studies (Figs. 21, 22). Charcoal is particularly prized for the ease with which it can produce a wide range of darks and lights of varying textures. Values from light gray to black result from dragging the stick on its side (Fig. 23) or from the application of sets of parallel or cross-hatched lines. When grays of minimum texture are desired, parallel lines and cross-hatching can be fused by rubbing gently with the fingers, with soft paper, or with a paper stump known as a **tortillon** (Fig. 24). Charcoal can be easily erased. Large areas can be wiped away with a piece of chamois; more precise corrections can be made with a kneaded eraser that can be shaped to a rather sharp point. Accumulated charcoal dust can be removed from a chamois by flicking it against something solid or by washing it, while charcoal picked up by the eraser disappears in the process of kneading and shaping the eraser.

21. Pablo Picasso (1881–1973; Spanish–French). *Still Life*. c. 1919. Charcoal on white paper, 28 × 20¾″ (71 × 53 cm). Private collection.

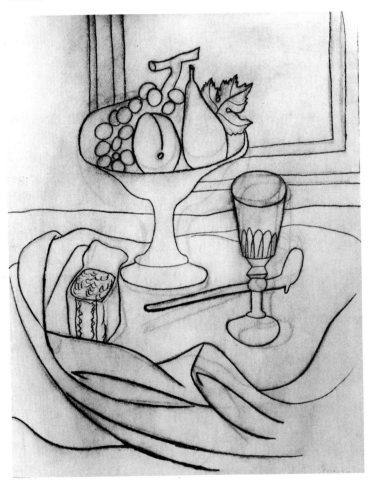

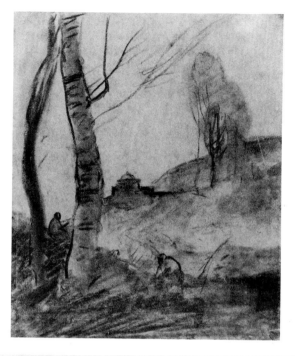

left: 22. Jean Baptiste Camille Corot (1796–1875; French).
The Great Birch: Souvenir of Ariccia.
1871–72. Charcoal on brown paper, 10⅝ × 9⅛″ (27 × 23 cm).
The Art Museum, Princeton University (gift of Frank Jewett Mather, Jr.)

below: 23. Käthe Kollwitz (1867–1945; German).
Self-Portrait with Pencil.
1935. Charcoal on gray paper, 16 × 17″ (41 × 43 cm). National Gallery of Art, Washington, D.C. (Rosenwald Collection).

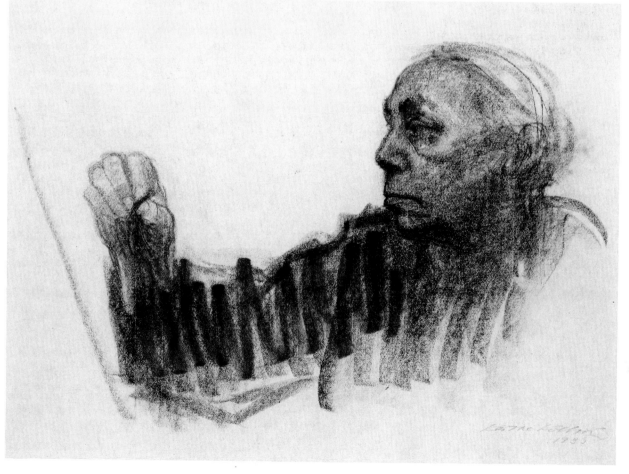

24. Pierre-Paul Prud'hon
(1758–1823; French).
Head of a Woman (Marguerite).
c. 1808. Charcoal,
14 × 11″ (36 × 28 cm).
Art Institute of Chicago
(Simeon D. Williams Collection).

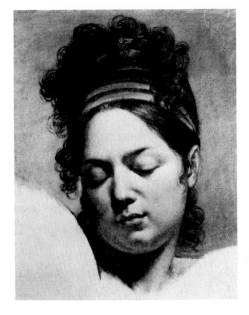

Project 2.1 Familiarize yourself with the nature of charcoal by drawing lines using varying amounts of pressure and changing the angle at which you hold the charcoal stick. Practice building tones with rapidly drawn clusters of diagonal parallel lines and cross-hatched lines. With the side of a piece of charcoal, lay down a smooth gradation of tone from black to very light gray. Do the same with lines fused by your fingers, reinforced by subsequent applications of charcoal and rubbing. Notice that excessive rubbing can result in the loss of freshness. In these preliminary exercises you will quickly become aware that while charcoal can be easily blended, it can be just as easily smudged, which necessitates learning to draw without resting your hand on the paper. To steady your hand for precise details, reach across and grasp the opposite side of the board with your other hand, using that arm to support your drawing hand.

Study the drawings in Figures 21 to 24 for the use of charcoal. Picasso's *Still Life* (Fig. 21) is drawn with a line of essentially uniform width. By wiping out rather than erasing completely, he allows us to see how carefully he has considered the exact shape and placement of each form. The drawing, which at first glance seems deceptively simple, suggests that it is unimportant that a line or a shape be correct as first drawn, as long as you change it.

In the second two examples the artists have relied upon the direct application of charcoal with gradations in tone resulting from variations in pressure rather than from blending. In her *Self-Portrait* (Fig. 23), Käthe Kollwitz not only represents herself at the drawing board but also allows the viewer to experience both the mental and physical process of drawing in the powerfully kinetic zigzag line that moves along the length of the arm connecting the eye, mind, and hand. Notice how she grasps the short piece of charcoal in her fingers, the length being equal to the width of the bold strokes in the drawing. Perhaps nowhere has the act of drawing been more graphically illustrated.

Most of the grain evident in these drawings derives from the texture of the paper itself. The paper used in the 19th century for most charcoal drawings—and still preferred by many artists—has a grainy texture that holds the charcoal (Fig. 23). Newsprint has almost no texture, so you cannot expect the same effect. When you advance beyond these initial drawings you probably will want to use better-quality papers.

Compressed charcoal is often referred to as chalk, and indeed many chalks are similar to charcoal, except that they tend to be harder to erase. All the activities of Project 2.1 could be executed in chalk as well.

Spraying finished charcoal drawings with a protective coating of fixative will prevent smudging. "Workable" fixative allows you to work back into the drawing after it has been fixed. To apply, hold the can upright about nine to twelve inches (about .3 meters) in front of the surface of the paper and spray with a back and forth motion. Use only in a well-ventilated room or better yet, in the open air. Caution should be taken not to inhale the spray, nor should it be used near a flame.

Pencil

The primary virtues of pencil for drawing are familiarity and relative cleanliness. We all learn to handle pencils in early childhood, if not for drawing, certainly for writing.

Holding a pencil in an upright position as for writing produces an essentially uniform line (Fig. 25) and encourages finger control most appropriate for working on small details. Although beginners generally feel most comfortable holding the pencil and other drawing tools in this manner, the result is often small, cramped images. Drawing on full sheets of paper using broader movements of both the hand and arm will result in looser, freer drawing.

Many artists prefer holding the pencil under the hand (Fig. 26) because it permits easier variation in thickness of the line; a slight shift of hand position utilizes either the point or the side of the lead to produce a line of greater interest. The latter position encourages a freer drawing, since neither the hand nor the arm rests on the paper. It also prevents smudging when working with soft drawing pencils, charcoal, and other media that smear easily.

Project 2.2 Before starting to draw specific things, spend a little time playing with the pencil so that you begin to think of it as a drawing tool rather than as a writing implement.

Observe the quality of line produced by the point of the pencil and by the side of the lead as you scribble freely on a piece of newsprint paper. Note the difference in line quality achieved by holding the pencil in the writing position (Fig. 25) and by holding it between the thumb and forefinger but under your hand (Fig. 26).

It is possible, using one pencil, to create a full range of gray tones (values) by increasing or decreasing the pressure. Fill in a series of two-inch (5-centimeter) squares with even tones of varying degrees of darkness, using broad strokes made with the side of the lead rather than with the point. It is not necessary to work for a smooth blending without any visible strokes as long as you achieve the effect of a uniform tone.

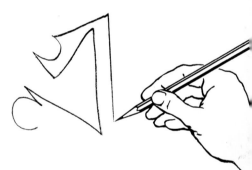

25. Line made by a pencil held in writing position.

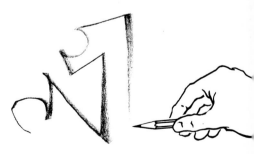

26. Line made by a pencil held under the hand.

Patterns of strokes—regular and uniform (Fig. 29) or more random and spontaneous (Fig. 30)—add visual interest to a pencil drawing. You will discover that the successful laying down of tones depends on learning to control pressure.

Project 2.3 With bold pencil strokes, produce gradations of tone from light to dark. Explore different directional strokes and patterns to create both gradations and uniform tones.

Figures 27 to 30 reveal a variety of lines, textures, and values. After tentatively locating, then repositioning, the figure, Degas indicates the body of his *Jockey* (Fig. 27) with long, sure lines made with sweeping movements of the hand, while the head is delineated more precisely. The drawing conveys the impression of Degas observing and thinking before drawing, whereas in Alberto Giacometti's *The Artist's Mother Sewing* (Fig. 28) we sense that observation and drawing are simultaneous, the artist's arm, hand, and pencil following the continuous movements of his eyes as they search form and space. Very different is Mary Cassatt's *Portrait of an Old Woman Knitting* (Fig. 29). Although the forms are generalized, the tones have been carefully and methodically studied. John Constable's landscape study, *Abingdon from the River* (Fig. 30), employs a more vigorous pattern of broad strokes with a soft pencil to achieve gradations of tone and to suggest textural differences. Strong, rich, dark accents stand out distinctly against the white of the paper.

27. Edgar Degas (1834–1917; French). *Jockey.* 1878. Pencil on light gray paper, 12¾ × 9⅝″ (32 × 24 cm). Detroit Institute of Arts (John S. Newberry Bequest).

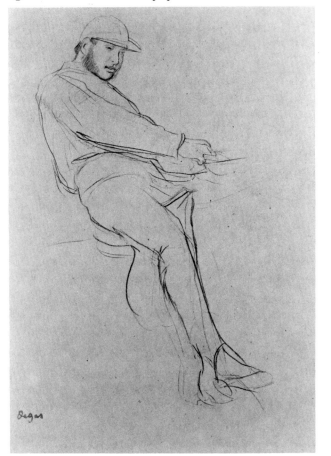

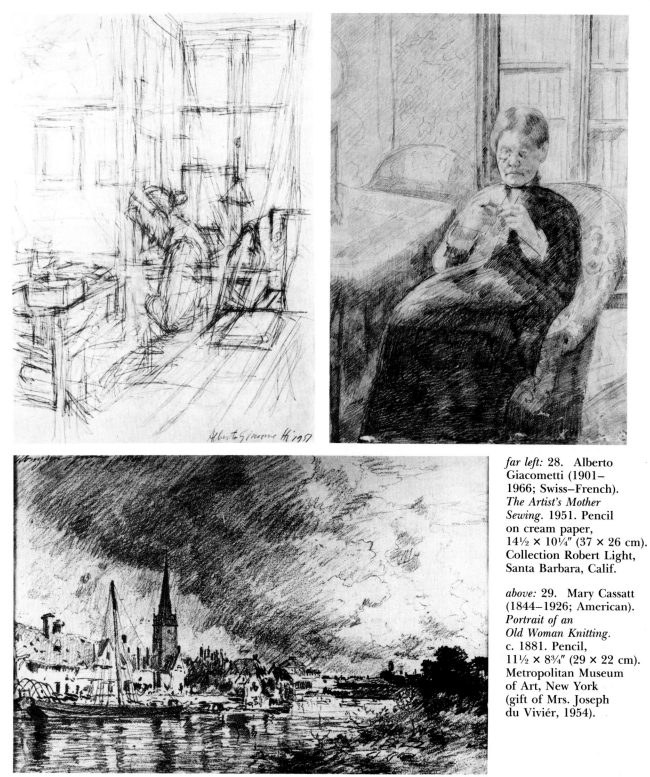

far left: 28. Alberto Giacometti (1901–1966; Swiss–French). *The Artist's Mother Sewing.* 1951. Pencil on cream paper, 14½ × 10¼″ (37 × 26 cm). Collection Robert Light, Santa Barbara, Calif.

above: 29. Mary Cassatt (1844–1926; American). *Portrait of an Old Woman Knitting.* c. 1881. Pencil, 11½ × 8¾″ (29 × 22 cm). Metropolitan Museum of Art, New York (gift of Mrs. Joseph du Viviér, 1954).

30. John Constable (1776–1837; English). *Abingdon from the River.* 1821. Pencil, 6¾ × 10¼″ (17 × 26 cm). Victoria & Albert Museum, London (Crown Copyright).

Project 2.4 Practice using a drawing pencil to create lines, values, and textures similar to those seen in Figures 27 to 30, applying the techniques to subjects of your choice.

Ball-Point and Felt-Tip Pens

The familiar, easy-to-use ball-point, fiber-tip, and felt-tip pens are capable of producing a variety of line widths. They therefore provide the beginner with a graceful transition from pencil and charcoal to brush and ink. Some inks are nonsoluble; others are water soluble and can be smeared with a wet thumb or a brush with water to introduce a painterly quality.

If you are not familiar with ball-point and felt-tip pens other than for ordinary writing purposes, you should be aware that the inks, particularly colored inks, are of questionable permanence and often subject to pronounced fading from extended exposure to light. To test for fading, block out half of a drawing with heavy lightproof paper and place it in direct sunlight for at least two weeks.

When directed to draw with a ball-point pen, beginning students are inclined to draw in outline. Feliks Topolski's pen-and-ink drawing *E. M. Forster and Benjamin Britten* (Fig. 31) suggests a method, easily duplicated with ball-point pen, that avoids strict outlining. Paul Schmitt combines a simple, loosely drawn outline with lively, sketchy textures to create a feeling of warmth and informality (Fig. 32). David Park has used broad felt-tip markers to establish large, simplified patterns of light and dark (Fig. 33).

Project 2.5 Experiment with using ball-point and felt-tip pens of varying widths, taking full advantage of the strength and rich textures these pens permit. Thumbing through the book and looking at examples of pen and ink drawings will suggest other drawing styles.

31. Feliks Topolski
(b. 1907; Polish).
E. M. Forster and Benjamin Britten.
Pen and brown ink,
9¾ × 7¾″ (25 × 20 cm).
Sotheby Parke-Bernet.

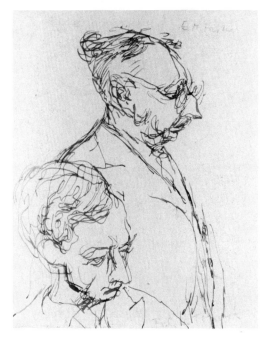

above: 32. Paul Schmitt
(b. 1937; American). *Farfields.*
c. 1971. Felt-tip pen,
10 × 13¾″ (25 × 35 cm). Collection
Dan W. Wheeler, New York.

33. David Park (1911–1960;
American). *Standing Nudes.* 1960.
Felt-tip pen, 11 × 9″ (28 × 23 cm).
Courtesy Maxwell Galleries, Ltd.,
San Francisco.

Initial Experiences **27**

Brush and Ink

Brush and ink demand a certain assurance of execution, since lines cannot be erased. The bold, fluid lines that result from the free play of brush and India ink give a certain authority to a drawing, and a self-confidence emerges from the successful use of the brush. The flexibility of the pointed brush allows for a rich variation in lines and effects.

The choice of line contributes to the expressive character of a brush drawing. The impression of lightness and aliveness in Picasso's brush drawing (Fig. 34) results, in part, from the contrast between the long, flowing lines of the figure and the broad, individual strokes of the vegetation. Using an almost weightless line, and without shading, Picasso subtly introduces a sense of volume through the subtle thickening of the contour line. In viewing Picasso's drawing together with Matisse's *The Necklace* (Fig. 35), executed with such directness and certainty, we not only see very different qualities of line, but at the same time can feel the physical difference in the way each artist held and manipulated his brush.

Hokusai (Fig. 36) and Ben Shahn (Fig. 37) both use clusters of lines to depict folds in garments, but the character and effect differ. Hokusai's rhythmic patterns of curved lines are as animated as the poses of his figures. Each line is one continuous brush stroke, while the lines in Shahn's drawing are a series of short, broken, ragged strokes. In both examples the choice of line is appropriate to subject and mood.

below: 34. Pablo Picasso (1881–1975; Spanish–French). *L'Amour Masqué.* January 5, 1954. Brush and ink, 12½ × 9⅜″ (32 × 24 cm). Courtesy Galerie Louise Leiris, Paris.

below right: 35. Henri Matisse (1869–1954; French). *The Necklace.* 1950. Brush and ink, 20⅞ × 18⅛″ (53 × 46 cm). Museum of Modern Art, New York (Joan and Lester Avnet Collection).

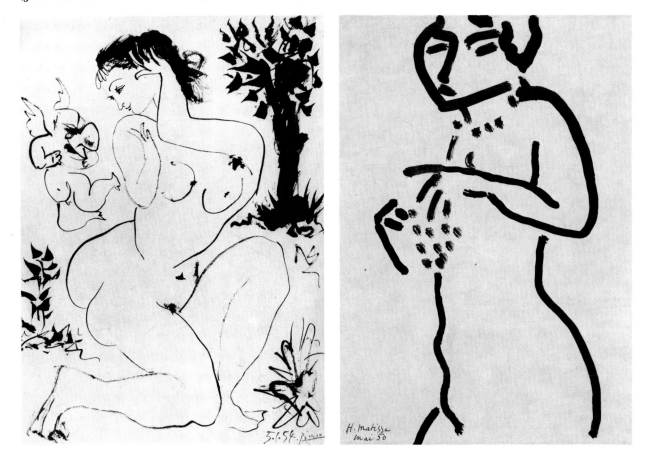

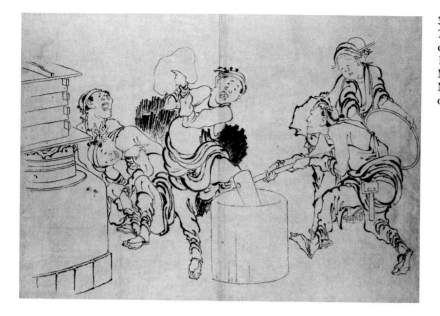

36. Hokusai (1760–1849; Japanese).
The Mochi Makers, from an album
of studies. Brush and ink,
16¼ × 11⅝″ (41 × 30 cm).
Metropolitan Museum of Art,
New York (gift in memory
of Charles Stewart Smith, 1914).

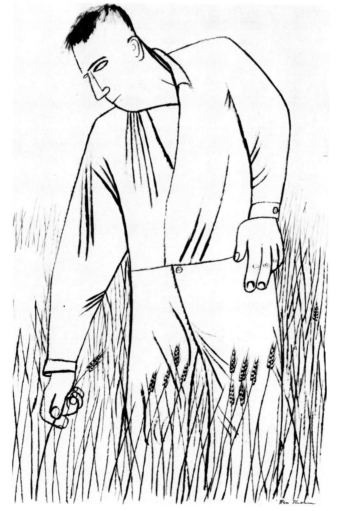

37. Ben Shahn
(1898–1969; Russian–American).
Man Picking Wheat (or Beatitude).
1950. Black ink on paper,
38 × 25″ (97 × 64 cm).
Harvard University Art Museum,
Cambridge, Mass. (bequest of Meta
and Paul J. Sachs).

38. Henri Matisse (1869–1954;
French). *Nude in a Folding Chair*.
c. 1900. Brush and black ink on white
paper, 25⅞ × 18⅜″ (66 × 47 cm).
Art Institute of Chicago (gift of Mrs.
Potter Palmer, 1944).

Project 2.6 To commence drawing, dip your brush in India ink and
then press it against the side of the bottle neck to remove excess ink
and create a point. Begin by exploring the different kinds of lines you
can make with the brush—lines similar to those illustrated, lines that
change from thin to thick and back to thin by increasing and decreasing
the pressure with which the brush is applied to the paper.

Your first attempts may seem hesitant and awkward. Gradually, if
your intention is to do more than simply cover the paper with brush
strokes, you will start to feel more comfortable working with the brush;
you will begin to develop the control necessary to give meaning and
expression to brush drawings.

Project 2.7 Make a number of drawings of the same subject or ob-
ject, using different kinds of lines for each drawing. Repeat individual
drawings until you are satisfied that the quality of the line is effective. A
good test is to ask yourself whether you would find the drawing inter-
esting if it had been done by someone else.

Broad areas of tone used in combination with line can produce
interesting painterly effects. In *Nude in a Folding Chair* (Fig. 38), Ma-
tisse departs from simple outline to suggest volume by introducing
modeling on the figure and creates space by placing the light figure
against a dark background. The textural patterns and suggestions of
modeling are done with a fully loaded brush. The bold brush drawing
Swann and Odette (Fig. 39) is an illustration by Luis Marsans for Marcel
Proust's *Remembrances of Times Past*. The figures are silhouetted
against a patterned and textured background. By placing Odette so

39. Luis Marsans (b. 1930; Spanish). *Swann and Odette*. 1968. Ink on paper, 9 × 9⅛″ (23 × 23.2 cm). Courtesy Galerie Claude Bernard, Paris.

she is seen both light against dark, and dark against light, Marsans creates a sense of volume to offset the flatness of the silhouettes. The texture in the drawing reveals the use of **drybrush.**

Project 2.8 Do a group of drawings that will allow you to introduce solid and broken areas of tone. To produce drybrush effects, wipe excess ink from the brush on paper toweling before dragging the brush lightly over the paper.

Summary

It is not important if the exercises done for the assignments in this chapter are not of exhibition quality, or even if they fall into the "awful drawing" category. If you did more than a single drawing for each assignment, you probably began to experience, perhaps in only a limited sense, that practice contributes to competence and control.

Further explorations into the uses of media and technique will elaborate on these preliminary experiences.

3 Learning to See

. . . there's something that's very intense about the experience of sitting down and having to look at something in the way that you do in order to make a drawing or a painting of it. By the time you've done that you feel that you've really understood what you were looking at . . . and somehow it becomes a method of possessing the experience in a unique way.

—Robert Bechtle

Perhaps the most fundamental discipline involved in drawing is learning to record what one sees. Contrary to popular misconceptions, this is not primarily a matter of manual skills. The physical requisites for drawing are minimal: average sight and average manual dexterity. *Drawing is a matter of seeing*, rather than of 20-20 vision and deft fingers. Here we are not considering the special qualities of an original or powerful artist but rather the skill and habits involved in becoming an adequate draftsman—a person who can look at an object, analyze the relationships of size, shape, space, value, and texture, and then create an analogous set of relationships on paper as a graphic record of visual perceptions.

Learning to draw necessitates learning to see in a new way. From earliest childhood our hands, our bodies, and most of all our eyes—placed in our swivel-pivoting heads—appraise objects in terms of their three-dimensional character. This is how we know them. It is, therefore, frequently difficult for a beginner drawing a cube placed at eye level to avoid showing the top plane of the cube, knowing that it is there even though it cannot be seen. Rather than looking at the object and drawing only what can be seen, the beginner draws according to a preconception about the object—and often cannot see the difference.

When we commence to draw, we are surprised to discover the degree to which any object except a sphere presents a different appearance each time we change the position of our eyes in relation to it. The beginning draftsman is faced with a new problem: three-dimensional patterns based on a fixed relationship between the draftsman's eyes and the object being drawn. Since actual spatial depth is absent from the surface of the drawing paper, three-dimensional reality must

be interpreted as a two-dimensional pattern. *Descriptive drawing is illusion.* Much of learning to draw consists of discovering how things *appear* rather than how they *are,* and it is not until we begin to draw that most of us realize the tremendous difference between what we *know* about objects and what we *see.*

Learning to draw, then, demands a reevaluation of visual experience, a new dependence on visual cues about the appearance of objects and their relationships in space. Most of us are familiar with the art of children, which is based upon concepts of how things are; near forms are placed at the bottom of the page, and more distant objects appear higher on the page, with each separate form depicted as a complete image. Folk artists and traditional Oriental artists often employ the same devices for representing spatial depth. Most people in Western cultures, however, readily accept two other concepts relating to forms in space: (1) one object placed in front of another partially obscures the object in back (think how you shift your head in a movie theater to prevent the relatively small head immediately in front of you from obscuring most of the giant screen); (2) objects appear to diminish in size when seen at a distance. In Toulouse-Lautrec's *The Laundress* (Fig. 40) the woman's basket and the carriage at the left, as drawn shapes, are measureably equal in size; her head is as large as the carriage on the right, twice the size of the full figure farther to the right.

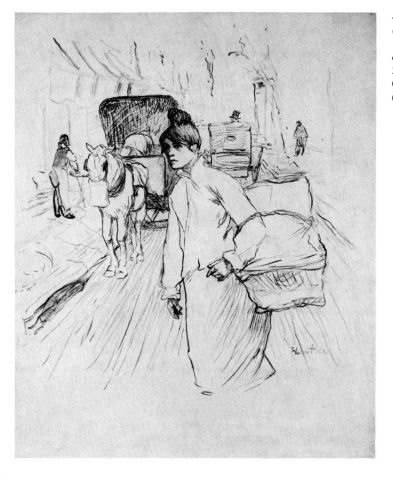

40. Henri de Toulouse-Lautrec (1864–1901; French). *The Laundress.* 1888. Brush and black ink, with opaque white on cardboard; 30 × 24¾″ (76 × 63 cm). Cleveland Museum of Art (gift of Hanna Fund).

Perspective, Foreshortening

Changes occur in the appearance of three-dimensional forms when seen from a variety of viewpoints. Geometric or architectural objects are seen and drawn in **perspective,** which can be accomplished by following a system of rules (see Chapter 9). **Foreshortening** is the term that applies specifically to organic and anatomical forms seen in perspective. Drawing a foreshortened view depends on the careful observation of overlapping shapes and diminishing scale rather than on a set of rules. *Carolyn* by Theophilus Brown (Fig. 41) reveals both perspective and foreshortening. A more dramatic use of foreshortening is evident in Charles White's *Preacher* (Fig. 42).

Project 3.1 The perspective of simple rectangular forms can be introduced by making some drawings of this book. The book will appear as a perfect rectangle only if held vertically at eye level or placed flat on a table and viewed directly from above. In any other position it becomes a rectangle seen in perspective and acquires a nonrectangular shape.

Draw the book in a number of positions seen from varying viewpoints. In doing so, do not think of it either as a book or a rectangle. See it simply as a series of shapes enclosed within four straight lines,

41. Theophilus Brown
(b. 1919; American).
Carolyn. Pencil,
11½ × 14½″ (29 × 37 cm).
Courtesy the artist.

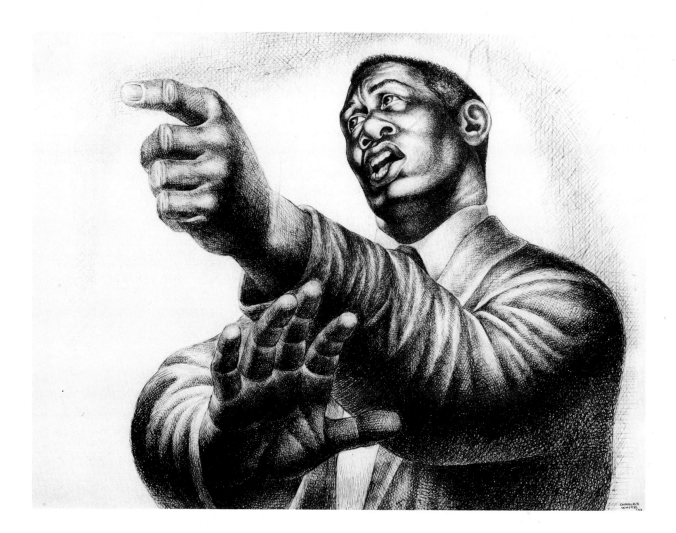

lines that sometimes appear to be parallel, sometimes appear to converge. Though you know the actual shape and proportions of the rectangle, draw what you see, even when what you know to be the narrow width of the rectangle appears to be much greater than its length. You will become aware that visual analysis of a geometric shape is unrelated to determining the exact dimensions of the object; it is a matter of establishing relative proportions. A more systematic development of perspective will be undertaken in Chapter 9.

Project 3.2 Drawing the complex undulations of large leaves involves a careful analysis of the twistings and turnings of foreshortened forms. Take a branch with three or four leaves on it—magnolia or avocado leaves are excellent (Fig. 43). Tracing a single leaf pressed flat provides one description of the leaf but one having little to do with its appearance as it exists in space. As similar as they may be in size and shape, no two leaves will be seen as the same shape, nor will any single leaf retain the same appearance when viewed from a different angle. When drawing, it is necessary to observe your subject continuously. Most drawing mistakes occur from not looking at the model.

42. Charles White (b. 1918;
American). *Preacher*. 1952.
Ink on cardboard,
21⅜ × 29⅜″ (54 × 75 cm).
Whitney Museum of American Art,
New York (purchase).

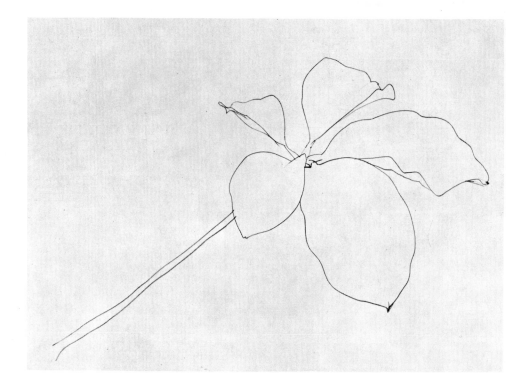

43. Ellsworth Kelly (b. 1923; American). *Five-Leaved Tropical Plant.* 1981. Pencil on paper, 18 × 24″ (46 × 61 cm). Collection Mr. and Mrs. S. I. Newhouse, Jr., New York.

Draw the cluster of leaves from several different angles, noticing the constantly changing relationships of shape, size, and proportions. It is most important in this and subsequent projects to base your drawings on visual analysis. Look repeatedly at what you are drawing. Draw exactly what you see, not what you think you know or what you think it should be. You will discover that you produce more accurate descriptions of the forms selected by attending to lines, shapes, and proportions than by thinking about drawing leaves.

Project 3.3 Make a similar sequence of drawings of other fairly large, solid, organic objects.

Mechanical Aids to Perception

We have been working with relatively simple forms to acquaint the beginning student with habits and concepts involved in representational drawing. The next project, involving more complex forms, introduces certain mechanical aids and procedures useful in determining relationships of size and shape. Although the ultimate goal is to develop eye, mind, and hand coordination, there are a number of simple mechanical aids that can help ascertain size and shape relationships and help determine the correct position or angle of a line. Sometimes such devices help to guide initial judgments at the start of a drawing; sometimes they help identify mistakes.

Certain poses and gestures are frequently employed to identify particular activities. To mimic an artist at work, one has only to close one eye and sight along an upright thumb extended at arm's length. In truth, this gesture depicts one of the most useful aids to perception. It is an action that even the most experienced artists employ to great

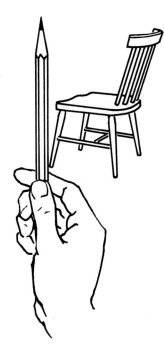

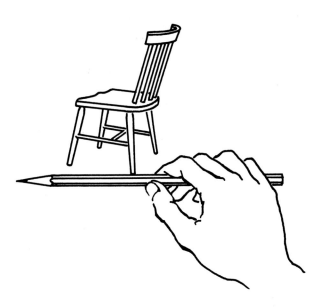

advantage, especially during the preliminary stages of drawing and painting from life.

Figures 44 to 46 illustrate: (1) how a pencil can be used to check critical vertical and horizontal alignments; (2) how it can serve as a measuring device to determine proportional relationships.

Vertical and Horizontal Alignments

In Figure 44 the pencil, used as a plumb line, indicates that the bottom of the chair leg is to the left of the front corner of the seat. The angle formed by the pencil and the leg clearly shows the degree to which the leg varies from vertical. As the pencil is moved to the right it will reveal other significant alignments.

The pencil held in a true horizontal position (Fig. 45) is equally useful in determining relationship of above and below. If the pencil were moved up so that it appeared to touch the bottom of the right front leg, for example, it would be possible to ascertain whether that detail should be drawn above or below the point where the rung connects with the left back leg.

It is possible to determine horizontal by sighting along the top edge of a drawing board and to find vertical by looking at the line of a door frame or the corner of a room.

Proportional Relationships

In spite of what we actually see, it is startling to discover how much our perception, unchecked, is influenced by what we know about an object. When we know that in physical reality one dimension is greater than another, our natural inclination is to draw it that way, being

44-46. Any drawing instrument can be a useful aid in perceiving alignments.

44. Held in a vertical position, a pencil serves as a plumb line to determine vertical alignments.

45. Held as a true horizontal, a pencil helps to determine horizontal alignments.

convinced that we also see it that way. Developing the habit of using the pencil as a measuring device to establish relative proportions is one of the most important aids in learning to see—thus learning to draw. Consistent measurements depend on holding the implement at arm's length, since any change in distance between the pencil and the eye destroys the accuracy of the measurement. Closing one eye eliminates double vision.

The chair in Figure 46 is viewed frontally from above. One might have difficulty in determining the proportion of height to width. Holding the pencil at full arm's length and allowing the tip of the pencil optically to "touch" the left edge of the seat, you can mark the width of the seat on the pencil by moving your thumbnail to the point corresponding to the right edge of the seat. Turning the pencil vertically, being certain to keep your thumbnail in place on the pencil, allows you to estimate that the height of the chair, as drawn, is about two and a quarter times greater than the width of the seat. (If it were viewed exactly at eye level, the depth of the seat would be subtracted, making the proportion about two to one.)

The measurement, based on the image seen, is taken from the lowest point to the highest point—in this example the bottom of the front legs to the center point of the top piece. You should be aware that although in actuality the entire top edge of the back of the chair would be equidistant from the floor, the center of the back appears to be higher than the outer corners when viewed from above because it curves deeper into space.

below: 46. A pencil held horizontally at arm's length permits optical measurement of the chair seat.

right: 47. Egon Schiele (1890–1918; Austrian). *Organic Movement of Chair and Pitcher.* 1912. Pencil and watercolor, 18⅞ × 12⅛″ (48 × 31 cm). Albertina, Vienna.

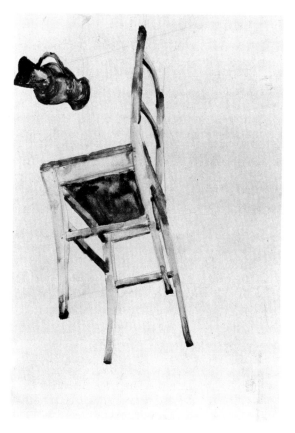

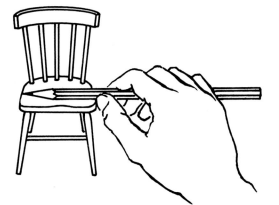

Project 3.4 Study a wooden chair placed in front of you in a number of positions: facing you, turned away from you, sideways, at an angle, on its side, upside down, and tilted. Note how the size and shape relationships between the parts change with each different position. Use your pencil in the manner described to locate and align major points, to determine correct angles, and to estimate relative proportions.

When you begin to feel comfortable using the pencil as an aid in perceiving the chair, do a number of drawings of the chair in various positions, letting your pencil serve as a measuring device as well as a drawing implement.

Anyone wishing a greater challenge is invited to choose a more difficult subject, such as a bicycle. Even objects of great complexity can be depicted with amazing accuracy when the pencil is used to search out the essential visual clues.

It is difficult for the inexperienced artist to perceive the potential of interesting forms inherent in very familiar, commonplace objects. Notice how Egon Schiele created a very interesting drawing (Fig. 47) by selecting an unusual viewpoint from which to look at a simple chair.

Project 3.5 At various times throughout the book it will be suggested that you "draw without drawing." It is an activity that does not require drawing materials other than your eyes and your finger as a substitute for a pencil to check vertical and horizontal alignments and make measurements. Take advantage of free moments to look at things around you and imagine how you would draw them. Determine size and shape relationships, check angles and relative positions of above and below, and right and left.

Proportional Rectangles

Any single form or group of objects can be drawn in correct proportion by first drawing a rectangle to enclose the subject. Measure the maximum height and width of the subject and lightly draw a rectangle of that proportion on the paper. Divide the rectangle into quarters by drawing a vertical and a horizontal line through the point where the diagonals of the rectangle intersect. Locate the midpoint of the subject by measuring with a pencil to determine what part of the subject fits into each section of the rectangle. If the subject is complex, individual quarters can be subdivided. Block in the major shapes, the main structure, before getting involved with details.

Drawing proportional rectangles and fitting the objects into them requires that you study each form carefully. As suggested in Project 3.2, seeing and drawing objects simply as shapes rather than as specific, identifiable things often results in more accurate representation.

Defining Forms with Negative Space

A viewfinder created by cutting a small square or rectangular opening in a piece of light cardboard or stiff paper serves as another aid to perception. It can be used to study vertical, horizontal, and proportional relationships, and if cut to the proportion of the drawing paper, it can be used like the viewfinder of a camera to frame a composition. If taped to something transparent, such as Plexiglas or clear acetate on which a grid has been drawn, it can be used in a manner similar to that of a divided proportional rectangle.

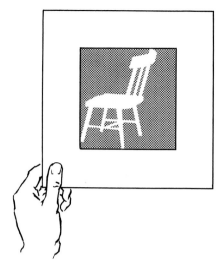

Another function is illustrated in Figure 48, in which the viewer is held at a distance that permits the entire object (**positive shape**) to be seen through the aperture. By allowing the object to fill as much of the square as possible, letting the object appear to touch the edges of the opening, the **negative space** that surrounds the object becomes defined as shapes. Often it is possible to draw an object more correctly by delineating the negative space rather than the object itself, since an artist generally has fewer concepts about the shape of space as compared to what is known about the object.

Project 3.6 Cut a two-inch-square (5-centimeter) opening in a piece of cardboard or stiff paper. Look at a chair placed in a number of positions through the viewer. Do a drawing of the negative spaces—the areas left between the edges of the square and the contour of the chair. Also draw as shapes the spaces you see between the rungs, legs, stretcher bars, and other parts. Even a simple wooden chair provides an excellent exercise in drawing, since it consists of a number of parts of

above: 48. A simple viewing square cut from cardboard or stiff paper enables the artist to see vertical, horizontal, and proportional relationships, and permits analysis of negative space.

right: 49. Fairfield Porter (1910–1975; American). *Study.* Date unknown. Ink on paper, 13½ × 10¼″ (34 × 26 cm). Whitney Museum of American Art, New York (gift of Alex Katz).

varied shapes. Its forms are not strictly geometric, nor are they as subtle as anatomical or organic forms. For additional drawings, arrange the chair so that it is viewed from an unusual angle—tipped on its side, turned upside down, or rotated to an unfamiliar position.

Negative space plays a significant role in the drawings and paintings of Fairfield Porter. *Study* (Fig. 49) might appear, at first glance, to be a sheet of six separate landscape sketches in which one is uncertain whether Porter has drawn shapes or spaces. When the viewer becomes aware that the intervals between the individual panels are the window frames of a screened porch, what seemed to be negative space is transformed into positive shapes. Realizing that the drawing defines both indoor and outdoor space, a very noticeable shift in focus is necessary to move from interior to exterior. It is almost impossible to see foreground and background at the same time. Even though there is no variation in the line, nor any attempt to create space through the use of light and dark, once the notion of space is suggested, it cannot be ignored. If, however, you choose to overlook the clues such as the ends of the roof beams that cut notches into the upper rectangles, and think of the panels as paintings hanging on a wall, everything, including the landscapes, becomes flat and no refocusing is required.

Right Brain, Left Brain

Using a pencil, or any other implement, for measuring and as vertical and horizontal guides, using a cutout rectangle as a viewer and grids to clarify relationships of parts, and focusing on negative spaces to define positive shapes are valuable aids to perception because each activity isolates seeing and drawing from knowing and identifying. What is drawn becomes the result of perception (seeing), rather than conception (thinking).

As a teacher of drawing, Betty Edwards, author of *Drawing on the Right Side of the Brain* (J. P. Tarcher, Inc., 1978), was puzzled as to why some students found it easy to draw when for others it was difficult, and why certain drawing activities produced better results than did others. The answer, she was convinced, related to different methods by which the two hemispheres of the brain process information—the left brain controlling verbal and analytical processing, the right brain controlling that which is intuitive, spatial, and relational, all that is part of visual processing, of seeing/perceiving.

In her classes and in her book, Edwards provides drawing experiences that tap into the special functions of the right hemisphere of the brain. For some people the mental shift into what Edwards calls "right-mode" happens automatically; they are the persons who draw easily. For others, the process can be learned. The various activities that have been discussed in this chapter as aids to perception are all part of the process. They are methods that experienced artists use, part of what Edwards describes as "the magical mystery of drawing ability."

4 Copying and Sketching

I have always, undoubtedly for a number of reasons, wanted to copy and taken pleasure in copying, either from originals, but above all from reproductions, every work of art that touched my feelings or stirred my enthusiasm or just interested me particularly.

—Alberto Giacometti

The Tradition of Copying

What comes across in reading what artists have to say about their own work is how much they acknowledge looking at, being influenced by, and learning from the work of other artists. Contemporary American painter Wayne Thiebaud credits most of his training to reading about artists and studying reproductions of their works in library books. He explains that art history remains a primary source for his paintings, and he acknowledges that he continues to make copies of paintings and drawings in order to learn from them.

Copying, in its various forms, is a legitimate activity, not for the purpose of imitation, but as a means of learning—learning to see, learning about styles and techniques—as well as stimulating the imagination. During the Renaissance, drawings existed only as preparatory studies for paintings and as patterns to be copied by apprentice artists as part of their training. It was not until the 16th century that drawings came to be considered works of art to be collected. At that time monarchs and wealthy families began amassing impressive collections of drawings, but their collections generally were inaccessible except to those artists directly favored with their patronage. Museums and galleries as we know them did not come into existence until the early 19th century.

Even though we do not all live in major metropolitan areas with museums and galleries, we have unprecedented access to art from all periods through reproductions in books, catalogs, and periodicals. In fact, it is so easy for us to see art today that we tend to forget how difficult it was in the past for artists to see and study masterworks.

During the 17th century, for example, the only place where Rembrandt was able to see and study masterworks was in auction houses. He was fortunate that Amsterdam had become the world capital for trading art, and that many major Italian collections were sent there to be sold. Rembrandt went to auctions not just to look, but to buy. Kenneth Clark describes him as an "eager and extravagant" collector, explaining that "certain works of art were absolutely necessary to him. He needed to possess them not simply to enjoy them, but to learn from them," and when he could not afford to buy, he made sketches of pieces that interested him.

Clark, in tracing Rembrandt's debt to the Italian Renaissance, notes that "all great artists have studied the work of their predecessors and borrowed from it, if they have felt the need . . ." Rembrandt, for example, knew Leonardo da Vinci's *Last Supper* from engravings and made various studies based upon that work (Fig. 50). Later he was to introduce the rising figure from the left end of the table into his own painting *The Syndics* (Fig. 51).

Nineteenth-century French artist Edgar Degas described his own art as "the result of reflection and study of the great masters." Like Rembrandt, Degas was an avid collector. His interest was focused par-

50. Rembrandt (1606–1669; Dutch). *Copy of Leonardo de Vinci's "Last Supper."* Red chalk on paper, 14 × 18¼″ (37 × 48 cm). Metropolitan Museum of Art, New York (Robert Lehman Collection).

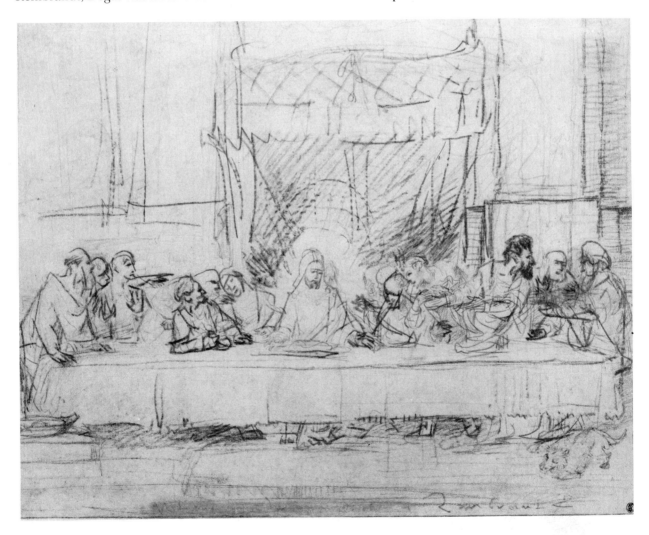

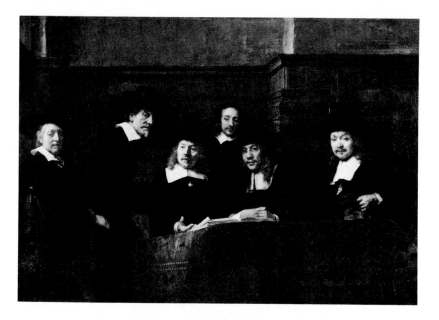

above: 51. Rembrandt (1606–1669; Dutch). *The Syndics.* Oil on canvas, 6'7⅞" × 8'11⅞" (1.85 × 2.74 m). Rijksmuseum, Amsterdam.

right: 52. Edgar Degas (1834–1917; French). *Sketch after Ingres' "Bather."* 1855. Pencil on paper, 6 × 4⅛" (15 × 11 cm). Bibliothèque Nationale, Paris.

ticularly on Ingres, Delacroix, and Daumier, whom he regarded as the "three great draftsmen" of the 19th century. He owned 20 paintings and 90 drawings by Ingres; 13 paintings and 190 drawings by Delacroix; and 6 paintings and drawings, plus 1800 lithographs by Daumier. Degas made direct copies of works he admired (Figs. 52, 53). Frequently, he introduced ideas adopted from other artists' work into his paintings as acts of tribute.

Ancient and Renaissance sculpture, in the original or in plaster replicas similar to those still found in art schools, introduced the human figure to countless generations of art students and provided them with acceptable standards for "noble physiques" and "eloquent poses." The highly finished study of the head of Michelangelo's *Guiliano de' Medici* (Fig. 54) is credited to someone from the workshop

left: 53. Jean Auguste Dominique Ingres (1780–1867; French). *Bather.* 1808. Oil on canvas, 4'8¾" × 3'2¼" (1.44 × .97 m). Louvre, Paris.

of the Venetian painter Tintoretto. It might have been drawn during a visit in Florence where the figure comprises part of the Medici tombs in the Church of San Lorenzo. The drawing would have been instructive not only to the artist, but to other artists in Venice who had not seen the original work.

Peter Paul Rubens executed many copies of High Renaissance masterpieces during the eight years he spent in Italy. It is from one of his drawings, in fact, that we have knowledge about the appearance of a Leonardo da Vinci painting that has since disappeared from view. Rubens also made studies of antique Greek and Roman sculpture, including the vigorous pen drawing *Head of Hercules* (Fig. 55), apparently drawn from a Greek Hellenistic figure discovered in Rome only a half-century earlier. The structure of the head and the convoluted patterns of the hair and beard have been executed with deftness and certainty.

If we look at other drawings done from Greek sculpture, it is interesting to compare Paul Cézanne's study of *The Borghese Martyr* (Fig. 56), its focus on volume and structure, with Giacometti's free-flowing, searching analysis of the exaggerated and complex movement of *The Laocoön* (Figs. 57, 58).

Giacometti copied from everything, tracing lines with his fingers when he had no pen or pencil in hand. He explained that in the evening and during periods of waiting he would open art books at random and make copies. For him copying was a means of clarifying

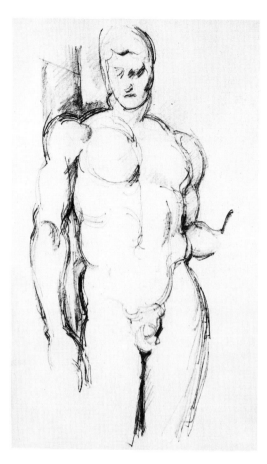

left: 56. Paul Cézanne
(1839–1906; French).
Il Marte Borghese, studio dall' antico.
c. 1895. Pencil, 8 × 4¾″ (21 × 12 cm).
Kunstmuseum, Basel.

below left: 57. Alberto Giacometti
(1901–66; Swiss–French).
The Laocoön (Vatican Museum, Rome).
Ball-point pen on paper,
8¼ × 11½″ (20.9 × 29.2 cm).
Collection Louis Clayeux, Paris.

below: 58. Agesander, Athenodorus,
and Polydorus of Rhodes.
Laocoön Group. c. 150 B.C.
Marble, height 8′ (2.44 m).
Vatican Museums, Rome.

his knowledge about what he was seeing—not by a slavish line-for-line duplicating of the work or the photograph, but almost by feeling form, rhythm, and placement with his pen, pencil, or finger.

A question that often must be asked when looking at a work of art is whether it is original, copied, or merely influenced by someone else. Visual artists, like musicians, often acknowledge those that they admire. Picasso, for example, did a series of variations of both Delacroix's *Algerian Women* and of Velásquez's *Maids of Honor;* the English artist Francis Bacon used the Velásquez *Portrait of Pope Innocent X* as the basis for a number of paintings. John Piper's ink-wash value study of Giorgione's *Tempest* (Fig. 59) offers a simplified analysis of the use of light and dark as an important aspect of pictorial composition.

Perhaps as a response to art history classes, as well as to the staggering market for fine art reproductions that exists today, a number of contemporary artists have turned to art as the subject for art, creating drawings and paintings that are reproductions of reproductions. Larry Rivers, in his study for *Rainbow Rembrandt*, has improvised on *The Polish Rider*, until recently credited to Rembrandt (Fig. 60). The title refers to the row of squares with color notations across the top of the drawing, inspired by the color scale used by commercial photographers when copying a work for reproduction. It is doubtful that Rembrandt would object to Rivers' reinterpreting his painting since we have seen that Rembrandt himself took delight in revising the works of Leonardo da Vinci.

59. John Piper (b. 1903; English). *Copy of Giorgione's "Tempest."* 1952. Black ink and gray wash over purple crayon on white paper, 15″ (38 cm) square. Harvard University Art Museum, Cambridge (bequest of Meta and Paul J. Sachs).

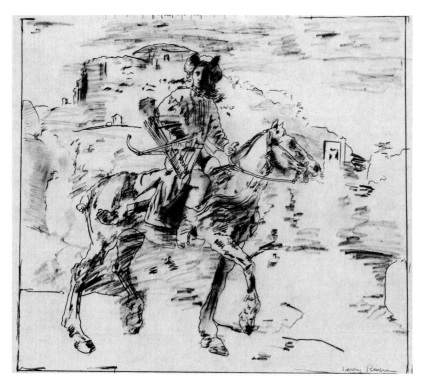

60. Larry Rivers (b. 1923; American). *Study for Rainbow Rembrandt.* 1977. Pencil on paper, 29¾ × 41¾" (76 × 106 cm). Courtesy Robert Miller Gallery, New York.

Copying Activities

Each of the drawings considered represents an aspect of copying, but not one of them is an exact copy, nor are you encouraged to attempt to copy any drawing line for line to produce a facsimile of the original for there is little value in that. It would be appropriate and beneficial, however, to practice drawing in the manner of some of the many examples reproduced in this book, which have been selected to acquaint you with a variety of creative uses of media and techniques and to introduce you to different approaches to handling form, composition, and subject matter. Use other art books and museum catalogs, as well, to broaden your pictorial vocabulary. In the process, do not allow yourself to become intimidated if your drawings do not exhibit the same mastery of media and technique.

Looking at reproductions is but a poor substitute for studying original works. Try to see original drawings whenever possible. If it is not convenient to copy directly from them, study them line for line, detail by detail, as you would if you were making a copy.

The Tradition of Sketching

The late-19th-century French painter Gustave Moreau stunned his more conservative teaching colleagues at the Ecole des Beaux-Arts in Paris by sending his students, including Henri Matisse, into the streets to observe and sketch life around them. While it might not have been deemed appropriate academic procedure, sketching in the streets certainly was not a new concept. Just as artists throughout history have

61. Salvator Rosa (1615–1673; Italian). *Six Studies of Figures for the Angel Raphael Leaving the House of Tobit.* Pen, brown ink, and brown wash; 5½ × 8″ (14 × 20 cm). The Art Museum, Princeton University (bequest of Dan Fellows Platt).

62. Isabel Bishop (b. 1902; American). *Men, Union Square.* Pencil, 12½ × 12¾″ (32 × 33 cm). Courtesy Midtown Galleries, New York.

copied, so too have they done quick drawings from life, frequently in the streets and other public places where people gather.

Whether or not the lively figures in Salvator Rosa's *Studies for the Angel Raphael and Tobit* (Fig. 61) actually were sketched in the street, they have a directness and spontaneity that could be expected from such drawings done by an artist with a keen eye and quick hand.

The denizens of Union Square in New York City—unemployed men standing and sitting about in the street during the Depression, young working women perched on stools in drug store soda fountains—became the unsuspecting models of Isabel Bishop. For drawings such as *Men, Union Square* (Fig. 62), she was forced to work rapidly before the men altered their poses.

Sketchbooks

Leonardo da Vinci suggested: "You will be glad to have by you a little book of leaves [pages] . . . and to note down notions in it with a silver-point . . . when it is full, keep it to serve your future plans, and take another and carry on with it." Leonardo's "little book of leaves," what we refer to as a sketchbook, is one of an artist's most important tools. As Leonardo indicated, a primary purpose of the sketchbook is collecting information and recording ideas, either jotted down quickly or explored and developed more fully, depending on the occasion. A second purpose of perhaps greater importance, particularly for beginners, is that sketching helps train the eye and the hand.

Degas did as Leonardo directed. Preserved in the Bibliothèque Nationale in Paris are 38 of Degas's notebooks containing more than two thousand pages of sketches, studies, and copies, plus more than five hundred individual sheets of drawings, notes, projects, and quotations. The notebooks include quick sketches as well as more detailed studies of works of art he admired, theatrical performances he attended, and persons and places he observed, plus preliminary sketches as well as specific details for projects he was planning. A page from Notebook 4 combines both copying and sketching in a study he made of Titian's *Pope Paul III* (Fig. 63).

A sketchbook can be of any form—bound, spiral, a looseleaf binder, even loose sheets carried in a folder or envelope. While some sketchbooks are manufactured with quality drawing paper that can be used with a variety of media, an adequate and inexpensive substitute is a bound or spiral notebook with blank pages, commonly available in college bookstores. The obvious advantage of a bound or spiral book is that both eliminate the problem of losing individual sheets. A disadvantage of a bound book is the inevitabilty of wanting to discard one or more pages. A sketchbook, however, is not meant to be a book of finished drawings with the book itself being considered a work of art. Anyone looking through the pages of Degas's notebooks immediately perceives that the drawings were done only for himself, yet in spite of the inclusion of bad drawings, false starts, and seemingly meaningless doodles, the collection offers a remarkable record of creative activity.

Approaches to Sketching

Sketching is an essential activity for both amateur and professional artists in collecting and recording information, but sketches are of little value as reference unless the lines, shapes, and forms have meaning. Rembrandt's *Three Studies of Women, Each Holding a Child* (Fig. 64), sketched directly with a fast-moving pen, reveals that clarity of concept is not dependent on completeness or detail. Even without drawing full figures, he presents a strong sense of aliveness and human caring. Almost as a bonus, the sheet includes a characterful sketch of a bearded man in a large fur hat. Rembrandt's drawings were done mostly on individual sheets that he filed by subject for later use in his paintings and prints.

Somewhat similar to the Rembrandt example of a group of separate sketches assembled on a single sheet is Picasso's *Scène de Bar* (Fig. 65). The various studies are related only in that, as the title indicates, they depict figures observed in a bar. Individual heads and figures are placed wherever space is available, rather than to establish a composition. Although it is barely defineable, in the center of the page Picasso suggests what appears to be a tangled party of inebriates struggling to

63. Edgar Degas (1834–1917; French). *Copy of Titian's "Pope Paul III, Naples,"* from Notebook 4. Pencil. Bibliothèque Nationale, Paris.

64. Rembrandt (1606–1669; Dutch). *Three Studies of Women, Each Holding a Child.* Pen and brown ink, 7⅜ × 5⅞″ (19 × 15 cm). Pierpont Morgan Library, New York.

65. Pablo Picasso
(1881–1973; Spanish–French).
Scène de Bar, page of studies. c. 1900.
Conté, 5 × 8⅛″ (13 × 21 cm). Courtesy
Christie, Manson & Woods, Ltd.

hold each other upright. The figure in the lower right corner is indicated in a very simplified manner, while the woman at the left is defined with greater individuality. Picasso maintained a daily routine of sketching as evidenced by the 175 sketchbooks discovered following his death in 1973.

The term **sketch** generally implies a drawing done quickly with minimal or no elaboration. Effective sketching requires being able to see quickly and clearly, being able to concentrate and make judgments. The regular practice of sketching contributes to continuous development so that in time the response of the hand to the eye becomes spontaneous.

It is unfortunate that increasingly the camera has come to be accepted as a 20th-century substitute for the sketchbook. It is true that the camera is useful in gathering and recording information, traditionally a function of the sketchbook. What a camera cannot do, however, is perform a second function of much greater value to the beginning artist, that of training the eye, mind, and hand. It is precisely that training, gained through years of sketching, that permitted Jean François Millet, in his crayon sketch *Morning* (Fig. 66), to suggest the strong, steady, yet graceful movement of the donkey with lines, some tentative and searching, some direct and assertive, some not even drawn. The effectiveness and beauty of the sketch lies in the skill and sensitivity with which he responded to the moment of vision with the appropriate choice of lines. Even though awkwardly drawn, the stride of the figures provides an interesting visual contrast to that of the animal. It seems unlikely that a drawing done from a photograph of the same grouping would have produced so satisfying an image.

Henri de Toulouse-Lautrec lived at a time when cameras and photography were becoming more popular, and although he sometimes used photographs as a source for his work (Figs. 289, 290), he seemed to be more amused by posing for the camera. Toulouse-Lautrec sketched obsessively. According to one writer, "He had a sketchbook everywhere he went, and his pen or pencil was always running in fluid nervous lines through it, or on any other surface that was handy . . ."

66. Jean François Millet (1814–1875; French). *Morning.* Black crayon, 6¾ × 10″ (17 × 25 cm). Louvre, Paris.

Individual artists evolve their own style or styles of sketching, sometimes using different techniques depending on the subject being depicted and the medium being used. In decided contrast to the quiet, gentle mood created by Millet, Toulouse-Lautrec's *Vintage in Celeyrau* (Fig. 67) depicts energy and power with a pen line equal in strength and intensity to that of the straining animals.

Sketches are not intended to be highly detailed, finished drawings. The degree to which individual sketches are developed is determined by time limitations, the purpose for which the sketch is in-

67. Henri de Toulouse-Lautrec (1864–1901; French). *Vintages à Celeyran.* 1883. Pen and ink, 9⅜ × 13¾″ (24 × 35 cm). Musée Toulouse-Lautrec, Albi.

tended, and the amount of information needed. While Alfred Sisley's *The Moret Road at St. Mammès* (Fig. 68) provides only a scribbled indication of shapes and masses, his years of accumulated experience as a landscape painter would allow him to extract the necessary information from so few lines and squiggles. Sisley's sketch, however, might well seem useless to someone such as Thomas Cole. Cole, one of America's first important landscape painters, would hike into the wilderness, sketchbook in his backpack, to make highly detailed drawings, including written notations (Fig. 69), for paintings to be done in his studio during the winter months.

right: 68. Alfred Sisley (1839–1899; English–French). *The Moret Road at St. Mammès.* 1883. Pencil, 4¾ × 7½″ (10 × 19 cm). Cabinet des Dessins, Louvre, Paris.

below: 69. Thomas Cole (1801–1848; English–American). *Maple, Balsam Fir, Pine, Shaggy Yellow Birch, White Birch.* 1828. Pencil, 10¾ × 14½″ (27 × 37 cm). Detroit Institute of Arts.

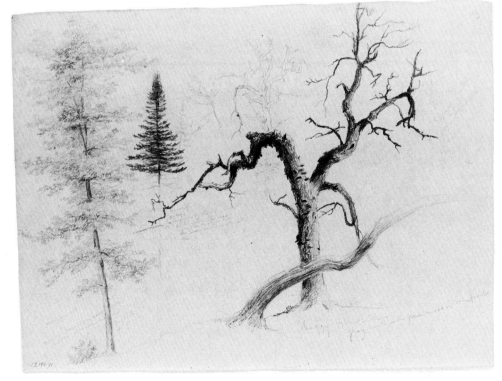

Sketchbook Activities

If you choose to follow Leonardo's guidance, you will carry a sketchbook with you at all times and draw in it whenever you have a few free minutes, sketching anything and everything—people, animals, things (Fig. 70). Even objects that do not seem "artistic" can prove intriguing to draw. Whether it is intriguing or not, draw whatever you see before you. If you accept that every sketch, every drawing you do is a learning experience, you need not be concerned about choice of subject matter—anything and everything is available and appropriate.

Remember that sketches are not meant to be finished drawings; more often they are merely notations in which an artist records a visual impression of something seen, remembered, or imagined. John Sloan's *Sketch for "McSorley's Bar"* (Fig. 71), which was developed into one of his finest paintings, was drawn on two overlapping scraps of paper, apparently all that he could rummage together as he stood at the bar.

Sketchbooks for artists are like journals for writers. They provide a continuous source of motifs and ideas for composition as well as an entertaining record of the past. They also play a key role in teaching you to see and draw.

70. Vincent van Gogh (1853–1890; Dutch–French). *Cows in a Meadow,* from an Auvers Sketchbook. 1890. Black crayon on squared paper, 3⅜ × 5¼″ (9 × 13 cm). Rijksmuseum Vincent van Gogh, Amsterdam.

left: 71. John Sloan (1871–1951; American). *Sketch for "McSorley's Bar."* 1912. Pencil, 6 × 6½″ (15 × 17 cm). Huntington Library and Art Gallery, San Marino, Calif. (gift of the Virginia Steele Scott Foundation.)

PART 3

The Art Elements

Line is defined in the dictionary as "a long thin mark frequently made with a pencil." A device invented to describe and circumscribe, it provides the basis for the simplest kinds of artistic expression, but also serves in the creation of the most complex and sophisticated works of art.

Value is the quality of relative darkness or lightness through which we perceive form. It also contributes to emotional impact, to a sense of drama.

Form, the most fundamental of the art elements, is experienced from our earliest stages of awareness and continuously thereafter. Round, square, organic, geometric, and numberless other descriptions of form are known to us consciously or unconsciously. The two-dimensional aspect of form is **shape.** In its negative aspect, we know form as **space.**

Texture, a surface attribute of form, is experienced through more senses than sight alone. Roughness, smoothness, and other textural qualities can be experienced through the sense of touch and are even an important part of taste.

Composition is the organization of line, value, form, shape, space, texture, pattern, and color as the underlying structure of a picture. Just as in learning to write one can profit from dissecting a sentence to study the parts of grammar separately, so in drawing, the interrelationships of parts to the whole can best be perceived by understanding the various elements and developing resourcefulness in their manipulation.

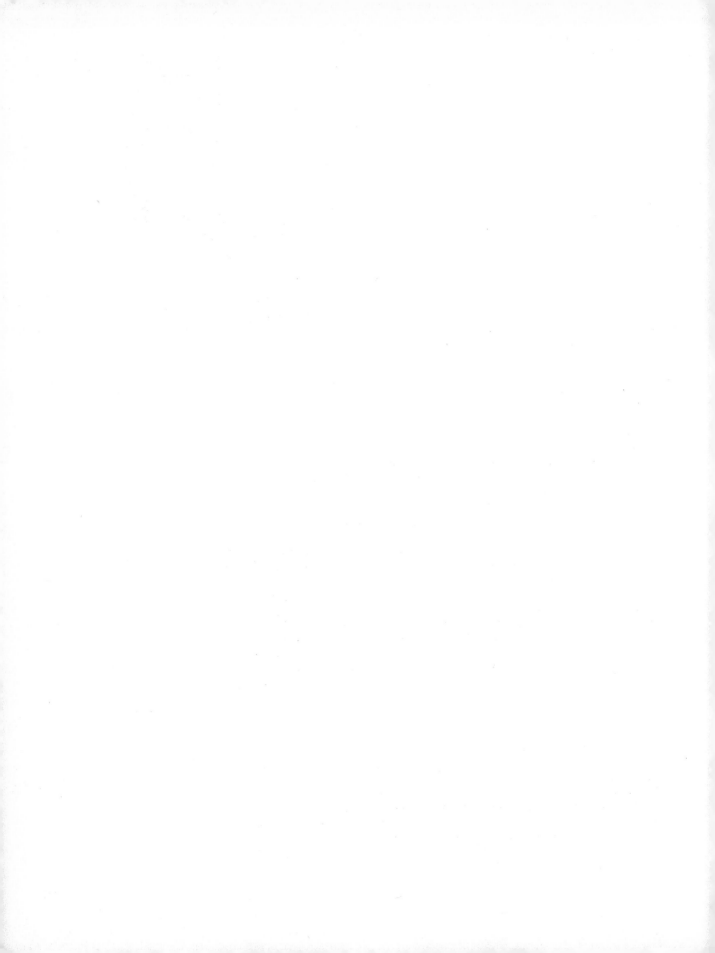

Line 5

*Everyone knows that even a single line
may convey an emotion.*
—Piet Mondrian

Line is the most important graphic element—it can be used objectively to describe forms and record visual observations, or subjectively to suggest, evoke, and imply an endless variety of experiences, conceptions, and intuitions. There is almost nothing that cannot be symbolized with a line. The beginning student, learning to draw, soon discovers what is involved in assuming command over so powerful a tool.

The simplest line suggests direction; divides space; has length, width, tone, and texture; and may describe contour. As soon as the line begins to change direction—to move in curved or angular fashion, to fluctuate in width, to have rough or smooth edges—its active and descriptive powers increase many times. Every mark made on paper, whether it be a thoughtful line or just a scribble, inevitably will convey something of the maker to the sensitive observer. It is possible for the viewer to conclude that Robert Blum's lively, energized sketch of the painter and teacher William Merritt Chase (Fig. 72) is as revealing of the temperament of the artist as it is expressive of the nature of the subject.

The Contour Line

Line is a convention that artists use to translate that which they see as three-dimensional reality into visual symbols on a flat, two-dimensional surface. As we observe forms we do not see lines; we see edges of forms. As the subject moves or is moved, as the position of the viewer/artist changes in relation to the subject, other aspects of the form and new edges are revealed. Lines that delineate the edges of

forms, separating each volume or area from neighboring ones, are termed **contour lines.**

In its simplest and most characteristic form, as in Amedeo Modigliani's *Seated Nude* (Fig. 73), contour line is of uniform width, is not reinforced by shading, and does not seek to describe modulations of surface within the outer contour unless they constitute relatively separate forms, as in Gaston Lachaise's *Standing Male Figure* (Fig. 74). At its most expressive, contour line appears to follow the artist's eye as it perceives the edge of a form.

To develop sensitivity and skill at contour drawing, the student tries to master an exact and almost unconscious correspondence between the movement of the eye as it traces the precise indentations and undulations of the edge of a form and the movement of the hand holding a pencil or pen. This faculty of eye-hand coordination is invaluable in all drawing activities, because it involves knowing what the line should reveal before it is drawn.

Project 5.1 A soft pencil is best for beginning contour drawing because it produces a firm, relatively unmodulated line. Contour drawings can be made of any object, but geometric forms are not as interesting to draw as irregular subjects such as a shoe or boot, a book bag, a baseball mitt, or your own hand or foot. (Strictly symmetrical objects are not

good because beginners are likely to be disturbed by the inevitable deviations from symmetry that occur in contour drawing.)

Although it may seem unnatural, position the object so that you must turn away from your paper to see it. This way, you will be less tempted to keep glancing at your drawing. Start drawing at some clearly defined point, attempting to work about life size. Let your eye move slowly along the contour of the form, keeping your pencil moving in pace with the movement of your eye. Try to respond to each indentation and bulge with an equivalent hand movement. Do not let your eye get ahead of your pencil. Both looking and drawing should be slow and deliberate; speed is not your goal. When you come to a point where the contour being followed disappears behind another or flattens out to become part of a larger surface, stop, glance back at your drawing if necessary to determine another starting point, and commence drawing the adjoining surface.

Contour drawings done with minimum reference to the paper often grow wildly out of proportion, but accuracy is not a primary concern; rather, contour drawing is an exercise in coordinating the eye and the hand.

Change the position of your subject and repeat the procedure. Draw other objects, placing them in other than their usual position. Seeing them in a different perspective forces you to look more carefully. After you begin to feel some confidence in your drawings, attempt the same exercise, this time drawing with your other hand.

Project 5.2 As a challenge and a valuable exercise, close your eyes and draw the same object from memory by re-creating the visual and physical sensation. The process is more important than the immediate results, stimulating as it does visual recall, which provides the basis for drawing from memory.

Project 5.3 Do a contour drawing of a more complex form or group of objects—a bunch of bananas, celery, beets, or carrots; a paper bag or basket with onions, leeks, or other vegetables or fruits of irregular shape; various kitchen utensils such as an eggbeater or electric mixer; a telephone. Remember that very ordinary objects increase in visual interest when tipped on their sides or seen in other than their customary positions. Still-life subjects are suggested because they are so readily available, but do not hesitate to draw the human figure whenever possible.

Begin with the closest form or the most forward part. Try to draw all around each form or part without checking your drawing. Draw with long, continuous lines rather than short, sketchy lines; do not be concerned about making corrections. You will notice that the distortion that naturally occurs contributes to the expressive character of your drawing. Later you may deliberately choose to introduce a similar kind of distortion into other drawings.

Sketchbook Activities

Practice contour drawings in your sketchbook, establishing the habit of looking at the subject rather than at your drawing. Effective drawing depends upon learning to see. Even when you are not drawing, practice looking at objects as if you were, letting your eye slowly examine every fraction of an inch of contour. Later, try drawing such objects from memory.

74. **Gaston Lachaise (1882–1935; French).** *Standing Male Figure.* **1930. Pencil, 18½ × 11¾″ (47 × 29.8 cm). The Memorial Art Gallery of the University of Rochester (gift of Dr. and Mrs. James Sibley Watson).**

The Contour of Varied Width

A continuous contour of uniform weight results in a persistently two-dimensional effect. By introducing variations in thickness and weight, you can make a line appear to advance and recede in space, contributing a suggestion of three-dimensionality to drawn forms. Thick and thin lines produce a degree of dark and light, which is a key factor in understanding volume. The variations that result from changing pressures of the hand can be in response to visual stimuli—the importance of a detail, a shift of direction in a contour, or an overlapping of forms. Using line variations that are more spontaneous than studied, Lee Adair Hastings's *Nude* (Fig. 75), celebrates roundness, softness, and aliveness.

The very act of drawing, involving as it does such factors as varying directions of movements or modifications in hand position, produces thicker and thinner lines. The viewer is very aware of the physical manipulation of the pen and changing positions of the artist's hand in Philip Guston's untitled still-life drawing (Fig. 76). Placing the individual forms so that they just touch or nearly touch adds tension and drama to otherwise ordinary subject matter.

Project 5.4 To explore the use of contour line that varies in width, select a subject involving some overlapping of forms. A house plant with broad distinctive leaves or a cabbage with several leaves peeled back would work well. Alter pressure on the pencil to describe overlapping forms, darkness of shadow, movement in space, and any other aspects of form that can be implied by changes in the width and darkness of line. Vary the pressure on the drawing instrument in accordance with your instinctive appreciation of the importance of each contour, rather than changing line widths in a consciously calculated manner.

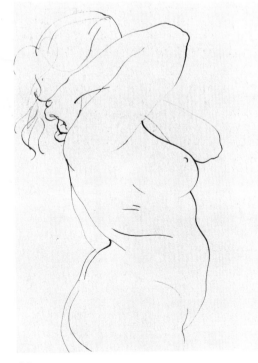

left: 75. Lee Adair (b. 1934; American). *Nude.* 1970. Pen and ink, 16 × 21″ (41 × 53 cm). Courtesy the artist.

below: 76. Philip Guston (1913–1980; American). *Untitled.* 1966. Ink, 19 × 25″ (48 × 64 cm). Minnesota Museum of Art, Saint Paul.

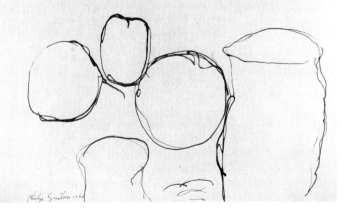

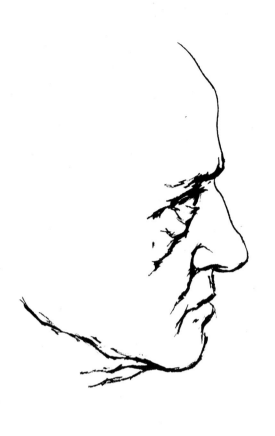

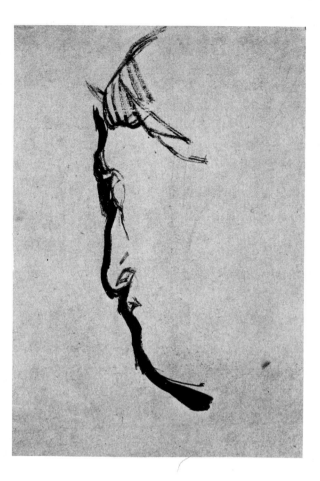

Two profile studies, *Araldo* (Fig. 77) and Josef Albers's *Self-Portrait VI* (Fig. 78), both drawn with sensitivity and strength, reveal very different and personal approaches to contour drawing, each contributing to a strong sense of the individuality of the subject. In *Araldo* the artist differentiates between hard and soft edges, drawing the forehead with a firm, sure line, changing to an irregular, seemingly less certain line for the fleshier features. Apart from the quality of the line, the positioning of the drawing on the sheet adds significantly to the impression of mass. Albers's boldly brushed line seems almost a contradiction to the subtle perception of form evident in the drawing. Instead of drawing a contour line of the face, he has revealed the form by defining the negative space. The inside and outside edges of the brushed line are distinctly different.

The expressive power evidenced in Figures 77 and 78 results from two factors; a careful study and consequently a more subtle perception of form; and second, a sensitive linear expression of those perceptions.

Project 5.5 If someone you know is willing to be a model, you might feel ready to attempt a contour drawing of the human figure. Be assured that contour drawings can be made of clothed, as well as unclothed, models. If no one else is available, be your own model. Sit before a mirror and draw a self-portrait. An arrangement of two mirrors will allow you to see yourself from other than a head-on frontal view.

above left: 77. Duane Wakeham (b. 1931; American). *Araldo.* 1986. Conte pencil, 8½ × 6¾" (21 × 17 cm). Collection Richard R. Sutherland, San Francisco.

above: 78. Josef Albers (1888–1976; German–American). *Self-Portrait VI.* c. 1919. Brush and ink, 11½ × 7¾" (29 × 20 cm). Collection Anni Albers and the Josef Albers Foundation, Inc.

Focus your efforts on creating a sense of volume rather than achieving an exact likeness.

Lost and Found Edges

Drawings have greater visual interest when lines, and the edges they define, receive different treatment. In Figure 77 each variation serves to heighten visual description. Although in both Figures 77 and 78 the artists have chosen to represent only the profile, each provides a continuous separation between the form and the space that surrounds it.

Sometimes as we view a form we do not always perceive complete contours, depending on the light it receives and its relationship to surrounding objects. A strong light falling on a smooth, unbroken surface; overlapping forms of the same or similar value; the turning away of a form—all can result in the disappearance of the separating contour line. The edge becomes lost, to reappear again when another condition exists. Leaving out the line when it cannot actually be seen duplicates, in part, the effect that caused the line to disappear. It also serves to transform the paper into the light, air, and space in which the form exists, rather than the surface upon which it is drawn. Except for the minimal introduction of tone to model form, Rico Lebrun's *Figure in a Dust Storm* (Fig. 79) relies upon **lost and found edges**, as does Toulouse-Lautrec's drawing of Marcel Lender (Fig. 80).

It is also possible to "lose a line" by stopping it short before it passes behind another form, thereby creating a sense of space between forms. Broken or discontinuous contours should not create a problem for viewers because the eye/mind is perfectly capable of completing the outline.

left: 79. Rico Lebrun (1900–1964; Italian–American). *Figure in a Dust Storm.* 1936. Ink and conté crayon, 24½ × 18″ (62 × 46 cm). Santa Barbara Museum of Art, California (Artist in Residence Fund).

below: 80. Henri de Toulouse-Lautrec (1864–1901; French). *Marcel Lender.* 1895. Red chalk on gray paper, 6⅝ × 10¼″ (17 × 26 cm). Musée Toulouse-Lautrec, Albi.

Project 5.6 Using lost and found edges effectively depends on training your eye to be aware of the conditions that allow a line to disappear and those that demand that a line be drawn. As you look at forms and draw them, notice when an edge seems to disappear. Also try to determine when you can appropriately leave out a line, but avoid the inclination to dispense with lines randomly.

The Searching Line

The approach to contour drawing that has been discussed depends upon the slow and deliberate delineation of form. Some of the drawings reproduced, however, begin to suggest a second technique that encourages greater freedom and spontaneity through the use of a **searching line.** As the term implies, it is an approach to drawing in which the hand and drawing instrument move freely and quickly across the surface of the paper, either in continuous rhythm (Fig. 81) or in a series of more broken lines, sometimes following contour, at other times drawing through, around, and across form (**cross-contour**) to find the gesture and major lines of movement within the form.

Unlike contour drawing with its single outline, the searching line results in a multiplicity of lines generally suggestive of energy and vitality. The rapid movement and frequent directional changes produce variations in pressure, line width, and degree of darkness that automatically produce accents plus a feeling of volume. The searching line is not to be construed as undisciplined, meaningless scribbling. As a technique it requires that you begin to see, feel, and draw total form, rather than isolated details. In Figure 81, the artist, even after estab-

81. Anonymous (16th century; Italian). *Dancing Figure*. Red chalk. Metropolitan Museum of Art, New York (gift of Cornelius Vanderbilt, 1880).

lishing the lines of movement, the gestures, continued to explore the form to find the lines that give the desired degree of definition.

Project 5.7 For beginning students the searching line works best with pencil, crayon, chalk, ball-point pen, or a pen that has its own ink supply.

Select any readily available subject. (Although we are all inclined to want to draw things that interest us, you should realize that these projects are meant as learning exercises and that subjects need not be chosen for any particular aesthetic value.)

Before you begin drawing, spend a few minutes looking at the object you have chosen. Let your eye roam around, through and over the form freely without stopping to focus on any one part. As you look, become conscious of the continuous movement of your eyes; when you begin to draw, allow your hand the same freedom of movement. Draw with one continuous line without lifting your pencil from the paper. Look at the object as you draw, glancing at your paper only when necessary. You will experience the same distortions as you did in the earlier contour drawings. The purpose in drawing without looking at your paper is to develop a direct connection between seeing and drawing, eliminating as much as possible the intermediate step of thinking about how to record what is seen as well as the subsequent judgment of what is correctly drawn.

Repeat this assignment frequently, eventually drawing the human figure or other living forms. Remember that mirrors allow you to be your own model. Try to re-create the experience of drawing with your eyes closed as in Project 5.2.

Sketchbook Activities

Add to your other sketchbook activities the habit of interpreting things that you observe with a searching line. You will find it a useful technique for recording people on the move, letting it serve as pictorial shorthand.

The Modeled Line

Artists frequently feel the need to reinforce pure outline with suggestions of modeling, for many subtleties of form cannot be revealed by the single line, even one of varying thickness. There is a natural tendency when drawing to amplify differences in line width by means of additional lines, hatchings, or other graduated values to help describe the complexities of form perceived in the model. This begins to be evident in René Bouché's portrait of Frederick Kiesler (Fig. 82). Departing from simple outline, Bouché produces a splendid example of selective emphasis of features and details to convey the thoughtful attentiveness of the sitter.

The drawings by Kokoschka (Fig. 83) and Raphael (Fig. 84) reveal remarkable similarity in form and concept; the only significant difference is in media and style. Both artists have augmented contour with modeling to give greater plasticity to the figures; Kokoschka's drawing is bold and vigorous, Raphael's more precise and disciplined. Many aspects of contour drawing that have been discussed can be identified in Kokoschka's study.

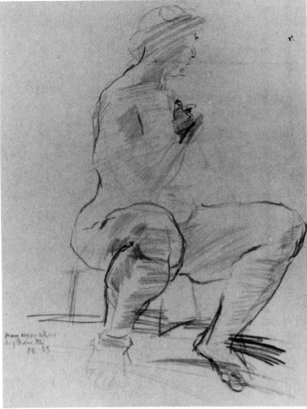

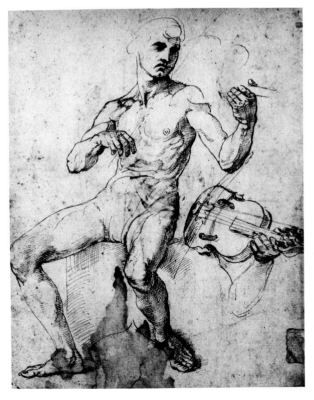

above left: 82. René Robert Bouché (1905–1963; Czech–American). *Frederick Kiesler.* 1954. Pencil, sheet 25 × 19″ (64 × 48 cm). Museum of Modern Art, New York (gift of the artist).

above: 83. Oskar Kokoschka (1886–1980; Austrian). *Female Nude.* 1953. Crayon and pencil, 23 × 17½″ (59 × 45 cm). Collection Mrs. Leonard S. Meranus, Cincinnati.

left: 84. Raphael (1483–1520; Italian). *Apollo Playing a Viol,* study for *Parnassus.* Pen and ink, 10⅝ × 7⅞″ (27 × 20 cm). Musée des Beaux-Arts, Lille.

Project 5.8 Select a subject of some complexity, one that seems to call for more than contour. Draw it freely in outline, allowing your hand to move easily so that the lines are not rigid. Observe the form carefully as you draw, letting your line be sensitive to roundness, flatness, and meeting of surfaces. When the initial drawing is complete, shade the form near the contour with groups of light, parallel lines that curve according to the direction the form seems to take. Study the edges carefully, and modify the curvature of the shading lines in any way that seems to describe the form more fully.

Develop your facility with this method of using line by drawing many different objects. Do not attempt full modeling in light and shadow—merely add supplementary lines, tones, and textures to reinforce the contours to create a fuller sense of form than can be achieved by pure outline.

Hatching, Cross-Hatching, and Scribbled Tones

Figures 85 through 87 illustrate the use of **hatching** (parallel lines), **cross-hatching** (crisscrossing patterns of parallel lines) and **scribbling** (random, multidirectional lines) to build tone and define both shape and volume. A cursory glance through the pages of this book offers abundant evidence of the reliance artists place on these methods.

Project 5.9 Make an arrangement of several relatively simple objects that possess a fullness of form—two or three apples, pears, or tomatoes grouped with an open paper bag, which can be standing upright or placed on its side; an unoccupied pair of shoes, either neatly arranged side by side or left as they were dropped.

85. Harold Altman (b. 1924; American). *Matriarch.* 1961. Felt-tip pen, 16½ × 20″ (42 × 51 cm). Philadelphia Museum of Art (gift of Dr. and Mrs. William Wolgin).

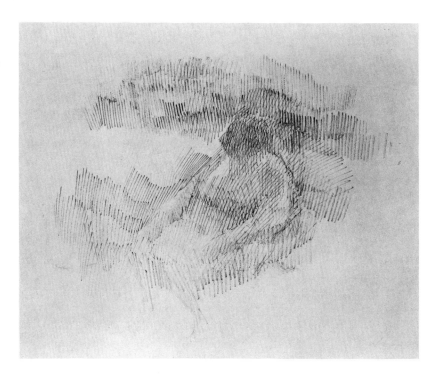

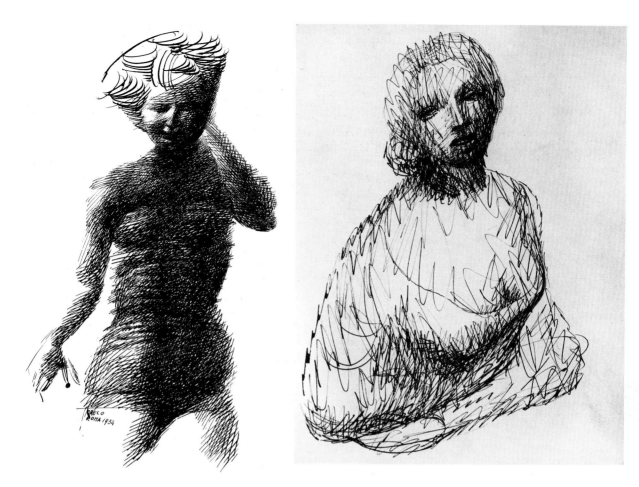

Do separate drawings using hatching, cross-hatching, and scribbling to define forms and produce tonal differences. Vary both the thickness of line and the spacing between lines to produce different tones. Establish the placement of the objects with a light pencil line, but develop the forms without relying on contour line. Experiment with a variety of drawing tools—crayon and pen and ink as well as pencil or a cluster of bamboo skewers dipped in ink. The sizes of your various drawings will be determined by the medium selected.

The Calligraphic Line

Calligraphy is defined as "beautiful writing." In drawing and painting, when the beauty of line that emerges from a flourish of execution becomes a major aesthetic aim, the result is a true **calligraphic line.** Study the drawings in Figures 88, 89, and 214—all splendid examples of calligraphic virtuosity.

Beautiful and meaningful calligraphic line demands more than taking brush in hand to make lines of varying thickness. The beginner, without months, perhaps even years of practice, cannot hope to do more than become aware of the factors involved. Variations of line width, which characterize a calligraphic line, are determined by the gesture with which the line is made, in combination with the amount

above left: 86. Emilio Greco (b. 1913; Italian). *Nude Study for Sculpture.* 1954. Pen and ink, 19⅝ × 14⅛″ (50 × 36 cm). Victoria & Albert Museum, London (Crown Copyright).

above: 87. Henry Moore (1898–1986; English). *Half-Figure: Girl* from *Heads, Figures, and Ideas* sketchbook. 1956. Pen and ink, 8¾ × 6⅞″ (22 × 17 cm). Courtesy the artist.

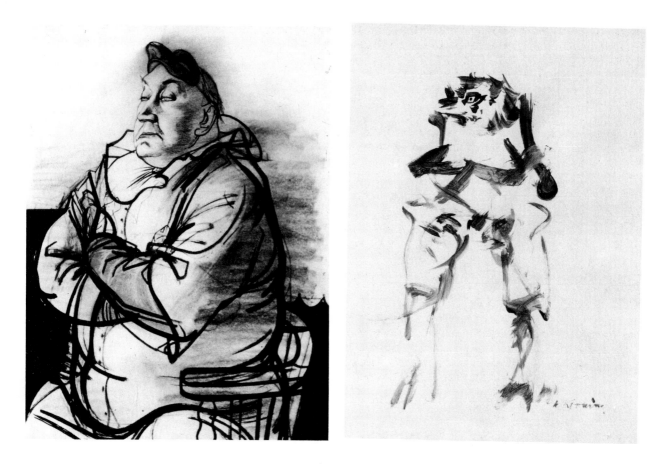

above: 88. Rico Lebrun (1900–1964; Italian–American). *Seated Clown.* 1941. Ink and wash, with red and black chalk; 39 × 29″ (99 × 74 cm). Santa Barbara Museum of Art, California (gift of Mr. and Mrs. Arthur B. Sachs).

above right: 89. Willem de Kooning (b. 1904; Dutch–American). *Woman.* 1961. Brush and ink on paper, 23¾ × 18¾″ (60 × 47 cm). Hirshhorn Museum and Sculpture Garden, Smithsonian Institution, Washington, D.C.

of pressure with which the brush is applied to the drawing surface. For example, a sweeping stroke—made rapidly, commenced while the hand is in motion in the air and finished by lifting the hand while still in motion—usually creates a tapered line that reveals both the action by which the line was drawn and the variation in pressure. In the work of an experienced and excited draftsman, such gestures, far from being self-conscious and deliberate, result naturally from the action of drawing.

Beyond the gesture of execution, the character of a calligraphic line results from the medium used, for medium, to a degree, controls the gesture. A pointed brush with ink permits the greatest fluidity (Fig. 88); a flat bristle brush produces a more abrupt, slashing change from thick to thin (Fig. 89). Pencil, charcoal, and chalk also respond to differing emphasis and reflect the movement of the hand in changes of width and value; lines become progressively fuller and darker with increased pressure.

Project 5.10 To begin this project, practice using both a well-sharpened pencil and a one-inch piece of charcoal. Hold each between the thumb and first two fingers as if you were extracting a thumbtack from your board (Fig. 28). This position encourages maximum facility in modulating line width. Keeping arm and wrist relaxed, make free, swinging, wavy lines, spirals, and gently curved shapes. Increase line widths by shifting pressure from the tip to the side. (The charcoal will allow greater variety of line width.) Holding your pencil or charcoal parallel to the di-

rection of your line will make a narrow mark; turning it at right angles to the direction of the line increases the width. After exploring the different kinds of line, begin making large, rapid drawings of simple objects, working for an assortment of line widths.

When you begin to feel a freedom in your arm movements, switch to brush and ink. Begin all lines in the air, gradually allow the brush to touch the paper; finally, lift the brush as you complete the line. Keep the movement of your arm and hand and brush as fluid as possible. After an initial period of practice, look carefully at the quality of lines in the examples illustrated. Do not copy the drawings, but aim for a similar flexibility of line and freedom of execution.

Project 5.11 Execute this project in soft pencil, charcoal, or chalk, then in brush and ink. Choose a subject that offers undulating contours—a wide-brimmed hat, a hiking boot or work shoe, a cluster of large leaves, potted geraniums and other plants, or a few vegetables. Spend a few minutes looking at the subject, seeing it in terms of both contour and searching line, then begin to draw freely, allowing variations in line width to grow from the act of drawing. Keep your drawing sufficiently large so that your gestures can be free and unconstricted. Since drawings of this type should be executed quite rapidly, repeat each a number of times and finally select and keep the drawings you think have the most linear character and best express the character of the subject, the nature of brush and ink, and the act of drawing.

Experiencing Different Line Qualities

Line functions objectively to define and describe shapes, spaces, volumes, gestures and movements; line used subjectively focuses on the expressive qualities of drawing.

The expressiveness of a drawing is determined not only by the choice of drawing instrument and technique, combined with skill in manipulation, but also by the artist's attitude. If line were not expressive of the individual artist, all drawings would be very much alike—and yet, the drawings selected to illustrate this chapter are all very different from each other in their quality of line. They are expressive of individual personalities of artists, reflecting feelings, attitudes, and points of view at the same time that they define and describe (Figs. 90, 91). Artists find ways of working that are satisfying, comfortable, exhilarating, and "right" for their temperaments.

Project 5.12 Using the medium of your choice, explore some of the different ways to handle line that you have observed in these illustrations. Draw in the manner of the examples provided rather than engaging in self-conscious copying. Accuracy is not as important as getting the "feel" of a way of working. You will discover that you like certain kinds of line movements, that they seem to come naturally to your hand. Be aware of that, and continue experimenting. Work to develop versatility. When you have developed a familiarity with a variety of line qualities, make your own selection of subject matter that appears appropriate to each way of working, trying not to limit yourself to subjects similar to those illustrated.

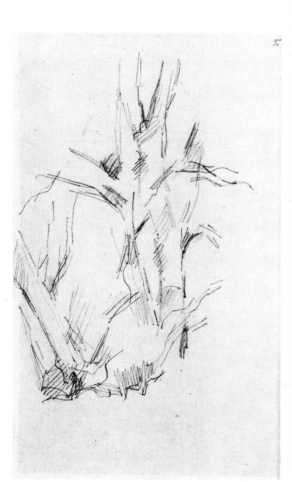

above: 90. Paul Cézanne (1839–1906; French). *Alberi spogli.* 1887. Pencil, 8¼ × 5¼" (21 × 13 cm). Kunstmuseum, Basel.

above right: 91. Jacques de Gheyn II (1565–1625; Flemish). *Chestnut Tree with a Man Sitting on the Roots.* Pen and ink over black chalk, 14¼ × 9¾" (36 × 25 cm). Rijksmuseum, Amsterdam.

Project 5.13 Remaining conscious that expressiveness is to be found in choice of line as well as in subject matter, develop a series of drawings of the same subject, allowing the quality of line to convey different moods. For this exercise the nature of the subject is less important than the handling of line—a potted plant, a still life of familiar household objects, fruits and vegetables, a view of the corner of a room, a small area of a garden, a section of a tree.

Whatever subject you select, consider the placement of your drawing on the paper and avoid letting images float in the middle of an essentially blank page. Draw large. Use as much of the full sheet as possible.

Whenever you commence drawing, think about the kind of line that seems equally right for the subject, for the medium, and for your own artistic temperament. Gradually you will discover that you have developed an intuitive sensitivity to line, as well as the other art elements, so that choices need not always occur at a conscious level. The most important goal now is to work freely, experimentally, even playfully, realizing that impulse and feeling remain the catalysts for creative activity.

Value

*If I could have had my own way I would have
confined myself entirely to black and white.*

—Edgar Degas

In the visual arts the term **value** denotes degrees of light and dark.
White under brilliant illumination is the lightest possible value, black
in shadow the darkest; in between occurs a range of intermediate
grays. Pure black, white, and gray seldom occur in the natural world,
for almost every surface has some local coloration, which in turn is
influenced by the color of the source of illumination. Every surface,
however, no matter what its color, possesses a relative degree of light-
ness or darkness that the artist can analyze and record as value.

While line adequately represents the contours of an object, sub-
jects as a rule display characteristics and suggest moods that cannot be
described fully by contour alone. Values clarify and enrich the space
defined by simple line in five readily identifiable ways.

1. Three-dimensional form becomes apparent through the play of
 light and shadow, represented by shading.
2. The degree of value contrast determines the placement and rela-
 tionships of form in space. Forms can be made to advance or re-
 cede through the degree of value contrast employed.
3. Value provides a fundamental element for creating pattern, for
 modulating and describing surface texture.
4. The pervasive mood of a drawing—dark and ominous, light and
 cheerful—derives from the artist's emphasis on tones at either end
 of the value scale.
5. Value contrasts convey dramatic power. Strong contrasts of light
 and dark, for example, can be manipulated to create points of ac-
 cent in a composition and so draw attention to areas in terms of
 their importance.

The Value Scale

Learning to see relationships of value is essential to producing convincing visual images. The full range of values that exists in nature cannot be duplicated, which means that an artist can only approximate the effect of natural light. A value scale of nine steps (Fig. 92) duplicates the number of value changes that can be distinguished by most people.

Perception of value depends upon a number of factors: (1) the actual coloration of the subject, (2) its lightness or darkness relative to its surroundings, (3) the degree to which the subject is illuminated or in shadow.

Beginners often lose sight of value, seeing only color instead. Yet color has value, which must be analyzed as to its relative lightness or darkness, not only when being translated into a black-and-white drawing, but also for drawing in color. The apparent value of an area is relative to the value that surrounds it. The white, middle gray, and black dots superimposed on the value scale (Fig. 92) reveal the optical variations that occur in the apparent lightness and darkness of the same value when seen in relation to tones of greater or lesser contrast.

Rodolfo Abularach's fine pen-and-ink drawing *Circe* (Fig. 93), with its rich range of values from the heavily cross-hatched, deep black pupil to the gleaming white, central highlight provided by the exposed paper ground, duplicates the value scale in pictorial form. Notice that the highlight and dark of the pupil are intensified by being placed side by side against the low dark of the iris.

The artist must learn to see value relationships, rather than being influenced by what is known to be the **local value,** which can be

92. Value scale.

93. Rodolfo Abularach (b. 1933; Guatemalan). *Circe.* 1969. Ink on paper, 23 × 29″ (58 × 74 cm). San Francisco Museum of Modern Art (gift of the San Francisco Women Artists).

perceived only when seen free from the effect of light and shadow. Under illumination, local values are lightened or darkened depending upon the degree of light. In Sidney Goodman's double portrait *Ann and Andrew Dintenfass* (Fig. 94), the only local value that can be identified with any degree of certainty is the darkness of the young woman's hair. Notice, however, that the highlights of her hair and the lighted portion of her face are the same value, while the shadowed areas of the face and arm are nearly as dark as her hair. The local value of the young man's hair and pants might be either light or dark as influenced by intense sunlight. The novice often fails to acknowledge such effects, thinking of a white form entirely as light, although areas of it in shadow appear as medium or dark values, representing a dark surface as dark even though brilliantly illuminated. Only with experience do artists attain a sharply analytical sense of values as they are affected by color and lighting.

Part of an artist's basic vocabulary is the ability to control dry and wet media (Chapters 10 and 11) to provide a full range of value. Because of the vigorous range of lights and darks that can be created, either charcoal or conté will prove convenient for many of the activities suggested in this section (conté is cleaner to work with and smudges less easily). With both charcoal and conté it is easier to move away from contour drawing into full three-dimensional modeling of form. They also seem to encourage drawing in a larger scale than does pencil or pen. For projects using charcoal or conté, you may wish to

94. **Sidney Goodman (b. 1936; American).** *Ann and Andrew Dintenfass.* 1971. Charcoal 27 × 32½″ (68.6 × 82.5 cm). Courtesy Terry Dintenfass Gallery, New York.

add charcoal paper to the list of beginner's materials (see p. 19). It affords greater texture than newsprint, is more durable, and so permits a more finished drawing. You can experiment with other materials as well. The dimensions of Figure 93 suggest that the use of pen and ink is not limited to small-scale works.

Project 6.1 Assemble and arrange four or five objects of different colors. Study the value relationships and do a drawing of corresponding tones. Be concerned with general shapes rather than with details. Placing the forms in direct sunlight (Fig. 94) or introducing artificial light will alter the value relationships. (Small, high-intensity reading lamps provide strong illumination and offer adjustable positioning as well as ease in moving.) Each repositioning of the source of light, each regrouping of the objects will alter the relationships. Focusing just on the objects by squinting at them through a cardboard viewfinder will allow you to determine tonal differences more accurately.

Form Defined by Light

Every object has a specific three-dimensional character that constitutes its **form.** The simplest forms are spheres, cylinders, cubes, and pyramids; the human head, in contrast, is a form of greater three-dimensional complexity. We are made aware of the unique aspects of each form as it is defined by light and shadow, by changes of value. Direction of light determines what portions of a form will be lighted. Surfaces at right angles to the source of light receive the most light; those areas that turn away from the light and are hidden from direct rays of light fall into shadow. Changing the position of the source of illumination can greatly alter the appearance of any object. Angular forms result in abrupt changes from light to dark (Fig. 95); spherical forms are defined by subtle gradations of tone (Fig. 96).

below: 95. Polyhedron with value planes suggesting illumination from a single source of light.

below right: 96. Sphere showing the value gradations of traditional chiaroscuro.

Project 6.2 Place a white or very light-colored geometric form (a cube or other polygonal shape) on a piece of white paper or a light surface, positioned so that it receives strong light from above and to one side.

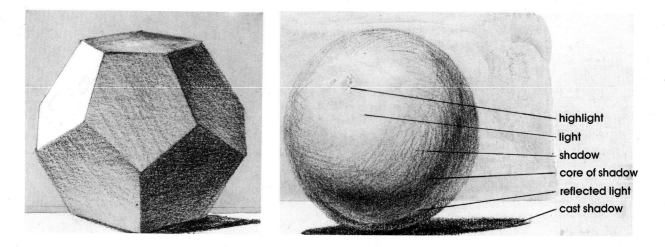

highlight
light
shadow
core of shadow
reflected light
cast shadow

You can easily see how the form is revealed by light since the angular edges dividing its planes create sharp changes of value. (If you do not have access to white geometric forms, a small cardboard carton with flaps opened at varied angles would be suitable.) Observe the object and its cast shadow carefully. Using any suitable technique, build gradations of value corresponding to the separate planes of the form. Leave the white paper for the lightest surface, defining that plane by surrounding it with a gray tone rather than with a line (Fig. 95). The darkest value will be the shadow cast by the object.

As you study the separate planes, notice that each surface appears lighter or darker at its outer edges, depending on the value of the adjoining planes (the same optical illusion can be detected between the steps of the value scale). A slight exaggeration of light and dark where planes join results in a stronger feeling of three-dimensionality.

Project 6.3 Do a series of quick studies depicting the changes that occur as the form is lighted from different angles—side, three-quarter, front, overhead, behind, below. Notice the shifting position of the cast shadow as the direction of light changes (see Chapter 9, Perspective).

In this and other projects, draw the objects as large as is practical for the medium you have chosen. Learn to use the full sheet of paper. Students have a tendency to draw too small, partly because smallness seems easier to encompass. A pencil drawing is too big when it is difficult to build values of even texture; a charcoal drawing is too small when the stick of charcoal seems clumsily oversize.

Chiaroscuro

Since the Renaissance, artists have employed **chiaroscuro,** or continuous gradations of value, to create the illusion of three-dimensional form. Chiaroscuro, which combines the Italian words *chiaro* (light) and *oscuro* (dark), involves systematic changes of value, easily identified in Figure 96, which shows a sphere under strong illumination. The elements of the system are highlight, light, shadow, core of the shadow, reflected light, and cast shadow. **Highlights,** the lightest values present on the surface of an illuminated form, occur on very smooth or shiny surfaces. They are the intense spots of light that appear on the crest of the surface facing the light source (compare with Fig. 95). **Light** and **shadow** are the broad intermediate values between the more defined areas of highlight and the **core of the shadow,** which is the most concentrated area of dark on the sphere itself. Being parallel to the source of light, the core of the shadow receives no illumination. **Reflected light**—light bounced back from nearby surfaces—functions as fill-in light, making objects appear rounded by giving definition to the core of the shadow. Reflected light is never lighter than the shadow area on the lighted portion of a form. Shadows thrown by objects onto adjacent planes are known as **cast shadows** and are always darker than the core of the shadow.

Project 6.4 Place a white or light-colored sphere, such as a beach ball or styrofoam ball, on a light surface. Provide strong illumination angling from above—a single light source plus reflected light is best, since multiple light sources create confusion. Study the form carefully before you begin to draw, observing relative values. The shadow becomes intensified as the form turns away from the light, with the core

of the shadow receiving neither direct nor reflected light. No portion of the surface in the shadow area is as light as the part that receives direct light. The light reflecting up into the shadowed portion of the sphere from the table top is lighter than the core of the shadow but darker than the lighted surface of the sphere.

Proceed with your drawing, using the method you prefer to create smooth gradations of value. If the surface of the sphere is shiny, reserve the white of the paper for the highlight. Adding a light gray background will intensify the effect of brilliant illumination.

Project 6.5 The amount of the sphere's surface that is lighted or in shadow depends on the placement of the light source. If positioned directly at the side, one half of the sphere will be lighted and one half in shadow with the core of the shadow perpendicular to the angle of light. Make a number of simplified drawings indicating the relative amounts of light and shadow as the direction of light changes, giving emphasis to the core of the shadow.

George Biddle's portrait of *Edmund Wilson* (Fig. 97) follows the same system used for the sphere, modeling form with broad areas of light and shadow separated by a clearly defined core of shadow. Although there are no highlights, small areas of cast shadow under the nose and chin help define the form while the absence of dark accents at the back of the neck and ear causes the form to recede. A sense of luminosity results from the drawing's generally light tone in combination with the broad simplification of light and shadow. Biddle's handling of the shadow side of the face reveals that it is not necessary to render everything you see.

97. George Biddle (1885–1973; American). *Edmund Wilson.* 1956. Charcoal, 13 × 11¼″ (33 × 29 cm). Sotheby Parke-Bernet.

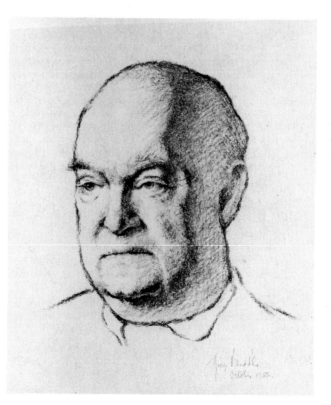

Project 6.6 Try drawing a head from life. If you are self-conscious about asking a friend to pose, do a self-portrait working with a mirror. (Do not draw from a photograph.) Position your model so that the play of light and shadow from a light source above and to the side clarifies the structure of the head. Work for solidity of form, rather than concentrating on achieving a likeness. Do not be concerned with details.

Study of a Seated Man by Jacob Jordaens (Fig. 98) illustrates how artists employ chiaroscuro to describe a complex form with broadly established areas of light, shadow, reflected light, and cast shadows. The core of the shadow functions effectively to delineate the division between light and shadow and combines with the reflected light to give a sculptured fullness to the folds. Since most cloth, other than silk and satin, does not have a shiny surface, rendering of fabric rarely requires highlights.

Project 6.7 Pin a light-colored piece of fabric (a napkin or a handkerchief will do) to a wall or vertical surface. Gather and drape the fabric to create folds of some complexity. Add a strong light source to provide definition. As you draw with charcoal or pencil, pay particular attention to the way in which the core of the shadow, reflected light, and cast shadow cause the folds to stand out in bold relief.

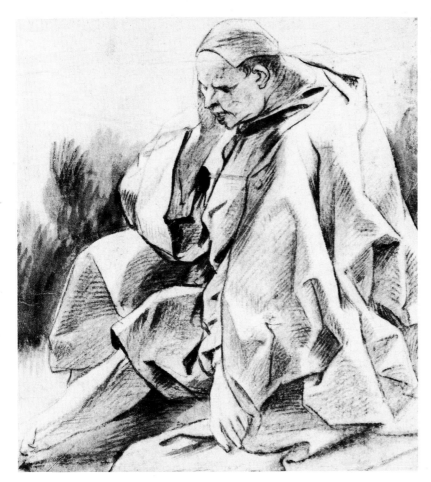

98. Jacob Jordaens (1593–1678; Flemish). *Study of Seated or Sleeping Man.* Chalk, brush, and wash; 11¼ × 10½″ (29 × 27 cm). Los Angeles County Museum of Art (Los Angeles County Funds).

Qualities of Light

Value changes can be gradual or abrupt, depending on the character of the form and the suddenness with which it turns away from the light. The degree of value change, or contrast between light and shadow, also depends on the source of illumination. Brilliant light results in strong light-dark contrasts with sharply defined dark shadows (Fig. 94); diffused light produces less contrast and softened cast shadows. Because of the amount of reflected light in nature, shadows cast by sunlight are generally lighter and more luminous than those created by artificial light. To maintain consistency in a drawing an artist must consider the source and quality of light.

Form and Space

Space is understood as the negative aspect, or complement, of **form.** Space, like form, is defined by light, which artists re-create in terms of value. Value not only defines objects, it also places and separates forms in space. Using boldly simplified patterns of light and dark with almost no modeling of tone, Richard Diebenkorn creates both volume and space in his drawing of a woman seated in bright sunlight (Fig. 99). The strong light-dark contrast between the figure's right arm and her upper garment makes the arm appear to project; less contrast in value between the face and the background places the head deeper in space as well as shadowing the face from the sun.

Project 6.8 Do a drawing in which you establish spatial relationships by attending to the principle that light forms advance and dark forms recede. Arrange a group of familiar objects such as cups, jars, canisters, and pots so that by their placement you are aware of space. Define space through the deliberate manipulation of value, using the lightest value for the closest object and increasingly darker values as the forms recede, with the darkest value reserved for the background. A strong light seen against a bold dark will appear to project more than the same light placed against a less contrasting value.

In Peter Paul Rubens's *Lioness* (Fig. 100), the rump and the rear legs have been made to project toward the viewer through the addition of light chalk to create strong value contrast. The head of the animal, although rendered with strong darks, holds its place in space because no light accents have been added.

The full effect of form and space in Rubens's drawing depends on value used in conjunction with line, overlapping forms, and dramatic foreshortening. Effective drawing generally involves the interplay of various elements (see Chapter 8, Composition).

Further study of Figure 100 allows us to see Rubens manipulate value to place and separate forms in space. In the upper left quarter of the drawing the form is defined by contour line with little apparent differentiation in value between figure and background. In contrast, the entire length of the right side of the body, starting from the ear, appears darker than the background, except where the rear leg is seen as light against the shadow. The cast shadow, which lightens as it moves away from the foot, relates the animal to surrounding space by defining the ground plane.

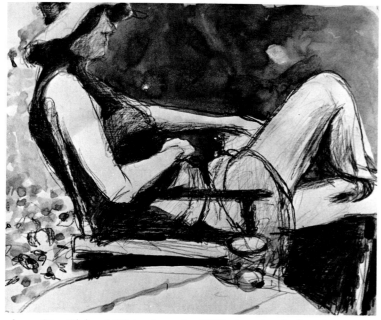

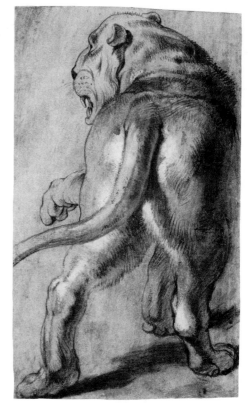

above: 99. Richard Diebenkorn (b. 1922; American). *Seated Woman with Hat.* 1967. Pencil and ink wash, 14 × 17″ (36 × 43 cm). Courtesy the artist.
right: 100. Peter Paul Rubens (1557–1640; Flemish). *Lioness.* c. 1618. Black, white, and yellow chalk; 15⅝ × 9¼″ (39 × 23 cm). British Museum, London (reproduced by courtesy of the Trustees).

Sketchbook Activities

Begin to see form and space as defined by light and shadow. In your sketchbook, draw with masses of dark and light whether the subject be an object, figure, or landscape. Try blocking in shadow shapes without depending on preliminary contour lines. Even a complicated subject can be reproduced with amazing accuracy when the artist concentrates on duplicating patterns of shapes and value rather than trying to draw the object itself.

Pattern

The term **pattern** is often used in reference to all of the individual shapes, defined by changes of value, which combine to construct form and space. The Diebenkorn drawing (Fig. 99) was described as "simplified patterns of light and dark."

Pattern, in addition to defining form and space, can function decoratively. Flat, unmodulated surfaces of dark and light produce pattern rather than form. We see the shape of an area and are conscious of its silhouette, but the sense of volume is minimized.

Patterns need not be limited to a regularly repeated design. The crows on the 17th-century Japanese screen (Fig. 101) create the impression of a strongly decorative pattern, yet very few of the shapes have been repeated, and the groupings are highly irregular. The birds, which in reproduction appear as silhouettes, are seen in bold value contrast to the gold-leafed background. Looking at the spaces between the bird shapes, one begins to understand how an artist as

above: 101. Anonymous
(early 17th century; Japanese).
The Hundred Black Crows, one of a pair
of six-fold screens. Early Edo period.
Gold leaf and black ink with lacquer
on paper, height 5′1¾″ (1.57 m).
Seattle Art Museum
(Eugene Fuller Memorial Collection).

right: 102. M. C. Escher
(1898–1972; Dutch).
Mosaic II. 1957. Lithograph,
12½ × 15½″ (32 × 39 cm).
Escher Foundation, Gemeentemuseum,
The Hague.

inventive as M. C. Escher could conceive a work such as *Mosaic II* (Fig.
102) with its fascinating play of positive and negative areas. In the
Escher lithograph, the viewer's eye is entertained constantly by the
way in which dark forms command attention, only to give way to the
figures that emerge as light-colored shapes. The delightful ambiguity
of the grotesque and imaginative creatures that swarm over the page
results from an almost equal distribution of light and dark. Escher has
increased the visual complexity by modifying each form with added

detail, but if one squints to the point where detail disappears, a rich pattern of dark and light shapes predominates.

Project 6.9 Work boldly and freely with India ink and brush to create patterns of black and white in which positive and negative shapes vie for attention. At this point, do not attempt anything as calculated as Escher's *Mosaic II*. Although the desired effect can be achieved through the repetition of a geometric design, look once again at the amazing richness and variety seen in Figure 101 and work for a similar feeling of animation.

Pure silhouette, whether black on white or white against black, provides the greatest possible value simplification, yet by itself it is not sufficiently complex to be very entertaining. We can see how Aubrey Beardsley's elaboration of pattern in *The Peacock Skirt* (Fig. 103) in-

103. Aubrey Beardsley(1872–1898; English). *The Peacock Skirt,* from *Salome.* 1894. Pen and ink, 9⅛ × 6⅝" (23 × 17 cm). Fogg Art Museum, Harvard University, Cambridge, Mass. (Grenville L. Winthrop Bequest).

104. Claudio Bravo (b. 1936; Chilean). *Package.* 1969. Charcoal, pastel, and sanguine; 30⅞ × 22½" (78.4 × 57.2 cm). Baltimore Museum of Art (Thomas E. Benesch Memorial Collection).

creases the visual interest of his illustration. In the lower portion of the composition the pattern is white on a black shape that is silhouetted against a white background. The peacock fan and the headdress use black patterns and lines on a white ground, while elements in the drawing, such as Salome's face and the bodies of both figures, are outlines creating the effect of white pattern on white ground. The stippled border of the fan plus the linear complexity of the man's garment further enrich the decorative scheme.

Texture

Choice of value and manner of application are important in creating the illusion of different textures and surfaces. Value permits the depiction of characteristics that cannot be described by line alone, such as the smooth sheen of heavy brown wrapping paper in Claudio Bravo's *Package* (Fig. 104). Even gradations of tone best describe hard, smooth, polished objects, while broken patterns of light and dark are appropriate to surfaces with stronger textural characteristics.

Project 6.10 It is possible to develop a rich variety of textures and surfaces, smooth or rough, hard or soft, by drawing on middle-value gray charcoal paper, using white chalk to build lights, adding dark with charcoal or conté (Fig. 100). Reserve the gray of the paper for all middle values; avoid mixing the chalk and charcoal to produce gray tones. By building the light and dark tones separately your drawing will appear cleaner, crisper, and more certain.

Explore a number of different subjects that offer textural contrasts. A starched napkin, folded and pressed, provides an interesting

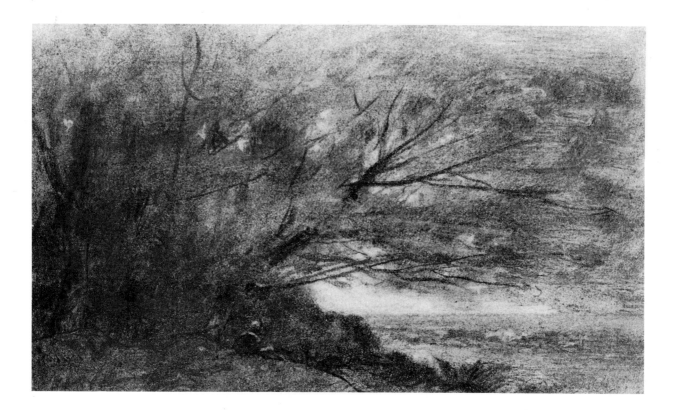

pattern of crumpled angularity and soft flowing surfaces when pinned to a wall. A very different quality characterizes silk, satin, or taffeta, which require exaggerated highlights. The broad flat planes of a fresh paper bag must be rendered differently from those of a sack that has been crushed. Try to distinguish between a transparent object such as a glass or jar and the polished reflective surface of a metallic bowl (Pl. 11, p. 173).

Project 6.11 Make your own gray paper by laying an even tone of charcoal over a full sheet of white paper, using either soft charcoal or crushed compressed charcoal, which can be applied by rubbing gently with a soft cloth or piece of paper towel. Darker values are drawn in with compressed charcoal, while lighter tones and white are lifted out with a kneaded eraser, as in Camille Corot's *Landscape (The Large Tree)* (Fig. 105).

105. Jean Baptiste Camille Corot (1796–1875; French). *Landscape (The Large Tree).* c. 1865–90. Charcoal, 9½ × 16¼" (24 × 41 cm). Collection Mrs. Noah L. Butkin, Shaker Heights, Ohio.

Range of Values and Expressive Use of Value

The use of value can range from pure black and white to drawings incorporating one or two intermediate grays or a full gradation of tones. Intermediate values of gray bring additional enrichment to black and white, whether decorative pattern or representational image. Beyond that, value assumes a dominant role in determining the expressive mood of a drawing. A work that exploits full contrasts of value conveys a feeling of aliveness and vigor (Fig. 103). Compositions in which close value relationships dominate while contrasts are minimized may create a sense of quiet, soothing restfulness or of introspection and brooding subjectivity (Fig. 105). Predominantly light

compositions carry a sense of illumination, clarity, and perhaps a rational, optimistic outlook. On the other hand, compositions predominantly dark in value often suggest night, darkness, mystery, and fear.

An artist selects and chooses from the value scale (Fig. 92) in much the same manner that a composer works with scales and keys to give mood and expressive character to a musical composition. In fact, the terms **high key, middle key, low key,** and **full range** are used to describe the general tonality of a drawing or painting.

High Key, Middle Key, Low Key

Drawings categorized as high key, middle key, and low key are those based upon a limited number of closely related values. **High key** refers to the light values—white through middle gray on the value scale, in which case the darkest value is no darker than middle gray. This is evident in *Still Life: In Restauro* of William A. Berry (Fig. 106). The faceted surfaces of basic geometric forms, plus the angularity of the drape, allow Berry to translate the upper half of the value scale into a drawing of lyrical beauty, building values with a slow, deliberate, mechanical cross-hatching (Fig. 107). Drawings done on white paper in hard pencil—in fact, most line drawings irrespective of medium—carry as basically light in value (Fig. 192).

A **middle-key** drawing includes the five values in the middle of the scale between light and dark; the dark half of the scale provides the **low key** (Fig 105). In practice, it is the overall tonality that determines the key of any drawing rather than an exact duplicating of specific values. For example, in spite of some dark accents, Edwin Dickenson's drawing of his studio (Fig. 108) is essentially a high-keyed drawing. Working on a lightly toned graphite background, Dickinson defined forms by adding darks and erasing the lights, a technique well suited for developing high-key drawings.

below: 106. William A. Berry (b. 1933; American). *Still Life: In Restauro.* 1985. Colored pencil, 30 × 40″ (80 × 102 cm). Courtesy the artist.

below right: 107. *Still Life: In Restauro,* detail.

left: Plate 1. Edmond-François Aman-Jean
(1860–1935; French). *Les Confidences.*
c. 1898. Pastel on blue paper affixed to
canvas, 4′ × 3′2″ (1.22 × .97 m).
Achenbach Foundation for Graphic Arts,
Mildred Anna Williams Fund,
The Fine Arts Museums of San Francisco.

below: Plate 2. Willem de Kooning
(b. 1904; Dutch-American).
Two Women's Torsos. 1952. Pastel,
18⅞ × 24″ (48 × 61 cm).
Art Institute of Chicago
(John H. Wrenn Fund).

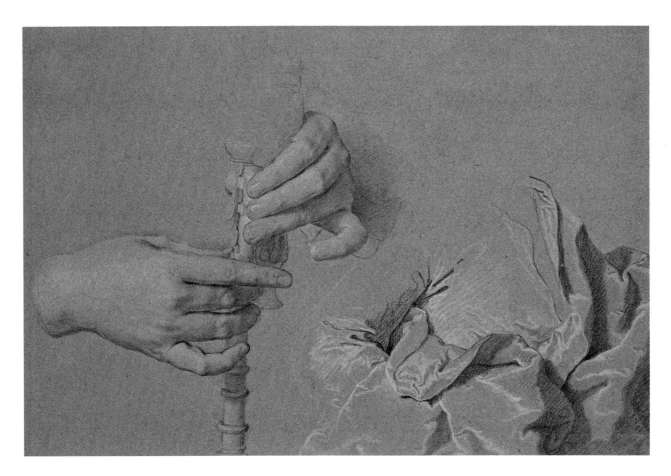

above: Plate 3. Hyacinthe Rigaud
(1659–1743; French).
Study of Hands and Drapery.
1735. Pencil heightened with
white chalk on blue paper,
11¾ × 17¾″ (30 × 45 cm).
Fine Arts Museums of San Francisco,
Achenbach Foundation for Graphic Arts
(gift of Mr. and Mrs. Sidney M. Ehrman).

right: Plate 4. Alanson Appleton
(1922–1985; American).
David Roinski. 1976.
Pen and ink with pastel,
10 × 8½″ (25 × 22 cm).
Collection Mrs. Alanson Appleton,
San Mateo, Calif.

Plate 5. Odilon Redon (1840–1916; French). *Woman with Flowers*. 1903.
Pastel, 26 × 19¾″ (65 × 49 cm). Collection David A. Schulte, New York.

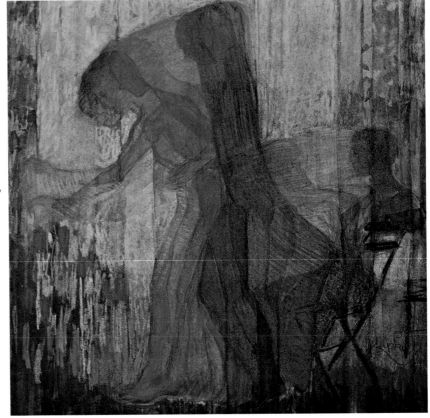

Plate 6. Martha Alf (b. 1930;
American). *Two Pears No. 3
(for Michael Blankfort).*
1982. Pastel pencil on paper,
12 × 18″ (31 × 46 cm).
Collection Alan S. Hergott.

Plate 7. František Kupka
(1871–1957; Czech).
*Study for Woman Picking Flowers
No. 3.* 1909–10.
Pastel on blue paper,
17½ × 18½″ (45 × 48 cm).
Musée National de l'Art Moderne,
Centre Georges Pompidou, Paris.

Project 6.12 Select a subject appropriate to a high-key (light-value) rendering—for example, a sunlit landscape or a still life devoid of strong darks and extensive shadow areas, perhaps one composed of basically light forms, such as eggs or lemons in a white bowl. As a greater challenge, any subject, no matter what its actual tonality, can be transposed into a high-key drawing (Fig. 108). To do so, establish what will be the lightest and darkest values and work within that range. It will be necessary to simplify the values you see in order to compress them into the allowable number.

Determine size and shape relationships quickly, lightly, and without elaboration; block in broad value patterns as simply as possible; then study and define edges of forms, adding dark accents and highlights, as in the Dickinson drawing.

108. Edwin Dickinson (1891–1978; American). *Studio, 46 Pearl Street, Provincetown.* 1926. Pencil, 17⅞ × 12¼″ (45 × 31 cm). Collection E. C. Dickinson.

To produce a similar effect, create a drawing surface of an even tone of pale gray by rubbing a small amount of powdered graphite onto a sheet of paper (graphite in stick or pencil form can be powdered on sandpaper). Use a fairly hard pencil (2H or 3H) to delineate your composition, add middle and darker values with pencil or rub in more graphite, and erase out lights. If you need darker accents, draw them with a soft pencil. Selecting a very white fine paper such as Bristol board results in a pale tonality of great elegance.

Project 6.13 Select a theme that will lend itself to a predominantly dark (low-key) composition. Night subjects are, of course, ideal, but a wide variety of less obvious representational or symbolic concepts can be given a special character when presented in low key. A subject as radiant as a bouquet of summer flowers can be transformed into something ominous and mysterious through a change of value. You may wish to work on gray charcoal paper, allowing the value of the paper to determine your lightest light.

Full Range

As the term implies, a drawing with a **full range** of values is one that uses a complete gradation of tones from white to black (Fig. 109). Full range does not require equal distribution of all values. As in Charles Sheeler's *Interior, Bucks County Barn,* many of the tones play only a supporting role to the featured values, black and white.

In developing any drawing, it is a valuable practice to determine the lightest light and darkest dark as a gauge from which to work. As a student, Paul Cézanne is said to have determined his values in relation to a black hat and a white handkerchief that he placed beside his

109. Charles Sheeler
(1883–1965; American).
Interior, Bucks County Barn. 1932.
Conté, 15 × 18¾″ (38 × 48 cm).
Whitney Museum of American Art,
New York (purchase).

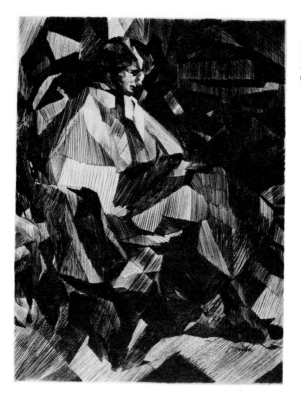

110. Jacques Villon (1875–1963; French). *Yvonne D. de Profil.* 1913. Drypoint, 21½ × 16¼″ (55 × 41 cm). Los Angeles County Museum of Art (Los Angeles County Funds).

models. Without establishing some reference points, it is easy to over-work an area. It is generally advisable to err on the side of lightness since it is easier to darken an area than to lighten it. Many student drawings, intended as full-range drawings, lack interest because strong lights have been lost through overworking while the darks have not been made rich enough.

Compare your immediate response to Figures 108 and 109, no-ticing that the artists' deliberate handling of value elicits very different feelings.

Value Contrasts for Emphasis

Strong contrasts of light and dark, along with linear movements, create focal points that can direct the viewer's attention to parts of the composition according to their relative significance. Emphasis through dramatic value contrasts works equally well whether a composition is representational (Fig. 109) or abstract. Jacques Villon's *Yvonne D. de Profil* (Fig. 110) demonstrates an ascending sequence of darks silhouetted against lighter values and of lights flashing out against dark to create a visually satisfying pattern of dramatic complexity.

Project 6.14 Review the various drawings you have done for the projects in this chapter. Could some forms be made to appear more sol-idly three-dimensional by stronger modeling in light and dark? Could objects be made to exist more convincingly in space by increasing light-dark contrast to make forms project, lessening contrast to make them recede? Do the drawings lack interest because everything is presented

with equal emphasis? Is it possible to produce a greater sense of drama and visual interest by intensifying focus on some forms or areas? Make whatever changes seem appropriate by altering value relationships. In some cases you may prefer to make a new drawing of the same or similar subject. Rarely are problems solved or techniques mastered with a single drawing.

Color and Value

Almost every beginning student at some time feels limited working in black and white and longs to discover the beauty and excitement of color. Although color can be considered as a separate element, it is introduced in this chapter because it is so closely linked to value.

To draw in black and white requires translating color into corresponding tones of gray; to draw in color demands perceiving color in terms of light and dark. All that has been discussed about value as black and white is applicable to drawing/painting in color. The most common error made in moving from black and white into color is seeing and thinking only in terms of **local color,** failing to notice value relationships within and between colors. The introduction of color into a drawing does not negate the fact that variations in degrees of dark and light provide one of the most effective means for giving definition to forms in space, yet many students seem reluctant to accept the concept that the success of a drawing in color depends more on correct values than on correct colors. Defining and separating forms requires more than simply a color change.

Dimensions of Color

Color has three dimensions: **hue, value,** and **intensity. Hue** corresponds to local color. It is the quality that distinguishes one color from another—redness, blueness. **Value** refers to the lightness or darkness of a color in comparison to white and black. **Intensity** describes degrees of strength and brilliance—the brightness or dullness of a color. Value and intensity can changed, but the hue remains. Although light red might commonly be referred to as pink, it is a light-value red; "shocking" pink would suggest a high-intensity light red.

Hue

The basic hues—violet, blue, green, yellow, orange, and red—and their intermediate gradations are designated as primary, secondary, or tertiary colors. **Primary colors**—red, yellow, and blue—are so called because they are pure colors that cannot be obtained by mixing together any other hues. **Secondary colors**—orange, green, and purple—are derivative hues produced by mixing two primaries. **Tertiary colors** are the intermediate steps between the six basic hues. They are given hyphenated names—blue-green, red-orange. (Ordinarily the primary is named first, followed by the secondary hue. A reversal, as in "orange-red," implies that the hue contains more orange than red.)

When arranged in a circle to form a color wheel, hues opposite one another are called **complementaries.** Yellow and violet are complementary, as are red and green, blue and orange. Complementary tertiary hues also face each other across the color wheel. The role of complementary colors will be discussed in relation to intensity.

Value

Each color has its own value: Yellow is the lightest, violet the darkest; orange, blue, red, and green all cluster near the middle of the value scale, with orange just above the middle, blue just below, and red and green generally corresponding to middle gray. Each color can be lightened to a **tint** (high value) by the addition of white, or darkened to a **shade** (low value) by adding black. The value of a color will appear to change when it is placed against different backgrounds, in the same way that spots of white, gray, and black are seen to change in the value scale (Fig. 92). Value is always relative. It is imperative to begin to see and analyze color in terms of value, determining whether what is seen is lighter or darker than something else, not just a different hue.

Working in color, degrees of value contrast are equally important in creating volume and space. Greater contrast projects forms forward; less contrast causes forms to recede. Dramatic effect and mood are also influenced by the range of values employed. Edmond-François Aman-Jean, in his richly developed pastel drawing *Les Confidences* (Pl. 1, p. 87), has skillfully manipulated value both to define space and to establish mood. Although he has chosen a very limited range of values, subtle light-dark differences serve to define three-dimensional forms and space. The separation of the seated figure's left shoulder from the foliage results from change of value as much as from color change. The highlight on her right shoulder indicates fullness of form. The ribbon of the hat and the slats of the garden bench provide the strongest light-dark accents to project that part of the bench forward, whereas darker and closer values place the back of the bench deeper in space. Value differences in the leafy background are almost imperceptible. The closeness of values and the lack of bold value contrasts contribute significantly to the mood of gentle reverie. It is not necessary to be conscious of the subtle handling of color, value, and intensity to respond to the beauty of Aman-Jean's drawing, but as an art student it is important to sharpen your awareness by studying all such drawings carefully and thoroughly.

Intensity

Looking once again at the Aman-Jean drawing, we see that the colors in the lower half of the drawing are generally stronger and brighter than those above. The foreground colors have somewhat greater intensity, which combines with aspects of value to reveal space. The dominant red-orange of the seated figure's dress is obvious. It is perhaps more interesting, however, to compare the rose on the hat with the dress of the standing figure. Although almost identical in value, the light area of the sleeve is almost colorless in contrast to the more vibrant color of the rose. It is also important to note that the hair of the standing woman is the same hue as the dress of the seated figure— red-orange, but of a darker value and lower intensity.

The intensity of color is affected by light and by its surroundings. Color seen in strong direct light, either natural or artificial, is more brilliant and vibrant than the same color viewed in subdued light or on a gray day. Believability in representational art derives from such awareness. Color is rarely seen in isolation; it is influenced by neighboring colors. Colors of similar intensity placed side by side hold together, whereas contrast produces separation. The higher the intensity of a color, the more it appears to project; the lower the intensity, the more a color recedes.

Project 6.15 Although Willem de Kooning's *Two Women's Torsos* (Pl. 2, p. 87) is a decidedly different interpretation of figures in a landscape than that of Aman-Jean's (Pl. 1, p. 87), careful examination of the two drawings reveals strong similarity in the way in which color has been employed. Analyze de Kooning's use of color—hue, value, and intensity. Determine the points of similarity between the two works.

Altering the intensity of a hue by adding white or black is of limited effectiveness, since the addition of either results in changing the value as well. In paint, most pigments are at their most intense as they come from the tube. Blue and violet are exceptions; their brilliance is increased by adding a small amount of white. It is possible to alter a color's intensity by adding some other color, but not without changing the hue as well.

Complementary colors. Complementary colors play two roles: They can either nullify or intensify each other. Mixed together, complements neutralize or lower the intensity of one another. In theory, true complements combined in the proper proportions will produce a neutral or colorless gray. However, in practice it is difficult to find exact complementaries, and the resulting mixture usually retains traces of one of the two colors. Placed in juxtaposition, complementaries increase the apparent intensity of each other, or truly "complement" one another; the effect is called **simultaneous contrast.** A spot of low-intensity orange placed against high-intensity blue will appear distinctly more intense. When orange and blue of corresponding high intensity are placed together the colors will appear to vibrate almost to the point that the eye can barely discern a precise separation.

Warm and Cool Colors

Color temperature has psychological and spatial impact. The hues on one side of the color wheel—yellow, orange, red, and their neighboring tertiaries—are called **warm** colors. The hues on the opposite side of the wheel—green, blue, violet, and the intermediate tertiaries—are termed **cool.** Warm colors seem to project forward in space; they are considered aggressive, psychologically arousing, and stimulating. Cool colors, in contrast, tend to recede in space, seem quiet and more restful. The effect of warm and cool is more evident when the two are seen together. Temperature is relative and any color can be made to appear either warm or cool, or both, as evidenced in the hair, shadowed face, and hat of the seated woman in Plate 1 (p. 87).

Drawing in Color

The Aman-Jean drawing (Pl. 1, p. 87) is so fully developed that it might well be described as a pastel painting. When color is introduced, the distinction between drawing and painting is sometimes arbitrary. Color mixing is generally more related to painting than to drawing, and although drawing is conceived as employing less than full modulations of color, a familiarity with the components of color is useful.

To explore the use of color in drawing, it will be necessary to expand your supply of materials. Today there exists an unparalleled abundance of colored drawing materials that provide a range of hues,

values, and intensities equal to that available to painters. Colored chalks, pastels, colored pencils, colored pens, and colored inks—all readily available, relatively inexpensive, and easy to use—will equip the beginner for a comfortable introduction to color. Although at sometime you will want to experiment with a variety of media and techniques, any one of the suggested media will be sufficient for initial excursions into color. (See Part 4, Drawing Media.)

In *Study of Hands and Drapery*, Hyacinthe Rigaud (Pl. 3, p. 88) introduces a limited sense of color by drawing with black-and-white chalk on blue paper, a technique that first came into use in Italy in the early 16th century. The color of the paper provides the middle value; the white and black are never blended together. The same technique would accommodate the substitution of a light, warm color and a dark, cool color for the white and black. Drawing papers are available in a variety of colors. They are most effective when the color and tone of the paper are incorporated into the drawing, as Rigaud has done.

Red chalk (red oxide) is one of the oldest pigments known, but it did not become popular as a drawing medium until the late 15th century. Used for **monochromatic** value studies, just the one color imparts a certain vitality to figure drawing because of its closeness to the color of flesh.

Adding first black and then white to red expanded the coloristic possibilities as demonstrated in Alanson Appleton's portrait study (Pl. 4, p. 88). Appleton has chosen to combine pen and ink with pastel in place of chalk, but the color concept remains unchanged, except for the addition of blue for the eyes. Although so obviously a drawing, the model seems amazingly alive.

The addition of yellow ochre to red, black, and white makes possible an even fuller range of color. Drawing with these four colors of chalk or crayon on medium gray paper permits the approximation of a full spectrum of color. Ochre and red combine to make orange; ochre and black make green; seen in relation to the other colors, black and white produce a bluish-grey; red and black, similarly, result in violet. None of the colors match their pure spectrum counterparts, but seen within the context of the drawing, the effect is perceivable. All of the color mixtures will be of a low intensity, even more so if the component colors have been blended, which tends to deaden the color and eliminate a sense of the directness of drawing.

Chalk and pastel drawings have greater vibrancy and vitality when color is applied directly as areas of unmodulated color (Pl. 5, p. 89) and juxtaposed strokes of pure color (Pls. 6–8, pp. 90, 171). The separate strokes of color are mixed by the eye/mind of the viewer, not by the thumb of the artist, to create **optical color.** Lights and darks are achieved by selecting light and dark chalks, rather than by adding white or black to a middle-value color.

Colored pencils are becoming an increasingly more popular drawing medium, partly because they are cleaner and less susceptible to smudging, but perhaps more because of their versatility (Pls. 9–12, pp. 172–174). In drawing with colored pencils, value and intensity are determined by pressure. Light pressure results in light value and color without much brilliance; greater pressure produces darker, more intense color. Colored pencils have a degree of transparency. Applying one color over another produces a third color that is often richer and more interesting than either of the originals, since individual colors tend to be somewhat harsh. A color can be lightened by applying

white or some other lighter color, or darkened with black or other darker colors. (A question remains about the permanency of color. In spite of manufacturers' claims, art conservation laboratories caution that the color of colored pencils is fugitive and should be tested for fading by controlled exposure to light.)

Project 6.16 Select one of the color media—pastels, colored pencils, pen and colored ink, possibly in combination with chalk—and adopt the various techniques discussed and illustrated to subjects of your own choosing. (Characteristics of individual media and suggested methods for using each are the subject of Part 4.) Begin with limited color before launching into full color. Be attentive to value and intensity, as well as hue.

Project 6.17 Arrange and light a group of several objects. Ignore the color that you see; draw only the values that you see and translate them into pure hues. Use yellow for the lightest areas, violet for the darkest, and other hues depending on the value of each and the value to be matched. (Hues become increasingly darker as you move in either direction on the color wheel from yellow toward violet.) You might want to consider color temperature in relation to both light and shadow and advancing and receding forms. Individual objects will be multicolored. Although the colors in the drawing will not correspond to what appears before you, the values should, and if they do, the sense of volume and space should be convincing.

Color, whether used in a literal way or more freely, can describe form and create the illusion of space, if attention is given to all three dimensions of color—hue, value, and intensity—with emphasis on value and intensity. Such concern is not limited to representational drawing/painting; it is a consideration for abstractionists as well.

Drawing in color introduces students to the realm of painting, provides a means of expanding the expressive potential of drawing—and perhaps makes students realize anew the power and beauty of black and white.

Texture

7

When we look at the world about us, we are conscious not only of form, space, color, dark, and light, but also of tactile qualities, a sense of the feel of surfaces, of roughness and smoothness, hardness and softness—**texture.** Skillfully used, texture can contribute significantly to expressiveness; lacking a decisive sense of texture, a drawing tends to appear flaccid and weak. The textural character of a drawing is determined by several factors, including the surface portrayed, the drawing materials employed, the method of application, and the artist's sense of invention.

Familiar Surfaces

The convincing duplication of surface texture—the actual visible and tactile surface characteristics of an object—lends a sense of authenticity to representational drawing. In drawing we are concerned primarily with reproducing the visual aspects of texture, yet we know that our most immediate experiences with texture are tactile.

Most children, at one time or another, have reproduced the images that appear in relief on coins by placing a piece of paper over a coin and rubbing it with the side of the lead of a pencil. Robert Indiana's *The American Eat* (Fig. 111) was created by exactly the same method. The technique is called **frottage.** The beauty of Indiana's drawing lies not so much in the letters of the brass stencil, but in the variety and richness of the tones created by his hatching with conté crayon.

Max Ernst was perhaps the first person to use the frottage technique to create a work of art, as opposed to simply making a copy. In

111. Robert Indiana (b. 1928;
American). *The American Eat.*
1962. Conté crayon rubbing,
25 × 19″ (64 × 48 cm).
Yale University Art Gallery,
New Haven, Conn.
(lent by Richard Brown Baker).

112. Max Ernst (1891–1976;
German). *La forêt pétrifiée.*
1929. Charcoal.
Musée National de l'Art Moderne,
Centre Georges Pompidou, Paris.

the charcoal drawing *Composition* (Fig. 112), he superimposed rubbings made from various pieces of weathered plank. Although the natural patterns of the wood grain are perceptible, the drawing seems to be of, but not necessarily about, wood. Whatever his intention, he has produced texture that is both visual and tactile. Not only do we see texture, we also experience what it would be like to touch it, because the texture no longer seems to reside in the wood, but in the drawing.

The wood grain patterns in René Magritte's *The Thought Which Sees* (Fig. 113) resemble those in the previous drawing, but beyond that the character of the two drawings is very different. Unlike Ernst, Magritte employs a variety of complex, obviously drawn linear patterns to suggest texture. The pattern chosen for the wood grain is appropriately the most descriptive, since it defines the only element in the drawing that is not ambiguous.

The precisely ruled vertical and horizontal ink lines of Ilya Bolotowsky's *Blue and Black Vertical* (Fig. 114) can be seen as texture of elegant richness, suggestive of, though not representing, sections of beautifully finished fine-grained wood. Whether or not the Bolotowsky drawing actually depicts wood, if for the moment you think of it as such, it allows a valuable comparison with Figures 112 and 113. Of the three examples, Figure 112 offers the most authentic description of wood texture because it was lifted directly from pieces of real wood, while the suggestion of texture in the other two is based on linear patterns. In each drawing the character of line conveys specific visual and tactile qualities of the texture. Thinness and regularity

below left: 113. René Magritte (1898–1967; Belgian). *The Thought Which Sees.* 1965. Graphite, 15¾ × 11¾″ (40 × 30 cm). Museum of Modern Art, New York (gift of Mr. and Mrs. Charles B. Benenson).

114. Ilya Bolotowsky (1907–1981; Russian–American). *Blue and Black Vertical.* 1971. Pen and ink, 30 × 22″ (76 × 56 cm). Private collection.

of ruled ink lines create the sensation of smoothness and variations in darkness suggest the sheen of polished wood in the black-and-white reproduction of Bolotowsky's drawing, in contrast to the rough, weathered feeling of the heavy, irregular patterns of Ernst's charcoal rubbing. In spite of pattern variations, Magritte's repetitious use of short vertical lines creates a wall totally without character. It might just as well have been left blank, except that without the texture it would appear as space rather than as a wall. Magritte has provided sufficient variety in the wood grain pattern to avoid monotony, but not enough to detract from the visual paradox of the drawing.

Project 7.1 Even though rubbings produce a reverse image, we often become more conscious of the visual qualities of texture when we see them presented as a pattern of marks on a sheet of paper, isolated from the object or surface itself. This project is intended to integrate the visual with the tactile; to increase visual awareness of familiar textures through seeing them translated into images on a sheet of paper.

Use a soft pencil, stick graphite, or a black crayon with bond paper or tracing paper (newsprint tears too easily). Make rubbings a few inches square from textured surfaces in your immediate environment—interior and exterior, natural and manufactured, hard and soft, fine and rough. The possibilities multiply in relation to your awareness and sensitivity. As you study the samples you will be aware that durable materials result in stronger patterns than soft materials such as fabric, a distinction that provides you with a clue about rendering textural differences. Rubbing methodically and uniformly will produce an effect close to the actual surface. A freer, irregular approach will result in a more visually interesting double texture, as in Figure 111.

Rendering Textures

When it is introduced into a drawing, either through direct rubbing or as torn or cut shapes pasted onto the drawing, texture created by rubbing will appear as a relatively two-dimensional pattern. Representational drawing often demands a more three-dimensional rendering of different surface characteristics, such as Joseph Stella's *Tree Trunk* (Fig. 115), in which raking light from the side reveals both texture and volume. (Jacques de Gheyn II described a similar subject with a stylized linear approach in Figure 91.)

Some artists such as Mary Claire Draeger (Fig. 116) reveal an almost passionate fascination with the meticulous rendering of surfaces, textures, and details. Yasuhiro Esaki's *Blue Sheet No. 9* (Fig. 117) is one of a series of full-page **tromp l'oeil** (fool-the-eye) drawings produced over a five-year period in which the artist explored the wrinkled and folded surface of a bedsheet, transforming the soft cloth into both a topographical map and a lyrical abstraction.

Project 7.2 Enlarging the scale of a surface provides an excellent means of becoming aware of its exact character. On close examination, the texture of many a familiar surface—a natural sponge, a crocheted afghan, the skin of a cantaloupe—proves visually fascinating. Light a familiar textured surface sharply from above and to one side (a "raking" light) to emphasize and clarify its texture. Fill a 4- by 5-inch (10- by 13-centimeter) rectangle with a pencil rendering of the surface magnified many times, using dark and light values to create a maximum sense of

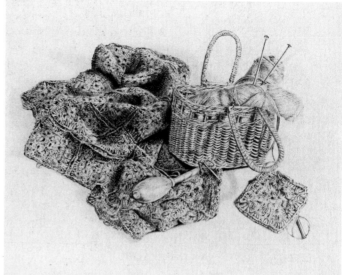

left: 115. Joseph Stella (1877–1946; Italian–American). *Tree Trunk.* Pencil and crayon, 17 × 11½" (43 × 29 cm). New Jersey State Museum Collection, Trenton (gift of the Friends of the N.J.S.M. in recognition of the services of Mrs. Robert D. Graff as its president, 1974–76).

above: 116. Mary Claire Draeger (b. 1960; American). *Cloey's Afghan.* 1980. Pencil, 9 × 11½" (23 × 29 cm). Courtesy the artist.

117. Yasuhiro Esaki (b. 1941; Japanese–American). *Blue Sheet No. 9.* 1979. Pencil and acrylic on paper, 28⅞ × 21½" (73 × 55 cm). Courtesy the artist.

its texture. Use a variety of hard and soft pencils on Bristol board to duplicate the texture as accurately as possible. Plan to spend several hours on this project, working slowly in whatever intervals your patience allows.

Textures of the Artist's Media

Different media produce different textures as do different papers—for example, crayon or coarse chalk on rough paper as contrasted to fine pencil on smooth paper. The textural pattern of Georges Seurat's *The Artist's Mother* (Fig. 118) is determined solely by choice of materials. Uniformly textured paper and soft conté crayon applied without indication of direction of stroke combine to create an impersonal surface. The drawing is about materials and technique rather than being descriptive or expressive of the subject.

Textural quality, as determined by various combinations of media and paper, significantly influences the expressive character of a drawing. Comparing Käthe Kollwitz's *Self-Portrait* (Fig. 119) and Daniel Mendelowitz's *Portrait of Annie* (Fig. 120), there is an appropriateness in the choice of paper (rough; smooth), media (coarse chalk; pencil), and method of application (bold, forceful; gentle, caressing) that contributes to the haunting beauty of each woman. It is nearly impossible to conceive of reversing the images.

Project 7.3 Gather papers of varying roughness, smoothness, and surface grain (see pp. 158–159); collect chalk, crayons, pencils, ink, and assorted pens, brushes, and sponges. Explore the effects that result from different combinations of media and papers. Use both the sides and points of dry media; cross-hatch and stipple (see p. 187) in both dry and wet; combine all types of pens, sponges, brushes, and so forth.

Comparative Textures

Project 7.4 Develop a full-page composition with texture as your subject using a media and paper combination from the last project. Cover the sheet with a random, free-flowing pattern of some complexity drawn with light pencil lines. Using the medium selected, perhaps pen and ink, begin by adding texture to one shape. Move to adjoining shapes and introduce different or related textures, working to integrate them so that the completed drawing conveys a sense of unity, rather than appearing as a two-dimensional patchwork of unrelated patterns. Allow patterns of light and dark to emerge by grouping shapes of the same or closely related values, working to achieve the effect of movement in space. The completed drawing should offer a richness of textural elaboration enhanced by a full range of values.

Project 7.5 Explore the expressive potential of texture by doing two drawings of the same subject, perhaps a still life with some textural variety, using two contrasting combinations of media and paper (Proj. 7.3). Do not make meticulously detailed renderings, but devote some attention to suggesting textural differences. Study the completed drawings; determine the effectiveness of each in relation to the subject; decide which materials and technique were most satisfying to use.

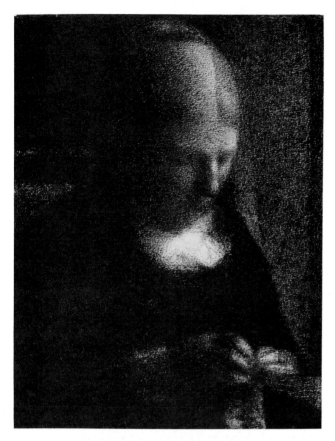

left: 118. Georges Seurat (1859–1891; French).
The Artist's Mother. Conté on paper,
12¼ × 9½″ (31 × 24 cm). Metropolitan Museum of Art,
New York (purchase, Joseph Pulitzer Bequest, 1955).

below left: 119. Käthe Kollwitz (1867–1945; German).
Self-Portrait. 1911. Chalk, 13¾ × 12⅛″ (35 × 31 cm).
Kupferstich Kabinett, Staatliche Kunstsammlugen,
Dresden.

below: 120. Daniel M. Mendelowitz (1905–1980;
American). *Portrait of Annie.* 1963. Rubbed graphite
pencil and eraser, 16 × 12″ (41 × 30 cm). Collection
Mrs. Daniel Mendelowitz. Stanford, Calif.

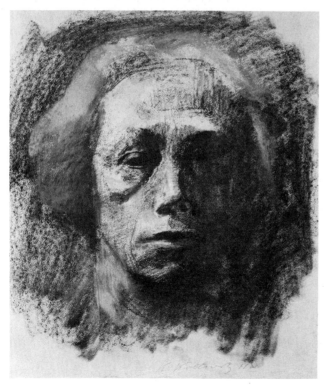

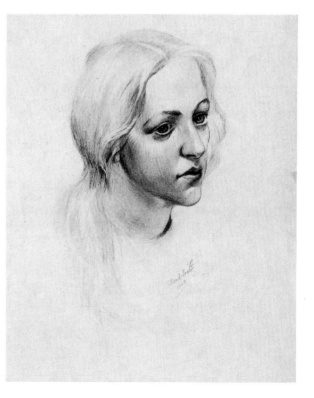

121. Giorgio Morandi (1890–1964; Italian). *Countryside at Grizzana.* 1932. Etching on copper, 7¾ × 7" (20 × 18 cm). Private collection, Milan. Reprinted from *L'Opera Graphica di Giorgio Morandi* by Lamberto Vitale. Published by Giulio Einaudi Editore, Turin.

122. Josef Albers (1888–1976; German–American). *Pine Forest in Sauerland.* c. 1918. Pen and ink on paper, 12⅝ × 9⅝" (32 × 25 cm). Collection Anni Albers and the Josef Albers Foundation, Inc.

Uniform Texture

Some artists prefer that the texture of a drawing assume an abstract character, determined by the mode of applying the medium rather than the nature of the subject. This method tends to emphasize the formal aspects of a drawing, as was evident in Seurat's portrait of his mother (Fig. 118) and seems best suited for stylized modes of expression, where a uniform texture prevails throughout a drawing. Such uniformity enhances the patternlike qualities of texture (Figs. 121, 122).

Project 7.6 Select an appropriate subject or plan a composition permitting a range of values using one uniform texture throughout. Simplify forms; work to achieve a maximum sense of volume and space. The size of your drawing should be influenced by the scale of the texture chosen. Some suggested ways of working are: (1) scribbling in curved and circular movements; (2) scribbling in angular and straight-line movements; (3) cross-hatching; (4) stippling, using dots or commalike marks; (5) combining or modifying one or more of the above methods.

Invented Texture

Creating uniform textures based on the suggestions in the previous assignment calls forth a sense of invention. Giorgio Morandi's *Countryside at Grizzana* (Fig. 121) and Josef Albers's *Pine Forest in Sauerland* (Fig. 122) are examples of both uniform and invented texture, as is Mark Tobey's *Long Island Spring* (Fig. 123). While the hatching and

123. Mark Tobey (1890–1976; American). *Long Island Spring.* 1957. Sumi ink, 24 × 19½″ (61 × 50 cm). Private collection.

124. Jennifer Bartlett (b. 1941; American). *In the Garden #123.* 1980. Pen and ink on paper, 26 × 19¾" (66 × 50 cm). Courtesy Paula Cooper, Inc.

125. Vincent van Gogh (1853–1890; Dutch–French). *Tree in a Meadow.* Reed pen, black and brown ink over charcoal sketch on ivory wove paper; 19⅛ × 24" (49 × 61 cm). Art Institute of Chicago.

cross-hatching used by Morandi might suggest light flickering on foliage masses, it is a formal device that he employs to define shape and mass, no matter what the subject. (It can be argued whether tonal hatching should be regarded as texture.) Albers, on the other hand, seems deliberately to have chosen (invented) his linear texture to more accurately describe the appearance and feeling of a pine forest, while Tobey's nearly abstract spattering and flecking explode with the vibrancy of new growth.

Expressive Use of Texture

The textural character of a drawing is influenced by the nature of the surface being depicted, the choice of materials and the manner in which they are used, plus the inventiveness of the artist. Expressiveness, in turn, is determined by the textural character of each artist's style. Jennifer Bartlett (Fig. 124), Vincent van Gogh (Fig. 125), and Jean Dubuffet (Fig. 126), each employing essentially the same medium, have responded to somewhat similar subjects with uniquely expressive textural drawings.

The beginner frequently shows conscious preferences that take the form of admiration for one master's way of working, and very often gives legitimate expression to these preferences by following the manner of the master. As the student matures as an artist, gaining assurance and independence from admired models, a unique and personal style of working will evolve.

Project 7.7 Study drawings with texture, not just those included in this one chapter. Select ways of working that achieve descriptive, vigorous, appealing textural character, and adapt the method to objects or subjects of your own choosing; perhaps you might want to reinterpret

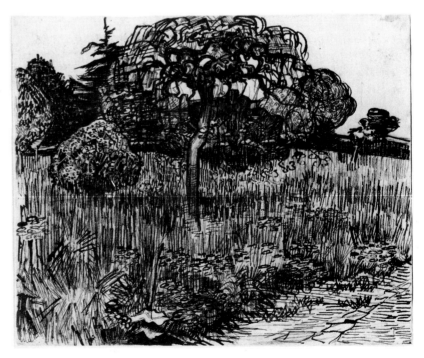

some of your earlier drawings. To become familiar with any one technique, it will be necessary that you do numerous drawings in the same manner. At first you will probably want to refer to the master drawing; then as you acquire a feeling for the technique, put aside the model. It is important to work with similar materials if you wish to achieve similar effects. Van Gogh's patterns and textures, for example, depend upon the quality of line produced by a reed pen (Fig. 125), for which a bamboo pen offers a suitable substitute. Let it be your intention to learn to use a technique, not to make a copy. Feel the mood of the style and the manner in which it was carried out, whether slowly and methodically or rapidly and impulsively, whether with small finger strokes or large hand movements. Allow deviations to occur. It is important to discover the most satisfying ways of developing texture with a minimum of self-consciousness so that it becomes an integral element in composition, contributing to expressiveness.

126. Jean Dubuffet (b. 1901; French). *Garden*. 1952. Pen and carbon ink on glazed white wove paper, 18¾ × 23¾" (48 × 61 cm). Art Institute of Chicago.

Sketchbook Activities

When you find a way of working that appeals to you, either because it feels comfortable or because you like the results, practice it in your sketchbook (and elsewhere) so that it becomes a natural part of your drawing vocabulary.

Composition

Composition . . . alters itself according to the surface to be covered. If I take a sheet of paper of given dimensions I will jot down a drawing which will have a necessary relation to its format—I would not repeat this drawing on another sheet of different dimensions . . .

—Henri Matisse

The success of a drawing derives in part from the appropriate matching of medium to subject matter. Effective drawing, however, requires more than learning to manipulate media skillfully to produce a satisfying representation of an object, for neither choice of subject nor beauty of technique is sufficient if the artist has not also been concerned with composition.

Composition, which is the structure of a picture as separate both from subject and style, is essentially abstract design. It is the selection and organization of line, shape, value, texture, pattern, and color into an aesthetically pleasing arrangement embodying such principles of design as balance, harmony, rhythm, repetition and variation, dominance and subordination, and focus. The final desired effect of composition is a sense of unity. It has been suggested that good composition "supports the image so discreetly that it is never noticed."

Principles of composition are not hard and fast rules, never to be broken. They should be considered as guides or suggestions that have been recognized and used effectively by successful artists for centuries. The same artists felt free to interpret the principles, and you are urged to do the same, as long as the result justifies whatever you chose to do. To break rules effectively it is first necessary to know what they are.

A drawing or painting (sculpture, music, and literature as well) is composed of three elements—subject matter, form or composition, and content. Subject matter alone is not a sufficient condition for a work of art. The significance of any work lies in its content or meaning. The meaning given to the subject depends largely upon the form (composition) selected by the artist. Beyond having the skill to repro-

duce the likeness of an object and control media, the artist must know the principles of composition and be able to use the art elements expressively to ensure full meaning to every drawing.

The focus of this chapter will be on composition as the underlying abstract structure of drawings/paintings, with attention given to subject, style, and content only as they relate to pictorial design. The projects will be presented primarily as design problems that, depending on individual preference, can be approached abstractly or representationally.

Compositional Studies

Many drawings fail from lack of planning. Compositional studies made as quick thumbnail roughs allow you to consider different alternatives and to solve many major compositional problems in advance. In an on-the-spot rough sketch (Fig. 127) Mary Cassatt established the essential composition for her painting *At the Opera* (Fig. 128). Boldly simplified shapes of light and dark provide an effective visualization of the subject without elaboration of detail other than a few lines of written notes.

Sketchbook Activities

When you visit museums, and as you look at paintings and drawings reproduced in art books and periodicals, analyze the composition of various works. Develop the habit of making rough thumbnail sketches of the works.

below: 127. Mary Cassatt (1844–1926; American). Study for *At the Opera*. 1880. Soft pencil on paper, 4 × 6″ (10 × 15 cm). Museum of Fine Arts, Boston (gift of Dr. Hans Schaetter).

right: 128. Mary Cassatt (1844–1926; American). *At the Opera*. 1880. Oil on canvas, 32 × 26″ (81 × 66 cm). Museum of Fine Arts, Boston (Charles Henry Hayden Fund).

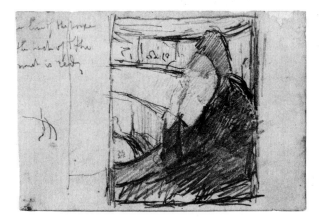

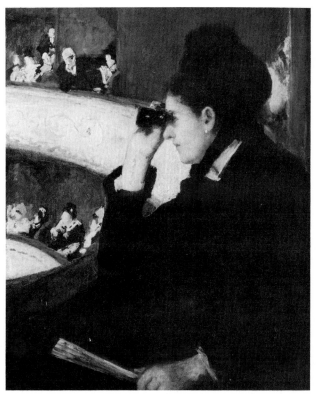

Although they need be no more complete than Figure 127—forms reduced to bold shapes, values simplified to white, black, and middle gray—it is important that the proportions of your study match those of the original. If you are enrolled in an art history class, you have the perfect opportunity to engage in this activity. Doing such sketches will make you more aware of how the elements of composition are integrated into a finished work of art. (Review Chapter 4.)

Selecting Format

Composition begins with the size and shape of the paper, with the edges of the paper becoming the first four lines of a drawing. Composition is the relationship of all lines, shapes, and elements to the four edges as well as to each other.

Students have a tendency to start drawing without regard for the size of the paper, sometimes drawing objects so large that they run off the sheet, but more frequently, drawing forms so small that wide borders of blank paper are left. It is important to learn to use the full size of the paper. If a drawing is to be smaller than the full sheet, four lines can be drawn to define the perimeter of the picture plane and establish the format of the composition (Fig. 127).

The rectangle is the most common compositional format. Working from nature or life, it is helpful to use a viewfinder with a rectangular opening to select what and how much to include. Moving the viewfinder closer to your eye or holding it farther away controls the amount of area you see. Use it exactly as you would the viewfinder of a camera to find the most interesting view of the subject and to determine whether a horizontal or vertical format is more appropriate. Two artists looking through viewfinders at the same subject might well arrive at totally different compositions, both equally satisfying.

Unlike photographers, who are limited essentially to what they see in the viewfinder, artists have the option to shift objects around within the space of their pictures. Forms can be added or eliminated if such changes will provide better balance, create stronger visual interest, and improve composition.

Open and Closed Composition

Within the format selected, elements can be arranged into a **closed composition** in which the forms seem well contained by the edges of the picture plane, or into an **open composition** in which images appear unrelated to the size of the paper, creating the impression that the composition, unlimited by the outer edges, extends beyond the boundaries of the picture. "Open" implies something free, expansive, flowing, unrestrained, spacious, undefined; "closed" suggests images that are contained, controlled, compact, complete (see p. 126).

Balance

Among the principles of composition, **balance** is given first consideration. In fact, composition is defined as the balancing of the elements of design. Balance may be either symmetrical or asymmetrical.

Symmetrical balance calls for dividing the composition into two halves with seemingly identical elements on each side of a vertical axis. Rembrandt's *Canal and Bridge beside a Tall Tree* (Fig. 129) demonstrates that the two sides need not be exactly identical as long as a feeling of balance is maintained. The freshness of the pen line and the degree of variation between the two halves of the drawing prevent the composition from seeming stiff and static, which can be the effect of symmetrical balance. Symmetry lends an aura of dignity and formality to a composition.

Most artists, agreeing that diversity offers greater interest than sameness, prefer **asymmetrical balance.** There are no rules for asymmetrical balance; it is based upon a visual sense of equilibrium that can be felt more than it can be measured. It can be likened to a teeter-totter. For children of the same size the board is placed with one half on each side (symmetrical), whereas with a small child and a larger person it becomes necessary to shift the position of the board to provide more weight for the smaller of the two (asymmetrical). With this image as a basis, heavier shapes are placed nearer the middle of a composition. In Figure 130 the small, intense light accent of the lamp

129. Rembrandt (1606–1669; Dutch). *Canal and Bridge beside a Tall Tree.* Pen and brown ink, brown wash; 5⅝ × 9⅝″ (14 × 24 cm). Pierpont Morgan Library, New York.

130. F. H. Potter (1845–1887; English). *Rest.* Black chalk, 9⅝ × 13″ (24 × 33 cm). Tate Gallery, London.

offsets the greater complexity of muted form and pattern in the right half of the composition. The function of the hand of the figure as the fulcrum point is made more apparent by the central positioning of the picture frame above.

Asymmetrical balance offers the artist greater compositional freedom. It is more flexible, more dynamic. It allows the introduction of greater movement and action.

Directional Lines

Line fulfills a number of compositional functions: It defines shapes; divides space; sets up movement, rhythm, and pattern; provides structure. Learning to control the placement of each line, and the patterns created by combinations of lines, provides a means of adding expression to a composition.

While any composition incorporates various linear elements, a dominant mood can be established by placing emphasis on **directional lines.** Long, relatively unbroken, horizontal lines are calm and restful, suggestive of peace, tranquility, and serenity; vertical lines convey a feeling of dignity, stateliness, stability, and strength. Combining vertical and horizontal elements produces a solid and orderly sense of structure similar to architectural construction.

Diagonal lines are dynamic, suggestive of action. Broken patterns of diagonals result in confusion and disorder; opposing diagonals create conflict and strife. Diagonal compositions generally are more forceful and disturbing than those based on a vertical and horizontal organization.

Curved lines are associated with grace, elegance, and gently flowing movement, while more complicated patterns of curves with frequent reversals produce greater animation, even agitation. By combining arcs and diagonal lines, Charles Sheeler (Fig. 131) and Cy

131. Charles Sheeler (1883–1965; American). *Yachts.* 1924. Lithograph, 8¼ × 9¾″ (21 × 25 cm). National Museum of American Art, Smithsonian Institution, Washington, D.C. (Museum Purchase).

Twombly (Fig. 132) create strongly contrasting moods, the first gentle and relaxing, the second expressing turbulence.

Directional lines can be introduced without actually being drawn, as evidenced in the invisible though unmistakable verticality of Matisse's *Plumed Hat* (Fig. 133). Although softened by the rich pattern of loops and gracefully undulating curves, it is the figure's almost rigidly upright pose that evokes such regalness.

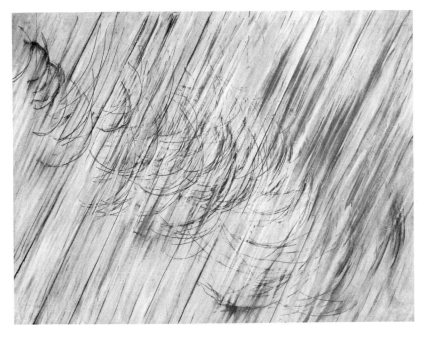

above: 132. Cy Twombly (b. 1929; American). *Untitled.* 1972. Oil on canvas, 4′9⅜″ × 6′4″ (1.47 × 1.95 m). Collection Nicola del Roscio, Rome.

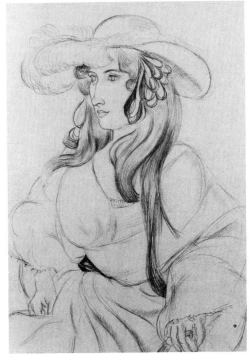

left: 133. Henri Matisse (1869–1954; French). *The Plumed Hat.* 1919. Pencil on paper, 29⅞ × 14⅜″ (53 × 37 cm). Detroit Institute of Arts (bequest of John S. Newberry).

Shape

Shape refers to the flat, two-dimensional aspects of form as opposed to volume. When a three-dimensional form is reduced to silhouette we become conscious only of its shape. Shapes can be defined by contour line and by changes of value, texture, and color, alone or in combination.

Project 8.1 One shape drawn on a piece of paper immediately sets up a relationship between it and the paper. Select a single shape, either a geometric shape such as a circle or triangle, or the simplified silhouette of a familiar object such as a cup or pitcher. In a series of thumbnail studies explore the relationship between the shape and the surrounding space as you move the shape within that area. Enlarge and reduce the size of the shape. Let the shape dominate the space; then let the space dominate the shape. Create both pleasing balance and disturbing tension. Introducing a second shape will establish a new set of relationships that must be balanced. Each shape that is added sets up other conditions requiring adjustments to previous solutions—decisions about placement, keeping forms separate, letting them touch, allowing them to overlap. Philip Guston's still-life drawing (Fig. 54) deals exactly with this problem.

A shape cannot exist alone in a drawing; it can be seen only in relation to adjacent shapes and the space that surrounds it. Composition, therefore, involves **positive shapes** defined by **negative space** (see Chapter 3). It is as necessary to compose negative space as it is to be concerned with positive shapes.

The interlocking of positive and negative is perhaps most apparent when represented in the extremes of black and white (Fig. 134). Franz Kline's intention was "to create definite positive shapes with the whites as well as with black." It is surprising, considering the force of

134. Franz Kline (1910–1962; American). *Untitled.* 1960. Ink on paper, 8½ × 10½" (22 × 27 cm). Whitney Museum of American Art, New York (gift of Mr. and Mrs. Benjamin Weiss).

above: 135. Georgia O'Keeffe
(1887–1986; American).
Drawing IV. 1959. Charcoal on paper,
18½ × 24½″ (47 × 62 cm). Whitney
Museum of American Art,
New York (gift of Alex Katz).

right: 136. Beth Van Hoesen
(b. 1926; American). *Leeks.* 1960.
Engraving and etching, 8 × 9¾″
(20 × 25 cm). Courtesy the artist.

his gesture and the scale of his brush strokes, to realize that the draw-
ing is only slightly larger than the page size of this book.

Georgia O'Keeffe's *Drawing IV* (Fig. 135), stark and dramatic in
its use of positive and negative, is an aerial view of a river and its
tributaries. O'Keeffe explained that although she was afraid to fly, she
enjoyed what she could see. "I made many drawings about one and a
half inches square of the rivers seen from the air. At home I made
larger charcoal drawings from the little pencil drawings. Later I made
paintings from the charcoal drawings."

Beth Van Hoesen combines a literal describing of leeks with an
animated interplay of positive shapes and negative space presented
almost as two-dimensional design (Fig.136). Even though the back-
ground is considered negative space, it can be seen as shapes every bit
as interesting as the leeks. The way in which the leeks intersect only
the lower and side edges of the composition in contrast to the unbro-
ken upper edge adds vitality to the image.

Project 8.2 Continue to work with a series of small sketches or stud-
ies. Begin with a rectangle or square and cut (draw) five notches into
the outer edges. They may be large or small and of any shape, although
similar shapes result in a more unified design. Shade either the remain-
ing shape or the cut-away segments to emphasize positive and negative.
Experiment with symmetrical and asymmetrical balance, with dominance
and subordination. Explore the possibilities of leaving one, two, or even
three edges unbroken.

137. Underpainting by Nonomura
Sōtatsu (1576–1643; Japanese),
calligraphy by Honnami Koetsu
(1558–1637; Japanese).
Poem, with birds in flight.
Ink on gray-blue paper, gold-flecked;
7⅝ × 6⅝″ (19 × 16 cm).
Nelson Gallery–Atkins Museum,
Kansas City, Mo. (gift of
Mrs. George H. Bunting, Jr.).

By rotating your drawings, you will become aware that the impact of the same composition can be altered by seeing it from another angle. Artists frequently look at a work in progress upside down, or view it in reverse in a mirror, to find compositional weaknesses.

Concern must be given to how light and dark areas are distributed and balanced. Equal amounts of light and dark with equal emphasis between shape and space can result in a reversal of images. First you see one shape, then the other; it is impossible to focus on both images at the same time. In the Escher work (Fig. 102) this leads to purposeful confusion. When the effect is unintentional, it is simply confusion.

Repetition—Pattern

The **repetition** of similar elements—lines, shapes, patterns, textures, and movements—contributes to a sense of **unity.** The purposeful repetition of a shape or other element to create or suggest an overall design is **pattern.**

The Japanese master Sotatsu needed no more than two or three carefully chosen calligraphic brush strokes to place a crane in flight (Fig. 137). Repetition of the motif begins to establish a pattern, yet by varying the intervals between the individual images and confining them to one area of the composition, the resulting pattern is neither monotonous nor decorative. The same brilliant balancing between repetition and pattern is evident in Figure 101.

Variation—Contrast

To prevent the repetition of any element from becoming either too obvious or monotonous, **variety** can be introduced to provide **con-**

trast. *Apples* by Ellsworth Kelly (Fig. 138) and *Six Persimmons* by Mu-Ch'i (Fig. 139) are both compositions based on the repetition of circular shapes with subtle variations in shape and spacing. In each example one of the circles stands alone, while the others are tangent one to another, or overlap. Mu-Ch'i provides contrast by outlining the shapes at each end, using solid areas of ink for the others. Kelly and Mu-Ch'i both provide variety to the stems and other details that identify the circles as pieces of fruit.

138. Ellsworth Kelly
(b. 1923; American).
Apples. 1949. Pencil on paper,
sheet 17⅛ × 22⅛″ (43 × 56 cm).
Museum of Modern Art, New York
(gift of John S. Newberry).

139. Mú-Ch'i (13th century;
Chinese). *Six Persimmons.* Ink on
paper, 14½ × 11¼″ (37 × 29 cm).
Ryoko-in, Daitokuji, Kyoto.

140. Charles Roth (b. 1948; American). *Servants: From a Line of Men, 1930*. 1979. Etching and aquatint, 29¾ × 40½″ (76 × 103 cm). Courtesy the artist.

Unified compositions are not built on sameness. There can and must be variety; yet with each element introduced, with each principle considered, the determining factor is always balance. That which applies to two-dimensional design applies equally to compositions built around recognizable subject matter rendered three-dimensionally. Students too frequently think of design as existing apart from representational drawing, when in fact the two are inseparable. Charles Roth's *Servants: From a Line of Men, 1930* (Fig. 140) combines three-dimensional representation with an emphatically two-dimensional design that demonstrates skillful use of positive and negative, repetition, and variation.

Dominance—Subordination

In successful composition certain elements assume more importance than others. As a center of interest, such elements become dominant; all other parts are subordinated to them. Although the artist wants the viewer to be conscious of everything in the drawing and to look at every detail, attention ultimately focuses on a dominant element. However, should that part be so dominant that it overwhelms everything else, it throws the composition out of balance. In symmetrical composition the center of interest will be placed in the middle of the composition. Generally, the focus of interest will not be centered in asymmetrical composition.

Movement

A picture with only one center of interest soon bores the viewer. Like a dramatist, novelist, or composer, an artist introduces secondary focal points, subplots as it were, leading the eye of the viewer from one to another, eventually directing attention back to the dominant focal point. The artist determines the sequence in which the eye moves

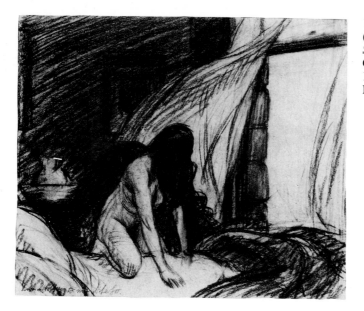

141. Edward Hopper
(1882–1967; American).
Study for "Evening Wind." 1921.
Conté and charcoal on paper,
10 × 13⅞" (25 × 35 cm). Whitney
Museum of American Art, New York.

from one area to the next, ultimately focusing on the center of interest.

The viewer's gaze seems to focus first on the white rectangle of the open window in Edward Hopper's *Study for "Evening Wind"* (Fig. 141) as does that of the woman in the drawing, but the viewer's attention does not remained fixed there. The space is essentially empty and devoid of any real visual interest. Instead, it is the woman, particularly her head, nearly centered on the page, that is the focal point. The contour of her head as it is silhouetted against the curtain is the most sharply delineated detail in the drawing. The curtains billowing into the room and the circling back of the bedcovers direct attention to the figure. A seemingly incidental detail—the dimly suggested pitcher and wash basin at the left—contributes to compositional balance and functions as a secondary focal point pulling the viewer back into the room.

Just as the flow of traffic can be programmed, so too the way the eye of the viewer moves through a composition can be controlled by a skillful artist. The eye tends to move rapidly between large shapes, moving more slowly through small complicated areas as it pauses to examine details. What appears as casual disarray in Richard Diebenkorn's *Still Life/Cigarette Butts* (Fig. 142) is actually a very thoughtful traffic flow pattern in disguise.

Project 8.3 The subtlety and complexity of Figure 142 deserves careful analysis. What details, for example, set up the counterclockwise movement? It would be instructive to do a diagram of the composition. Begin by drawing a pair of lines corresponding to the left and bottom edges of the white shape (sheet of drawing paper) centered at the right, continuing both lines across the full width and height of the drawing. Repeat with the bottom and right edges of the white shape at top center. Indicate all elements that fall into alignment with those four major compositional lines. Add important diagonals and circles. Notice how skillfully Diebenkorn has integrated all aspects of composition thus far discussed into this one drawing.

Project 8.4 Divide a rectangle of any size (from 4 by 6 inches [10 by 15 centimeters] to a full sheet of paper) into shapes that are interesting both individually and in relation one to another. The shapes should be varied in size and outline, providing areas of both simplicity and complexity. The design can be derived from straight lines, curved lines, irregular free-form shapes, or a combination of forms. Remember that similar shapes create unity, but variety contributes to pictorial interest.

Introduce white and black, plus an intermediate value, to establish centers of interest. Simplify shapes or engage in additional breaking up of space as you develop a flow of movement through the composition. Allow directional lines, linear patterns, and the repetition of shapes, spaces, intervals, and values to set up paths of movement. Incorporate as many principles of design as possible into your composition.

Rhythm

Repetition, variation, and movement combine to create **rhythm** in both musical and pictorial composition. The word rhythm automatically seems to evoke an image of flowing lines (Fig. 143), yet it is not limited to curvilinear forms. Patterns of straight lines with attention to the repetition of groupings and intervals as well as direction of lines also establish rhythm (Fig. 144).

Project 8.5 Develop a composition with a rhythmic pattern created by only vertical, horizontal, and diagonal lines. Let each line intersect two borders of the paper or rectangle with no change in direction within any single line. Establish rhythm through changes in spacing and density of

above: 143. Mark Tobey (1890–1976; American). *Mountains*. 1952. Crayon on paper mounted on cardboard, 37⅜ × 47″ (95 × 119 cm). Courtesy Preston, Thorgrinson, Ellis & Holman, Seattle.

left: 144. John Marin (1870–1953; American). *Bridge and Buildings*. c. 1913. Pencil, 5⅜ × 7⅝″ (14 × 19 cm). Art Institute of Chicago (gift of Georgia O'Keeffe).

lines. Be concerned with creating an interesting composition with balance and centers of interest, rather than repetitious pattern.

Project 8.6 Follow the same instructions for the last assignment, substituting curved lines. Reverse curves or S-curves can be used.

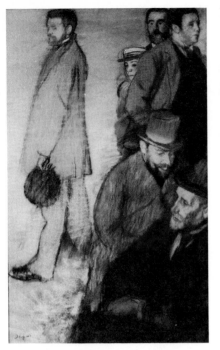

145. Edgar Degas (1834–1917; French). *Six Friends.* c. 1885. Pastel and black chalk, 45¼ × 28" (115 × 71 cm). Museum of Art, Rhode Island School of Design, Providence (Museum Appropriation).

Depth

In both two-dimensional design and three-dimensional representation overlapping forms suggest spatial depth (Fig. 145). We automatically see them as being one in front of another. The effect is heightened when the overlapped shapes also diminish in scale. When two similar shapes are represented in different scale we are inclined to see the larger form as being closer. That interpretation comes from our conditioning in looking at illusionistic art in which the scale of an object is determined by its distance from the viewer.

Project 8.7 Select several interestingly shaped objects, including a teapot or some similar form that has both positive and negative elements inherent in its design. Line them up on a table without grouping them into a composition. Study each form and see it as a flat shape. It will be helpful to do a simple contour drawing of each object.

Create a composition representing the objects as two-dimensional shapes, overlapping the forms to suggest spatial depth. Explore different ways of overlapping the shapes so that partially revealed forms are interesting as shapes apart from the objects they depict. Organize the objects to provide visual interest to the surrounding space. Develop the drawing in flat areas of light, dark, and intermediate values, using contrast as a means of providing focus. Overlapping shapes of the same value will result in new shapes, which can enhance the composition. As long as the old and new shapes can be understood and do not interfere with spatial relationships, they need not be separated. Remember that a balance of simplicity and complexity contributes to an interesting composition.

Value

Value is an essential element in pictorial composition. It functions to define/separate forms, establish balance, provide movement, maintain spatial unity, and introduce expressiveness. A common failure in many pictures by inexperienced artists is a lack of purpose in their tonal structure. An artist who understands how to control value, rather than being bound to a literal copying of what is seen, can rearrange, reverse, or intensify patterns of light and dark to strengthen a composition, whether working from life or imagination.

Distribution of Value

The impact of a picture is based to a large degree on the distribution of light and dark. Strong patterns of dark against light and light against dark (Fig. 142) create a much different effect than light and dark used with middle-value grays (Fig. 145). Even against middle values, the impression of white and black depends upon whether they are separated, appear side by side, or are surrounded one by the other.

Project 8.8 Arrange three simple shapes (squares) in a rectangle so that one shape is completely surrounded by two shapes that appear to float in front of the background. Using compressed charcoal, fill in each separate area with a different value—white, light gray, dark gray, and black. Repeat the exercise four times, using each of the values as the

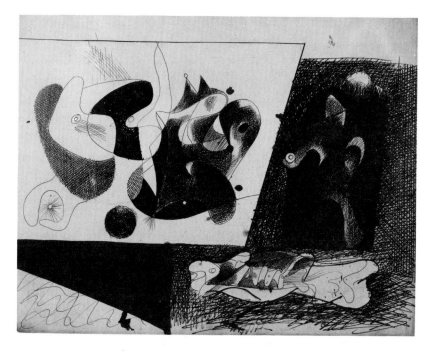

146. Arshile Gorky
(1904–1948; Armenian–American).
Abstract Forms. 1931–32.
Pen and India ink,
22½ × 29″ (57 × 74 cm).
Art Institute of Chicago
(Grant S. Pick Memorial Fund, 1968).

background and altering the values of the other shapes. Observe the changes in impact.

Project 8.9 Compose a second, more elaborate composition using abstract or representational shapes. Plan a major center of interest and two minor ones. Develop the composition in values, using the previous assignment as reference. Areas of greater contrast create focal points and separation; subtle value changes provide transition and subordination.

Value Defines Space

Forms are made to advance and recede through degrees of value contrast (Fig. 146). Against a dark background, light shapes advance to the degree of their brilliance; against a white background, light tones are held closer to the background while dark shapes are projected forward (Fig. 92). The stronger the contrast, the more a form advances. When contrast is lessened, forms appear to recede.

Separation and Integration

Joseph Raffael solves the problem of defining and separating light shapes against other light shapes by creating dark haloes where the flower petals overlap in his drawing *Hyacinth* (Fig. 147). Shapes separated in this manner take on a strongly decorative character, yet notice the way the petals stand out in relief, as compared to Kelly's *Apples* (Fig. 138).

Project 8.10 Using such objects as tea kettles, cups, jars, and other familiar objects, develop a composition in which shapes of similar value are made to stand out in bold relief one from another through the

147. Joseph Raffael (b. 1933; American). *Hyacinth*. 1975. Ink and ink wash, 22½ × 30″ (57 × 76 cm).

method of separation suggested above. The method is most effective when it combines both sharp and softened edges.

Closed form, in which a value is confined within the contour or silhouette of an object, stresses separation. **Open form,** in which a value blends into a similar surrounding area without any obvious separation, allows the integration of various elements as well as producing a feeling of aliveness. When the same or similar values are placed side by side, edges begin to disappear and forms begin to merge. Such transitions serve to introduce movement by permitting the eye to flow from one area to another.

The same value can be made to function as both foreground and background without any loss of spatial depth, as seen in Elmer Bischoff's *Girl Looking in a Mirror* (Fig. 148). The figure and its reflection are joined together where the reflected foot becomes one with the upper leg of the figure, allowing the eye to move from the foreground into the space of the mirror. Bischoff has used value contrast to separate the figure from the background in some areas; in other areas closely related values allow the figure to merge into the background. The eye is invited to move freely into and out of the picture space. Notice that volume is suggested through relatively flat areas of tone without extensive modeling.

Project 8.11 In a series of charcoal studies, explore the use of limited value to establish the effect of movement into and out of space. Reserve white and black for accents. Use broad, simplified shapes. Use contrast to separate forms and focus attention, letting closely related values provide transition. Let light and dark flow from one area to another to provide movement and to prevent individual shapes from becoming too isolated. Avoid equal emphasis on light and dark; balance does not depend upon an even distribution of values. In each study let one value predominate. A limited number of values, well handled, can convey the impression of many tones.

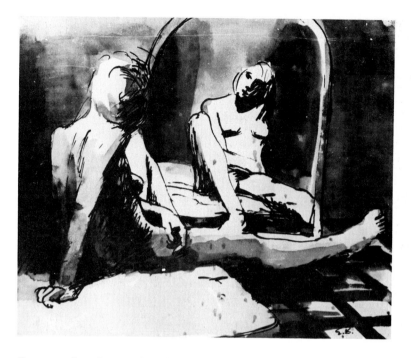

148. Elmer Bischoff (b. 1916; American). *Girl Looking in a Mirror.* 1962. Ink and wash, 14¾ × 17⅞" (37 × 45 cm). San Francisco Museum of Modern Art (purchase).

Expressive Use of Value

The choice of value scale determines the expressive tone of each drawing. Light pictures generally suggest happiness and aliveness; dark pictures, heaviness and gloom. (Compare Fig. 34 and Fig. 39). Consider, for example, how lighting is used to establish mood for films and television; popular television comedies are brightly lighted while more serious dramas often rely upon darkness. In drawings and paintings the exaggerated use of **chiaroscuro** (pp. 77–79) contributes to a heightened sense of theatricality.

Color

Assembling objects for a drawing in black and white requires no particular concern about color; drawing and painting in color is another matter. Everyone does not have access to a variety of objects harmonious in color; consequently, duplicating the colors of the assembled objects might not produce a pleasing balance of color. Artists are free, however, to alter color as they choose.

Color Schemes

A number of **color schemes** have been formulated to provide a sense of color harmony and unity. An understanding of the different systems gives the beginner a point of departure for selecting and combining colors. The three most widely recognized color schemes are **monochromatic, analogous,** and **complementary.**

Monochromatic Color Scheme

A **monochromatic** scheme involves varied hues and intensities of a single hue. Black and white, not being colors as such, can be introduced without violating the one-hue limitation.

Analogous Color Scheme

An **analogous** color scheme employs unlimited values and intensities of neighboring hues on the color wheel, the range not to exceed the bounds of two consecutive primary colors. Analogous character is most emphatic when a single primary hue dominates. Though more animated than monochromatic, the analogous scheme can also create a harmonious and quiet mood due to the close relationship of its component hues. Martha Alf's *Two Pears No. 3* (Pl. 6, p. 90) is suggestive of analogous color.

Complementary Color Scheme

Contrasting hues are the basis of the **complementary** color scheme. The addition of other hues is permitted, as long as they do not overwhelm the requisite pair of complementaries (Pl. 1, p. 87).

Two pairs of colors, such as blue and orange plus red and green, comprise a **double-complementary** scheme. Willem de Kooning's *Two Women's Torsos* (Pl. 2, p. 87) introduces yet a third pair, yellow and violet.

A **split-complementary** scheme poses one hue against the two hues flanking its complement; an example would be yellow with red-violet and blue-violet.

According to Henri Matisse, the quality of color is determined by the quantity of color. Some color theorists who advocate a proportional use of color suggest that a balance between complementaries requires equal amounts of red and green, two times as much blue as orange, and three times as much violet as yellow. (Plate 1, page 87, comes close to meeting the red-green specifications.)

Project 8.12 While most artists settle for a pleasing balance of color, it is instructive to experiment with various color schemes. To experience the interaction of color, use graph paper and colored pencils or pastels to create images, even portraits, by filling in individual squares with a single color. Let gradations of color and tone result from changing colors in adjacent squares. The completed drawing will have somewhat the effect of a mosaic or needlepoint when seen close up; at some distance the squares will disappear. Do a drawing on graph paper in which the juxtaposition of the three primary colors of red, yellow, and blue create the secondary colors orange, green, and violet.

Project 8.13 Do a drawing based on the proportional balancing of complementary colors. It is not necessary to have equal amounts of each pair; one set can be dominant. Value and intensity changes will contribute to a more painterly effect, as will introducing more than one color into a shape or object.

Other aspects of color are discussed in Chapter 6, pp. 94–98.

Point of View

Even after careful consideration and application of the principles of composition, a drawing might well seem dull and uninteresting simply because the subject has been presented from a very ordinary point of view.

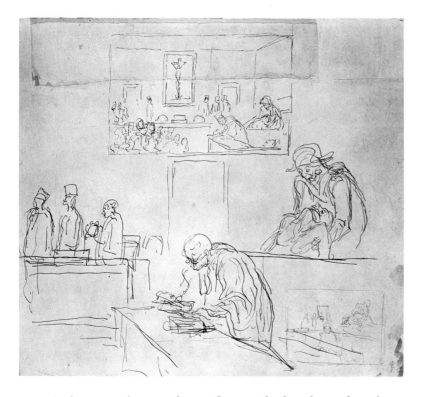

149. Honoré Daumier (1808–1879; French). *Courtroom Scene*. Pen and ink on gray paper, 13⅝ × 16⅜″ (35 × 42 cm). National Gallery of Art, Washington, D.C. (Rosenwald Collection).

Artists, not just students, frequently let themselves become trapped into relying upon a single point of view, either out of habit or because of restricted studio space. In drawing classes, instructors often confront space limitations when arranging setups, which must be visible to everyone in the room. Because it is rarely possible to provide a rich variety of viewpoints, students must take the initiative to find interesting positions from which to draw. They should not, as some students are inclined to do, select one drawing bench or easel and stay there for an entire semester, so that every still life or figure tends to be viewed from exactly the same eye level.

Compositions need not be monotonous if the point of view is varied. Develop the habit of making quick thumbnail sketches to examine possibilities for expanding your compositional vocabulary. Add variety, drama, and interest by shifting to high or low eye levels; occasionally employ an eccentric or unusual viewpoint.

A composition can be enhanced by cropping or by opening up and adding more space. Be certain that cropping is deliberate, not the result of poor planning. Thumbnail sketches allow you to consider different alternatives (Fig. 149).

Multiple Points of View

Representational drawing traditionally assumes a consistent point of view, each object drawn from the same eye level, each object occupying its own space, yet no single fixed viewpoint exists for either the artist or viewer. Our visual perception of three-dimensional form and space depends upon continuous eye movement. Interestingly, to experience a drawing the eyes of the viewer must shift from one area to another in exactly the same manner that the eyes of the artist move around objects to draw them.

150. Gino Severini (1883–1966;
Italian). *Self-Portrait in Straw Hat.*
1912. Charcoal, 21½ × 21⅝″
(54 × 55 cm). Art Institute of
Chicago.

151. Jacques Villon (1875–1963;
French). *The Dinner Table.* 1913. Dry
point, 11⅛ × 15″ (28 × 38 cm).
The Museum of Modern Art,
New York (Purchase Fund).

Acknowledging this aspect of seeing has resulted in a freer ap-
proach to drawing, which introduces movement through the use of
multiple points of view. Paul Cézanne, recognizing that no object
could be fully explained when drawn from one viewpoint, chose to
look at individual objects from different vantage points. By combining

the various views into a composite image, he strengthened the sense of volume and structure.

Unlike Cézanne, the cubists used multiple viewpoints to shatter the solidity of three-dimensional form. Objects were broken into fragments, which were reassembled in such a manner to tell the viewer more about the original object than could be visible from a single point of view, as in Gino Severini's *Self-Portrait in Straw Hat* (Fig. 150) and Villon's *La Table Servie* (Fig. 151). In departing from strict literal representation based on a static single viewpoint, images took on a great sense of aliveness.

Project 8.14 A cubist approach involves juxtaposing segments of the three separate views—top, front or back, and side—into a composite drawing creating the impression of movement around the object in space. On separate sheets of tracing paper draw three different views of one object, keeping all drawings in the same scale. Place the three drawings one over the other. By shifting them slightly, incorporate the most interesting sections into a single drawing that reveals the character of the object as fully as possible and suggests movement around it. Do not attempt to maintain a literal representation with a recognizable contour. Allow for distortion that will require the viewer to reassemble the fragments of information. Use shading to emphasize important contours and to suggest volume and space. Integrate the form into a complete composition. The initial planning of the composition can be done on tracing paper. Do a finished drawing in a medium of your own choosing.

Summary

Composition forms the underlying structure of a drawing or painting; it exists separately from subject matter, medium, and style. Some experienced artists suggest that pictures design themselves. Possibly, but that is not to say that subconscious decisions and intuitive choices are not influenced by knowledge and experience. An awareness of elements of composition allows us to see possibilities and identify problems we might otherwise overlook. It also allows us to notice and take advantage of chance compositional happenings.

A knowledge of composition develops from looking at other works of art. Students in any field of creative activity learn by studying the work of others, not for purposes of copying, but to develop an awareness and sensitivity to composition. Those who never study the works of other artists tend to limit themselves. The creativity of professional artists is frequently stimulated by the works of others. Rembrandt, who collected prints and drawings by other artists, delighted in reworking their ideas, re-creating them to satisfy his own artistic sensibility.

Although you may develop a preference for certain compositional devices, avoid becoming dependent upon formulas. Remain alert to the many possible approaches to combining media, technique, and style with the elements of composition to provide the fullest expression to your subject. It was suggested at the beginning of this chapter that artists have the freedom to interpret the principles of composition. There is no rule that cannot be broken; the only consideration is whether, by breaking a rule, you make the composition more effective.

Perspective

To create depth on a flat surface is to create an illusion. Much of the success of illusionistic art depends upon the skillful use of perspective.

Linear perspective is a scientific method of determining the correct placement of forms in space and the degree to which such forms appear to diminish in size at a given distance. The principles of the system were formulated early in the 15th century by young Italian Renaissance artists seeking a logical means for creating unified, measurable space. Filippo Brunelleschi's interest in perspective stemmed from direct observation and analysis of visual phenomena. His original experiment involved painting a building on a small panel into which he drilled a peephole at a point corresponding to the eye level of the artist. Rather than looking directly at the painting, people viewed its reflection in a mirror by peering through the peephole from the back. Confined to what could be seen with one eye through the small hole, Brunelleschi restricted vision to precisely the fixed point of view upon which linear perspective is predicated.

With the invention of the camera, photographs duplicating views previously depicted by artists (Figs. 152, 153) verified the system devised by the Florentines—the lens of a camera being a single eye in a fixed position. In both Giovanni Battista Piranesi's 18th-century engraving of the interior of St. Paul Outside the Walls in Rome and a photograph of the same structure, converging horizontal lines and the regular diminution of equally spaced elements create the illusion of vast interior space on a flat, two-dimensional surface. (Many aspects of perspective, as they will be discussed in this chapter, can be seen in Figs. 152, 153.)

Empirical perspective, unlike linear perspective, relies upon direct observation rather than on a set of rules. An artist with a well-trained eye for seeing size and shape relationships, and who can determine angles by sighting against established verticals and horizontals, can create convincing and relatively accurate perspective without having to engage in the mechanical construction of space on a large drawing board using T-squares, triangles, and thumbtack vanishing points.

above: 152. Giovanni Battista Piranesi (1720–1778; Italian). *Interior of St. Paul Outside the Walls, Rome.* 1749. Etching, 16 × 23¾″ (41 × 61 cm). Reprinted from *Views of Rome Then and Now* by Herschel Levit. Published by Dover Publications, Inc., 1976.

left: 153. Interior of St. Paul Outside the Walls, Rome. Photograph.

Why Study Perspective?

Computers have rendered obsolete the tools traditionally relied on to make precise perspective drawings, such as architectural renderings. Unless you choose to be a computer artist, an understanding of empirical and linear perspective will assist you in re-creating the visible three-dimensional world convincingly on a flat piece of paper or canvas. A knowledge of perspective is perhaps more valued today because of the revived interest in representational art.

The assignments in this chapter are presented only as exercises to assist you in learning how perspective works, how it can be used to support and strengthen your drawings. The mechanics of linear perspective—actually drawing the horizon line and vanishing points—can be set aside once you understand how the system works. But you will have a backup system available for checking and correcting what you think you see.

While knowledge of perspective is useful in drawing from nature, it is essential when drawing from imagination. The ability to construct space, to show the viewer how things would look if they existed, to determine dimensions accurately, and to figure the degree to which any dimension diminishes at a given distance, all make the effort involved in learning perspective worthwhile. David Macaulay's remarkable book illustrations (Fig. 154) attest to the pictorial freedom and creative possibilities that can be derived from understanding linear perspective.

154. David Macaulay (20th century; English–American). Constructing a Gothic cathedral. Pen and ink. From *Cathedral* by David Macaulay. Copyright © 1973 by David Macaulay. Reproduced by permission of Houghton Mifflin Company.

155. Lorraine Shemesh (b. 1949; American). *Paint Box.* 1983. Graphite on paper, 22¼ × 30⅛″ (57 × 77 cm). Glenn C. Janss Collection.

Fixed Viewpoint and Cone of Vision

The rules of linear perspective are dependent upon a single, **fixed point of view,** when in fact we almost never view anything under that condition. Even when we hold our heads in a fixed position, our eyes are almost constantly in motion. Perspective drawing, in theory, demands that you not shift the position of your head nor the direction of your gaze.

All that can be seen without moving your eyes is contained within a **cone of vision.** The limits of your cone of vision—between 60 and 80 degrees—are easily determined by extending your arms and inscribing within a vertical circle all that can be seen clearly as you look directly forward. Only a small portion of the immediate foreground falls within your lines of sight in contrast to the expansive distant view.

Picture Plane

The **picture plane** is an imaginary vertical plane that slices through the cone of vision. If you were to place before you a sheet of glass with the intention of drawing just what could be seen through the glass, the glass would represent the picture plane. Substitute a sheet of drawing paper for the glass and the paper becomes the picture plane. How much would be seen through the glass and represented on the paper picture plane depends on how close you stand to the picture plane.

The closer an object is to the picture plane, the larger it will be projected. Lorraine Shemesh creates an almost overwhelming sense of immediacy by placing the front edge of the paint box right at the picture plane (Fig. 155).

Horizon Line, Ground Plane

The **horizon line** indicates where sky and earth would appear to meet if the ground were perfectly flat and nothing blocked the view. It also

corresponds to the eye level of the viewer. In perspective drawing, as the viewer is elevated higher above ground level, the horizon line rises on the picture plane to reveal more of the ground (Fig. 154); the closer to ground level, the lower the horizon line (Figs. 152, 153). It is the artist who determines eye level; the viewer has no choice but to accept it. No matter how you look at Macaulay's drawing of the Gothic cathedral under construction, whether holding it above your head or at waist level, you cannot change the point of view he has selected. The placement of the horizon line determines the angle from which all objects are viewed, and its location must be established even when it does not appear on the picture plane.

The **ground plane** is a flat horizontal plane that extends to the horizon. It is also called the **floor plane** in drawings of interior spaces, the **table plane** when drawing objects on a table. Only when drawn at eye level will the back edge of a floor plane or table plane coincide with the horizon line.

Line of Vision, Central Vanishing Point

The **central line of vision,** centered in the cone of vision, is an imaginary line from the eye to the horizon line. Anything, such as the edge of a table, a line between floorboards, or a curb line, that lies exactly in the line of vision will appear as a vertical line. Extended, it will meet the horizon line at a right angle. The point of intersection, the **center of vision** or **central vanishing point** (CVP), lies directly opposite the viewer.

One-Point Perspective

Parallel lines by definition always remain equidistant, yet in our common visual experience they appear to converge as they recede. The basis of **one-point perspective** is that all lines parallel to our line of vision, whether to the side, above, or below, will appear to meet at the CVP (Figs. 152, 153, 155).

One-point perspective seems most effective when the central vanishing point is placed near the center on the horizon line. Jan Vredeman de Vries (Fig. 156) has cut off almost half of what we would expect to fall within the cone of vision by positioning the CVP (and the viewer) near the right edge of his drawing, a condition that tempts the viewer to turn and look diagonally across the space rather than holding fast to the CVP. In one-point perspective, lines parallel to the picture plane (such as those defining the risers of the steps in Fig. 156) do not converge; they are drawn parallel to the horizon line. When forms are set at some distance from the viewer there is no problem, but a certain distortion occurs when the forms are at close range.

Additional parallel lines, neither parallel to your line of vision nor to the picture plane (such as the diagonals of the floor tiles), converge at other points along the horizon with a separate VP for each different direction. One set of diagonals can be seen to converge at a VP to the left. The opposite diagonals would converge at a point located the same distance to the right of the CVP. (This is the basis of two-point perspective, p. 143.)

156. Jan Vredeman de Vries (1527–after 1604; Dutch). Stairs, one-point perspective. From *Perspective* (Leiden, 1604). Republished by Dover Publications, Inc., 1968.

Establishing a Grid

A series of exercises, starting from direct observation and moving to some basic drawings with horizon lines and VPs, will demonstrate a system for determining the position and scale of objects in space. *Understanding how to draw just one square in perspective is really all that is necessary to create complex perspective studies.*

Project 9.1 An 8-inch (20-centimeter) square of paper or cardboard appears perfectly square only when you look at it directly from above or held vertically in front of your eyes. From all other points of view it is a square in perspective. Held horizontally at arm's length and square to your body, it will appear as a single line at eye level, but will change as you move it above and below eye level. Move it from side to side, viewing it without turning your head. Make similar observations with the card held vertically and parallel to your line of vision.

Although the shape enclosed by its four edges changes with each different position, if you maintain arm's length the dimensions of the front and back edges will remain constant while the length of the sides will change. They will become longer as the square is raised and lowered from eye level (the horizon line) and when it is moved out to the sides (away from the CVP).

Project 9.2 Sit at a table and study the square placed at arm's length in front of you, square to and centered on your line of vision. Hold your pencil at arm's length to determine the measurable vertical distance be-

tween the front and back edges (depth of square) as compared to the width of the front edge. Calculate the angle at which the sides converge either by checking against the vertical of your pencil held at arm's length (see p. 37) or by measuring the relative width of the front and back edges.

Draw the shape as observed and measured. Center it near the bottom of a full sheet of newsprint and let the front edge be approximately 3 inches (8 centimeters) in length. Using a T-square and triangle might seem too mechanical, but you will probably find it easier and more accurate than drawing freehand. The depth measurement is critical; be as accurate as possible. The result will be a **foreshortened** square—a square seen in perspective. Locate the CVP by extending the side edges until they meet. Draw the horizon line through that point.

Project 9.3 Moving the cardboard square one full width to either side places it in a new perspective. The overall shape changes as the back edge shifts in relation to the front edge and the side edges both angle somewhat in the same direction. Each additional move will alter the shape enclosed by the lines representing the four edges.

Based on the one square drawn **empirically,** it is possible, using **linear perspective,** to develop an elaborate drawing in one-point perspective without having to move, study, or draw the cardboard square. All necessary measurements have already been established; no further decisions need be made.

Project 9.4 Extend the lines of the front and back edges of the original square horizontally across the page. Mark off the width of the front edge of the square along the bottom line, connecting each mark to the CVP to create a full row of squares. Although the shapes are different, each represents a square. Notice that the units of measure representing the back edge of each square are also equal.

Project 9.5 To continue adding rows of squares is relatively simple, but first draw a 2-inch (5-centimeter) grid on the cardboard square and add a diagonal line connecting two opposite corners. If you have measured accurately, the diagonal line will touch the opposite corners of each of four squares. Place the square back on the table and return to your drawing.

Starting from the lower outside corner of one of the end squares, draw a diagonal through the square and extend it to cut across all of the converging lines. Add a horizontal at each point of intersection to create a grid as many units deep as it is wide. The width of all the squares has already been established, and since the diagonals of equal squares are equal, the diagonal establishes the depth for each additional row (Fig. 157).

Repeating the procedure using one of the squares in the back row allows you to continue extending the grid toward the horizon line. The grid can be expanded to the sides by extending all horizontal lines across the width of the drawing and repeating the horizontal measurement of any line.

Project 9.5 demonstrates that *once the depth of the first unit has been determined, the depth of all other units of equal size is automatically established.* No additional decisions are necessary; therefore, it is imperative that the first unit be measured and drawn as accurately as possible.

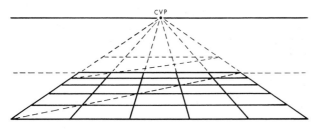

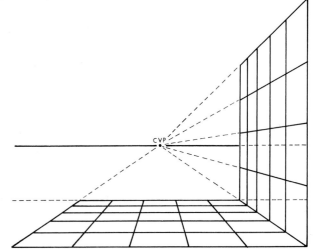

above: 157. Use of diagonal to establish horizontal grid in one-point perspective.

right: 158. Constructing vertical grid in one-point perspective.

When creating perspective from imagination, it is necessary to have a keen sense of how much depth would be seen at the eye level selected. In Figure 156, for example, it is difficult to determine whether the floor tiles are meant to be squares or rectangles—whichever they are, the depth chosen results in curiously extended stair treads.

Project 9.6 To construct a matching vertical grid, add vertical lines where each horizontal intersects one of the outer receding ground lines. Transfer the unit of measurement from one horizontal line to its adjoining vertical; complete the vertical grid by connecting each mark to the CVP (Fig. 158).

Equal units of measurement on adjoining horizontal and vertical lines that are parallel to the picture plane remain constant. Equal units diminish only on lines that recede from the picture plane. Such observations will aid you in seeing and understanding foreshortened forms as you draw from life and will allow you to draw convincingly from imagination.

Horizontal grids can be raised or lowered to any level; vertical grids can be swung to the left or right. As the horizontal plane approaches eye level (the horizon line), you see less space between the lines defining the front and back edges of each row until it reaches eye level and becomes a single line identical with the horizon. The same changes occur as the vertical plane swings toward the CVP.

Project 9.7 Diagonals of the squares of a grid are parallel lines and, as such, appear to converge at common points—on the horizon for those of the horizontal plane (Fig. 156), on a vertical line drawn through the CVP for those of the vertical plane. Draw one or two diagonals in each direction on both grids to verify this. (The horizontal diagonals will become the basis for two-point perspective; the diagonals of the vertical grid will become the means for determining the perspective of inclined planes.)

Almost everything else included in this chapter will be but a variation on what you have already done.

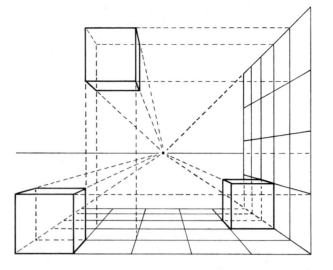

Project 9.8 Three-dimensional solids, such as cubes and blocks, are merely a series of contiguous vertical and horizontal planes. To create a cube, add vertical lines at each corner of a square on the horizontal grid. Carry a line across from the vertical grid to establish the height for one corner, and complete the cube with the help of the CVP (Fig. 159).

Project 9.9 You now have the information necessary to create a one-point perspective "fantasy" constructed out of solid square blocks and units composed of multiples of blocks. Spread the blocks across the width of the page, push them deep into space, stack them, let some of them float above the ground plane (Fig. 159). You might prefer to do the drawing on tracing paper in order to preserve the grids. If so, include only the horizon line, not all of the grid lines.

Establishing Scale

Scale is established by assigning a specific dimension to the length of one side of one square. The dimension can be changed for different drawings done from the same grids as long as the scale remains constant within any single drawing.

The grids of the preceding assignments had an established scale of 8 inches (20 centimeters), based on the square with which the projects began. Using that dimension, you can determine the height of your eye level above the table plane (since the square was placed on the table) by checking where the horizon line cuts across the vertical grid. If your observation and drawing of the first square was accurate, the eye level in the drawing should approximate the measurable distance of your eye level above the table.

Using Diagonals to Establish Depth

The illusion of depth is particularly noticeable when objects of the same size recede into space at regular intervals, such as the columns in Figures 152 and 153. Using the grids developed in the preceding projects, it would be possible to construct a facsimile of the church interior, but linear perspective also provides alternatives for determining size and distance that are not dependent upon a complete grid system.

160. Jacopo Bellini (c. 1400–1471; Italian). *Funeral Procession of the Virgin.* Pen and brown ink over black chalk underdrawing on tan paper, 3¾ or 8⅛ × 11⅞″ (10 or 21 × 30 cm). Fogg Art Museum, Harvard University, Cambridge, Mass. (bequest of Charles A. Loeser).

A relatively simple method employing the use of diagonal lines might well be the manner in which Jacopo Bellini determined the spacing of the figures in *Funeral Procession of the Virgin* (Fig. 160). The system is based on the principle that diagonals cross at the exact center of a plane; lines drawn through the center point divide the plane into equal halves, as demonstrated in Figure 161.

Project 9.10 Draw a set of converging lines more or less corresponding to the heads and feet of the figures in the Figure 160. Add vertical lines to represent the first two figures in the procession. Forgetting for a minute about people, notice that the verticals and converging horizontals create a plane seen in perspective. Locate the center of that plane by connecting the four corners with diagonals. A line from that center point to the VP will establish the midpoint of any additional verticals. A diagonal line from the top of the first vertical through the midpoint of the second to the base line establishes the position for a third vertical spaced at the same interval (Fig. 161).

This use of diagonals allows for the repetition of any regularly spaced elements—vertical or horizontal. Notice, however, that in Bellini's *Procession* (Fig. 160) the spacing of the figures is not mechanically repetitious; the distance between the last two figures in the first group is almost double that between the other figures.

161. Use of diagonals to determine spacing of repeated interval.

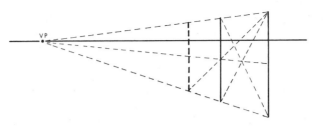

Calculating Scale and Distance

An object or form whose size can be comprehended establishes the scale for everything else in a perspective drawing. It is possible, for example, based on the height of an average figure, to state with some certainty that the city wall in Bellini's drawing (Fig. 160) is just over 30 feet (9 meters) high and lies approximately 120 feet (37 meters) from the viewer, and that the procession passes between 15 and 20 feet (5–6 meters) to the right. These dimensions can be calculated by placing a figure against the wall seen between the figures at the right. The height of such a figure has already been established; since all figures in the drawing are viewed at eye level, his eyes would fall on the horizon line, his feet at the base of the wall. Repeating the height of the figure (probably less than 6 feet [1.8 meters]) vertically gives us the height of the wall; marking off the same unit of measure on a horizontal line projected from his feet to a point immediately below the CVP (just outside the left edge of the drawing) provides the other dimensions.

162. Determining scale of figures in space.

Figures in Space

It was possible, without a grid, to add a distant figure of equal size to the Bellini drawing because scale, ground plane, and eye level were already established. When all three conditions are known, a figure can be placed at any spot within perspective space with the assurance that the size of the figure will be correct at the distance selected.

Project 9.11 Figure 162 includes three sets of figures plus a dot indicating where a fourth figure of matching height is to be placed. In each group, draw lines from the head and feet of the two outer figures through the head and feet of the center figure and extend the lines until they converge. A single line drawn through the VPs establishes the horizon line for each group.

A line carried from the feet of one figure through the spot to the horizon line, then returned to the head of the same figure, determines the height for a fourth figure standing on the spot, or at any point along that line. If additional figures are to be taller or shorter, the difference in height should be added or subtracted from the key figure before the head line is drawn to the horizon line.

Placing Figures at Different Levels

In Figure 162 the vertical alignment of the three groups is purposely the same, the measurable height of corresponding figures is identical, and the resulting VPs can be connected by vertical lines. This means that the same figure in each drawing stands at exactly the same distance from the picture plane. With so many things identical, why don't the three drawings match?

The changing position of the horizon line indicates that each group is viewed from a different eye level—Group 1 from below, Group 2 at eye level, Group 3 from above. *When figures of the same size are shown standing on a level ground plane, whether in the foreground, middle ground, or background, all will be seen in exactly the same relationship to the horizon line.* In Group 1, the horizon line intersects all figures at about knee level, indicating that the heads of the figures are about 4 feet (1.25 meters) above the eye level of the viewer, assuming that the figures are between 5 and 6 feet (1.5–1.8 meters) tall. Group 2 is seen at eye level by a person of the same height—the heads all appear at the horizon line. The figures in Group 3 are viewed from a vantage point about 12 feet (4 meters) above ground level because the space between the horizon line and the head of each figure is equal to the height of each figure; dropping the figures by another full measure would elevate the viewer to 18 feet (5.5 meters) above the ground. The vertical grid from earlier projects revealed that units of equal measure remain constant.

Project 9.12 Determine how high you, the viewer, are above the floor in Piranesi's church interior (Fig. 152).

Project 9.13 Basing your work on Figure 162, do a drawing in which several figures, adults and children, are placed on different levels so that they are viewed from above and below, as well as at eye level. Define actual levels, perhaps similar to those seen in Figure 156, so the figures do not appear to hover in space. Calculate exact distances above and below your eye level.

Two-Point Perspective

Learning to draw cubes in perspective provides the raw material for constructing almost any form, since very few objects exist that cannot be enclosed within a square or rectangular container. Blocks placed square to the picture plane are seen in one-point perspective; blocks set at an angle necessitate the introduction of **two-point perspective.** Nineteenth-century American painter Thomas Eakins, a dedicated practitioner of linear perspective, uses both one-point and two-point perspective in his study for *Chess Players* (Fig. 163). The drawing also illustrates how simple blocks below began to be transformed into detailed specific forms above.

Project 9.14 The characteristics of two-point perspective can be studied empirically by placing a cube or square box just close enough to you that you can reach out and move it easily. A clear plastic cube, such as those used for displaying photos, would be particularly effective.

Begin with the cube directly in front of you, square to your line of vision. Observe the changes that occur as you slowly rotate the cube clockwise. The front surface becomes the left side as the right side appears; the configuration of the top begins to change; the bottom edges are seen as diagonal lines. As the rotation continues and you see less of the left side and more of the right, the measurable height dimension of the left corner begins to diminish, and that of the right outer corner increases. The less you see of a side, the greater will be the angle between the base of that side and the horizontal of a pencil held at arm's length. When the cube reaches a 45-degree angle, you see

163. Thomas Eakins (1844–1916; American). *Perspective drawing for Chess Players*. 1876. Pencil and ink on cardboard, 24 × 19″ (61 × 48 cm). Metropolitan Museum of Art, New York (Fletcher Fund, 1942).

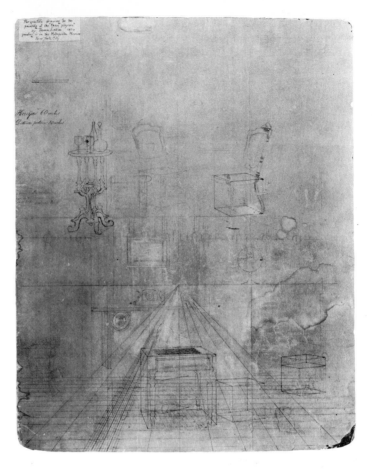

equal amounts of both side planes receding at the same angle, the front and back corners in exact vertical alignment. Until that moment, the back corner was to the left of the front corner; rotated beyond 45 degrees, it will move to the right. Depending on the size of the cube, you might be able to detect the convergence of the sets of parallel lines delineating the separate planes.

Drawing a cube in two-point perspective requires two VPs. For a cube sitting at a 45-degree angle, both VPs will be equidistant from a CVP. At any other angle, the less you see of a side, the closer its VP will be to the CVP; the more you see of a side, the farther away will be its VP.

Project 9.15 Draw a series of cubes rotated to different angles seen above, at, and below eye level in relation to one horizon line. You might want to compare your drawing with the plastic cube. When it is positioned at random angles to the others, each cube must have its own set of VPs.

Do a second drawing of a number of cubes spread across the width of the paper, with each constructed in relation to just one set of VPs placed near the outer ends of the horizon line. A single set of VPs automatically positions the cubes square to one another.

Project 9.16 Either on tracing paper or in a new drawing, select one cube positioned below eye level and extend it in both directions, using

the system of diagonal lines from Project 9.10 to determine the depth of each additional cube. Extending the top or bottom edges of all the cubes in the two rows to the VPs will produce a horizontal grid drawn in two-point perspective. Vertical grids can be constructed exactly as in Project 9.5. Figure 164 rotates Figure 159 into two-point perspective.

Project 9.17 You might choose to do a two-point perspective "fantasy" similar to that suggested as Project 9.9.

Inclined Planes

Project 9.18 Do a freehand drawing of a box with open flaps placed on the floor in a position somewhat similar to that shown in Figure 165. Measure with your pencil to establish size and shape relationships, and to determine critical vertical and horizontal alignments.

Project 9.19 Set your drawing aside and make a tracing of Figure 165. Use a straightedge to locate the VPs for all planes of the box, including the flaps. Draw the horizon line through the VPs of the sides. Notice that because they are parallel to the ground plane, the long edges of the flaps vanish at those points on the horizon line, while the short sides of the flaps converge at different VPs above or below the horizon line.

VPs on the horizon line relate only to lines and planes parallel to the ground plane. The flaps are not parallel to the floor. They are **inclined planes.** They have VPs on vertical lines that pass through the corresponding VP on the horizontal line. VPs for **ascending planes** appear above the horizon; those for **descending planes** fall below the horizon. (Review Proj. 9.6.) Ascending planes angle upward away from the viewer, descending planes angle downward from the viewer. Flap A might appear as a descending plane because it falls below the rim of the box, but extending its short sides reveals that they converge upward. Viewed from the opposite side of the box, it would be seen as a descending plane.

Project 9.20 Check your freehand drawing of the box to see whether empirically you drew the flaps in correct perspective. Do the long edges converge toward VPs on the horizon line? Do the short edges converge to VPs above or below the horizon? On a tracing paper

below left: 164. Figure 159 seen in two-point perspective.

below: 165. Drawing inclined planes: box with flaps.

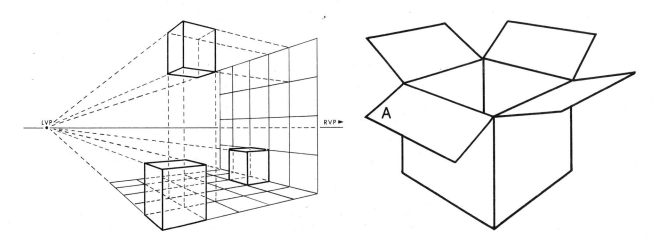

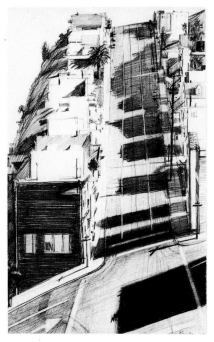

166. Wayne Thiebaud (b. 1920; American). *Ripley Ridge.* 1976. Pencil on paper, 22 × 15″ (57 × 38 cm). Collection Robert A. Rowan, Pasadena, Calif.

overlay, redraw the box so that all lines converge toward the appropriate and correctly aligned VPs.

Uphill and Downhill Streets

Inclined planes are to be found with surprising frequency in landscapes and cityscapes. Pitched roofs, for example, are inclined planes, as are up and downhill streets and roads.

You may experience total confusion the first time you are confronted with representing an uphill or downhill street lined with buildings. Until you have attempted to draw such a scene, it is very probable that you have never really looked at buildings on a hill in terms of perspective. The scene becomes easier to draw when you remember that in spite of the inclined street plane, houses are built with level floors and vertical corners. All horizontal elements, such as the flat roof of the house in the left foreground of Wayne Thiebaud's *Ripley Ridge* (Fig. 166), are drawn to VPs on the horizon line, always at the eye level of the observer, whereas lines of inclined planes—sidewalks, curbs, tops of utility poles or parking meters, and objects parallel to the street, such as automobiles—will converge at VPs either above (looking uphill) or below (looking downhill) the true horizon line. Thiebaud has placed the VP so far above the horizon that the street appears to be nearly vertical, which is precisely the impression many first-time visitors have of San Francisco's hills. Rarely can an uphill or downhill street be drawn as one continuous inclined plane, since the roadbed levels out at cross streets (as in the immediate foreground of Figure 166), and that section must be drawn to the true horizon.

A puzzling phenomenon occurs when you do a drawing looking downhill. Even though the hill drops away from you in space, the lines representing the edges of the street are drawn as ascending lines. The angle of ascent, however, is less than for lines representing a level plane, so that VPs of downhill street lines appear below the true horizon line. (Only in a drawing of the underside of a descending plane, viewed from below, would the edges converge downward.)

Project 9.21 Place tracing paper over Figure 166. Locate the horizon line and establish your eye level by extending the lines of the front of the dark-sided building and those of the foreground intersection. The VP for the ascending hill will be in vertical alignment, but above the horizon line by almost twice the height of the drawing. Thiebaud has added drama by tilting the intersection as the cross street drops away in an exaggerated, dizzying effect.

Project 9.22 Locate a site that offers both inclined planes and other forms that can be drawn in perspective—a city street with houses and cars, a country road with fences and farm buildings, or perhaps a campus view. Although stairs are a series of vertical risers and horizontal treads, the angle of a stairway is an inclined plane, as is a sloping roof. Study your subject thoroughly; do a drawing in which all forms and planes appear in correct relationship.

Three-Point Perspective

In perspective, vertical lines remain vertical as long as the head is held level. The corners of a rectangular object placed above or below eye

level continue to appear vertical if the object is viewed from sufficient distance. When the same object is viewed from such close range that you must tip your head to look up or down at it, the corners appear to converge at a VP above or below. Looking up or down, by itself, does not create **three-point perspective** unless the object, as in Charles Sheeler's *Delmonico Building* (Fig. 167), is also placed at an angle. In this age of skyscrapers, when we have frequent opportunities to view great heights both from above and below, three-point perspective has become a familiar visual experience for most people.

Project 9.23 A group of vertical blocks viewed from above (the reverse of Fig. 167) offers a challenging three-point perspective problem that can be done from imagination. Working vertically on a full sheet of newsprint, establish a horizon line near the top of the page and two VPs out to the sides. Locate a CVP near the bottom of the page for the downward convergence of the verticals. The lower the CVP, the less exaggerated the foreshortening will be. (Keeping the various VPs within the picture plane is simply for your convenience in doing this project. The VPs in Figure 167 are placed well outside the edges of the drawing.)

Construct a cluster of simple vertical blocks that rise to various heights. If you choose to elaborate on your drawing and transform the blocks into buildings, be aware that in three-point perspective, equally spaced units appear to diminish depending on whether you are looking down or up. Diagonal lines, introduced in Project 9.7, can be used to divide your imaginary structures into equally spaced floors.

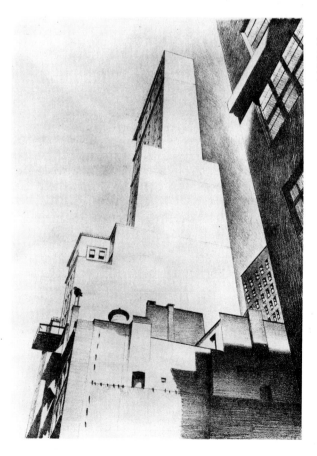

167. Charles Sheeler (1883–1965; American). *Delmonico Building*. 1927. Lithograph, 9¾ × 6¾″ (25 × 17 cm). Library of Congress, Washington, D.C.

above left: 168. Drinking glasses with circular edges drawn in faulty perspective.

above right: 169. Diagram: determining circle drawn in perspective.

left: 170. Ellipses drawn in varying perspectives.

Circles in Perspective

A look at the rims and bases of bowls, cups, and other circular objects in the drawings of most students, and even those of some advanced artists, indicates that the perspective of a circle is little understood. The three most frequent errors are re-created in Figure 168: (1) outer edges drawn as points, (2) front and back edges flattened, (3) upper circle drawn too full as compared to lower circle.

A circle seen in perspective assumes the shape of an **ellipse** (compare examples 1 and 2 in Figure 168 with the circles in the floor pattern of Figure 153). The exact shape of an ellipse can best be visualized as a circle inscribed within a square projected into perspective. (Making an enlarged copy of Fig. 169 that can be moved to various positions and distances might allow you to see more clearly the effect of perspective on a circle.)

Project 9.24 Figure 169 provides the necessary clues for drawing an ellipse. In the foreshortened square provided, draw diagonals to locate the center lines. Correct positioning of the points where the circle crosses the diagonals can be determined by transferring the measurements from the bottom edge of the diagram to the front edge of the square and drawing lines to the CVP. Draw the circle so that it touches each of the eight reference points. Make certain that it is a continuous curved line with no points and no straight lines.

Notice that as with a foreshortened rectangle, the center point of the circle in perspective is not equidistant between the front and back edges. It falls behind the widest dimension of the ellipse, making the front half of the circle measurably larger and fuller than the back portion.

Ellipses in Varying Perspective

The third common error—mismatched ellipses—creates an effect of a shifting point of view (Fig. 168). The fullness or openness of an ellipse is determined by eye level (Fig. 170). Viewing the rim of a drinking glass in a sequence of positions from well below eye level to high above will allow you to duplicate the diagram three dimensionally. By turning the drawing sideways you see the same progression occur with a circle standing vertically or a disk rotated on a vertical axis.

Drawing Circular Objects

Cups, plates, bowls, glasses, bottles, tea kettles, coffee pots, pans, flower pots, baskets, lamp shades, records, wheels—the list of circular objects in our immediate environment available for drawing is not easily limited. When drawing a circular object from life, the correct degree of openness for an ellipse can be determined by using your drawing tool as a measuring device (discussed in Chapter 3, pp. 36–37) to calculate the proportional relationship of the vertical measurement between the front and back midpoints of the ellipse as compared to its maximum width.

Project 9.25 To draw two circles of the same size in perspective, one above the other, and ensure that they are correctly foreshortened, first draw a cube in one-point perspective. Add circles to the top and bottom planes using diagonals and center lines as in Figure 169.

Connect the two circles with vertical lines at the outer edge to create a cylinder. The verticals should join the lower ellipse just behind its widest point to create the fullest effect of roundness. The width of the cylinder, as drawn, will be greater than the dimension of the center line of the circle.

Project 9.26 Do a tracing that includes the complete upper ellipse, the two connecting verticals, and only the front portion of the lower ellipse. The cylinder will appear more three dimensional. Notice that the curve of the bottom rim is fuller than the curve of the upper rim. When students cannot see the full ellipse, they have a tendency to draw the bottom curve flatter than it should be.

Do a series of tracings in which you treat the cylinder first as hollow, then solid, and with various vertical sections cut out. Remove a full quarter of the cylinder, various quarters, one half diagonally. For each separate image, trace only those portions of the upper and lower ellipses that would be visible, adding necessary verticals and connecting lines.

Project 9.27 Turning the paper sideways transforms the drawing into a cylinder resting on its side at eye level. Practice drawing vertical ellipses and cylinders resting on their sides, seen both from above and below. Using the one-point and two-point grids from earlier projects and the diagram from Figure 169 will allow you to place cylindrical forms both parallel to the picture plane and at angles.

Few circular objects we see and draw are plain cylinders. In profile the sides curve, bulge, or flare, sometimes all in the same object, so that circles of various diameters are involved. To draw such objects correctly, you must center all the ellipses one above the other.

Project 9.28 Small plastic glasses with tapered sides are perfect for studying forms with ellipses of different sizes. Observe how the space between the upper and lower ellipses changes when a glass is viewed from the same eye level, but at different distances. As you pull the glass toward you the ellipses get closer together until they overlap. Draw the glass as it appears at various distances, also when held at different levels. In each drawing the upper and lower ellipses must be centered on each other. Remember to calculate proportional relationships, not only of the separate ellipses, but of the overall dimensions of the glass.

While the tapered forms that you have drawn could also represent clay flowerpots, the reason for using the plastic glass is that the transparency of the glass allows the lower ellipse to be seen. Although glasses or flowerpots best serve their function when maintained in an upright position, they become interesting and challenging drawing problems when resting on their sides.

Project 9.29 Study a plastic glass or flowerpot tipped on its side. In profile, neither the top nor the bottom is vertical, nor is an imaginary center line connecting top and bottom horizontal. Be aware, however, that both the top and bottom would be at right angles to a center line. Slowly rotate the object and watch the ellipses open as you look more directly into the container, then become narrower as the glass approaches profile position. Make freehand drawings of the glass in several positions.

Ellipses in an Architectural Setting

Arches, circular windows, the capitals and bases of columns, domes, and towers—all involve the perspective of circles and partially circular forms. These curvilinear elements usually appear in conjunction with rectangular forms, and if the two are not handled consistently, the drawing will be weakened. It is frequently helpful to use divided squares as a basis for constructing elliptical forms (Fig. 169).

Two mid-18th-century architectural fantasies, both of which project a series of arched forms into planes at varied eye levels, provide an interesting comparison. Piranesi's *Monumental Staircase Leading to a Vaulted Hall* (Fig. 171) is an imaginative freehand study, admirable for vigorous, expressive drawing rather than for accuracy, since neither the architectural forms nor the spatial relationships can withstand careful analysis.

Equally imaginative is Giuseppe Galli Bibiena's design for painted stage scenery with its tiers of arcades and seemingly endless corridors (Fig. 172). Meticulously constructed in two-point perspective, the design combines a brilliant use of scale with the repetition of architectural elements to create a spaciousness that cannot be contained within the frame. With the view of the inner courtyard seen through the arch at the left comes the realization that the columns partially visible at the top of the drawing are but the bottom half of another story towering above. Except for the staggering amount of intricate architectural detail, careful analysis of the perspective—basically two sets of parallel planes set at right angles—reveals that the drawing is merely an elaboration of the assignments in this chapter.

Shadows

Both Piranesi and Bibiena recognized the importance of light and shadow in establishing volume and creating drama in their perspective fantasies (Figs. 171, 172). It appears that Piranesi introduced his shadows somewhat arbitrarily, while Bibiena calculated his as methodically as he constructed the architecture.

All objects in direct light cast shadows that can be determined by perspective. Three factors govern the drawing of shadows.

1. The **source of light** may be either natural or artificial. Natural light produces parallel rays, artificial light creates radiating rays. It is

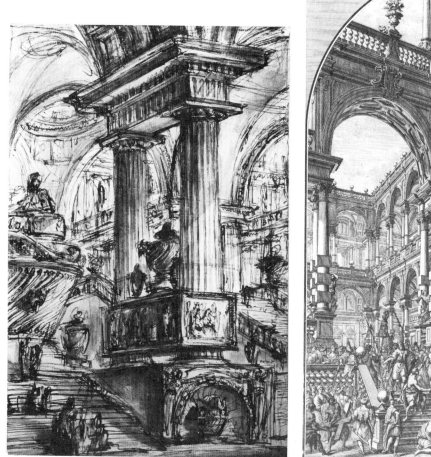

true that light radiates from the sun, but from a distance of about 92 million miles, the rays are virtually parallel when they reach the earth.

2. The **direction of light** determines the direction in which shadows fall. When the source of light is to one side, shadows are cast to the opposite side. With the light at your back, shadows fall away from you. When you look into the light, shadows are cast toward you.

3. The **angle of light** determines the length of shadows. A high source of light creates short shadows, a low light produces long shadows.

Sun from the Side

Project 9.30 Shadows cast by natural light coming directly from the side are the easiest to draw. Select a section of the "one-point fantasy" (Proj. 9.8) as the subject for this assignment.

Shadows are cast by **shade lines** that separate the areas of light and shade on any object. The shade lines of a block correspond to various corners and edges of the form. When light comes directly from the

left: 171. **Giovanni Battista Piranesi (1720–1778; Italian).** *Monumental Staircase Leading to a Vaulted Hall.* c. 1755. Pen and brown ink over red chalk with brown wash, 15 × 10½″ (38 × 27 cm). British Museum, London (reproduced by courtesy of the Trustees).

above: 172. **Giuseppe Galli Bibiena (1696–1756; Italian).** Architectural perspective design for the theatre. From *Architectural and Perspective Design* (Vienna, 1740). Republished by Dover Publications, Inc., 1964.

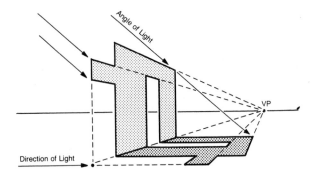

side, shadows appear on the ground plane as horizontal parallel bands (Fig. 173). If blocks are drawn in one-point perspective, shadows will be cast only by the sides opposite the sun and by the bottom surfaces of forms that float or do not rest fully on the ground.

Select the direction of light—from the right or left—and extend horizontal lines from the bottom corners of the opposite sides of each block. Decide on the angle of light—high or low—and draw a line at that angle through the top corner of the shadow side to establish the length of the shadow for that corner. The length of the shadow will be shorter than the height of the corner if the sun is high, longer if the sun is low, and equal to the height of the corner when the sun is 45 degrees above the horizon. Having found the length of the shadow of one corner, you can complete the shadow by drawing a line from that point in the direction of the CVP, since lines parallel to the ground plane, as is the upper edge of the block, cast shadows parallel to themselves (Fig. 173).

If another block lies in the path of a shadow, the horizontal shadow lines are diverted vertically up the side to meet the angle of light line. If the second block is low and the shadow long, it may be necessary to continue the shadow onto the top surface.

To plot shadows for objects that are not resting on the ground, locate direction-of-light lines by vertical lines dropped from the corners of the suspended forms to points on the ground plane immediately below (Fig. 173). For a three-dimensional block (as opposed to the single plane in the diagram), two angle-of-light lines must be drawn—one through the bottom corner of the side facing the sun, one through the upper corner of the shadow side. Lines drawn toward the CVP complete the shadow.

Add shading. The cast shadows should be darker than the shaded surface of the blocks (see p. 151).

Project 9.31 To calculate the shadow for a cube seen in two-point perspective, you must draw direction-of-light lines and angle-of-light lines at three corners of the cube and connect the three points of intersection.

Sun in Front of Viewer

When the viewer is looking into the sun, shadows are plotted in relation to the source of light located above the horizon and a **vanishing point of shadows** on the horizon line directly below (Fig. 174). Direction-of-light lines radiate from the vanishing point of shadows through the bottom corners of objects or through the base of imagi-

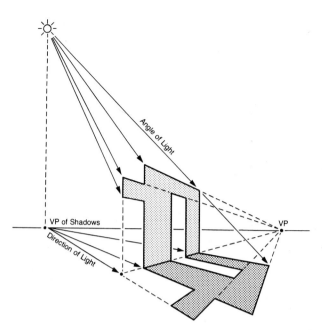

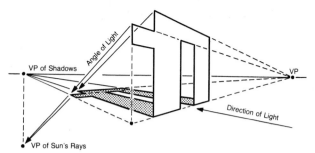

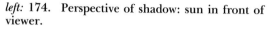

left: 174. Perspective of shadow: sun in front of viewer.

above: 175. Perspective of shadow: sun behind viewer.

nary verticals dropped to the ground line. The length of the shadow is determined by the point where radiating lines drawn from the source of light through the top points of all objects intersect the direction lines. Connecting the points of intersection defines the shape of the shadow. Because they are seen in perspective, the shadows appear wider as they approach the picture plane.

Sun behind Viewer

Shadows converge toward a vanishing point on the horizon line when the sun is at the viewer's back. The angle of light is determined from the **vanishing point of the sun's rays** (Fig. 175). This point is located below the horizon on a vertical line dropped from the vanishing point of the shadows—the higher the sun, the farther it falls below the horizon line.

Project 9.32 Become familiar with the system for constructing shadows cast both toward you and away from you by drawing simple cubes placed in various positions in relation to the source of light. Once you understand the basic procedure, apply it to a more complicated cluster of geometric shapes, even a cardboard box with flaps open. To locate the shadow of any point, you should first establish a spot on the ground plane directly below, through which a line is drawn to or from the vanishing point of shadows (Figs. 174, 175).

Project 9.33 Drawing the shadow of a simple cylinder allows you to see how shadows of curves can be plotted. Begin by marking off a series of points around the upper rim of the shadow side of a cylinder. Drop vertical lines from each point to locate corresponding points on the lower rim. Extend direction-of-light lines through all points on the bottom rim to intersect with angle-of-light lines projected through all points on the upper rim. Connect the resulting points with a curved line to define the shadow cast by the upper rim.

Note: To plot the shadow for a tapered form, such as a flower pot, first draw an ellipse corresponding to the upper rim on the ground plane and then proceed as with a cylinder. Connect the outermost points of the shadow of the upper rim to the point where the base of the form turns away from the source of light.

For any vertical circle, such as the end of a cylinder resting on its side, drop lines to the ground plane from points around the rim before proceeding in the usual manner.

Shadows from Artificial Light

Shadows from artificial light radiate from a point on the ground plane immediately below the light source. The direction of shadows is determined by lines drawn from that point through the base of each object. Rays from the light source through the top of each form establish the length of shadows. If a shadow meets a vertical surface, it changes direction and continues until cut off by rays from the light source.

If a light is centered above a group of objects, shadows will radiate in all directions. If objects rest on different levels, the shadows must radiate from the base level of each individual object. For example, the shadow of a table radiates from a point on the floor, while shadows of objects on the table radiate from a point at table level. Shadows of objects attached to a wall radiate from a point on the wall directly opposite the source of light.

Project 9.34 Place a group of simple objects around the base of a lamp. Draw them freehand, using the information above to calculate the correct position and shape of all shadows.

Reflections

176. Perspective of mirrored reflections.

An understanding of perspective allows artists to draw reflections and mirrored images convincingly. Beginners often misrepresent mirrored images as a reversed or inverted version of an object, failing to notice that a reflected image changes according to the angle from which it is seen and includes a view of the opposite, hidden side of the form. Another common error is not placing the reflection at the proper distance behind the mirror's surface. The plane of the mirror must appear to be halfway between the object and its reflection; the size of the object must diminish proportionally (Fig. 176). This can be accomplished by using diagonals to establish depth (Proj. 9.10).

Project 9.35 Draw a relatively simple object such as a straight chair, or a cardboard box with flaps in two-point perspective so that it is seen parallel to a mirror at the same time that it is sitting on a mirrored floor plane. All vertical measurements in the mirrored floor image will correspond exactly to those of the object; the dimensions of the reflection seen in the wall mirror will diminish. All parallel lines of the object plus its various reflections will converge at the same VPs.

Reflections in water tend to duplicate the effect seen with objects placed on a mirror. Reflections appear directly below the object reflected, with each point and its reflection being equidistant from the water line, exactly as in Project 9.35. When objects are set back from the water's edge, it is necessary to determine what the water level

would be at that distance and measure from that point. Sometimes the height of an object above water level is not sufficient to require a complete reflection, if any.

It is possible to simulate reflections in calm water by placing small objects on a mirror, making certain to duplicate the angle from which the object is viewed.

Drawing Designs in Perspective

Complex patterns and designs—geometric paving tiles, the patterns of Oriental rugs, curvilinear designs, lettering—can be drawn into one- or two-point perspective on horizontal, vertical, or inclined planes, or even on a curved surface, by squaring off the design and transferring it to a grid, properly scaled and drawn in correct perspective. The smaller the scale of the grid, the easier it is to transfer complicated designs.

Seeing and Using Perspective

Perspective need not be restrictive. Used imaginatively, it offers an artist great freedom, serving as a valuable aid to creativity and expression. We can identify elements of one-, two-, and three-point perspective in Rackstraw Downes's *The IRT Elevated Station at Broadway and 125th St.* (Fig. 177). His panoramic view of Upper Manhattan, sweeping from left to right in an arc so broad that it reveals the curvature of the earth, seems to include a broader view than would fall within the usual cone of vision.

177. Rackstraw Downes (b. 1939; English–American). *The IRT Elevated Station at Broadway and 125th St.* 1982. Graphite on paper, 19 × 35″ (48.3 × 89 cm). Collection Glenn C. Janss.

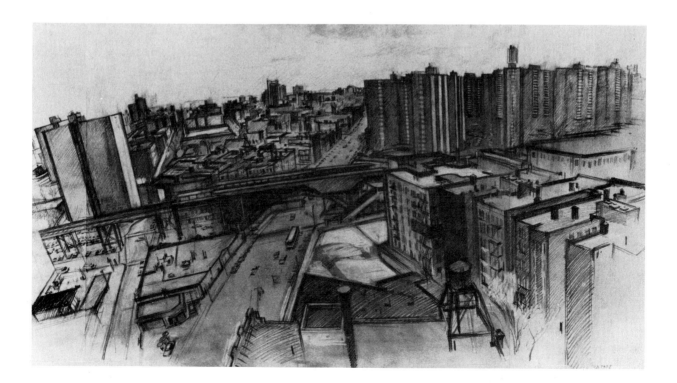

178. M. C. Escher (1898–1972; Dutch). *Other World.* 1947. Wood engraving, 12¼ × 10¼″ (32 × 26 cm). Escher Foundation, Haags Germeentemuseum, The Hague.

Continuous practice in perspective drawing sensitizes the eye, so that you will readily perceive errors. By studying the diagrams and doing the projects, you are better able to see forms as they exist in space and can avoid the errors most commonly made. You will be able to see when objects do not appear to rest on the same ground plane and when they are drawn out of scale.

Sketchbook Activities

In your sketchbook do perspective drawings from observation and from theory. Draw objects and scenes that are both simple and complex—a partially open door, a jumbled array of drawing benches and easels in an art classroom, the confusion of plates and cups and textbooks on a table in the cafeteria all offer opportunities to consider size, shape, and space relationships. If there is nothing to observe, draw objects from memory or imagination (Fig. 178). Construct large general forms first, then modify them. Remember that most objects can be placed in boxes, which can be transformed by cutting away. With much drawing and much looking, your uncertainties will become less frequent, your drawings more accurate.

PART

Drawing
Media

4

A feeling for media, sensitivity to their intrinsic beauty and expressive potential, and a delight in manipulating them are part of the makeup of most artists. For the novice artist, it is essential to discover the medium best suited for one's temperament and talents; exploration is the first step toward that discovery. Since pleasure in the craft is an important component of the artistic temperament, the joyful savoring of the particular qualities inherent in each material and each surface contributes to the total effect.

There are many different artistic personalities. Artists who enjoy working patiently and methodically naturally gravitate to those media that demand precise control, disciplined manual dexterity, and careful manipulation of difficult tools. At the other extreme is the artist who cannot put down ideas with sufficient speed, who can formulate and express an idea in a brief burst of creative energy. To facilitate this rush of enthusiasm, the ideal medium is one that demands neither great precision nor extensive preparation, one that encourages rapid visualization, one that can be worked and modified easily without seeming to imply a lack of technical facility. Between the two extremes lie a host of talents and temperaments. All of them can be accommodated by the range of available media. In fact, any attempt to define or limit the use of a medium to one type of temperament suggests a categorizing inherently false to the need for experiment and self-discovery.

Chapter 2 introduced the media most commonly employed in drawing by beginning students. This section will explore a fuller range of drawing materials, some more sophisticated and requiring greater skill. While the accompanying projects have been designed to encourage students to experiment with a wide range of materials, esoteric methods and recipes have been purposely avoided. Unduly detailed directives about the use of media, tools, and materials have also been avoided since step-by-step instructions frequently encourage self-conscious and mechanical procedures that interfere with direct and vigorous natural expression. In general, after accepting certain fundamental and very general procedures, artists work out their own methods. Students are urged to play freely with media before embarking upon their use, for only by a free and inventive manipulation of materials do artists discover and develop their personal preferences and ways of working.

It is suggested that you first read through this entire section and then select those media and exercises that sound interesting. When you fix upon a medium or technique that seems particularly satisfying, it is wise to explore it rather fully before moving to another. Single cursory encounters with a wide variety of materials and methods can result in confusion, while the production of works that satisfy the artist remains the greatest encouragement and stimulus toward further development.

Papers

Before exploring the categories of dry and wet media, a brief survey of standard drawing papers will afford the student a basic reference. **Newsprint,** manufactured from wood pulp, is the cheapest paper; it has a smooth surface, yellows badly, and is appropriate only for quick sketching in pencil, charcoal, conté crayon, and chalk. **Charcoal paper** has considerably more "tooth" (roughness created by an imprinted texture combined with fine sand) and is available in white, gray tones, and muted colors for use with charcoal, chalk, conté crayon, and pastels. **Soft sketching papers** are manufactured for use with soft pencils, ball-point and felt-tip pens, and colored crayons. **Rice paper,** the traditional surface for Oriental brush-and-ink drawing, provides a soft, very absorbent ground. **Bond papers,** familiar as stationery and typing paper, are smooth, relatively hard-surfaced, lightweight papers appropriate for use with pencil or pen and ink; they are available by pad or bulk in various sizes. **Bristol board,** a very fine, hard-surfaced paper, is manufactured in two finishes. **Kid finish,** by virtue of its very slight tooth, facilitates fine pencil work and rubbed pen-and-graphite combinations. **Smooth (plate) finish** encourages elegant studies in pen and ink or very hard pencil; it is available in different weights. **Illustration board** results from layers of variously surfaced papers mounted on cardboard backing. While expensive, illustration board tends to justify its price in its durability and resistance to wrinkling when wet. **Watercolor papers,** as the name indicates, are used primarily for wash and watercolor. The heavier the weight of the paper, the more absorbent, free from wrinkles when wet, and expensive it will be. There are three standard finishes for watercolor paper and illustration board. **Rough,** a surface produced in the best papers not by mechanized graining but as the result of a hand manufacturing proc-

ess, is best adapted to splashy, spontaneous techniques. **Cold press** is a moderately textured matte surface. **Hot press,** the smoothest and least absorbent surface, is excellent for very refined, controlled techniques.

Papers made of 100 percent rag are the most permanent—and also the most expensive. Charcoal paper, bond, and other common drawing papers are made either from wood pulp, rag, or a mixture of the two. The cost of supplies is an understandable consideration for beginning students, particularly when they are asked to explore a variety of materials; hence, the inexpensive pulp papers are most commonly used. The difference between drawing on pulp paper and on rag paper is immediately apparent, however, and as the student gains confidence and skill, works intended to be finished drawings should be done on pure rag papers.

Dry Media

*I recall how I loved the material itself, how the
colors and crayons were especially alluring,
beautiful and alive.*

—Vassily Kandinsky

The dry media—charcoal, chalks, pastels, conté crayon, wax crayons, pencil, stick and powdered graphite, and silverpoint—are those materials which leave granular deposits when they are drawn across a surface.

Charcoal

Charcoal, probably the oldest drawing medium, is a crumbly material that readily leaves a mark when rubbed against any but a very smooth surface. With it, tentative lines can be put down and subsequently erased; the same piece of charcoal can with ease serve for line drawing or—turned on its side—produce broad tonal masses. Charcoal is equally suited to the sketches and rapidly executed preliminary compositional plans of William Glackens (Fig. 179) and to the fully developed, large-scale value studies of Joseph Stella (Fig. 180). Disadvantages are that it is rather dirty, and because marks are not deeply imbedded in the ground surface, it is easily smeared by careless movements of the hand or arm across a drawing.

Stick charcoal is made by heating sticks of wood about ¼ inch (.6 centimeter) in diameter in kilns until the organic materials have evaporated and only dry carbon remains. It comes in varying thicknesses, the finest quality (called **vine charcoal**) made in very thin sticks of an even, soft texture. Manufacturers classify charcoal in four degrees of hardness: very soft, soft, medium, and hard. **Compressed charcoal** results from grinding the charcoal to powder and compressing it into chalklike sticks about one-quarter inch in diameter. Compressed charcoal is also labeled according to hardness, ranging from

179. William Glackens (1870–1938; American). *Study of a Woman Sewing*. Charcoal on tan paper, 7 × 8½″ (18 × 20 cm). Collection Paul Magriel.

180. Joseph Stella (1877–1946; Italian–American). *Miners*. Charcoal, 15 × 19⅝″ (38 × 50 cm). Yale University Art Gallery, New Haven, Conn. (H. John Heinz III Fund).

00, the softest and blackest, through 0 to 5, which contains the most binder and is consequently the palest and hardest. In general, because compressed charcoal is less easily erased, it is not well adapted to beginners' needs. It is most effective for large-scale, quick sketches or when rich darks are desired (Fig. 181).

Charcoal pencils are made by compressing charcoal into thin rods and sheathing them in paper or wood. They range in degree of

181. Odilon Redon (1840–1916; French). *Tree Trunks in the Forest.* c. 1890. Charcoal on white paper with erasures, 19⅜ × 14½″ (49 × 37 cm). Museum of Fine Arts, Houston (gift of Mrs. Harry C. Hanszen).

compression from 6B (extra soft) through 4B (soft) and 2B (medium) to HB (hard). A charcoal pencil offers cleanliness but lacks the flexibility of stick charcoal because only the point can be used effectively. The same criticism applies to using metal holders with stick charcoal.

Method

There are three common methods of working with stick or compressed charcoal. The direct free attack, using both the point and side of the charcoal stick, offers maximum flexibility of stroke and tone without the time-consuming fussiness of more finished modes (Fig. 179). An alternate process, involving a disciplined and relatively "pure" application of charcoal, is to build value relationships through systematically cross-hatched lines drawn with a pointed stick of charcoal (Fig. 180). Many enthusiasts consider most desirable a clearly grained texture without any of the soft fluidity of tone that accompanies rubbing (Fig. 180). A third manner of applying charcoal is the standard academic technique of the 19th century, which produces carefully developed value studies of even, graduated tone through repeated application of charcoal rubbed into the paper with dry fingers or a tortillon (Fig. 24).

A piece of chamois can be used to wipe away unsatisfactory charcoal lines and tones; a kneaded eraser can be shaped to eliminate small areas of tone, clean up smudges, sharpen an edge, and pick out small light accents. Some of the texture in Odilon Redon's *Tree Trunks in the Forest* (Fig. 181) has been created with an eraser.

Charcoal can be applied to many kinds of drawing paper. Newsprint suffices for quick sketches and studies that do not demand eras-

182. Matt Tasley (b. 1960; American). *Truck*. 1985. Charcoal on paper, 5′ × 7′1″ (1.52 × 2.16 m). **Arkansas Art Center Foundation Collection.**

ing, the careful building up of smooth tones, or permanence. Coarse drawing papers also provide acceptable grounds for quick sketches with all types of charcoal. Regular charcoal paper, which will take repeated erasures and rubbing without losing its grain, is best for sustained studies. Compressed charcoal can be used effectively on relatively smooth bond papers. Most charcoal papers are manufactured in the standard 18- by 24-inch (46 by 61 centimeters) size. Other suitable drawing papers are available in larger sheets or by the roll, which suits the needs of contemporary artists such as Matt Tasley (Fig. 182) and Chuck Levitan (Fig. 5), who work in charcoal on a more monumental scale.

Charcoal drawings can be "fixed" by spraying them with fixative (shellac or a transparent plastic substance dissolved in solvent).

Quick Sketching

Project 10.1 Quick sketching develops the capacity to put down rapidly the essential elements of a composition or the characterizing aspects of a physique, gesture, action, or typical posture without concern for minor details (Fig. 179). Making the same kinds of rapid summaries of buildings, trees, vehicles, animals, people on the street, and any other subject is equally important. Practice recording the essential character of form in one-minute, five-minute, and ten-minute sketches.

Finished Composition

Project 10.2 Select a subject that encompasses a wide range of value relationships—a complex still life, a self-portrait, or an abstraction. Be-

fore embarking on a highly finished drawing, establish a preliminary visualization of the linear and tonal patterns as thumbnail roughs on a piece of newsprint (Fig. 127), using the side of a short piece of charcoal to lay in the darks. Having determined the value pattern, develop a large-scale, full-value, finished drawing on charcoal paper. While it is possible to combine techniques, take care to achieve a consistency of handling throughout the drawing.

Chalk

The term **chalk** covers a wide variety of materials ranging in texture from coarse to fine, from hard to soft and crumbly, and from dry to greasy, shaped into rounded or square sticks. It is impossible to establish the point at which chalk becomes crayon or pastel, and the dividing line between chalk and compressed charcoal is equally tenuous.

Chalk affords the artist a technical versatility similar to that of charcoal. Like compressed charcoal, chalk is somewhat difficult to erase, but it offers ample compensation in the potential for richer, darker lines and solid masses. The numerous and satisfying possible effects are suggested in the open, energetic sketching of Marsden Hartley (Fig. 183); the full, but freely executed tonal studies of Henri Fantin-Latour (Fig. 184); the carefully finished drawings of Jean Baptiste Isabey (Fig. 185). The medium's chief advantage is color, permitting enriched tonal and compositional relationships.

below: 183. Marsden Hartley (1878–1943; American). *Self-Portrait.* Black chalk, 12 × 9″ (30 × 23 cm). Sotheby Parke-Bernet.

below right: 184. Henri Fantin-Latour (1836–1904; French). *Self-Portrait.* Black chalk on off-white paper, 7⅛ × 5¾″ (18 × 15 cm). Louvre, Paris.

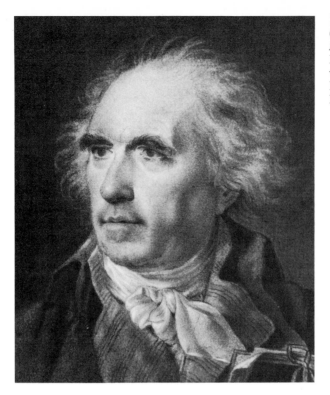

185. Jean Baptiste Isabey
(1767–1855; French).
Portrait of Hubert Robert. c. 1799.
Detail. Black and white chalk on cream
wove paper, 13 × 10″ (33 × 25 cm).
Minneapolis Institute of Arts (gift of
David M. Daniels, 1969).

Dark and Light on Toned Paper

Project 10.3 Using black and white or dark-colored and light-colored chalks on a middle-value paper facilitates both rapid visualization of tonal relationships and finished drawings of great beauty (Fig. 185). Select a subject that will allow a full range of values—a piece of drapery or a paper bag would be appropriate, or if you want to tackle something more ambitious, a well-lighted nude, costumed model, or head. Place your subject against a middle value background and draw on toned charcoal paper of a comparable value. Let the paper provide the transitional middle tones, as elegantly demonstrated in Plate 3 (p. 88), rather than mixing light and dark to create intermediate tones. Thoughtful analysis of light-dark patterns and preliminary planning will result in a fresh, unmuddied drawing.

If you choose to work in color, the paper and chalks should be closely related in color without strong differences in intensity (brilliance) and only a few value "steps" apart. For further interest, add accents in black and white, sparingly.

Pastels

Pastels are high-quality chalks of fine, even texture, available in a wide range of hues of graduated value and intensity. **Soft pastels,** traditionally called French pastels, consist of dry pigment mixed with an aqueous binder, usually compressed into cylindrical form. Soft and crumbly, this type of pastel is nonadhesive and thus requires both paper of decided tooth and fixative to assure a measure of permanence. Oil added to the binder causes **semihard pastels** (sometimes labeled **oil**

pastels) to adhere more readily to paper. Manufactured most commonly as rectangular sticks, semihard pastels possess a number of advantages over ordinary pastels: their oily texture and smooth sides render them less crumbly; the flat planes provide rapid coverage of broad areas; and the sharp corners make them effective for detailing and accenting. **Hard pastels,** a more recent development, share the basic characteristics of the semihard variety but are distinguished by an even firmer texture. Both semihard and hard pastels are difficult to erase, so it is wise to make a small preliminary color sketch before commencing on a large-scale composition.

Pastels, with more than five hundred distinct colors and values available, permit what might be termed "drawn painting" (Pl. 1, p. 87; Pl. 2, p. 87). The greatest richness of color results from the direct application of **analogous** or **complementary** colors (pp. 127–128) side by side or with cross-hatching (Pl. 7, p. 90; Pl. 8, p. 171), letting the color mix optically. Blending colors through rubbing produces lifeless color and uninteresting surfaces. The generally recommended procedure is to lay in middle values first, then work toward light and dark, saving details and accents for last.

"Fixing" pastels provides some protection, but at the cost of loss of freshness. Without it colors stay brighter, but pastel drawings smudge easily and pigment falls off. To store pastel drawings, place tissue paper or newsprint over the drawing and secure the covering sheet with masking tape to prevent it from shifting.

Any of the exercises in the sections on chalk and conté crayon afford practice in the use of pastel.

Conté Crayon

Conté crayon is a semihard chalk of fine texture containing sufficient oily material in the binder to adhere readily and more or less permanently to smooth paper. Conté crayons, ¼ inch (.6 centimeter) square and 3 inches (8 centimeters) in length, come in three degrees of hardness—No. 1 (hard), No. 2 (medium), and No. 3 (soft)—in white, black, brown, and sanguine (Venetian red), which is the most popular color. (Lithographic crayons are similar to conté crayons, but waxier.) In his self-portrait (Fig. 186), Josef Albers has made advantageous use of the square format of the crayon, using the flat side for broad strokes of graduated tone, while creating sharp accents with its corners. Used on rough paper, conté crayon produces the interesting granular effect seen in the Albers drawing and Seurat's study of his mother (Fig. 118). Conté, which is also available in pencil form, erases with difficulty and consequently best serves the needs of the sure, experienced draftsman.

Project 10.4 Break a stick of conté into two or three pieces. Do a series of rapid full-sheet drawings on newsprint of any subject that appeals to you—posed figures, animals, trees, plant forms, a casual grouping of fruit or vegetables. Work for a broad representation of essential forms and movements. When you view your subject through half-closed eyes, details are eliminated and you see basic forms as simplified patterns of light and dark. Use the side of the crayon to block in the shadow shapes, then add linear accents with the sharp corners of the crayon. Practice drawing contours and accents with the corner held flat to the paper rather than raised. Experiment with shifting from the cor-

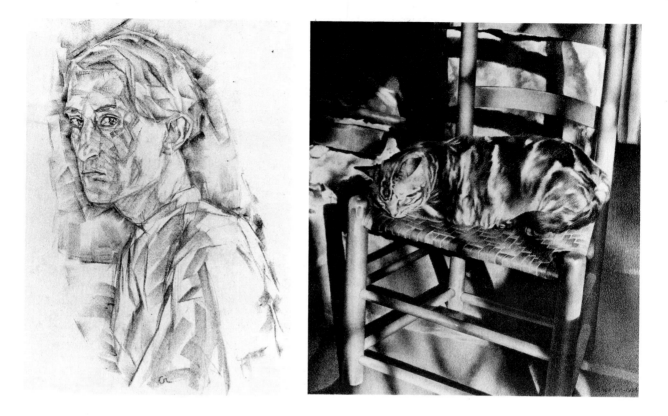

ner to the flat edge of the crayon within a single stroke, both for interesting line quality and to describe the contours of three-dimensional forms.

Fully Developed Drawing

The fine texture of conté crayon lends itself to the creation of carefully finished drawings with a full value range, as evidenced in Charles Sheeler's *Feline Felicity* (Fig. 187). Conté is greasy enough that it does not rub off readily, yet its softness allows smooth gradations of dark to light.

Project 10.5 Choose a subject for a highly finished drawing in conté; plan your composition in a series of rough layouts on newsprint. When you are satisfied with the composition, select a smooth, firm paper. Lay in your initial lines lightly, and then develop the drawing to full value. You may wish to strengthen drawings done in brown or red conté with black accents and white highlights.

Wax Crayons

Inexpensive sets of brightly colored wax crayons manufactured for children are familiar to everyone. The waxy substance adheres firmly to most paper surfaces and so presents a relatively clean medium to handle. The hardness of the crayons, however, makes them somewhat inflexible, and it is generally difficult to obtain deep, rich tones, since

above left: 186. Josef Albers (1888–1976; German–American). *Self-Portrait III.* c. 1917. Lithographic crayon, 19 × 15½″ (48 × 39 cm). Collection Anni Albers and the Josef Albers Foundation, Inc.

above: 187. Charles Sheeler (1883–1965; American). *Feline Felicity.* 1934. Conté on white paper, 21¾ × 17⅞″ (56 × 46 cm). Fogg Art Museum, Harvard University, Cambridge, Mass. (purchase, Louise E. Bettens Fund).

188. Käthe Kollwitz
(1867–1945; German).
Woman on the Bench. 1905.
Crayon and Chinese ink
on brownish paper, 19½ × 24½"
(50 × 62 cm). Courtesy Galerie
St. Etienne, New York.

the waxy strokes do not readily mix or fuse. Some artists find crayons appropriate only for sketching and preliminary color planning; others produce handsome finished drawings.

Grease crayons and lithographic crayons, when applied to grained papers, yield vigorous, clearly defined textures and a richness of values (Fig. 188). Disadvantages of crayons are that they do not erase or allow lines to be fused or blurred easily. On firm, smooth paper, lights can be retrieved by scratching or scraping with a knife blade or similar tool.

Pencil

The pencil has been an important and versatile drawing medium since the end of the 18th century. Until the invention of cartridge pens, it was the most commonly used implement for drawing and sketching outside the studio.

Pencils are available in an astonishing variety—graphite, carbon, charcoal, wax, conté, lithographic (grease), and a wide range of colors, both soluble and insoluble, each offering a particular quality that renders it valuable for certain effects. Our concern in this section is the common, so-called lead pencil, which actually is composed of graphite, a crystalline form of carbon having a greasy texture. Suppliers now manufacture graphite pencils in as many as seventeen degrees of hardness—6B, the softest, possesses the highest graphite content; 9H, the hardest, contains the greatest proportion of clay. The usual design for pencils is a slender lead sheathed in wood, coming to an exposed point. The so-called carpenter's pencil, with its wide (³/₁₆ inch, or .5 centimeter), flat, soft lead that must be sharpened with a razor blade or knife, is useful for laying in broad areas of tone, while the corner allows fine line work. It is also possible to buy drawing leads, black and

189. Paul Wonner
(b. 1920; American). *Still Life:
Interior with Daffodils*.
Pencil, 11 × 14″ (28 × 36 cm).
Courtesy the artist.

190. Mark Adams (b. 1925;
American). *Still Life: Chair and Towel*.
1965. Pencil, 14 × 17″ (36 × 43 cm).
Collection Duncan and Cynthia
Luce, Laguna Beach, Calif.

colored, to be inserted into metal holders, eliminating the need for sharpeners, knives, or razor blades.

Soft Pencil

Soft pencils (6B to 2B) are particularly well suited for contour drawings or other similarly free, primarily linear notations, such as Modigliani's *Seated Nude* (Fig. 73) and Degas's *Jockey* (Fig. 27). The soft lead also lends itself to informally applied parallel hatchings and loosely executed cross-hatching. Much of the vitality of Paul Wonner's *Interior* (Fig. 189) derives from the variety in thickness, density, value, and character of his energetic line. In contrast, Mark Adams's *Still Life: Chair and Towel* (Fig. 190) relies upon a more deliberate application of overlapping strokes and cross-hatching to build a range of values,

from the soft, light gray tones of the towel to the deep rich dark of the chair back, and to provide more precise definition to important contours.

Project 10.6 Produce a full range of values with soft pencils, either by using one pencil and changing pressure, or by selecting different grades of lead for different values. The softer grades (6B is softer than 2B) provide richer darks, but are not good for fine details because they lose their points too quickly. Less soft grades are better for linear detail but require more pressure to build dark tones, sometimes resulting in a shiny, mottled surface marked with indentations from repeated strokes.

Project 10.7 Select a pencil or pencils with the degree of softness most pleasing to you, and make some drawings of any subject you choose. Frequently, just whatever happens to be within your field of vision has a fresh interest because it has not been carefully selected and arranged (Fig. 189). A pair of hiking boots or running shoes, a friend sprawled in a chair, or a shirt and jeans tossed on a bed or carelessly draped over the back of a chair provide apt subject matter for this kind of drawing.

Let your drawings be free and gestural. Define shapes by tonal changes without relying on outlines. Block in forms and shapes lightly so that the lines will disappear as you introduce stronger patterns of strokes and values. Provide some dark accents, but only enough to begin to give definition to objects, and only after general value relationships have been established.

Sketchbook Activities

Practice scribble-style soft-pencil sketching to record the animation and vitality of people and events surrounding you. Concentrate on conveying mood rather than details.

Soft Pencil: Formalized Patterns; Directional Strokes

Soft and medium-soft pencils (6B to B) are frequently combined in a rather formalized manner for depicting architectural and landscape subjects. Asher B. Durand employed a formalized pattern of short strokes in *Bolton, Oct. 3/63* to suggest the laciness of the foliage masses in contrast to the more boldly delineated branch structure (Fig. 191).

191. Asher B. Durand (1796–1886; American). *Bolton, Oct. 3/63.* 1863. Pencil on paper, 16¾ × 22¾" (43 × 58 cm). New-York Historical Society.

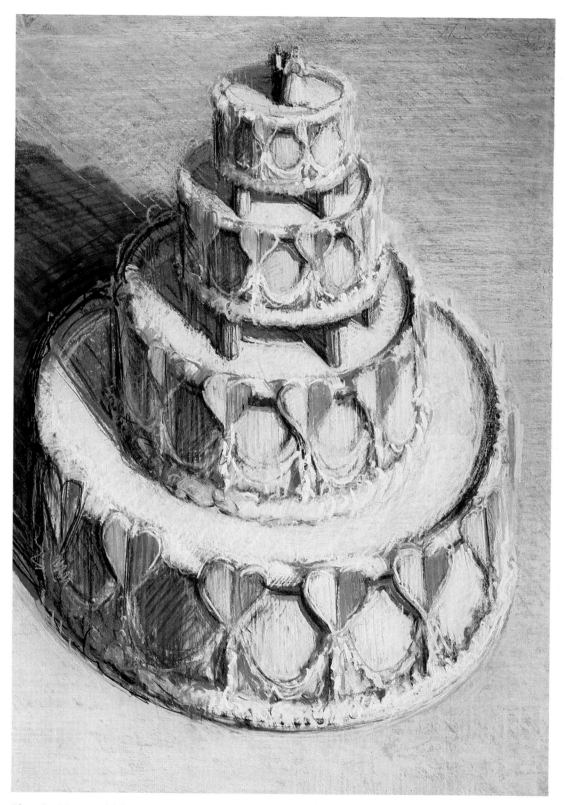

Plate 8. Wayne Thiebaud (b. 1920; American). *Wedding Cake*. 1973–82.
Pastel on paper, 32 × 28″ (81 × 71 cm). Private collection.

Plate 9. Jennifer Bartlett (b. 1941; American). *In the Garden #122.*
1980. Colored pencil on paper, 26″ ×19¾(66 × 50 cm).
Collection Chase Manhattan Bank.

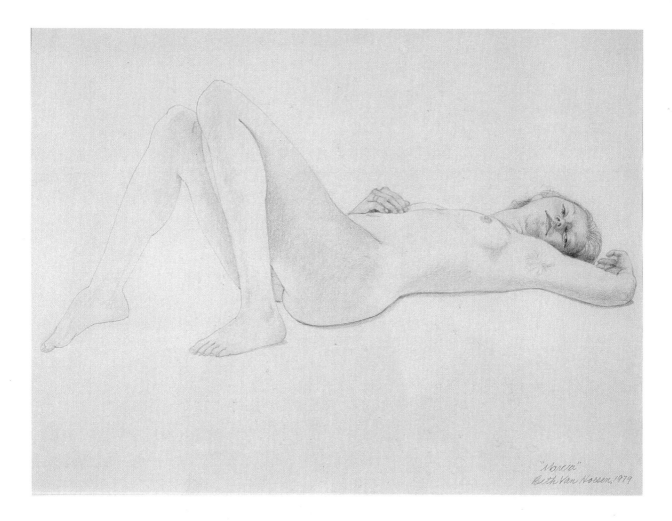

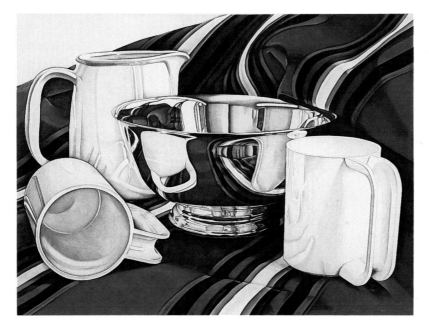

above: Plate 10. Beth Van Hoesen (b. 1926; American). *Marcia.* 1979. Colored pencil and graphite, 11½ × 15½″ (29 × 39 cm). Courtesy the artist.

left: Plate 11. Jeanette Pasin Sloan (b. 1946; American). *Silver Bowl Still Life.* 1978. Acrylic and colored pencil on board, 28½ × 38½″ (72 × 98 cm). Security Pacific National Bank, Calif.

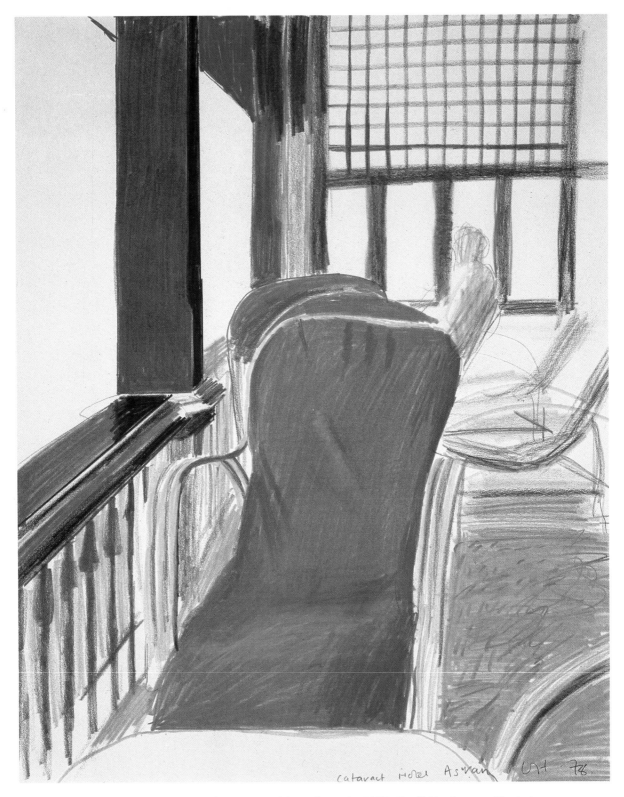

Plate 12. David Hockney (b. 1937; English). *Cataract Hotel, Aswan.*
1978. Crayon, 17 × 14″ (43 × 36 cm). David Hockney 1978.
Courtesy Petersburg Press.

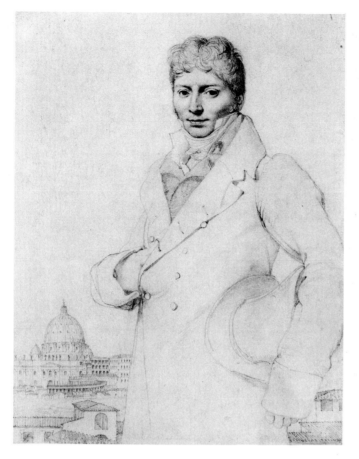

192. Jean Auguste Dominique Ingres (1780–1867; French). *Doctor Robin.* c. 1808–09. Pencil, 11 × 8¾″ (28 × 22 cm). Art Institute of Chicago (gift of Emily Crane Chadbourne, 1953).

Project 10.8 Select a subject in which form, texture, and other details can be suggested with a variety of lively pencil patterns—a building with some degree of surface articulation, such as boards, shingles, brick, and stone patterns, or trees and foliage. With foliage masses, be conscious of light and dark patterns that create volume.

Project 10.9 Use patterns of directional strokes to indicate the shifting angles of planes and tonal variations of a group of paper bags, a broad-leafed plant, or other interesting objects. Define forms by changes in the direction and value of the pencil strokes, rather than with outlines.

Hard Pencil: The Modeled Line

The clean-cut and silvery tone of hard pencil (H to 6H) can yield effects of great elegance, used either as pure line or augmented with light shading to convey a fuller sense of form than can be suggested by outline alone. The delicacy and sensitivity with which forms can be modeled and details rendered is nowhere more evident than in the figure studies, portraits, and architectural renderings of Jean Auguste Dominique Ingres, the acknowledged master of pencil drawing (Fig. 192).

Project 10.10 The darkest dark of a hard pencil is considerably lighter than the full rich darks of the softer B grades. The delicately in-

terlocked petals of a single rose provide a perfect subject for this me-
dium, as do glass, silver, and other smooth-surfaced objects. Life draw-
ings, portraits, costumed figures, and in fact almost any subjects are
appropriate, provided the artist concentrates on outline reinforced with
only a suggestion of modeling. Since some pressure is necessary when
using hard pencil, a firm, not-too-thin paper such as kid-finish Bristol
board is recommended to avoid an excessively engraved surface. Draw-
ings in hard pencil are best kept small; if they are too large the pale
lines and tone do not carry well.

Hard Pencil: Rendering

Rendering, as a drawing technique, demands the most precise depic-
tion of form, texture, and value in its quest for versimilitude. Hard
pencil is well adapted to that purpose. Bill Richards, described as a
"meticulous realist," uses a full range of hard pencils, from 2H to 9H,
in his rendering *Blinn Valley* (Fig. 193).

Colored Pencils

Contemporary artists, both in fine and commercial art, have begun
using colored pencils, alone and in combination with other media, for
works ranging from sketches to highly detailed renderings.

A uniform pattern of loose cross-hatching is used to define
shapes and values, and to create the optical color in Jennifer Bartlett's
colored pencil drawing *In the Garden #122* (Pl. 9, p. 172). Beth Van
Hoesen, a printmaker of distinction, first turned to colored pencils to
make preliminary studies for color etchings. She has since found them
to be an ideal medium for developing full-color drawings without loss
of the linear precision and sensitivity with which she is identified (Pl.
10, p. 173).

The overwhelming illusion of patterned fabric, molded plastic
forms, and mirrorlike metallic surface in Jeanette Pasin Sloan's *Silver
Bowl Still Life* (Pl. 11, p. 173) results, in part, from using colored pen-
cils to give increased definition to acrylic washes. Pencil lends itself to a
precise delineation of contour and to the skillfully controlled render-

ing that differentiates between the subtlety of the reflections in the plastic surfaces and the clarity of the reflections in the silver bowl.

Method

Paper texture, pencil pressure, even the shape of the point of the pencil influence the quality and intensity of color in colored pencil drawing. Colored pencils seem to work best on a medium-grained paper, but it is always best to experiment with any new paper before initiating a full drawing. Applied with light pressure, color touches only the raised portions of the paper's texture, resulting in a granular, light tone because some of the white of the paper still shows. Applied with greater pressure, color begins to fill in the hollows to eliminate the white of the paper and produce a more solid, darker and richer tone. The variations in the red of the veranda chairs in David Hockney's *Cataract Hotel, Aswan* (Pl. 12, p. 174) reveals how the degree of pressure determines both value and intensity. A sharp point contributes to stronger color because it gets into the depressions, whereas a blunt point glides across the paper's surface.

Bartlett's open cross-hatching (Pl. 9, p. 172) demonstrates a linear approach to creating color and tone, the effect being light and lyrical. Using a fine point and varying the direction of strokes, but with greater density so there is no space between the strokes, produces solid tones of strong color. Medium pressure with frequent directional changes in stroking gives the greatest uniformity in tone.

The semitransparency of colored pencils permits colors to be changed by applying one color over another, as suggested by the change that occurs when Hockney applies blue and red over the brown of the window frames seen in the background of Plate 12 (p. 174). A color used alone has a degree of rawness; combining colors by "layering" produces richer, more interesting colors. The maximum darkness of an individual colored pencil is that of the lead itself. If a darker value pencil is not available, the value of a color can be deepened by applying a layer of black. Using any other dark color will change the color as well as the value. Layering with white, or some other light color, both lightens the value and brightens the intensity of a color without sacrificing solid tone. The intensity of a color can be diminished by layering with neutral gray or the complement of the color.

Project 10.11 With colored pencils, richness and luminosity of color are achieved by applying layer upon layer of color. Experiment with building tones and changing colors, values and intensities. Begin by making several squares of the same color, then alter all but one by layering with different colors.

The surface quality of a drawing changes with increased layering of color. The most noticeable change occurs when white or other light colors are applied to a darker color using heavy pressure. The result is a smooth, polished surface; the technique is called **burnishing.** (Unburnished areas can be lifted by pressing against the surface with a kneaded eraser.)

Repeated layering of color under heavy pressure can produce a foggy quality called **wax bloom,** which usually can be eliminated by rubbing the surface of the drawing lightly with a soft cloth. Provided it does not alter the color, a light application of fixative can be used to prevent bloom.

Some colored pencils are water soluble and can be used to create effects similar to watercolor. Almost all colored pencils are soluble with turpentine. Although the result is not as fluid in appearance as that of water soluble pigments, turpentine as a solvent has the advantage of drying almost immediately. Particularly convenient when you are working out of doors is the solvent in a colorless art marker. Whichever solvent is used, the more color applied, the more pigment there is to liquify.

Project 10.12 Practice various drawing techniques, ranging from loose sketches to carefully finished drawings. Explore the possibilities of the medium in a series of small studies before undertaking a large-scale composition.

Stick and Powdered Graphite

Graphite is available in other than the familiar pencil form. Stick graphite (about ¼ inch square and 3 inches long, or .6 by 8 centimeters), available in gradations B to 6B, lends itself to drawing in an open, sketchy manner on a large scale. *Leopards* by Malcolm Morley (Fig. 194), drawn on paper nearly twice the size of a standard newsprint pad, displays a line quality identical to that in a smaller drawing done with a regular drawing pencil. In the Edwin Dickinson detail (Fig. 195), stick graphite is manipulated like conté crayon or square chalks. The point of the stick produces soft, rich lines, the flat sides deposit broad areas of gray, while the corners create sharp, dark accents.

194. Malcolm Morley (b. 1931; English). *Leopards.* 1980. Pencil on paper, 21 × 30″ (53 × 76 cm). Courtesy Xavier Fourcade, Inc., New York.

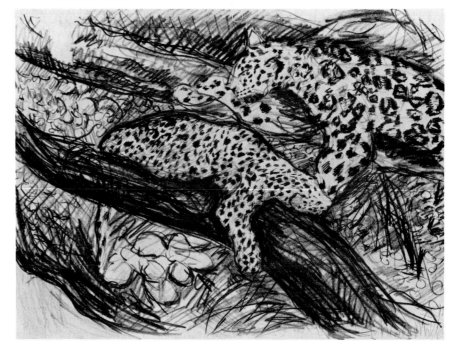

Project 10.13 Explore various techniques for drawing with stick graphite. Select a subject with planes and angles that will allow you to use the flat sides and corners of the stick to define form—architectural forms are particularly suitable. An adequate alternative would be a random clustering or nesting of empty cardboard boxes—the grouping can be made as complex as you wish. Work large; do not let your drawing become cramped.

Using a full sheet of paper, make a second drawing in which you treat the stick graphite like a giant pencil to sketch freely. Choose a subject rich in textures, such as an untended, overgrown garden; a field thick with grasses, weeds, and thistles; or a thicket of trees and brambles.

Graphite in either stick or pencil form can be powdered on sandpaper and applied with a finger, soft cloth, or paper towel to provide a smoothly textured tone that contrasts effectively with sharply drawn lines, a combination particularly apt for modeling the form of a nude figure. (Graphite also can be dissolved with benzine or turpentine for wash effects.)

Finely ground, powdered graphite, packaged in squeeze tubes for purposes of lubrication, can be purchased in hardware stores. Harder than stick graphite, it produces a pale, even, silvery tone of great beauty when rubbed onto a kid-finish Bristol board with a soft cloth or paper towel. Daniel Mendelowitz's *Wild Radish* (Fig. 196) is developed on such a toned background using medium-hard and hard pencil lines with white highlights recovered through erasure. The technique is well suited to drawings meant to convey a sense of elegance and delicacy.

195. Edwin Dickinson
(1891–1978; American).
Souvenir of the Fossil Hunters,
detail. 1927. Pencil,
entire work 7⅝ × 9⅞" (19 × 25 cm).
Private collection.

196. Daniel M. Mendelowitz
(1905–1980; American).
Wild Radish. 1965. Hard pencil
and rubbed graphite,
15½ × 21½″ (39 × 55 cm).
Collection Mrs. Daniel Mendelowitz,
Stanford, Calif.

Project 10.14 Leafy plants (Fig. 196), portraits (Fig. 120), glass or metallic objects with reflective surfaces (Fig. 236), or an abstraction of organic forms might prove workable for this project.

Rub powdered graphite into kid-finish Bristol board until you have a smooth tone of light gray. Begin drawing with light pencil lines; add darker shading and erase out whites. A firm eraser cut to a fine edge allows you to lift out narrow white lines and small, precise areas of light. Plan and work carefully since all marks, whether penciled darks or erased lights, show on the gray background. Working with an extra piece of paper under your hand will prevent smudging.

Silverpoint

Metal points preceded lead or graphite pencils as drawing implements. They were, in fact, used for that purpose in ancient Rome. Over the centuries silver has seemed to provide the most satisfactory metal point, its lovely gray color oxidizing to a gray-brown with the passing of time. A stout wire (preferably silver and available at jewelry and craft supply stores) not more than 1 inch (2.5 centimeters) long and pointed by rubbing on sandpaper provides a satisfactory silverpoint. For ease of handling, the wire can be inserted into a regular drafting pencil holder, a mechanical pencil, or a wooden stylus. Any smooth, heavy paper—again, Bristol board is excellent—surfaced with white tempera makes an adequate ground for the beginner. A more professional ground results from mounting two-ply Bristol board on a drawing board and coating the paper with thin applications of warm **gesso,** a white, fluid paste made by mixing gypsum or chalk with glue and water. (Commercially prepared liquid acrylic gesso, thinned to the consistency of cream, can be substituted.) When a smooth opaque surface has accumulated and the gesso has been burnished with a soft cloth, the ground is ready for silverpoint (Figs. 197, 198).

Silverpoint yields a thin line of even width, like that of a hard pencil. Lines executed in silverpoint will not blur; hence gradations of value must be achieved through systematic diagonal shading, clusters of lines, or cross-hatchings, evident in the Alphonse Legros *Head of a Man* (Fig. 197). Since silverpoint does not erase, students are advised to do a preliminary study in hard pencil, perhaps 4H. Silverpoint is most rewarding to individuals who enjoy methodical procedures and painstaking workmanship to produce drawings of exquisite finish. Although students are encouraged to work relatively small while they are developing a familiarity with the medium, silverpoint drawings need not always be limited in scale, as evidenced by Howard Hack's *Silverpoint #97, Lily #6, 1980* (Fig. 198), which measures 30 by 40 inches (76 by 92 centimeters). Rather than duplicate the natural light and dark relationship between blossoms and leaves, Hack focuses on the complexity of the combined forms seen almost as a reverse silhouette against the soft, gray-toned background.

above left: 197. **Alphonse Legros (1837–1911; French).** *Head of a Man.* **Silverpoint on white ground. Metropolitan Museum of Art, New York.**

above: 198. **Howard Hack (b. 1932; American).** *Silverpoint #97, Lily #6.* **1980: Silverpoint, 30 × 40″ (76 × 102 cm). Courtesy the artist.**

Project 10.15 Prepare a piece of Bristol board with four coats of tempera or gesso applied thinly to avoid brush strokes. Let each coat dry thoroughly. Brush alternate layers in opposite directions. Select relatively simple forms for your first attempt. Avoid subjects that call for rich dark tones: One or two yellow apples, lemons, or pears, or one egg placed on a saucer or in a small bowl would be fine. For greater visual interest, consider cutting a wedge or two out of a piece of fruit—drawing an apple doesn't require that it be left whole. A partially peeled lemon or orange with the strip of peel still attached offers interesting possibilities. Do not neglect the cast shadows of any object. Have patience; be willing to build your forms and values slowly.

Wet Media

*A truly sensitive artist does not find
the same image in two different media,
because they strike him differently.*
—Odilon Redon

Any fluid preparation an artist chooses to use could conceivably be termed a "wet" medium. For instance, artists sometimes draw in brush and oil or in printer's ink. Our primary interest, however, will be liquid **inks**—full strength or diluted for **wash.**

Inks, applied with pen or brush, were used for writing and drawing in Egypt, China, and elsewhere long before the beginning of the Christian era. Contrary to common impression, inks can take paste or solid form as well as fluid, but the quality most generally distinguishing ink from paint is fluidity. Inks are further identified by their purpose (lithographic, printing, writing); by special qualities (indelible, soluble, transparent); by color; and also according to their place of origin (India, China, and so on). Although the most common types of writing inks tend to be too thin and pale for other than sketching purposes, the deep, velvety black of India ink has long been prized as an artistic medium. Inks can be diluted to provide a tonal range in a drawing and can simulate watercolor effects.

Pen and Ink

For its elegance and clarity, the medium of pen and ink is unexcelled. It is a linear medium that demands precise and subtle control and does not indulge mistakes (Fig. 199). Michelangelo is reported to have acknowledged that it was a greater art to draw masterfully with the pen than with the chisel. Although the beginning student will probably have to tolerate initially clumsy results before achieving expertise, ink is a medium that allows the development of distinctively personal styles. (An added benefit is that ink, once dry, does not smear or smudge in a sketchbook as do pencil and other dry media.)

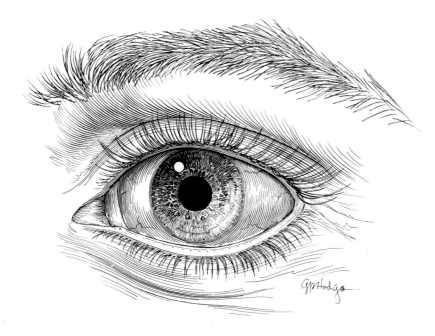

left: 199. Gerald P. Hodge
(b. 1920; American).
The External Anatomy of the Eye. 1980.
Pen and ink, 8½ × 11″ (22 × 28 cm).
Courtesy Gerald P. Hodge,
University of Michigan.

below: 200. Pen nibs and the lines
they produce (top to bottom): turkey
quill; reed pen; bamboo pen; two
drawing pens with metal points; two
lettering pens, with flat and round
metal nibs; "crow quill" pen;
Rapidograph pen; nylon-tip pen; felt-
tip marker and pen; ball-point pen.

Pen Types

The requirements of a pen are that it be pointed and that it have a tubular body to hold the ink that will flow from the body through the point to the paper (Fig. 200). To a much greater extent than any other media, the choice of pen determines the style of drawing.

Quill and reed pens have been in use for both drawing and writing since ancient times. **Quill** pens are cut from the heavy pinion feathers of large birds and shaped to a sharp or angular, coarse or fine point, depending upon the taste of the artist or scribe. As a result of their lightness and pliancy, quill pens respond readily to variations of touch and pressure to produce a responsive, smooth, and flexible line. Today it is traditionally trained calligraphers rather than artists who are most inclined to make and use quill pens.

Reed pens are hewn from tubular reeds or the hollow wooden stems of certain shrubs and cut to suit the user's taste. In general, reed pens are stiff; their nibs, or points, thick and fibrous. The lack of supple responsiveness results in a bold line. Because the reed pen does not glide easily across the paper surface, it contributes to a deliberate or even awkward strength of handling that tends to challenge the artist and thus inhibit overfacility and technical display. Interestingly, it seems to have been the favored drawing tool of Van Gogh (Figs. 201, 125, 259, 347). Contemporary artists who value similarly strong, brittle qualities of line, draw with **bamboo** pens, a type of reed pen imported from the Orient. Reed and bamboo pen nibs wear out quickly, but can be resharpened.

The **metal** pen point first appeared at the end of the 18th century. Used on very smooth, partially absorbent paper, the steel pen can be more completely controlled than either of its precursors as the vehicle for sharp detailed observation, as demonstrated by Gerald P. Hodge (Fig. 199). Nibs of varying sharpness, pointedness, and angularity permit almost any desired effect to suit the artist's purpose.

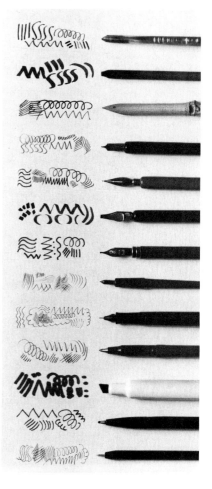

Drawing Media **183**

201. Vincent van Gogh
(1853–1890; Dutch–French).
Fountain in the Hospital Garden.
1889. Black chalk, pen, and brown ink
on paper; 19½ × 18 (50 × 46 cm).
National Museum Vincent van Gogh,
Amsterdam.

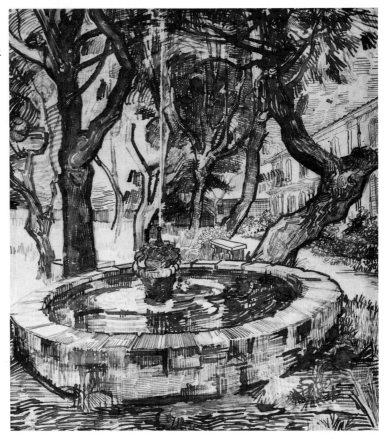

The multiplicity of steel pens available for drawing demands
much experimentation and exploration. For general sketching pur-
poses, many artists prefer a pen holder and interchangeable nibs. **Let-
tering** pen points come with round, straight, or angular nibs ranging
in width from ¹⁄₁₀ millimeter to more than ¼ inch (.6 centimeter). The
straight-nibbed lettering pens yield a line that in its stiff angularity
recalls the reed pen. Wide lettering pens allow the rapid filling in of
large areas. **Fountain** pens are generally more convenient for sketch-
book drawing—once filled they eliminate frequent recourse to a bot-
tle of ink (always a risk when being transported). Two general foun-
tain-pen types are specially manufactured for sketching and drawing;
quill-style pens, which will dispense India ink for an extended period
of time without clogging or dripping, and **stylus-type** pens, generally
termed **Rapidograph** pens, with a central cylindrical point that en-
ables the user to move the pen in all directions without varying the
line width. The latter must be held perpendicular to the drawing sur-
face for the ink to flow evenly. Thorough cleaning of pens—their nibs
and reservoirs—after usage greatly prolongs their effective life. Rapido-
graph pens, in particular, should be flushed out frequently in accord-
ance with the manufacturer's instructions to prevent irreparable clog-
ging of their delicate internal mechanisms. (It is also wise to use manu-
facturer-specified ink.)

For sketching purposes, nylon, felt-tip, ball-point, and marking
pens offer convenient substitutes for traditional pen and ink. Some
dispense a black, indelible ink very similar to India ink; some use a

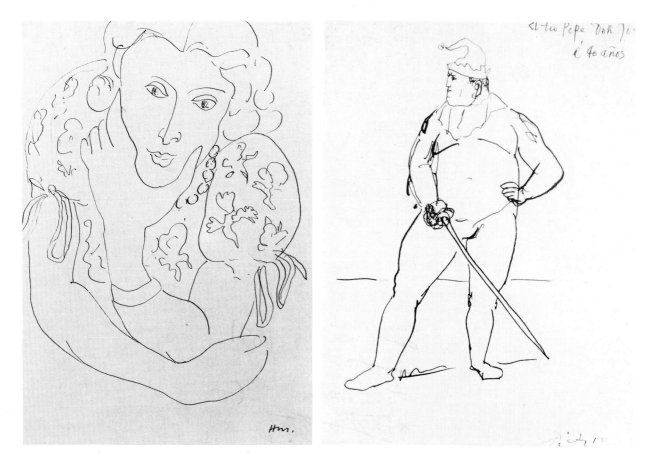

water-soluble ink. Some have replaceable ink cartridges, others are to be thrown away when the ink supply is exhausted. Although they lack the flexibility of a metal pen, their bold, simple lines have a special character (Figs. 32, 33, 200). Illustrators producing artwork for reproduction rely on them heavily, but uncertainty as to the permanence of their inks after prolonged exposure to strong light limits their use for fine art (see p. 26).

Simple Line Drawings

Pure, direct, and abbreviated, a black ink line drawn with pen on a white paper creates with incisive brilliance and energy a kind of shorthand impression of reality by recording only what the artist considers absolutely essential, eliminating all distracting details. *Femme à la Blouse Russe* (Fig. 202) demonstrates what Matisse acknowledged as "a seeming liberty" of line, contour, and volume that ". . . [does] not depend on the exact copying of natural forms, nor on the patient assembling of exact details . . ." The virtuosity evident in Matisse's line drawings resulted from making one drawing after another in rapid succession until he was satisfied that he had achieved maximum simplicity, fluidity, and freshness.

Picasso approached pen and ink, as he did all other media, with authority. *El Tío Pepe Don José* (Fig. 203) reveals a direct, bold, and brilliant use of the conventional flexible pen. The variations in the thickness of line are doubly descriptive—first, in revealing the physi-

above left: 202. Henri Matisse (1869–1954; French). *Femme à la Blouse Russe.* 1936. Ink, 15⅛ × 11⅛″ (38 × 28 cm).

above: 203. Pablo Picasso (1881–1973; Spanish–French). *El Tío Pepe Don José.* 1905. Black ink on cream paper, 10 × 8″ (25 × 20 cm). Collection Lee A. Ault, New York.

cal mass of the circus clown; second, in describing the process of drawing by documenting the pressure with which each stroke was made.

Project 11.1 Explore variations of simple pen-and-ink technique in a series of line drawings. Organic forms, vegetables, fruits, leaves, or flowers make logical subjects, since deviations in contours from those of the actual model are insignificant (Fig. 54). Portraits and figure studies present greater difficulties for the same reason, but compensate with increased interest. You will find value if, like Matisse, you make a number of drawings of the same subject, one after another.

Selecting paper is a matter of personal choice. Smooth paper is generally recommended, since metal points tend to pick up the raised surface of heavy grained papers. Bond paper is satisfactory for preliminary studies; for finished pen-and-ink drawings smooth-finish Bristol board provides a brilliant white, takes ink well, and permits fine pen lines. You might want to try heavy grained paper to experience a different line quality.

Take care not to overload the pen with ink; wipe the point against the side of the bottle before starting to draw, or the pen may deposit a large drop of ink when it first touches the paper. Should you have such an accident while drawing on good-quality Bristol or illustration board, allow the ink to dry, gently scrape away the excess ink with a razor blade, and then remove any remaining vestiges of the spot with an ink eraser. Do not, however, attempt to draw over the scraped portion or the ink will undoubtedly bleed into the disturbed surface. Except for drawings intended for reproduction, resist any temptation to block out mistakes or smudges with white paint, as the paint will always be far more obvious than the mistake or correction made by scraping.

below: 204. Canaletto (1697–1768; Italian). *Veduta Ideata: A Fountain on the Shrine of a Lagoon.* Pencil, pen and ink, black pencil, pen, and brown ink; 7½ × 10¾″ (19 × 27 cm). Royal Library, Windsor Castle, England (reproduced by gracious permission of Her Majesty Queen Elizabeth II).

below right: 205. Jacques Villon (1875–1963; French). *Jeune Fille.* 1942. Engraving, 11⅛ × 8⅛″ (28 × 21 cm). Courtesy of the Boston Public Library, Print Department.

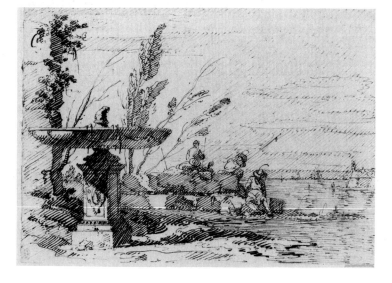

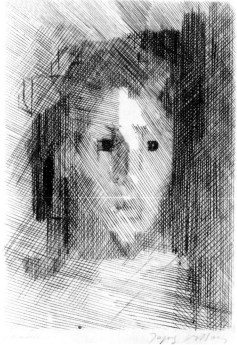

Value, Texture, Pattern

Because pen and ink is essentially a linear medium, dark values must be built up line by line, or dot by dot. Two standard methods for building pen-and-ink values by line are: **hatching,** the system of parallel lines seen in Canaletto's *Veduta Ideata* (Fig. 204); and **cross-hatching,** the crisscrossed patterns of parallel lines of Jacques Villon's *Jeune Fille* (Fig. 205). Both hatching and cross-hatching can be executed with painstaking, evenly spaced lines; with bold patterns of lines that move in many directions, sometimes as cross contours (Figs. 206, 207); or by scribbling (Fig. 89).

Initial attempts at pen-and-ink cross-hatching inevitably seem stilted, but in time, each artist develops a personal style. The beginner need not be unduly concerned with blotches and mistakes; fluent, consistent, unmarred pen-and-ink lines come only with much experience. It is important to have a fine-quality smooth paper for cross-hatching, lest the surface tear from repeated applications of the pen or become so absorbent that the ink lines lose their sharpness and become blurred. Cross-hatching actually appears crisper and cleaner when one set of directional lines is allowed to dry before the next set is applied. Bond paper is preferable to newsprint for practicing.

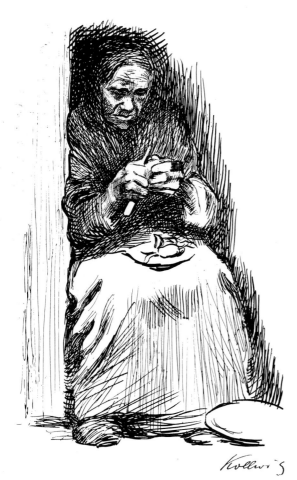

left: 206. Käthe Kollwitz (1867–1945; German).
Woman Peeling Potatoes. 1905. Pen and ink on white paper, 12⅝ × 9⅞″ (32 × 21 cm). Courtesy Galerie St. Etienne, New York.

207. Jacob de Gheyn II (1565–1629; Flemish).
Hippocrates Visiting Democritus. Pen and brown ink, 6⅞ × 9″ (17 × 23 cm). Museum of Fine Arts, Budapest.

Project 11.2 Practice cross-hatching until you gain some measure of control, then select a few simple objects and proceed to model them in dark and light. Do one drawing in the manner of Figure 205. In a second drawing, let the forms suggest the directional pattern for your lines (Fig. 206; Pl. 4, p. 88).

At the beginning, draw brightly illuminated, simple forms with clearly defined areas of shading and minimum surface texture. When you are ready to attempt a more complex study, you might find it profitable to translate some of the pencil drawings from earlier projects into pen and ink, having already established a familiarity with those subjects.

Pen and ink is well suited to drawings in which clearly defined patterns are desired for their descriptive, expressive, and decorative values. Van Gogh made extensive use of pattern—both decorative and descriptive in character—to impart vitality to his drawings (Figs. 201, 125, 347). Paul Klee has fancifully embroidered a system of essentially straight lines into an entertaining complexity of pattern and texture (Fig. 208).

Project 11.3 Approach this assignment as if you were doodling with pen and ink. Using lines—straight, curved, meandering—begin to invent patterns, letting them evolve, perhaps, into an imaginary landscape

In *The Survivor* by George Grosz (Fig. 209), a rich array of texture patterns has been employed both to characterize form and surfaces, and for expressive effects. The patterns reveal many varied uses of the pen, while some textures appear to result from pressing fabrics or other materials dampened with ink against the paper.

Project 11.4 Develop a pen-and-ink drawing in which you introduce textural patterns for descriptive or expressive purposes. Textures can be suggested rather than meticulously rendered. While some hatching and

208. Paul Klee (1879–1940; Swiss–German). *A Garden for Orpheus.* 1926. Pen and ink, 18¼ × 12½″ (47 × 32 cm). Paul Klee–Stiftung, Kunstmuseum Bern. © Cosmopress, Geneva/ADAGP, Paris/VAGA, New York, 1986.

209. George Grosz (1893–1959; German–American). *The Survivor.* 1936. Pen and India ink, 19 × 24¾″ (49 × 63 cm). Art Institute of Chicago (gift of The Print and Drawing Club, 1939).

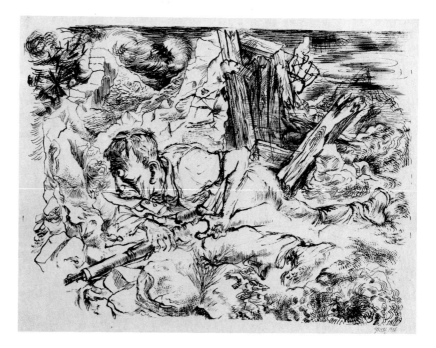

cross-hatching is inevitable, incorporate a variety of different linear patterns. Rocks, brambles, weeds, weathered wood, a derelict truck in a field offer interesting surfaces and textures (Figs. 126–128).

In highly detailed ink drawings, especially in scientific illustrations such as Bryony Carfrae's *Stone Crab* (Fig. 210), **stippling**—patterns of dots—serves to describe the very smooth gradations of value that define form, texture, or color modulation. Even the sharpest photograph would not reveal the details of form, texture, and surface patterns with the clarity of this drawing, for in a photograph reflected light and shadows would be intrusive. Stippling takes time and patience; the pattern of dots should be random, but never careless. It is the size of the pen, not pressure, that determines the size of the dots; it is the density of dots that produces darker tones. Rapidograph pens are ideal for stippling, but any pen can be used as long as the dots are kept uniform.

Project 11.5 In an earlier assignment you were asked to make a pencil rendering of a familiar surface, duplicating the texture as accurately as possible (Project 7.2). Now do a similar rendering in pen and ink, delineating a textured surface or object in as disciplined a manner as possible, using stippling. For this project a rather detailed preliminary pencil study is helpful.

Pen, Brush, and Ink

Pen and ink, amplified by brush, provides an obvious transition from pure pen-and-ink to brush-and-ink drawing. The surrealistic superimposing of images in Pavel Tchelitchew's *The Blue Clown* (Fig. 211), which can be viewed as the elaboration of a doodle, demonstrates how a pen allows linear detailing, while a brush facilitates lines of greater width than can be obtained with the pen nib, as well as extended areas of dark. Attempting to fill in large dark areas with a pen produces a scruffy surface.

Project 11.6 Select a subject with bold contrasts of dark and light—perhaps a self-portrait illuminated by strong light from one side—and develop it in pen outlines and brushed ink masses, using both tools to create transitional values and textures.

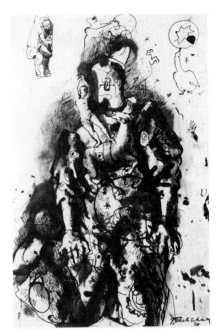

above left: 210. Bryony Carfrae (20th century; British). *Stone Crab.* 1977. Pen and ink, life-size; 2 × 3¾″ (5 × 10 cm). Courtesy the artist.

above: 211. Pavel Tchelitchew (1898–1957; Russian–American). Study for *The Blue Clown.* 1929. Pen and brush and ink, 16 × 10½″ (41 × 27 cm). Museum of Modern Art, New York (Mrs. Simon Guggenheim Fund).

Brush and Ink

The narrowness of line produced by a pen point gives it its bite and energy and at the same time limits its degree of flexibility and painterliness. When artists wish to expand the scope of line, they pick up a brush (Fig. 212).

All kinds of brushes can be used with ink, and each brush imparts its particular character to a drawing. A stiff bristle brush for oil painting produces brusque, angular lines, often with heavily drybrushed edges (Fig. 213); the long, very pointed Japanese brush is more responsive to pressures of the hand and so creates lines of unusually varied widths (Fig. 214); a red sable brush, while not as flexible as a Japanese brush, can be used in somewhat the same manner. Frequent and thorough rinsing of brushes, as well as careful storage (especially important so that brush fibers maintain their proper shape) ensures continued quality and dependability of the materials. To facilitate impromptu sketching with brush and ink without the awkwardness of carrying a bottle of ink at all times, manufacturers have produced a brush designed like a fountain pen with an ink cartridge and cap. Its tapered point offers much of the flexibility of a Japanese brush.

Papers also have much to do with the quality of line in brush-and-ink drawing (see pp. 158–159). Soft, absorbent papers like rice paper soak up ink the moment the brush touches them and so create lines that vary considerably in width and the character of the edge (Figs. 214, 215). Hard-surfaced papers, on the other hand, absorb a minimum of ink from the brush, and this contributes to continuity of line and clean-cut edges (Figs. 10, 136). A dry-brush effect inevitably occurs when a very rough, textured paper is used; conversely, it is almost impossible to achieve an interesting dry-brush quality on a very smooth paper.

212. Josef Albers (1888–1976; German–American). *Two Owls.* c. 1917. Brush and ink, 19⅞ × 28½″ (51 × 72 cm). Collection Anni Albers and the Josef Albers Foundation, Inc.

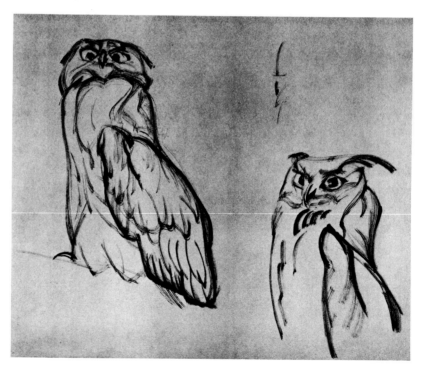

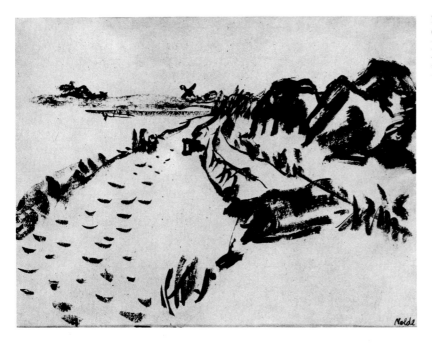

213. Emil Nolde (1867–1956; German). *Landscape with Windmill.* Brush and black printer's ink on tan paper, 17½ × 23¼″ (44 × 59 cm). Private collection.

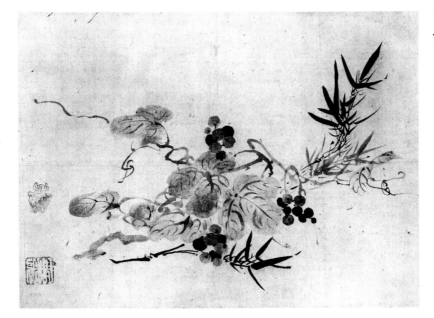

214. Sesson (1504–1589?; Japanese). *Grapes and Bamboo.* Ink on paper, 12½ × 17½″ (32 × 44 cm). Collection Kurt Gitter, New Orleans.

Other media—watercolor, tempera, poster paints, and oils—are appropriate for brush drawings. Many experienced painters prefer to draw with the tools and materials they use for painting to facilitate developing drawings into paintings. In such cases, it becomes impossible to tell when drawing ceases and painting begins.

Project 11.7 Explore the use of brush and ink, using whatever brushes you have available, including small inexpensive household paint brushes. Work on papers of different textures.

215. Awashima Chingaku (1822–1888; Japanese). *Cat.* Kakemono, ink and color on paper; 15⅜ × 40½″ (39 × 103 cm). Private collection of Harold Philip Stern, Ann Arbor, Mich.

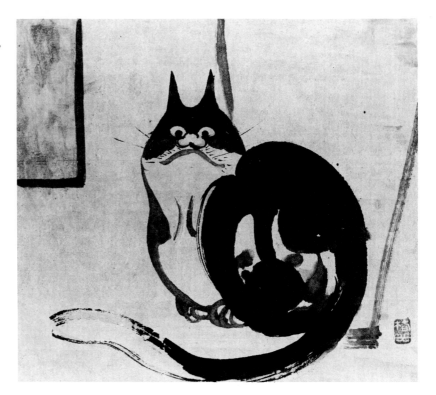

Oriental Calligraphy

Among the most sophisticated and beautiful brush-and-ink drawings are those of the Oriental masters (Figs. 214, 215). There has always been a particularly close connection between the art of writing and drawing in China and Japan, since the techniques involved in manipulating the brush are the same; and in both, the ornamental character of the line produced by skillful brush handling has been highly prized. Long years of copying the works of acknowledged masters and mastering an exact vocabulary of strokes constituted an arduous apprenticeship for the Oriental artist. In the drawings of such masters as Sesson (Fig. 214) and Awashima Chingaku (Fig. 215), one is aware of pure virtuosity of technique and decorative charm.

Oriental brush masters employ **sumi,** a stick of carbon ink that is ground and mixed with water on a shallow stone or ceramic block. This procedure permits great control over the density of tones. The brush itself is held in a vertical position above a flat ground, neither hand nor wrist being allowed to touch the paper or table support. By raising and lowering the hand and loading the brush in different ways—using the side or the tip alone, or combining heavy black ink in the tip with very thin, watery ink in the body of the brush—the artist can regulate an extensive repertoire of strokes. Since the traditional rice paper and silk fabric grounds are very absorbent, lines cannot be altered or deleted, and a skilled craftsman never repeats a line.

Project 11.8 A Japanese brush, newsprint or rice paper, regular India ink or black watercolor, and a saucer and water will allow you to explore the technique. For an initial exercise, study Figure 214 to gain a sense of

the hand and brush movements and the changes in pressure required for each stroke. Practice one stroke at a time rather than attempting to copy the complete painting.

Wash Drawing

A wash drawing offers an instructive transition between drawing and painting, and, in fact, often serves as a preliminary value study for a painting. Unlike brush-and-ink drawing, which depends for its effectiveness on more or less solid black contrasting with white, in wash drawing the medium is freely diluted with water to produce a wide range of grays. Both the brush and the diluted medium are extremely flexible vehicles that encourage an unusually fluid play of lines, values, and textures (Figs. 216–218).

Wash commonly refers to ink or watercolor that has been thinned with water to various value gradations. It can also encompass watercolor, and tempera, **gouache** (opaque watercolor), or acrylics, although these media tend to be less fine grained than ink or watercolor. Stretching the term still further, "wash" can include oil paints thinned with turpentine. Whatever the pigment or color, it is the principle of dilution that characterizes wash drawing.

The equipment needed for wash drawing is modest: brush, ink, black watercolor or tempera, and heavier absorbent paper. Because regular watercolor paper of a good quality and illustration board will

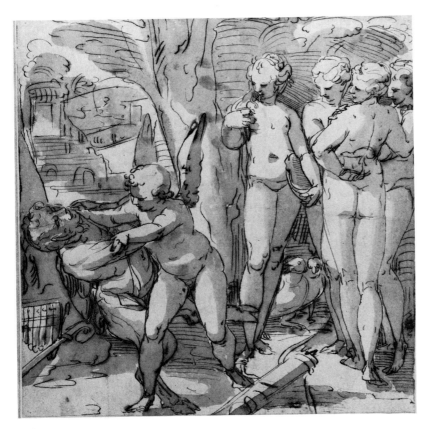

216. Luca Cambiaso (1527–1585; Italian). *Cupid Overcomes Pan While Venus and the Three Graces Watch.* Pen, ink, wash, black chalk sketch; 11⅛ × 11⅜″ (28 × 29 cm). Art Museum, Princeton University (bequest of Dan Fellows Platt).

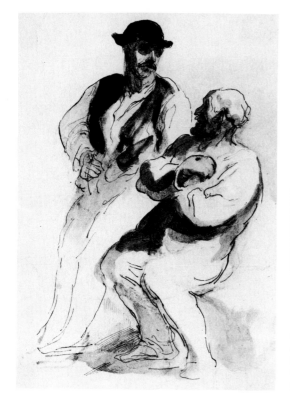

left: 217. Honoré Daumier (1808–1879; French).
Two Peasants in Conversation. Pen and wash.
Victoria & Albert Museum, London (Crown Copyright).

above: 218. Käthe Kollwitz (1867–1945; German).
Mother and Child by Lamplight at the Table
(self-portrait with son, Hans?). 1894. Pen and ink
with brush and wash, 8 × 10⅝″ (21 × 27 cm).
Courtesy Deutsche Fotothek Dresden.

not wrinkle or buckle when wet, they present satisfactory grounds for wash. Illustration board can be thumbtacked to your drawing board; watercolor paper is best mounted. To mount or stretch watercolor paper, wet it thoroughly on both sides, lay it on the drawing board for about five minutes or until the water has been absorbed, smooth it out slightly, and fasten the edges with paper (not masking) tape. Allow the paper to dry completely so that the buckling disappears.

You will need a quantity of clean water and absorbent rags. A natural sponge will prove helpful for wetting the paper or for picking up areas of the wash that appear too saturated. A white saucer, plate, or watercolor palette can serve as a container in which to mix your pigment.

Flat Washes

While the medium encourages free, spontaneous handling, a rather more cautious and systematic procedure is recommended for those with no experience in wash or watercolor.

Project 11.9 For your first wash drawing, select a subject with clearly defined planes of dark and light. If you have any sketches or drawings of buildings, they would be appropriate, as would the by-now-familiar cardboard boxes and paper bags. Keep to a modest size, no more than 8 by 10 inches (20 by 25 centimeters). Make a preliminary outline drawing. Plan the distribution of values, leaving pure white paper for the lightest areas. Place a couple of tablespoons of water in your saucer or palette and add enough ink or paint to make a light gray. Load your brush with this tone and spread it over all the drawing except those areas to be left

white. Be patient and allow the first wash to dry thoroughly before applying a second wash to the next darkest areas. Laying one wash over a partially dry surface inevitably results in an ugly mottled effect. You can achieve deeper tones more rapidly by adding more pigment to your wash.

Modulated Areas: Wash with Other Media

Wash is particularly suitable for free, fluid effects. It can be applied directly to paper without preliminary drawing, or combined with pencil, pen and ink, charcoal, or chalk. When augmented by other media, it is the artist's option whether the wash precedes or follows the pencil, pen, or charcoal lines, as well as the amount and strength of linear support.

Luca Cambiaso (Fig. 216) has supplemented pen and ink with two essentially flat washes of medium-light and middle values to give volume to the figures and separate them from the background. Honoré Daumier (Fig. 217), working over what appear to be preliminary charcoal lines, produced an imposing sense of volume by integrating loosely drawn ink contour lines with boldly brushed modulated washes, while Käthe Kollwitz (Fig. 218) relied almost completely on a more painterly wash technique, introducing pen line only to detail the forms and features of the two heads.

Project 11.10 To develop a painterly approach to wash drawing, mix a puddle of middle-value gray in your palette. Proceed to paint, adding water to your middle-value gray when you want lighter tones and concentrated pigment to yield darker tones. Do not strive for flat washes or smooth effects; permit brush strokes and gradations of value to show. Work into the washes only while they are still fresh. While an area is still wet, it is possible to recover lights by squeezing or pressing all the water from a rinsed brush with your fingers or paint rag, and lifting out the desired light with the brush. Once the washes have begun to dry, allow them to become completely dry before you introduce additional washes. For clearly defined edges, apply wash to a dry surface; for softened contours, wet the paper with clear water before applying the wash.

After experimenting freely with this technique, select a subject that lends itself to a more fluid handling of form. Choosing a subject already drawn in an earlier project not only allows you to work with familiar forms, but also offers you the opportunity to see clearly the differences that occur in treating the same subject in dissimilar media.

Project 11.11 An interesting variation of traditional wash drawing is to draw with ink or concentrated paint on wet paper. The unpredictable runs, blobs, and granular deposits create textures and lines quite unlike the limpid fluidity of typical wash drawing.

Klee appears to have used a different approach, drawing with pen and ink on dry paper, and, while the lines were still wet, he touched them with a water-filled brush (Fig. 219). This allowed him to control the direction and extent of the ink spread. Experiment with the methods described here for altering the character of ink line drawings.

Project 11.12 Colored wash reinforced by colored inks, pencils, chalks, and other tinted media offers an excellent vehicle by which students can make the transition to painting. Do a number of drawings with colored media calling forth various wash-and-line techniques. It would be prudent to limit selection to two colors for your initial experi-

219. Paul Klee (1879–1940; Swiss–German). *Canal Docks*. 1910. Pen and ink over hard pencil, with wash; 3 × 9⅞″ (8 × 25 cm). Albertina, Vienna.

ences—brown as a warm color, French ultramarine blue as a cool color. Applying a wash of one color over the other, or allowing the colors to blend will create a range of colors. Colored inks are brilliant and seem to retain their brightness even when colors are mixed; however, to maintain the purity of the color in each bottle, avoid dipping an ink-filled brush from one bottle to another.

Mixed Media

Some artists are purists by temperament and take the limitations of a medium as a challenge. They delight in bending the medium to their respective aesthetic wills and making it do what seems impossible. Jean Auguste Dominique Ingres accomplished this with pencil (Fig. 192), and Charles Sheeler with conté crayon (Figs. 109, 187, 224). Other artists, interested only in effect, freely combine media to realize their goals. Many drawings of old and modern masters have developed through improvisation with media. Such drawings frequently were begun in an exploratory medium, perhaps charcoal or chalk. At a later stage, wash or ink may have been added to intensify the darks and, subsequently, white tempera or chalk introduced to strengthen the lights—perhaps even a small amount of colored chalks added to provide a final enrichment (Pl. 4, p. 88). Freedom and invention in the use and combinations of materials, in the hands of an imaginative person, take on fresh and original dimensions.

220. Henry Moore (1898–1986; English). *Four Family Groups*. 1944. Pencil, crayon, and watercolor; 9 × 6¾″ (23 × 17 cm). Courtesy the artist.

Project 11.13 Experiment with using familiar media in unfamiliar ways and in different combinations. Ink adds richness and depth when drawn or brushed into charcoal and chalk drawings to provide dark accents. It is also possible to produce wash effects with all of the dry media. Charcoal, conté crayon, and chalk are soluble either with water or turpentine; graphite, wax crayons, and oil pastels dissolve only in turpentine or some other solvent. Because wax crayons and oil pastels are water resistant, interesting qualities result when they are overlaid with ink wash or watercolor (Fig. 220).

Also investigate different and unusual drawing implements. Try making line drawings using a cluster of bamboo skewers rather than the customary pen or brush. Create texture, build values, and model forms using a small piece of heavily textured cloth, such as corduroy, rolled into a compact ball, then dampened with ink and pressed against the paper. Try out any other schemes that occur to you. Some will be worth developing, others you will recognize as entertaining gimmicks. While it is essential that you maintain a sense of playfulness and a willingness to explore media and techniques, it is equally important that you refine your ability to discriminate, and reject that which is gimmicky.

Traditional Areas of Subject Matter

Still Life

*Common objects become strangely uncommon
when removed from their context and
ordinary ways of being seen.*
—Wayne Thiebaud

A certain artist in ancient Greece prided himself on the ability to paint
fruits so convincingly that birds would peck at them. With comparable
enthusiasm, artists of 15th-century Flanders reveled in the skill with
which they could depict glass, ceramics, fabrics, wood, and fruits.
Throughout the Renaissance and Baroque periods artists repeatedly
drew upon still-life materials to create an atmosphere of everyday
reality in their works. The emergence of a bourgeois society in the
17th century, with its glorification of middle-class values, made the
portrayal of material wealth a major thematic concern. In Flanders,
artists depicted tables laden with fruit, vegetables, fish, poultry, and
meat in what to our more health-conscious age seems a gluttonous
display. The Dutch masters of the period added flowers to their reper-
toire, painting prodigious arrangements complete with sparkling
drops of dew and insects. Still-life subjects continued to be popular
with early-19th-century American painters, who patterned their
works after Dutch precedents. The late-19th-century American *trompe
l'œil* artists William Michael Harnett and John Peto originated a bril-
liant style of still-life painting employing very shallow space, clearly
defined cast shadows, and a meticulous rendering of surface textures.
Unfortunately, preparatory drawings by masters working in the still-
life tradition are extremely scarce (Fig. 221). Thus, despite the long
popularity of still-life and the fascinating solutions devised over the
years to problems of composition, we must restrict our discussion
largely to 20th-century examples.

221. Abraham Bloemaert (1564–1651; Dutch). *Studies of Garden Plants.* Pen and ink, 11⅜ × 14⅞″ (29 × 38 cm). Ecole Nationale Supérieure des Beaux-Arts, Paris.

Advantages of Still Life

Still-life drawing presents a number of advantages, which have determined the preponderance of still-life subjects suggested in the preceding projects. Working alone in a quiet studio, the artist is free from many of the problems that accompany portraiture, life drawing, and landscape drawing. There is no need to schedule sittings with models or portrait subjects. The artist can ignore the caprices of weather and work uninhibited by wind, rain, changes in light, and all the other unpredictables that go with working out of doors. And the studio demands for the still-life artist are minimal; any quiet room with good light, whether natural or artificial, will serve.

For the novice, still life has yet another advantage. The subject, as the name clearly indicates, does not move. Thus, the beginning student has ample time to observe and learn to portray the tremendous variety of surface qualities that characterize all objects, to learn to see, as it were, and to develop the skills involved in depicting the appearances of what is seen. The rendering of form, light and shadow, texture, color and such subtle phenomena as lustre and transparency can all be attempted at an unhurried pace. Problems of perspective and foreshortening, both elementary and complex, will arise, and these problems can be worked on at the student's leisure. If the arrangement is placed where it need not be moved for some time, and if the subject is not susceptible to withering or decay (an old boot, for instance, in contrast to fruit or flowers), the student can experiment in as many media as desired.

Finally, still life involves little expense. Every home is filled with potential still-life subjects. You need only glance at the illustrations in this section to see that anything from old clothing to edibles, from tableware to cooking utensils, even sections of rooms and furniture, can serve as subject matter. A simple carton of eggs, for example, can provide an excellent subject for the artist with imaginative vision and a sense of composition (Fig. 222); for it is the sympathetic observation

222. Mark Adams (b. 1925; American). *Box of Eggs*. 1968. Pencil, 13¼ × 16¼" (34 × 41 cm). Courtesy the artist.

of familiar objects, accompanied by the capacity to project these observations into arresting and revealing works of art, that characterizes the true still-life artist.

An interesting composition need not be complicated nor even "artistic"; learn to recognize and use what could be called "ready-made" compositions, those spontaneous and natural groupings of objects discovered just where they were placed as part of daily routine. Sometimes you will see only clutter; just as often you will find an appropriate arrangement. What you must have is a change in perception about what one draws, a change that permits you to accept an egg carton, a cluster of cooking ware, or pillows on a sofa (Fig. 223) as objects of visual interest.

223. Catherine Murphy (b. 1946; American). *Still Life with Pillows and Sunlight*. 1976. Pencil, 8⅝ × 12½" (22 × 32 cm). Courtesy Xavier Fourcade, Inc., New York.

Project 12.1 Select a few ordinary nonperishable household items. Once the objects have been arranged, if that is necessary, proceed to draw, using whichever media and techniques fit the subject and your mood. Concentrate on form and textures. Good light is essential—the ideal light comes from above and to one side. Daylight has no particular advantage over artificial light, as long as the artificial light is brilliant. High-intensity reading lamps work well because of their flexible design. Set up the arrangement where it can remain undisturbed for as long as it is needed. If that presents a problem, be prudent enough to select a technique that allows completing the drawing in a single session or work with objects that can be reassembled easily with some accuracy.

Still-Life Forms

Value Study

Much early training in the 19th-century academies of art in Europe and America was devoted to the techniques of rendering forms through traditional chiaroscuro, for which still-life compositions provided ideal subjects. White plaster casts were favored for clear illustration of value gradations. Elements of chiaroscuro—highlights, light, shadow, core of the shadow, and reflected light (see pp. 77–79)—could easily be observed and analyzed on the smooth, colorless plaster surface.

Mark Adams (Fig. 222), Catherine Murphy (Fig. 223), and Charles Sheeler (Fig. 224) display an enviable virtuosity of technique and vision. All reveal form solely by value change with dramatic value contrasts in some areas to define forms in space.

224. Charles Sheeler (1883–1965; American). *Of Domestic Utility.* 1933. Black conté, 21¾ × 15⅞″ (56 × 41 cm). Museum of Modern Art, New York (gift of Abby Aldrich Rockefeller).

Project 12.2 Compose a still-life arrangement containing rather simple forms, closely related in value and preferably light so that the use of chiaroscuro will not be complicated by differences in color. Lemons and yellow or green apples, for example, would be better suited for this project than red apples of darker value. Illuminate the objects with a strong light from above and to one side. Place a simple background close enough behind the grouping so that shadows cast by the objects fall on the background, while the background surface reflects light back into the shadowed portions of the objects. Develop the drawing with one of the dry media. Sketch the objects in light outline to establish size and shape relationships; then proceed to model the forms in dark and light. Study the shapes of cast shadows carefully and render them as thoughtfully as you do the actual objects, paying particular notice to their degree of darkness as compared with the darkest shadow on the objects themselves. To the mature artist, all aspects of the visual experience are significant; the shadows cast by objects provide elements of pattern equal in importance to the objects.

Schematic Form

One of the basic problems in drawing is learning to create a convincing sense of solid, three-dimensional form when a solid object is translated into a series of lines, shapes, and shadings on a flat, two-dimensional sheet of paper. It is not uncommon for initial drawing assignments to be based upon simplified forms that require learning to perceive size, shape, and space relationships by using the measuring techniques described on pages 36–41, as well as introducing the use of chiaroscuro. Mastering such simple geometric shapes virtually assures equal success with even the most complex subjects, provided the same basic approach is followed—looking, measuring, duplicating shapes rather than drawing objects. Learning to see complex shapes schematically—reducing objects to their nearest geometric equivalents—is one of the most successful methods of understanding and representing three-dimensional form.

Project 12.3 Notice in Figures 222, 224, and Plate 6 (p. 90) how conscious we are of the basic structure of all the objects depicted. Set up a still life containing objects with clearly structured forms, but not necessarily only those objects that are simple geometric shapes. Your assignment is to reveal the structural relationships of objects by simplifying them into basic geometric shapes or interrelated combinations of shapes, and to intensify the sense of volume with bold chiaroscuro.

Composition and Treatment

Selecting appropriate subject matter creates one of the most persistent blocks for most beginning students, who are reluctant to relinquish the concept that what they choose to draw must be "artistic." It can truly be said that subject matter is unimportant. Throughout the history of art, significant subjects have been rendered meaningless, while seemingly meaningless subjects have been elevated to great significance. While expression remains a critical determining ingredient of significance, subject matter achieves aesthetic coherence and interest through the artist's sense of composition or viewpoint and the chosen method of treatment. The elements of still life—fruits and vegetables,

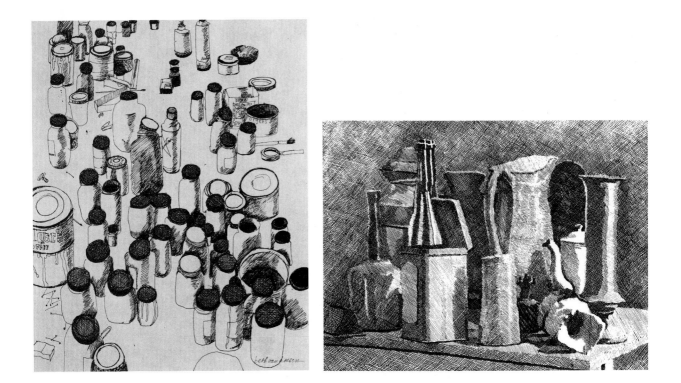

left: 225. Beth Van Hoesen (b. 1926; American). *Paint Jars.* 1969. Pen and ink, 9⅞ × 8″ (25 × 20 cm). Courtesy the artist.

right: 226. Giorgio Morandi (1890–1964; Italian). *Large Still Life with Coffeepot.* 1933. Etching on copper, 11½ × 15¼″ (30 × 39 cm). Private collection, Milan. Reprinted from *L'Opere Graphic di Giorgio Morandi* by Lamberto Vitale. Published by Giulio Einandi Editore, Turin.

pots, plates, bowls, flowers, and so on—all relatively unimportant subjects, can become vitalized by imaginative vision.

Beth Van Hoesen's original viewpoint is evidenced by both her ability to see the potentialities of unpretentious, familiar objects and her capacity to project them into arresting forms and patterns. *Paint Jars* (Fig. 225) transmutes studio litter into a rhythmic flow of jars and jar tops, interrupted by an occasional contrasting shape. Using an open composition in which forms are cropped by all four edges of the drawing allows the viewer to envision paint jars extending across a limitless tabletop.

Project 12.4 It is difficult to arrange objects as casually as we lay them down when we use them (Fig. 142). If your drawing materials are sitting out, draw them just as you see them, or grab a handful of household tools and lay them down without consciously making an arrangement. Rather than rendering the articles carefully, strive for the incisive vigor that distinguishes Figure 225.

A study of the works of Giorgio Morandi reveals the harmony and sensitivity with which he was able to rearrange the same objects over and over again (Fig. 226). The viewer soon develops a familiarity with Morandi's bottles, pitchers, tin boxes, and canisters, which appear so deceptively unarranged each time they are regrouped. The simplification of shapes and the integrity with which they are rendered lend a monumental dignity to very ordinary objects.

Project 12.5 Arrange several objects in close proximity so that they take on a group identity without losing their sense of individuality. As you draw, subordinate surface details and patterns to concentrate on

volume and space. Regroup the same objects into yet another configuration and make a second drawing. Do additional drawings with different media and techniques. Explore the use of closely related values—high key and low key—to create contrasting moods (pp. 86, 91–92).

Fresh fruit and vegetables might seem trite, but still-life artists, past and present, have transformed them into drawings of fresh and original effect. Jerome Blum produced an image of full, ripe succulence (Fig. 227) in a drawing that offers only one pear delineated with any clarity of form. The minimally descriptive, lost-and-found contours and soft shading evoke a poetic response to Norman McLaren's *Pears* (Fig. 228), which seem not to exist in this physical reality, in contrast to the monumentality of Martha Alf's solidly defined pears (Pl. 6, p. 90).

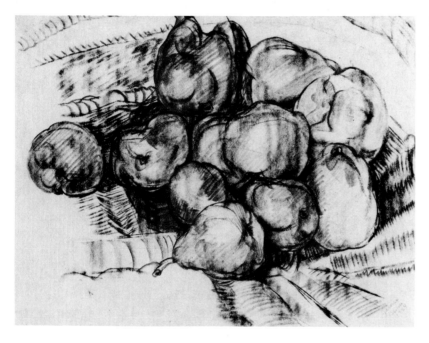

227. Jerome Blum (1884–1956; American). *Fruit.* 1924. Charcoal and pastel on rice paper, 12½ × 16½″ (32 × 42 cm). University of Michigan Museum of Art, Ann Arbor (gift of Mrs. Florence L. Stol).

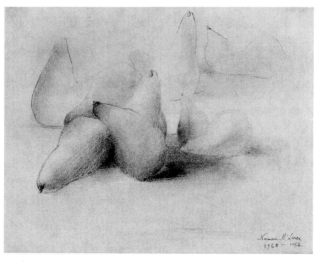

228. Norman McLaren (b. 1914; Scottish–Canadian). *Pears.* 1960–62. Pencil, 9 × 11¾″ (23 × 30 cm). Courtesy the artist.

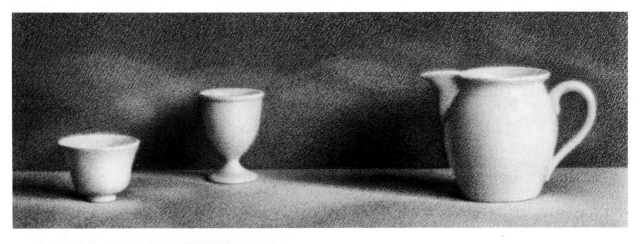

above: 229. Martha Alf (b. 1930; American).
Still Life #6, 1967. Charcoal pencil on bond paper,
8½ × 24½″ (22 × 62 cm). Courtesy the artist.

left: 230. Ben Nicholson (1894–1982; English).
December 1962 (interlocking). Oil wash and pencil
on paper, 20⅛ × 18⅛″ (51 × 46 cm).
Tate Gallery, London.

below: 231. Juan Gris (1887–1927; Spanish).
Bottle, Glass and Compote. c. 1917. Pencil,
24⅜ × 18⅞″ (62 × 48 cm). Kunstmuseum, Basel
(gift of the Burckhardt-Koechlin Fund).

Project 12.6 Place a group of fruits and vegetables on a table without consciously arranging them into a composition. Draw the group with pure, unmodulated contour lines. Observe any deviations from perfect regularity and describe these with linear exactitude, for they characterize the individuality of each object and differentiate it from its neighbors. Do a second drawing in which you use selected linear accents to reinforce forms defined first with a suggestion of modeling. Do a third drawing using any combination of media, technique, and attitude.

Bowls, cups, pitchers, and bottles are frequent victims of cliché, but need not be. The deceivingly simple elegance of Martha Alf's *Still Life #6* (Fig. 229) with its concern for the "visual organization" of shapes and spaces, Ben Nicholson's selection of the most significant profile reduced to pure contour (Fig. 230), and Juan Gris's fragmenting three-dimensional forms, then reassembling them to depict another concept of form and space (Fig. 231) illustrate some alternatives, none of which is a cliché.

Project 12.7 Do a number of thumbnail compositional sketches in which you see how many different ways you can group three to five cups, bowls, and related containers. Pay particular attention to the intervals between forms if they are separated, and to the overlapping and degree of touching if they are clustered. Do not limit yourself to the same vantage point. Select the most interesting compositions and develop them more fully using a variety of media and techniques. By now you have developed a sufficient repertoire of drawing techniques so that you can range beyond straightforward descriptive drawing.

A pair of scissors, a knife, a spoon, and a fork—ordinary in design, of no particular artistic qualities, and without any real significance—provide the subject matter for a wash drawing by Richard Diebenkorn (Fig. 232). Though the objects are seemingly casual in

232. Richard Diebenkorn (b. 1922; American). *Untitled*. Wash, 9½ × 12″ (24 × 31 cm). Collection Theophilus Brown.

arrangement, careful analysis reveals the skill with which Diebenkorn has produced a sense of drama through the precise positioning of each of the four forms.

Like Diebenkorn, František Lesak is "interested in observing an isolated object and its relationship to other objects." In a drawing of almost undecipherable complexity (Fig. 233), spoons, forks, plates, cups, bottles, and bottle openers, numerous beyond counting, have each been defined in the most precise perspective. Lesak explains that drawing is an accumulation of separate studies of the same objects shifted to many different locations on a tabletop.

Project 12.8 Choose a few kitchen utensils or household tools. Do one drawing of the most interesting grouping of the objects selected, with a major emphasis on positive shapes and negative space. Make a second drawing composed of multiple images of the objects seen in perspective, as in Figure 233, letting the placement be random and varied to avoid the suggestion of patterned design.

233. František Lesak (b. 1943; Czech). *Untitled.* 1974. Pencil on paper, 4′9″ × 5′8½″ (1.45 × 1.74 m). Stedelijk Museum, Amsterdam.

Transparency and Reflective Surfaces

Attention to the surface qualities of objects—rough or smooth texture, shininess, transparency—remains one of the prime concerns of many still-life artists. Glassware arranged on and reflected in sheets of plate glass fascinates Janet Fish as the subject for both drawings and paintings (Fig. 234). The images are depicted with exaggerated patterns executed with a crisp clarity. The artist complicated her task by working with objects filled with liquid to distort the shapes of forms that stand behind. Distortion and cropping transform strict representation into near abstraction in David Kessler's virtuoso rendering of the reflections seen in the highly polished surface of a new car (Fig. 235). A more gentle handling of reflective surfaces is evident in Walter Murch's study for *The Birthday* (Fig. 236). Diffused light, softened shadows, controlled use of light and dark accents, and broad areas of generalized texture combine to heighten the effect of this mixed-media drawing.

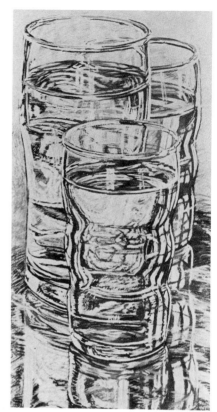

right: 234. Janet Fish (b. 1938; American). *Three Restaurant Glasses.* 1974. Pastel, 30¼ × 16″ (77 × 41 cm). Minnesota Museum of Art, Saint Paul.

below left: 235. David Kessler (b. 1950; American). *Cadillac Showroom Series: Cadillac #2 Reflection off Cadillac Fin.* 1975. Colored pencil, 36¾ × 24¾″ (93 × 63 cm). Minnesota Museum of Art, St. Paul.

below right: 236. Walter Murch (1907–1967; Canadian). Study for *The Birthday.* 1963. Crayon, pencil, and wash on paper; 23 × 17½″ (58 × 44 cm). Whitney Museum of American Art, New York (Neysa McMean Purchase Award).

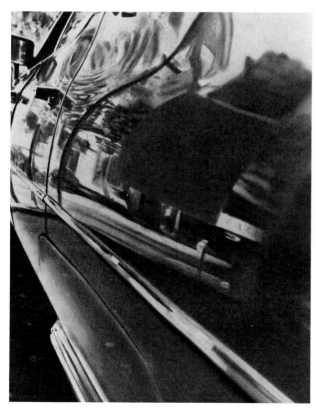

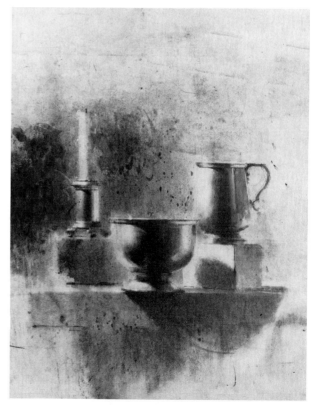

Project 12.9 Shine, transparency, and translucence are perhaps the most subtle and intriguing of surface qualities. Although they are generally thought to be difficult to draw, careful analysis of shapes, patterns, and values, divorced from any concept of what they are supposed to represent, is the key to rendering such effects (Pl. 11, p. 173). Concentrate your first efforts on a single relatively simple object—one spoon or a tin can, for example—and then proceed to more complicated subjects. Glass objects that are both reflective and transparent present one problem; highly polished metallic objects, such as a toaster, that reflect whatever is nearby (possibly including the artist), offer an even greater challenge. Analyze the quality of the surface and the nature of the reflections to determine what combination of media and technique would be most effective.

Expanded Subject Matter

While our conception of appropriate subject matter for still life is apt to be limited to small objects commonly found around the house, it can logically be extended to include large pieces of furniture and rooms and other inanimate or "still" things. Ben Shahn's *Silent Music* (Fig. 237), which shows a group of music stands and chairs left in disarray after the musicians have departed would certainly qualify as a still-life subject.

David Hockney's drawing of the veranda of the Cataract Hotel at Aswan (Pl. 12, p. 174), and Don Williams's *Studio at Night* (Fig. 238) both have as a primary concern the description of specific objects and

237. Ben Shahn (1898–1969; Russian–American). *Silent Music.* 1955. Screenprint, 17¼ × 35″ (44 × 89 cm). Philadelphia Museum of Art (purchase, the Harrison Fund).

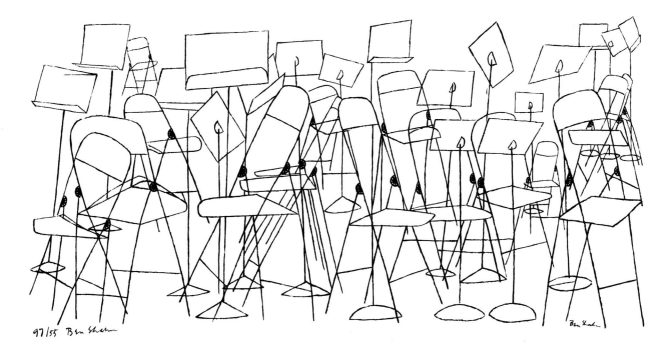

above: 238. Don Williams (b. 1941; American).
Studio at Night. 1983. Pastel on paper, 19 × 24″ (48 × 61 cm).
Private collection.

right: 239. Jacques Villon (1875–1963; French). *Interior.*
1950. Pen and ink, 9⅛ × 6¾″ (23 × 17 cm). Museum of
Modern Art, New York (gift of John S. Newberry
Collection).

locales. Jacques Villon departed from the initial real image to create a
richly textured, semiabstract *Interior*, which is elegant, fresh, and light
in mood (Fig. 239). Executed in open cross-hatching, the volumes and
forms play against one another with a beautiful and luminous now-I-
can-identify-it-now-I-can't ambiguity.

Project 12.10 Without changing the position of pieces of furniture
in your room, study areas through a rectangular viewfinder. Pick two or
three compositions that you find appealing and sketch them in the
medium of your choice. Edouard Vuillard's *Interior of the Artist's Studio*
(Fig. 340) and Edwin Dickinson's *Studio, 46 Pearl Street, Provincetown*
(Fig. 108) suggest some possibilities. Deserted drawing studios with ea-
sels and drawing horses in disarray before plaster casts and still-life set-
ups provide a frequently overlooked source of visual material.

Sketchbook Activities

If you accept still life in the broadest sense to include all the inanimate
objects in your environment, you will never lack for something to draw, no
matter where you are when you take out your sketchbook. Maintain a fresh
outlook; reject nothing. Drawing any object, no matter how insignificant,
increases your perception of form and space.

Landscape

Once Leonardo established that the structure of landscape was interesting, other artists too were fascinated by the subject, and landscape drawing was thereafter done for its own sake.

—Winslow Ames

When one surveys the drawing and painting of the Orient, Western Europe, and America one realizes that landscape provides a major stimulus for artistic expression. Its potentialities are infinite; variations of weather, seasonal changes, the thrilling expanse of great stretches of distance—all contribute to the diversity. The patterns and textures revealed by close-up details are frequently breathtaking in their beauty and fascinating complexity.

A view of *The Tiber above Rome* (Fig. 240) by the 17th-century landscapist Claude Lorrain, reveals an intense love of nature and its moods. It is one of the great wash drawings of all time, exhibiting a breathtaking virtuosity in both the handling of wash and the ability to catch a momentary late-day atmospheric effect with certainty and power. The open sweep of the Roman *campagna*, receding to the distant hills, is recorded in freely brushed wash strokes. In the middle distance a few towers, umbrella pines, and cypresses particularize the scene. In the foreground the gleaming surface of the Tiber reflects the luminosity of the twilight sky overhead, contrasting with the velvety darks of the heavy tree masses, deep in the shadow of late afternoon.

Needs of the Landscapist

It is most important for the landscape artist to be as comfortable as possible, for drawing *en plein air* (out of doors) can involve many discomforts. Heat, cold, glare, wind, human and animal intruders, in-

sects, changing lights and shadows are only a few of the problems. The famed 19th-century portrait painter John Singer Sargent, who painted landscapes as a welcome change from the demands of his portrait commissions, was able to hire a servant to accompany him and carry a great umbrella, a solid stool and easel, and other pieces of equipment that enabled him to work in comfort.

Few of us today can afford the luxury of servants, so we have to care for our own needs. Dark glasses, gray rather than colored, will help cut the glare of bright sunshine on white paper. Some artists are perfectly comfortable seated on the ground holding drawing boards on their laps. For others, a firm stool and lightweight easel are important. A small tool kit provides a convenient carryall for pencils, charcoal, erasers, a small sketch pad, and the like. A portable, lightweight drawing board is essential. The finest are of basswood, which is smooth, and soft enough to receive thumbtacks without difficulty.

The most logical media for the landscapist are those that permit one to work rapidly and easily to produce drawings that can be transported back to the studio without the problem of smearing. Pencils, various pens and brushes equipped with their own ink supply, and oil pastels allow the beginner to draw out of doors with a minumum of difficulty.

Landscape Imagery
Individual Elements

While we tend rather automatically to associate the term "landscape" with a panoramic view, artists often chose to focus upon a single facet of the landscape, both as an approach to understanding landscape texture and composition as a whole, and as a rich source of particularly expressive forms.

Cesare da Sesto's handsome study of a tree (Fig. 241) reveals a sensitivity to detail, but while the drawing is most certainly accurate, it

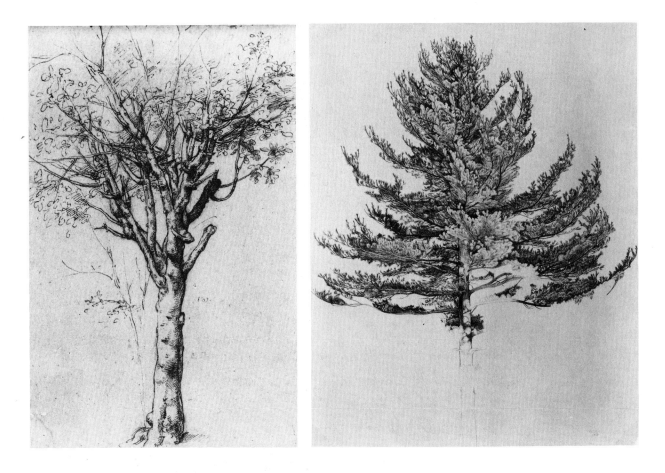

above: 241. **Cesare da Sesto** (1477–1523; Italian). *Study of a Tree.* Pen and ink over black chalk on blue paper, 15¼ × 10⅜" (39 × 27 cm). Royal Library, Windsor Castle, England (reproduced by gracious permission of Her Majesty Queen Elizabeth II).

above right: 242. **Charles Herbert Moore** (1840–1930; American). *Pine Tree.* Pencil with pen and black ink, 24⅞ × 19¾" (64 × 51 cm). Art Museum, Princeton University, N.J. (gift of Elizabeth Huntington Moore).

is not a slavish copying of nature. The artist has sought instead to define the tree's essence by focusing a selective eye on the characterizing joints, bumps, and movements of branches, and shadow accents.

Mid-19th-century American landscape painters working in the Hudson River School tradition were expected to be able to draw trees so that both their species and individuality were identifiable. Charles H. Moore's *Pine Tree* (Fig. 242) more than satisfies the requirements. It is a large (slightly larger than a standard sheet of drawing paper) rendering of meticulous detail and superb draftsmanship, providing greater clarity than one would expect from a photograph. Nothing has been suggested, nothing has been generalized; media have been totally subordinated to the image. Few artists possess the patience and stamina necessary to undertake such a rendering.

While not as precisely rendered, Richard Wilson's *Study of Foliage* (Fig. 243) pays close attention to the characterizing edges of individual leaves. By combining linear detail and accents with a suggestion of texture within the tonal areas, the leaves are made to stand out in relief.

A section of a hand scroll (Fig. 244) by Li K'an, a 14th-century Chinese artist, shows a deft, masterful handling of the conventionalized Oriental vocabulary of brush-and-ink strokes in describing the appearance and nature of bamboo. The subtle gradations of value, which prevent the leaves from appearing totally flat and decorative, achieve at the same time a gentle effect of atmospheric space.

243. Richard Wilson (1713–1782; English). *Study of Foliage*. Black chalk heightened with white, 11⅜ × 17⅛″ (29 × 43 cm). National Gallery of Scotland, Edinburgh.

244. Li K'an (1245–1320; Chinese). *Ink Bamboo*, detail. 1308. Hand scroll, ink on paper; entire work 1′2⅝″ × 7′8⅝″ (.38 × 2.38 m). Nelson Gallery–Atkins Museum, Kansas City, Mo.

Project 13.1 Select a close-up detail from the landscape around you—a cluster of rocks, a section of foliage, the complex branching patterns that become visible when you look up into a tree from below or into the interior of a bush, the structure of a patch of wild weeds. Decide which media and techniques would permit the most effective and sympathetic interpretation of the subject. Concentrate on the characterizing attributes of your subject and attempt to convey its uniqueness.

Sketchbook Activities

Direct observation of the endlessly intriguing details of nature should be added to your repertoire of sketchbook activities. Those of you who find particular satisfaction in studying the intimate details of nature might prefer to keep a separate sketchbook in which you develop more finished drawings, as suggested in the last project. As you gain confidence in your skills, a rewarding project is to create a permanent book of drawings, the book being, in effect, the complete work of art. Many handsomely bound drawing books, sometimes made with fine handmade papers, are available. Folded Japanese books, designed as two separate cover pieces attached to a continuous length of accordion-folded paper, provide an interesting format.

The Total Picture

How the artist perceives and treats individual elements of the landscape obviously has much to do with the overall sense of a landscape drawing. Camille Corot's study of the *Forest of Compiègne, with Seated Woman* (Fig. 245), executed in crayon and pen on white paper, reveals a most attentive consideration of the facts of nature. The slightly un-

245. Jean Baptiste Camille Corot (1796–1875; French). *The Forest of Compiègne, with Seated Woman.* c. 1840. Crayon and pen on white paper, 15⅝ × 10½″ (40 × 27 cm). Musée des Beaux-Arts, Lille.

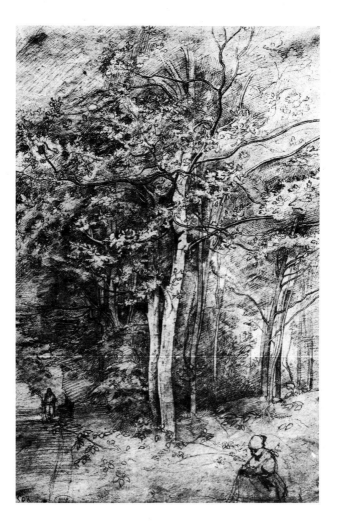

dulating movements of the slender trunks of trees formed by their search for sunlight as each tree moved upward over many years, the dark pattern of extended branches seen against the overhead light, the deep quiet of the shadowy underbrush, the dim mottled light and feathery spurts of foliage—all are presented with a certain gravity of vision.

The beauty of Corot's drawing lies not in details nor technique, but in the sensitivity with which he has selected from the myriad details before him those which are most telling. He then filtered that information through his unique artistic temperament to arrive at the precise balance of detail and suggestion, which through his discreet and skillful manipulation of media and technique, so completely reveals the atmosphere and mood of the scene. Nowhere does detail or technique take over at the cost of the subject, or detract from the total effect.

Texture and Pattern

The textures of landscape and the patterns they compose in conjunction with the play of light have fascinated artists for centuries. As explained in Chapter 6, the overall textural interest of a drawing derives from both the depiction of actual surface qualities in the subject and the medium employed—that is, the medium's own texture and the way in which it is applied. In other than fully rendered drawings of individual landscape elements (Figs. 193, 242), artists most commonly rely upon suggestion rather than a detailed depiction of the textures of nature. The textures of a drawing as seemingly detailed as Corot's *Forest of Compiègne* (Fig. 245) are built up of masses of hatching and cross-hatching in combination with scribbled squiggles that give definition and character to the nearer foliage. Treated as light patterns, the lacy foliage stands out in relief against the rich dense darkness of the trees beyond. The total effect is based on suggestion.

In a rare landscape study (Fig. 246), Titian employs a broadly generalized system of slightly curved parallel lines to provide texture

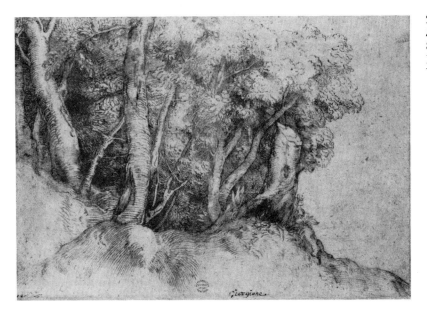

246. Titian (c. 1490–1576; Italian). *Study of Trees.* Pen and bistre, 8½ × 12½″ (22 × 32 cm). Metropolitan Museum of Art, New York (Rogers Fund, 1908).

left: 247. Frederic Church (1826–1900; American). *Goat Island, Aug '58.* 1858. Pencil and white gouache on brown paper, 17⅝ × 12″ (45 × 30 cm). Cooper-Hewitt Museum, The Smithsonian Institution's National Museum of Design, New York.

above: 248. Winslow Homer (1836–1910; American). Study for the watercolor *Waverly Oaks.* 1875–78. Pencil, white gouache on brown paper; 5⅞ × 8⅛″ (15 × 20 cm). Cooper-Hewitt Museum, The Smithsonian Institution's National Museum of Design, New York.

and form to tree trunks and ground, elaborating the pen-and-ink strokes a little more to suggest the soft, sensuous fullness of the foliage. Drawn in the manner of Giorgione, to whom the drawing was earlier attributed, nature has been transformed into visually soothing poetry.

The rich varied texture of *Goat Island, August '58* (Fig. 247) is also a matter of suggestion rather than delineation. The foreground undergrowth has been treated as penciled shorthand notation accented with scattered highlights in white gouache, with somewhat more attention given to defining the shapes of the foliage masses silhouetted against the sky. The alternating patterns of light against dark and dark against light throughout the drawing intensify the sense of mass, space, light, and atmosphere for which Frederic E. Church was famed.

Winslow Homer (Fig. 248) has chosen the same media as Church—pencil and white gouache on brown paper—to suggest the texture of foliage masses by attending to the animated broken patterns of sky seen through the tree. Linear detailing and tonal enhancement with both pencil and gouache combine to create a sense of volume and space to counteract the silhouette effect.

Except for some slight tonal variations within the main dark masses, most evident at the bottom right of the drawing, John Loftus has relied almost completely on silhouette in creating his powerful and evocative *Dark Landscape #1* (Fig. 249). He has used compressed charcoal to cover nearly the full sheet with a dense velvety black. Running across the top and middle of the page an irregular pattern of white shapes broken by boldly drawn angular lines gives definition to the trees separating the viewer from the open space beyond. The scale

of the trunk and branch pattern, plus the indication of tree tops along the upper edge of the drawing give evidence that the thicket of trees is at some distance removed from the spot where the viewer stands in what can be imagined as an open, but dark field. Loftus beautifully demonstrates the degree of simplification that is possible without loss of information. It should be noted that, although not precisely defined, the configuration of branches reveals keen observation of characteristic branching patterns.

Millet's *The Curtain of Trees* (Fig. 250) bears a certain similarity to the previous drawing. In both examples, foreground and background space are separated by a row of trees, and in both there is a feeling of fading evening light. However, Millet's trees offer no real barrier, and his light is gentle and poetic. He has suggested texture and pattern with amazing economy; broad, broken horizontal strokes describe rough barren fields, thin verticals echo the tall slender trunks of poplars, while a few diagonal squiggles suggest the laciness of branches.

In Karl Schrag's ink drawing *Tall Grasses* (Fig. 251) patterns of lines of different weights partially describe, partially symbolize the textures of nature in a style somewhat reminiscent of Van Gogh (Fig. 125).

Project 13.2 Texture and pattern in landscape drawing, as evidenced in the foregoing illustrations, can be as rich and varied as the textures of landscape itself, depending upon the temperament of the artist and the effect desired. As an ongoing assignment, explore the complete range of media and techniques, alone and in combination, to realize the fullest degree of expressive possibilities in the depiction of landscape. The proj-

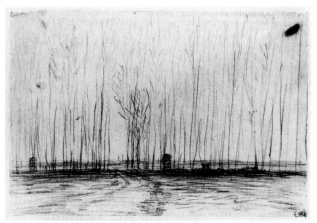

left: 249. John Loftus (b. 1921; American). *Dark Landscape #1.* Charcoal, 25 × 19″ (64 × 49 cm). Philadelphia Museum of Art.

above: 250. Jean François Millet (1814–1875; French). *The Curtain of Trees.* Black crayon, 7¼ × 11⅛″ (18 × 28 cm). Louvre, Paris.

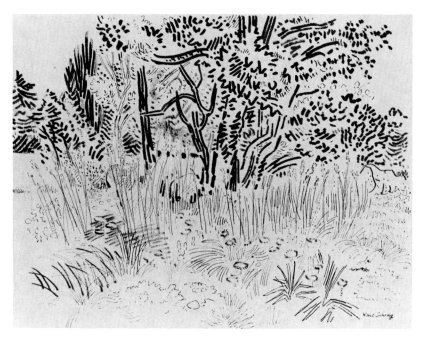

251. Karl Schrag (b. 1912; German–American). *Tall Grasses*. c. 1970. Ink, 11½ × 15½″ (14 × 39 cm). Minnesota Museum of Art, St. Paul.

ect might well take a lifetime. The purpose is to go beyond representation, beyond manipulation and technical dexterity, to drawing with expression and feeling.

Spatial Relationships in Nature

The conventional linear perspective devices of converging lines, diminishing scale, and overlapping forms are often sufficient to create the illusion of space in landscape drawing. Artists who wish to display a greater degree of spatial complexity in their landscape drawings and paintings introduce **aerial,** or **atmospheric, perspective** to reinforce the illusion of depth initially mapped out by linear perspective. Atmospheric perspective is based on two observations: (1) contrasts of value diminish as objects recede into the distance, with lights becoming less light, darks less dark, until all value contrasts merge into a uniform, medium-light tone; (2) color contrasts also diminish and gradually assume the bluish color of the air (more of a concern for the painter). If J. Francis Murphy's *Untitled Drawing* (Fig. 252) were presented as pure line drawing, the illusion of space would be a factor of linear perspective; the addition of tonal gradations suggests not only light and shadow but also atmospheric space.

Canaletto's *View of the Tiber* (Fig. 253) is bathed in Italian light. The strong black accents of the shadows in the front plane attest to the brilliance of the sun. Throughout the drawing, Canaletto has preserved the pure white of the paper for all fully lighted surfaces, while diminishing the darkness of receding shadowed areas by lessening the density of the hatching. The effect of light and space is amazingly convincing, even though the drawing is obviously ink lines on paper. It seems likely that Canaletto established the darkest darks first in order to determine how fully to develop the intermediate values.

In spite of bold light-dark contrast, Chen Chi creates a very different atmospheric effect in his brush-and-ink drawing *Winter* (Fig.

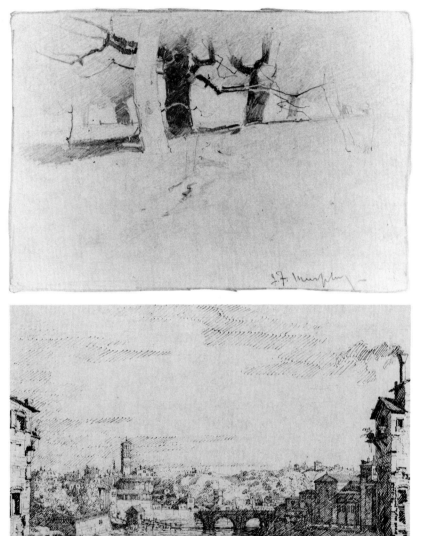

252. J. Francis Murphy (1853–1921; American). *Untitled Drawing*. Date unknown. Pencil, 5¾ × 8¼″ (14 × 21 cm). Private collection.

253. Canaletto (1697–1768; Italian). *View of the Tiber from the Ponte Quatro Capi*, detail. Pen drawing with crayon outlines, entire work 10⅝ × 14¾″ (27 × 38 cm). Royal Library, Windsor Castle, England (reproduced by gracious permission of Her Majesty Queen Elizabeth II).

254). The unmodulated white of the paper serves both as sky and snow-covered earth, separated only by an almost nonexistent horizon line. The absence of cast shadows adds to the bleakness of the scene. The concentration of stronger shapes and greater textural development in the foreground, and the slight softening and lightening of the thicket beyond, combine with converging lines to pull the viewer deep into space.

Project 13.3 Select a landscape scene encompassing numerous levels of distance, and do a line drawing with pen and ink or with pencils of varying hardness in which you attempt to delineate clearly a sense of deep space (Fig. 253). Remember that the boldest darks and whitest highlights occur in the foreground. As the scene moves into the dis-

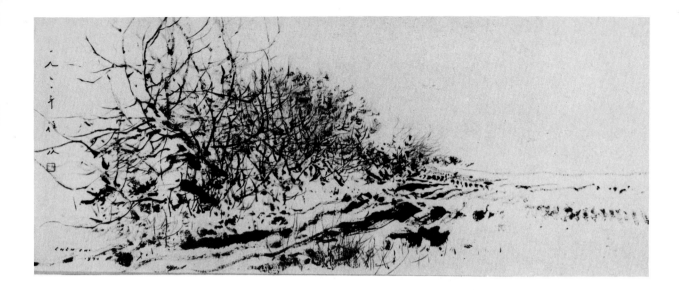

tance, the light and dark contrasts merge into a neutral gray. Next, try a brush-and-ink technique using full blacks contrasting with white paper in the front plane (Fig. 254). Charcoal, chalk, or pen and ink can serve just as well to create bold textures in the foreground to contrast with paler textures in the distance.

Project 13.4 When first beginning to draw landscapes, artists often overlook the importance of cloud configurations in determining the overall character of the scene. Clouds are also subject to the laws of linear and aerial perspective; the size and distance between forms diminish as the clouds recede, as does the contrast between light and dark. Do a series of skies with different cloud types—cumulus, cirrus, stratus, and so on. Rub charcoal or graphite into your paper to produce a graduated gray ground, darker at the top of the page, lighter as you near the intended horizon. Wipe out cloud patterns with a chamois or eraser. Clouds tend to appear more rounded overhead, becoming progressively flatter and more horizontal as they near the horizon.

Cityscape

Whereas 19th-century artists often chose to represent the picturesque charm of old or foreign cities, such as John Singer Sargent's *View of the Ponte Vecchio, Florence* (Fig. 255), 20th-century American artists have sought to depict and give dignity to the raw, intense vigor of the modern industrial city. The city itself, with its bridges, buildings, rooftops, fire escapes, streetlights, fire hydrants, and outdoor advertising, becomes the subject, instead of just providing a background for human activity (Figs. 167, 177).

The repetition of strong vertical shapes in contrast to the firm horizontal line across the foreground in Edward Hopper's *Study for Manhattan Bridge Loop* (Fig. 256) give solidity to both his subject and his composition. The volume of the buildings is emphasized through the broad simplification of light and shadow. Hopper partially relieved the severity of the geometry and the starkness of the scene by giving prominence to the curvilinear design of the street lamp in the

255. John Singer Sargent
(1856–1925; American).
View of the Ponte Vecchio, Florence.
1870–72. Pencil on cream wove paper,
3¾ × 5¾″ (9 × 15 cm).
Corcoran Gallery, Washington, D.C.
(gift of Miss Emily Sargent and
Mrs. Violet Sargent Ormond).

foreground and by utilizing the positive-negative aspects of the lamp, bridge structure, and broken roofline as they are silhouetted against the clear strong light of the sky.

Shifting patterns of smoke and smog that partly obscure distant skyscrapers combine with a greater variety of shapes and more specific detail in Henry Lee McFee's fine pencil study of city rooftops to create a sense of aliveness and vitality (Fig. 257). Using cross-hatching, McFee built value gradations of richness and subtlety that achieve the effect of light changing before the viewer's eyes.

Robert Cottingham explains that he "got turned on to art" at the age of twelve when he saw a painting of an urban scene by Edward Hopper (Fig. 256) at the Whitney Museum. Cottingham's *Ideal Cleaners* (Fig. 258) reveals his fascination with what he describes as "that

below left: 256. Edward Hopper
(1882–1967; American). Study for
Manhattan Bridge Loop, detail.
Lithographic crayon, entire work
8⅝ × 11⅛″ (21 × 28 cm). Addison
Gallery of American Art, Phillips
Academy, Andover, Mass.
(anonymous gift).
below: 257. Henry Lee McFee (1886–
1953; American). *The City.* c. 1935.
Pencil and crayon, 24⅛ × 18½″
(61 × 47 cm). Addison Gallery of
American Art, Phillips Academy,
Andover, Mass.

258. Robert Cottingham
(b. 1935; American).
Ideal Cleaners. 1979. Pencil on vellum,
15½″ (39.4 cm) square.
Courtesy the artist.

magic combination of neon, chrome, brick, and glass" of outdoor signs. A photorealist, Cottingham uses his camera as a sketchbook to provide the slides from which he works. Before beginning a painting, he makes a preliminary pencil drawing in black and white to establish a value scale.

Project 13.5 While you may not have a metropolitan view outside your window, do not neglect the urban setting in your search for subject matter. In older communities that have not been completely transformed by urban renewal, commercial buildings, particularly those portions facing away from the street, often provide considerable visual interest for the artist. Rooftops of older apartment buildings are always interesting, as are industrial areas. Notice patterns of light and shadow as sunlight streams across the facade of a building, and also the richness of shapes and patterns created by air vents, air conditioning units, and other hardware found on the roofs of modern buildings. The types of subjects suggested are not necessarily picture postcard material, which is just as well. You are encouraged, in all your drawings, to avoid subjects that could be considered clichés.

Seascape

Throughout time, water and the ocean have fascinated human beings and challenged the expressive powers of artists. All the complexities of water—its transparency and reflections (Fig. 30), its unceasing move-

ment, its colors and moods, the turbulent excitement of its surface in storms, and its capacity to yield patterns of calm repose or unsettling tension—have proved endlessly intriguing to many artists. It is interesting to note how closely Van Gogh's bold reed-pen patterning (Fig. 259) parallels that in Vija Celmins's photorealist study (Fig. 260). (How to calculate the perspective of reflections is discussed in Ch. 9, pp. 154–155.)

259. Vincent van Gogh (1853–1890; Dutch–French). *Boats at Saintes-Maries*. 1888. Reed pen and ink, 9½ × 12⅝″ (24 × 32 cm). Justin K. Thannhauser Collection, Solomon R. Guggenheim Museum, New York.

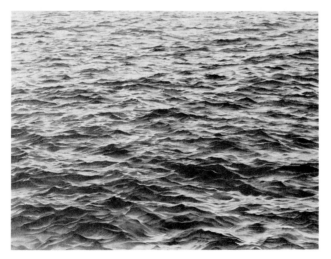

260. Vija Celmins (b. 1939; Latvian–American). *Untitled* (Big Sea #1). 1969. Graphite on paper, 34⅜ × 45½″ (87 × 116 cm). Collection Chermayeff and Geismar Associates, New York.

Abstraction

The landscape serves as a basic artistic resource even for those artists whose concerns lie in abstracting relationships of form and space. Alfred Manessier's *Montagnes près d'Aups* (Fig. 261) is one of a series of drawings made during a summer spent in the Alpine mountains in southeastern France by an artist who, until then, had known only the flat landscape of northern France. Speaking of his exuberance in discovering mountains, he said, ". . . it only found its outlet in drawing—in spontaneous, subtle, living lines, full of light and space, [and] rhythms . . ."

Out of what at first appears to be a sheet covered with random cross-hatching emerges Christopher Cook's *Mountain* (Fig. 262). He

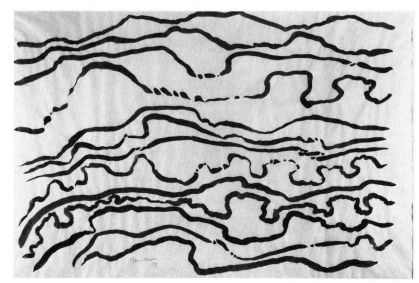

261. Alfred Manessier (b. 1911; French). *Montagnes près d'Aups*. 1959. Brush and Chinese ink, 25¼ × 38¾″ (64 × 99 cm). Musée National d'Art Moderne, Centre Georges Pompidou, Paris.

262. Christopher Cook (b. 1932; American). *Mountain*. 1962. Pen and ink, 22 × 30″ (56 × 76 cm).

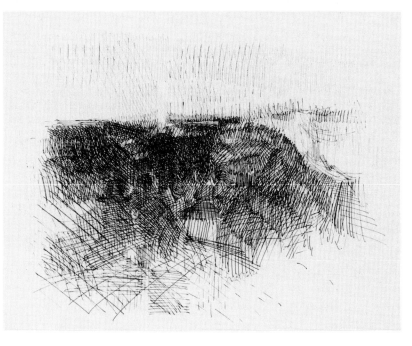

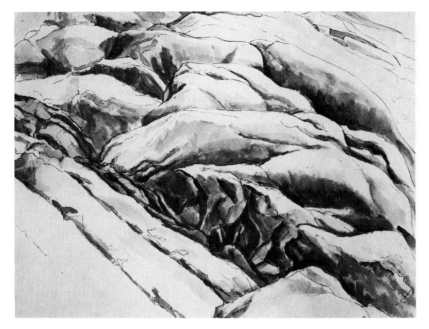

263. Philip Pearlstein (b. 1924; American). *Ridged Rock*. 1956. Ink wash on paper, 18¾ × 24¾″ (48 × 63 cm). Courtesy the artist.

provides no specific information; gradations of tone build a largely amorphous mass. In spite of the lack of details and definition, the drawing is amazingly descriptive, but that which the drawing represents is determined by each viewer's experience of natural phenomena.

Philip Pearlstein's *Ridged Rock* (Fig. 263) demonstrates that the term *abstraction* does not, in itself, preclude representational drawing. As he does with the human figure (Fig. 76), Pearlstein transforms a strongly literal study of rock formations into an abstract composition by cropping the subject to eliminate necessary clues that would allow the viewer to relate the shapes to a specific location. Probably everyone has experienced the inability to recognize a very familiar object seen out of context and without certain critical details that would permit immediate identification.

Project 13.6 Abstraction involves simplification, reorganization, or some alteration of a form without losing the essence of the subject. Do some drawings that evoke a feeling of growth in nature without relying upon naturalistic or obviously symbolic representation of landscape elements. Study the structure of bare trees or look up into a tree from below and make a series of drawings suggested by the branching patterns, attending to the negative spaces as well as the branches. Develop drawings that are rich in line, pattern, texture, and value without concern for specific details. Use whatever medium or media and technique or techniques seem appropriate.

Figure Drawing

*Before the first line is made there is a moment that,
at least for me, influences the entire course of the
drawing. It is the moment when I take my first long
look at the posed model, and automatically enter
into a curious partnership with him or her
that lasts for the duration of the pose.*

—Theophilus Brown

The human figure was depicted in prehistoric cave art as a crudely simplified symbol compared to the extraordinarily realistic images of bison, bulls, horses, and deer. As early civilizations evolved, the human figure came to be represented according to severely stylized conventions dictated by concepts of life and religion. Figures in Egyptian art, based on conceptual images rather than on direct observation, combined profile and frontal views into the same image (Fig. 264); differences in scale designated degree of importance rather than spatial relationships. Later, Greek and Roman artists developed remarkable skill in depicting the complex form of the human body mastering proportional relationship of parts and the principles of foreshortening (Fig. 265). With the emergence of Christian art in the 4th century, and for almost a thousand years following, naturalistic representation of the human figure was replaced by more symbolic forms stressing spiritual rather than physical qualities. By the beginning of the 15th century, the human figure reappeared to become the dominant theme in Renaissance art and establish a tradition that continues to absorb experienced and inexperienced artists.

Anatomical Drawings

In the years of the European Renaissance the need to understand natural phenomena and their interrelationships led to the merging of artistic and scientific inquiry in the development of linear perspective (Chapter 9) and the study of human anatomy. Not satisfied with mastering outward appearance, artists developed a curiosity about the underlying structure of the body and by the late 15th century were engaging in the clandestine dissection of cadavers. Raphael's study is

above: 264. Duck hunting and fishing scene, detail of wall painting from the tomb of Nakht, Sheikh abu el Qurna. c. 1425 B.C. Copy in tempera. Metropolitan Museum of Art, New York.

above right: 265. Karneia painter. Detail of red-figure lerater. Ceglie del Campo, c. 410 B.C. Terra Cotta. Museo Nazionale, Taranto.

right: 266. Attributed to Raphael (Raffaello Sangio, 1483–1520; Italian). *The Virgin Supported by the Holy Women,* anatomical study for the *Borghese Entombment.* c. 1500–07. Pen and brown ink over black chalk, 12 × 17⅞″ (31 × 20 cm). British Museum, London (reproduced by courtesy of the Trustees).

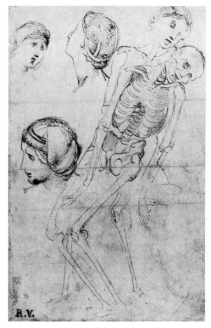

evidenced in a preliminary sketch entitled *The Virgin Supported by the Holy Women* (Fig. 266).

Only meticulous study of anatomy with the resultant understanding of the forms of muscles, bones, and tendons as they interlock and combine below the surface to create projections and hollows could have made possible the superhuman figures with which Michelangelo peopled his world (Fig. 267). These powerful, muscled bodies—with their small heads, hands, and feet and their great torsos, thighs, and arms—are convincing because they are based on a profound knowledge of bone and muscle structure. The musculature clearly articulated in these drawings is less evident when one looks at a living nude figure. Nonetheless, the grandeur of Michelangelo's figures was such that they established a stylistic ideal that was perpetuated throughout the Baroque period and into modern times.

Renaissance attempts to codify the proportioning of the body in the manner of the ancient Greeks departed from the newly acquired anatomical familiarity with the human body. Leonardo da Vinci's

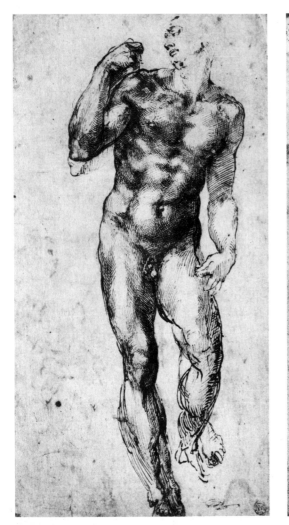

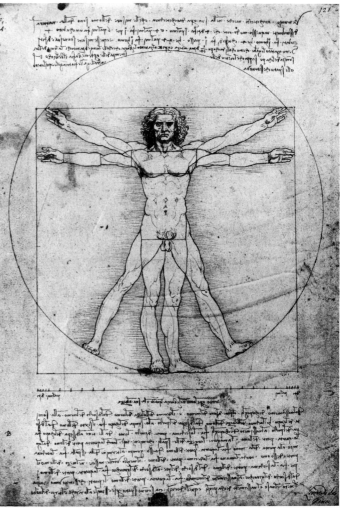

above: 267. Michelangelo
(1475–1564; Italian).
Figure Study. Pen and ink.
Louvre, Paris.

above right: 268. Leonardo da Vinci
(1452–1519; Italian).
*Study of Human Proportions
According to Vitruvius.* c. 1485–90.
Pen and ink, 13½ × 9¾"
(34 × 25 cm). Accademia, Venice.

drawing relating the male body to the perfect geometric forms of the square and the circle (Fig. 268) is the best-known example of this systematic approach to human proportions. He presents a figure of idealized proportions—eight heads high (the normal male stands about seven heads high), subdivided in even parts. The groin is halfway between the top of the head and the soles of the feet, the knees halfway between the groin and the feet, with other proportional divisions indicated on the arms and upper torso.

Project 14.1 Studying and drawing the nude figure permits a clearer understanding of proportion and construction. After familiarizing yourself with Leonardo's divisions of the body, have a model take a standing pose, feet slightly apart, one arm hanging at the side and the other hand on hip. If no model is available, use a mirror in which you can see your own full-length reflection. (Renaissance artists depended upon their students and apprentices as models, hence the preponderance of male nudes in the art of that period.)

Measure the distance from the chin to the crown of the head (use the system of optical measuring described on pp. 36–39), then calculate the number of units ("head heights") composing the total height

of the figure. Use that same unit measurement to determine the placement of nipples, groin, knees, elbows, and so on. It is highly unlikely that the proportions you see will correspond to those of Leonardo's idealized creation. Draw in charcoal or soft pencil to facilitate erasures and changes.

Traditionally an integral part of life-drawing classes, the study of anatomy is occasionally incorporated into today's curriculum, sometimes only as a series of anatomy plates to be executed. Some instructors continue to lecture on the subject, drawing diagrams on the chalkboard and pointing out on obliging models the relationship between tensed bulging muscles and the bony protrusions of the body (ribs, knees, ankles, and so forth), helping students to analyze what they see. An awareness of the body's basic construction is of obvious assistance in drawing the human form since inner structure influences outward appearance. Without benefit of instruction, you might find value in looking at one of the standard artist's anatomy books while drawing from a live model (Peck, Stephen Rogers, *Atlas of Human Anatomy for the Artist*, New York: Oxford University Press, 1951; Berry, William A., *Drawing the Human Form*, New York: Van Nostrand Reinhold, 1977, Chapters 6 and 7).

The highly finished drawings of 18th-century Dutch anatomist Jan Wanderlaer (Fig. 269) go far beyond the reference needs of medical or art students to become artistic works in and of themselves. The

269a. and 269b. Jan Wandelaer (1690–1759; Dutch). Anatomical drawings from Bernhard Siegfried Albinus's *Tabular anatomicae . . .* (London, 1747). New York Public Library (Astor, Lenox and Tilden Foundations).

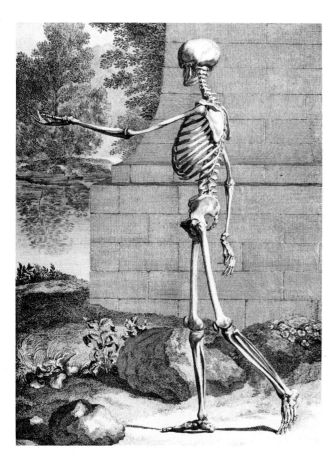

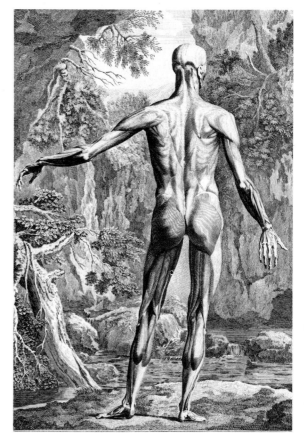

270. William Glackens
(1870–1938; American).
*Washington Square (A Holiday
in the Park)*. 1913. Pencil and wash,
touched with white over blue crayon
outlines; sheet 29 × 22″ (74 × 56 cm).
Museum of Modern Art, New York
(gift of Abby Aldrich Rockefeller).

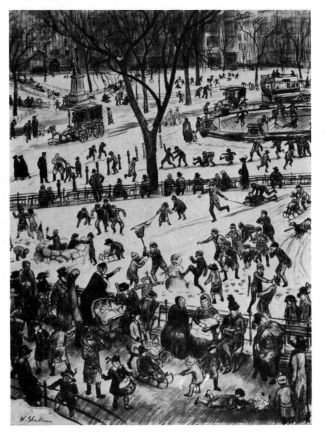

exquisite refinement of finish, the handsome backgrounds, the ideal-ized proportioning of parts—small heads, elongated bodies, delicately tapered extremities—all are far from purely factual rendering and as such are meant to appeal to the collector of works of art.

Project 14.2 Almost every art department can provide a skeleton, or a plastic replica of one, for study purposes. Although such skeletons are generally seen hanging from a stand in a decidedly lifeless manner, it is possible to move the limbs into positions approximating those of a living figure. It is useful to study the skeleton, and the more animated ana-tomical drawings of Wanderlaer, to become familiar with the underlying structure of the body. Observe your own body as well, noticing the di-rections in which you can twist, turn, and move with ease. Sense the way each shoulder can be moved independently; feel the rotation of your upper arm in the shoulder socket. Extend your arm, palm up, and then as you reverse the position of your hand, notice how the two bones of the lower arm respond.

Project 14.3 Probably at one time or another you have represented the human form by means of a simplified stick figure. Such figures gen-erally are rigidly angular and awkward because most people fail to ac-knowledge the curvature and movement of which the spinal vertebrae are capable, nor do they take note of the width of the shoulders and the hips. Attending to those three features allows us to create lively ges-tural drawings of the structural core of the body in the most simplified manner, which can be elaborated into fuller skeletal form and beyond

into the delightfully animated figures of William Glackens's *Washington Square* (Fig. 270).

Study a model or your own reflected image, or simply try to experience the movement in your body, and do a series of simplified gestural drawings as described above. Pay particular attention to the angle and rotation of the shoulders and hips and to the position of the head in relation to the placement of the feet. Notice the change that occurs in the position of the head when you shift your weight from both feet to one foot. Draw the body in a sequence of continuous movements—a perfect subject would be someone practicing t'ai chi.

Life Drawing—The Nude Model

Drawing from a living model—**life drawing**—serves as the principal discipline whereby students acquire knowledge of and sensitivity to the intricacies of the human form. The vitality that results in drawing from a live model cannot be duplicated when drawing from plaster casts or photographs.

In most life drawing sessions quick poses held for one to five minutes provide the student with a warming-up period. No matter how brief the pose, it is valuable to devote the first seconds or minute looking and projecting oneself into the pose before beginning to draw. Quick, gestural sketches are best executed on newsprint paper in charcoal or very soft pencil.

One or two 20-minute or 30-minute poses, which usually follow the quick-sketching period, permit more fully developed drawing with some modeling of forms in dark and light masses plus some indication of anatomical details. Isabel Bishop's ink-and-wash *Nude* (Fig. 271)

271. Isabel Bishop
(b. 1902, American). *Nude*. 1938.
Ink and wash, 5¾ × 6½″ (15 × 17 cm).
Collection Edward Jacobson.

above: 272. Alfred George Stevens
(1817–1875; English).
Studies of a Nude Figure.
Graphite and red chalk, 12¼ × 9⅜"
(31 × 24 cm). Fogg Art Museum,
Harvard University, Cambridge, Mass.
(Grenville Winthrop Bequest).

above right: 273. Victor Arnautoff
(1896–1979; Russian–American).
Study of a Model. 1928.
Red and black conté,
25 × 19" (64 × 48 cm). Department
of Art, Stanford University, Calif.

and *Studies of a Nude Figure* by Alfred George Stevens (Fig. 272) suggest the kind of drawings a skillful student might accomplish in thirty minutes. After the longer sketching period, the model generally assumes one pose for the remainder of the session. The pose, sometimes repeated at successive class meetings, allows students to complete a fully developed drawing and refine it over a period of hours or days (Fig. 273).

Whereas colleges and art schools provide regularly scheduled life drawing classes as part of the curriculum, students working independently often have only limited access to models. The cost of employing a professional model is generally prohibitive for most art students. Even professional artists who enjoy and find value in weekly life drawing sessions join together to share the expense of models. Some metropolitan area adult education programs provide figure drawing classes that attract both beginners and professional artists; local art associations sometimes organize life drawing sessions for their members. The models' fees are generally divided by the number of people in attendance, so that the cost to each person is minimal. While individuals have little control over the model and length of pose, most are content having the opportunity to draw the figure.

Project 14.4 Sketch a nude model in one-minute, five-minute, and ten-minute poses. For your initial attempts, use a short stick of compressed charcoal (a 1-inch or 1½-inch length, or 2.5 to 3 centimeters, usually works well). Keep the flat side of the charcoal against the paper and build broad areas of dark rapidly with a back-and-forth motion. You might well begin your drawings as a slightly expanded version of the

simplified skeletal drawing explored in the previous project. Establish the essential lines of movement—the **gesture**—followed by some indication of volume and size-shape relationships. As you begin to develop confidence, pay greater attention to shapes and patterns of light and dark. Introduce contour line last as time allows.

Avoid the temptation to plunge into drawing without taking time to look at the figure. Your drawing would be better served if you would spend the first half of each pose studying the model—drawing with your eyes—before setting charcoal to paper.

From Renaissance times on, artists have taken delight in beautiful drawings of the human figure, sometimes as studies for projected paintings (Fig. 267), but just as frequently for their own sakes. The figurative tradition continues in drawings ranging from the lyric classicism of Paul Cadmus (Fig. 274) to the pitiless realism of Philip Pearlstein (Fig. 275).

Project 14.5 The novice in life drawing derives the greatest benefit from working no more than half an hour on a single pose. Approach a 30-minute drawing in exactly the same manner as the quick sketches, using preliminary gesture lines to indicate the full figure. Then begin to establish general size and shape relationships of all the parts, using the measuring devices described in Chapter 3 to determine the location. Be alert to negative spaces as they define positive shapes.

Beginning students have a natural tendency to start by drawing the head, slowly working their way down the figure, often running out of paper before they reach the feet. Learn to utilize the full sheet of paper for the full figure. Start with a light preliminary sketch to deter-

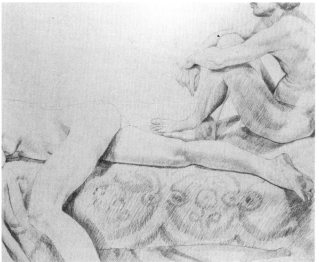

left: **274. Paul Cadmus (b. 1905; American).**
Male Mude NM 50. **Crayon, 24 × 18⅛″ (61 × 46 cm). Private collection.**

above: **275. Philip Pearlstein (b. 1924; American).**
Couple on Bed (Male Seated, Female Lying Down). **1972. Pencil, 19 × 24″ (48 × 61 cm). Collection Mr. and Mrs. Daniel M. Seifer.**

mine the overall height of the figure, then begin to break up that space by locating the shoulders, hips, knees, and so on. Broadly simplified patterns of light and dark provide a sufficient indication of volume.

Project 14.6 As you become more skilled, you can benefit from increasing the time spent on individual drawings of the figure. For fully developed studies, you might prefer a medium (such as conté crayon) that does not smear readily and thus permits reworking. You will want to work on good-quality charcoal paper. Have your model assume a comfortable, seated pose, similar perhaps to Figure 273 or Figure 274, which can be repeated easily since you might well spend three or four hours developing a finished drawing. Illuminate your subject with a strong light to reveal the anatomical forms in high relief. Study the model carefully and build a sense of form through the use of chiaroscuro (see pp. 77–78). If you have difficulty with any of the forms, make studies of that detail in the margins of your paper, as suggested in Figures 272, 276; then resume work on the main drawing.

Hands and Feet—Foreshortening

The Austrian artist Herbert Boeckl is quoted as instructing his life drawing students, "Draw the feet, draw the hands—the rest is easy." Feet and hands, perhaps the most complex and problematic parts of the body to draw, rarely receive sufficient attention in most student drawings. A remarkably beautiful page of preparatory studies by Michelangelo (Fig. 276), an instructional sheet of drawings of feet by Agostino Carracci (Fig. 277), and a modern page of foreshortened

below: 276. Michelangelo (1475–1564; Italian). *Studies for the Libyan Sibyl.* Red chalk on paper, 11⅜ × 8⅜″ (29 × 21 cm). Metropolitan Museum of Art, New York (purchase, 1924, Joseph Pulitzer Bequest).

below right: 277. Agostino Carracci (1557–1602; Italian). *Feet,* over an earlier sketch for an *Annunciation.* c. 1595. Pen and brown ink, 10¼ × 6⅜″ (26 × 16 cm). Royal Library, Windsor Castle, England (reproduced by gracious permission of Her Majesty Queen Elizabeth II).

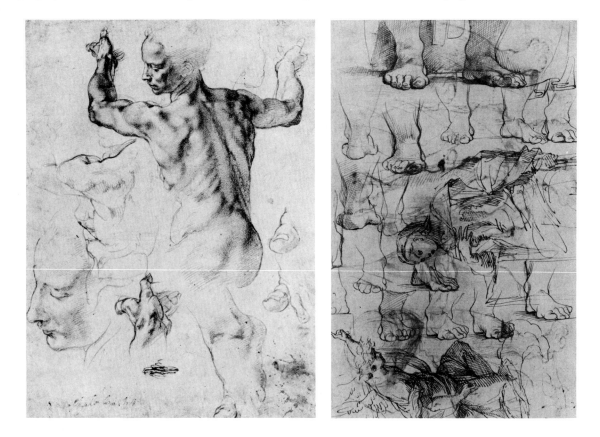

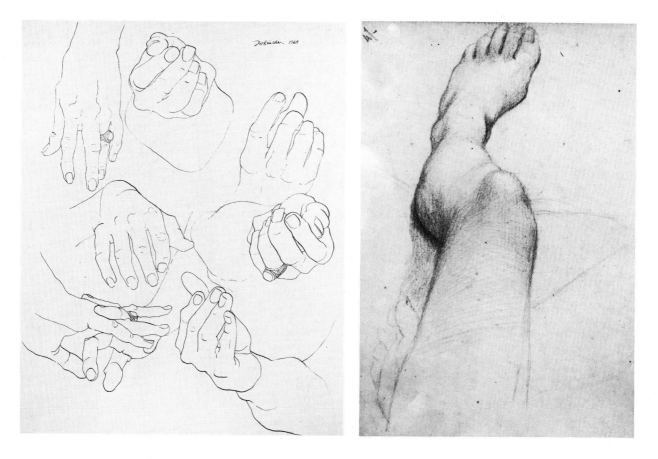

hands by Elinor Dickinson (Fig. 278) reveal a concern with mastering the complexity of form present in the extremities, recognizing that the hands in particular fulfill a significant expressive function. No matter how well drawn the head and torso, poorly drawn hands and feet substantially diminish the effectiveness of the figure. (The accumulation of details seen in Figures 276 and 277, the Carracci feet having been drawn over an earlier study of an *Annunciation*, suggests that during earlier periods, when all paper was handmade, it was a more precious commodity than we think of today.)

Project 14.7 Do extended studies of hands, feet, heads. Foreshortening of hands and feet presents a major challenge. If no model is available, use yourself, as Degas probably did for the drawing of his own leg and foot (Fig. 279). Remember that your task will be simplified if you concentrate on drawing size and shape relationships, rather than thinking about drawing hands and feet.

Project 14.8 Foreshortening is present in Figures 273 and 274. Undoubtedly some also occurred in your fully developed figure study (Proj. 14.6). To do a drawing involving maximum foreshortening, pose the model in a reclining position so that you see the body from head to toe or vice versa. Allowing the model to lie in a relaxed pose, perhaps with one arm extended above the head, and viewing the figure from a slight angle will provide a more visually interesting composition (Pl. 10, p. 173). Draw size and shape relationships as you see them rather than as you think you know them to be.

above left: 278. **Eleanor Dickinson (b. 1931; American).** *Study of Hands.* 1964. **Pen and ink, 13⅛ × 10⅛″ (34 × 26 cm). Stanford University Museum of Art, Calif.**

above: 279. **Edgar Degas (1834–1917; French).** *Sketch for Man's Leg (probably the artist's) Seen Foreshortened from Above.* **Bibliothèque Nationale, Paris.**

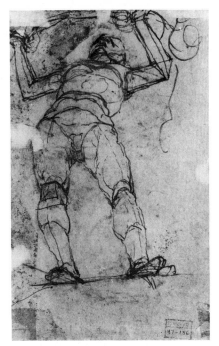

280. Giovanni Paolo Lomazzo
(1538–1600; Italian).
*Foreshortened Nude Man with
Arms Uplifted Looking Up.*
Pen and brown ink,
7½ × 4¾″ (19 × 12 cm).
Art Museum, Princeton University
(gift of Frank Jewett Mather, Jr.)

Project 14.9 Degas recommended setting up platforms of various heights so that by switching positions, the artist can view the model either from above or below. While the pose seen in Figure 280 could be duplicated by a reclining figure, the relaxed muscles would not convey the same energy and aliveness of a standing figure. Sitting on the floor below a model who is standing on a desk or solid table, or vice versa, will provide you with an exaggerated foreshortening of the figure.

Figure Groups

Students may become skilled at depicting single figures but remain unable to compose a successful group of related figures, largely because the problem is rarely addressed. Economic considerations restrict most life drawing classes to a single model; only occasionally do two models pose together. One must realize, however, that large-scale figure paintings of the past, often with a cast too numerous to count, were composed from individual figure studies, combined with imagination, visual memory, and accumulated knowledge and experience.

Project 14.10 The problem of integrating three or more figures into a single composition will be somewhat simplified if you work with two models since certain spatial relationships can be directly observed. If only one model is available, consider carefully the placement and scale of each figure. Since figures must not appear to occupy the same floor space and must appear to be drawn from a consistent point of view, an understanding of perspective will prove useful. Without changing your position, relocate the model in space to conform to the composition; chalk marks on the floor will assist you in this. Include reclining, semireclining, standing, and foreshortened figures. Work in charcoal so that confusing overlappings can be erased. It is possible to construct a figure composition from an accumulation of individual figure studies done at different times, but unless all were drawn from the same eye level, an inconsistency in point of view will probably occur.

Gesture Drawing

Life drawings can appear lifeless and without vitality if the figure is treated only as an accumulation of parts and details rather than as a complete form having within it an "essential line of movement" called **gesture.** That movement or gesture is not limited to "motion" in the sense of physical action. Filippino Lippi (Fig. 281), for example, has drawn the figure in four different standing poses, yet not one shows the figure rigidly at attention. Each pose has a sense of movement, a gesture, that characterizes the attitude of the figure.

Looking at any figure, we tend to perceive the essential gesture before we become aware of anything else. In fact, the eye probably makes a rapid sweeping movement that corresponds to that gesture since we are naturally inclined to look at the whole before we proceed to examine the parts. In **gesture drawing** the hand and the medium follow the same sweeping movements of the eye in setting down the gesture that sums up the pose or action. It might be accomplished with just a single line; sometimes the "searching line" discussed in Chapter 3 is more appropriate. A detail selected from a page of figure studies by Salvator Rosa (Fig. 282 and Fig. 61) combines the two approaches—one continuous brush stroke summarizes gesture and

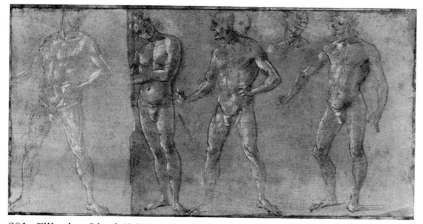

281. Filippino Lippi (1457–1504; Italian). *Studies of Nude and Draped Figures.* Silverpoint, heightened with white, on paper primed blue; 22¼ × 17¾″ (57 × 45 cm). Christ Church, Oxford University.

movement, not only of the model, but also of the eye and hand of the artist, while the searching pen line begins to give definition to the figure.

Quick one-minute poses allow for little more than just a line or two to establish the gesture. Using the flat side of a piece of charcoal or crayon, or a fully loaded brush, allows mass to be suggested at the same time. Structure, contour, and detail follow after, depending on the length of the pose. Figures 282 to 284 are identical in concept, differing only in degree of definition and refinement. Francesco Fontebasso's greater attention to chiaroscuro produces a fuller sense of

below left: 282. Salvator Rosa (1615–1673; Italian). *Studies for the Angel Raphael and Tobit,* detail. Pen, brown ink and brown wash; 5½ × 8″ (14 × 20 cm). Art Museum Princeton University, N. J.

below: 283. Giovanni Battista Piranesi (1720–1778; Italian). *Figure.* Black pencil and sanguine, 8½ × 8¼″ (22 × 21 cm). Louvre, Paris.

284. Attributed to Francesco
Fontebasso (1709–1768/69; Italian).
*Male Nude Standing and Gesturing
and a Second Reclining.*
Pen, dark brown ink, brown and
gray wash over black chalk;
15 × 10½″ (38 × 27 cm).
Art Museum, Princeton University
(bequest of Dan Fellows Platt).

volume (Fig. 284). To see the gesture of the pose, one need only look
at the core of the shadow as it moves from the back of the head to the
left shoulder, then sweeps down the back, pausing slightly to describe
the buttock before continuing down to the right ankle.

Even for longer poses and more detailed drawings, laying in a
light gesture drawing first provides an inner line of movement for the
figure, as well as locating it on the paper. Without that initial indica-
tion of gesture and size, it is all too easy to get caught up in drawing
the figure piece by piece, losing in the process the rhythm, movement,
and unity of the pose and the proportional relationship of the parts of
the body.

Sketchbook Activities

Figure drawing is not limited just to a model posing in the artificial environ-
ment of a studio classroom. Anyplace there are people provides the oppor-
tunity and the models. Unsuspecting models assume natural, unaffected
poses. They will not, of course, "hold the pose" for very long, but if you
develop the ability to summarize what you see quickly without being dis-
tracted by nonessential details, you will not need much time to put down
the basic gesture, even when figures are moving. Add whatever detail and
definition time allows (Figs. 282, 283). Remember that you can always prac-
tice drawing with your eyes when it is not convenient to draw with anything
else.

The Figure in Action

Depicting the figure in action successfully depends upon the ability to
isolate and represent the essential underlying gesture of that action.
Life drawing presupposes a model holding a pose without moving, if

only for a short time, even when the pose is meant to convey an action or motion. No matter how skilled the model, the mere act of assuming a pose transforms animation and movement into a frozen and static form. It is in short one-minute poses that models can most successfully convey the impression of movement, which means that quick sketches have an importance other than as warming-up exercises.

Many artists, skillful in depicting posed figures, cannot communicate a convincing sense of movement. One solution is to practice gesture drawing at every opportunity, always searching for the essential line or lines of movement that characterize a pose or action. Draw live figures in action as often as possible, projecting oneself into the action, re-creating as much as possible the physical sensation of performing the action. Perhaps most important is honing one's perception of the way the structure of the body influences visible form. The slightest movement affects the whole figure; the slightest gesture results in a muscular response; the slightest change in position can alter the vitality of the image.

Observing master drawings may suggest how to approach the problems involved in representing figures in action. George Romney uses bold, swiftly drawn, gestural pen lines to produce a flowing rhythmic movement in his drawing *Dancing Figures* (Fig. 285). The sense of movement within a single form is particularly evident in the shorthandlike notation of the figure at the right. Much of the charm of the drawing is that it effectively suggests a continuous sequence of movements. The figure of Mars that emerges out of the almost frenzied searching line of Giovanni Guercino (Fig. 286) conveys the impression of sequential movement which is the basis of film animation.

below: 285. George Romney (1734–1802; English).
Dancing Figures, detail of a page of studies. Pen and ink.
Metropolitan Museum of Art, New York (Rogers Fund, 1911).

right: 286. Guercino (1591–1666; Italian). *Mars and Cupid.*
c. 1645. Pen and brown ink on white paper,
10 × 7⅛″ (26 × 18 cm). Allen Memorial Art Museum,
Oberlin College, Ohio (R. T. Miller, Jr., Fund).

above: 287. Henri Matisse (1869–1954; French). Illustrations for Mallarmé's *Le Guignon.* c. 1930–31. Pencil, 13 × 10⅛″ (33 × 26 cm). Baltimore Museum of Art (Cone Collection).

above right: 288. Hokusai (1760–1849; Japanese). *Mad Poet,* detail from a page of drawings. Ink on paper, entire page 10⅜ × 15⅝″ (27 × 40 cm). British Museum, London (reproduced by courtesy of the Trustees).

Sweeping lines implying both motion and transparent draperies carry the eye in an unbroken flow of visual movement from the dancer's ankles to her upraised arms in Matisse's fine drawing (Fig. 287). In delightful contrast to the smooth graceful arc of Matisse's dancer, Hokusai's *Mad Poet* leaps about with wild, carefree abandon (Fig. 288), his head, arms, and legs projecting at unexpected angles from a complex swirl of drapery. It should be noted, however, that in spite of the poet's expansive gesticulations, the parts of the body have been thoughtfully positioned to ensure the effect of equilibrium.

It is interesting to compare Toulouse-Lautrec's poster image of Jane Avril (Fig. 289) with the photograph of the famed Parisian entertainer (Fig. 290). The photograph is obviously posed, since late-19th-century cameras were not sufficiently sophisticated to capture a figure in motion. The poster reveals Toulouse-Lautrec's amazing ability to animate the figure through exaggeration of gestures and shapes, most evident in his drawing of the legs and feet, creating an image far more physically convincing than the photograph. The sense of equilibrium conveyed is similar to that of Hokusai's *Mad Poet.*

Project 14.11 Draw figures engaged in relatively simple, repetitive motions—walking, running, or bending—beginning with quick gestural sketches to establish the lines of action. Attempt drawing a series of successive movements as overlapping images to suggest flowing move-

ment. When you feel ready, undertake more dynamic movements. While dancers and athletes seem to be obvious subjects, their movements are generally much too rapid for a beginning artist. Even the slow deliberate movements of a person practicing t'ai chi will seem fast as you attempt to record them, but it would be instructive to try. Concentrate initially on achieving a sense of action, even if it means sacrificing accuracy of shape and proportions, introducing important contours and details later. Notice how Guercino (Fig. 286) employs directional line patterns to suggest roundness and describe weight and mass as well as movement.

above left: 289. Henri de Toulouse-Lautrec (1864–1901; French). *Jane Avril, Jardin de Paris.* 1893. Lithograph, 4'2¾" × 3'⅝" (1.3 × 0.94 m). Musée Toulouse-Lautrec, Albi.

above: 290. Jane Avril, c. 1892. Photograph. Reprinted from *Lautrec by Lautrec,* by P. Huisman and M. G. Dortu. Published by Edita, S. A., Lausanne.

Drawing the Clothed Figure

Mastery in drawing the clothed figure equals in importance the depiction of the nude form but is often neglected in the training of beginning artists. The clothed figure presents a double challenge for the artist: drawing the body and the drapery. Solid background in anatomy and figure drawing gave a particular authenticity to Renaissance artists' treatment of costumed figures. We have seen Raphael's skeletal study for his *Virgin Supported by the Holy Women* (Fig. 266). Similar nude studies for paintings of the Madonna by Raphael also exist; Michelangelo's *Studies for the Libyan Sibyl* (Fig. 276) is a preparatory drawing for a clothed figure.

Skeletal and muscular details strongly influence the way clothing drapes on the body. Folds and creases are determined by the structure of the body, and it is important that they be accurately observed and rendered if the body inside is to be believable. While clothing can conceal as well as reveal, it is the latter effect that is important. Still-life studies of cloth of various weights and textures draped into complex folds, so often part of basic drawing curriculum, provide valuable and necessary background for drawing the clothed figure, but as Robert Henri cautioned his students, "Without knowledge and sense of the body, wrinkles and folds remain wrinkles and folds."

Theophilus Brown's *Seated Man* (Fig. 291) conveys a remarkable sense of physical presence; each fold and crease of the clothes lends emphasis to the weight and structure of the body underneath. The full weight of the figure settles solidly into the chair, the feet merely resting on the floor.

291. Theophilus Brown (b. 1919; American). *Seated Man*. Pencil, 11½ × 14½″ (29 × 37 cm). Courtesy the artist.

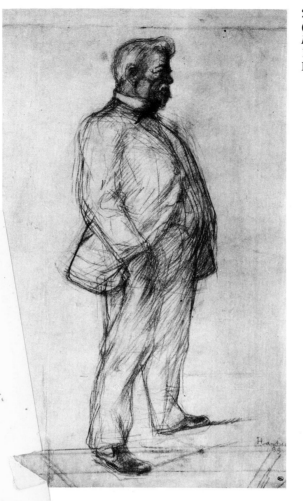

292. Henri de Toulouse-Lautrec
(1864–1901; French).
Portrait of a Man. 1899. Crayon,
19¼ × 11¾″ (49 × 30 cm).
Louvre, Paris.

292) allows no doubt, through the stance
⋯ and firmly placed—that the weight of
⋯ s Brown delineated the patterns of folds
⋯ ouse-Lautrec offers only a few hints, a
⋯ By attending to the silhouette and se-
⋯ ves character to both the man and his
⋯ accent at the bottom of the belly re-
⋯ y than any other part of the drawing.
⋯ould considerably alter the character of the

Project 14.12 Practice drawing the clothed figure as often as you
can, in the studio and elsewhere. Include the clothed figure as part of
your ongoing sketchbook activities. Since you are so constantly in the
presence of other people, the opportunities are limitless—on campus, in
the cafeteria, library, and classrooms, at shopping centers and outdoor
cafes, wherever people congregate. Be continuously aware of the body
inside the clothes and concentrate on revealing the stance or gesture of
the figure. Even in longer studies, learn to simplify the clothing, placing
emphasis on those lines, folds, and details that most define the body
form.

Temperament and the Human Figure

Viktor Lowenfeld, one of the most systematic students of the development of pictorial expression, perceived that various types of personalities react to visual experience in different ways. He theorized that there are two main types of expression representing two extreme poles of artistic personality: the **visual** and the **haptic.** Visual people concern themselves primarily with the visible environment; their eyes constitute their primary instrument for perception and they react as spectators to experience. Haptic, or nonvisual, people, on the other hand, relate their expression to their own bodily sensations and the subjective experiences in which they become emotionally involved; they depend more on touch, bodily feelings, muscular sensations, and emphatic responses to verbal descriptions or dramatic presentations.

The suggested projects in this chapter encourage both visual and haptic approaches to drawing the figure. Some assignments stress concern with the visual appearance of form; others urge students to project themselves into the pose of the model; many combine the two forms of expression.

Almost no one is completely visual or completely haptic in orientation. More than ever before, contemporary artists are exploring their experiences through senses and sources other than their eyes. Rico Lebrun's anguished image *Running Woman with Child* (Fig. 293) forcefully re-creates the physical "truth" of the bodily sensation of running.

The rhythmic movement in Irmagean's *Emerging* (Fig. 294) conveys a strong haptic response to dancing figures (compare with Fig. 285), while the handling of the voluminous drapery suggests an equally strong visual response. Forms that at one moment seem to define individual dancers suddenly disappear into broad sweeping strokes of charcoal that duplicate the actual movements of dancers' arms and bodies in time and space.

293. Rico Lebrun
(1900–1964; Italian–American).
Running Woman with Child.
Ink on gray paper,
18¾ × 25⅜″ (48 × 64 cm).
Sheldon Memorial Art Gallery,
University of Nebraska, Lincoln.

294. Irmagean (b. 1947; American). *Emerging.* 1980. Charcoal on paper, 24½ × 42⅛″ (62 × 107 cm). Courtesy the artist.

Imagination and the Figure

In our discussion the emphasis on learning to see as a fundamental factor in learning to draw has stressed an essentially representational approach to figure drawing. Once you develop your perceptive abilities and gain technical proficiency with media and techniques, you are free to begin interpreting what you see. While subject matter, choice of media, and technique contribute to the effectiveness of a drawing, it is the imaginative and expressive qualities to which the viewer most responds.

It is easy to settle into certain pleasing habits of drawing and neglect other avenues for perceiving and recording the rich and complex form, the human figure. The use of distortion and abstraction, for example, lends zest and variety to modern interpretations of the figure (Pl. 2, p. 87; Figs. 110, 293). To the degree that one remains receptive to a wide variety of stimuli, a rich and diverse imagination develops.

Project 14.13 Distortion, fragmentation and dislocation, ambiguity, shifting points of view, juxtaposition of multiple images, stylization, and flat patterning are means of approaching abstraction. De Kooning sometimes used the process of shuffling drawings on sheets of tracing paper placed one over the other to create new images. Working from some of the drawings done for other projects in this chapter, experiment with abstracting the human figure while exploring a variety of media and techniques.

The Portrait

*Do portraits of people in familiar and typical
attitudes; above all, give to their face
the same choice of expression given to the body.*
　　　　　　　　　　　　　　　—Edgar Degas

The face has long been an object of scrutiny for artists, because
through its myriad expressions pass all the fleeting thoughts and emo-
tions of human experience (Fig. 295). From earliest times the making
of portraits has been a means whereby human beings have tried to
evade the common destiny of all living creatures and to achieve some
degree of immortality. Until the invention of the camera in the early
19th century, portraiture, whether sculpted, painted, or drawn, was
the only way that physical likenesses could be preserved.

The illustrations in this chapter and elsewhere in the book reveal
the tremendous variety of approach to portraiture by individual art-
ists. Some portraits strive for exact replication of every bump and
hollow in the face (Figs. 296, 4); in others, there is a telling selectivity
(Fig. 297). Stylization sometimes becomes caricature, at other times
idealization. It is frequently argued whether the portrait involves psy-
chological perceptions made and incorporated in the work by the art-
ist or whether the telling irregularities that constitute the "psychologi-
cal" element—particularly those that convey tension, strain, and lack
of inner quietude—are "read into" the drawing by the viewer. Be-
cause of the inordinate complexity and expressive potential of the
subject matter, no field of drawing is more demanding, and perhaps
rewarding, than the portrait.

The impersonal, idealized portrait in which distinctive aspects of
appearance are sacrificed to a bland, generalized version of the sitter
has long been the accepted standard for "official" portraiture. The
drawings reproduced here, however, have been chosen for their aes-
thetic and expressive interest rather than their commercial acceptabil-
ity. Each work by a great portrait artist manifests a characteristic em-
phasis, a personal touch that constitutes the artist's genius and
distinguishes such work from the thousands of adequate but merely
routine likenesses that predominate in conventional portraiture.

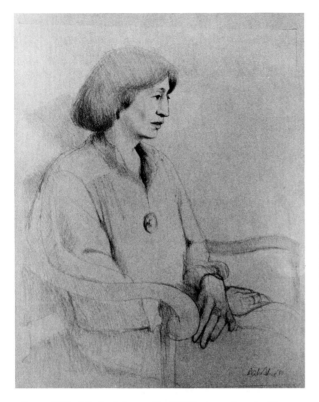

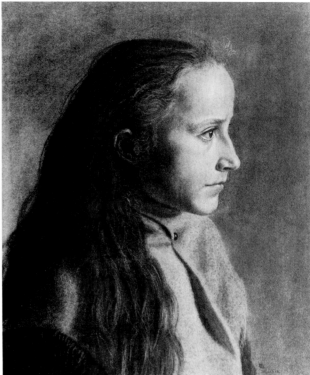

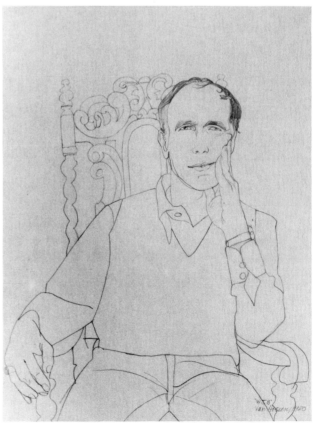

above: 295. Mark Adams (b. 1925; American). *Margery.*
1980. Pencil, 24 × 19″ (61 × 48 cm).
Courtesy the artist.

above right: 296. William Michael Harnett
(1814–1892; American). *Portrait of a Young Girl.*
Black crayon and gray wash with touches of white,
19⅜ × 16⅛″ (50 × 41 cm). Fogg Art Museum,
Harvard University, Cambridge, Mass.
(bequest of Meta and Paul J. Sachs).

right: 297. Beth Van Hoesen (b. 1926; American).
Theophilus. 1980. Pencil, 16¾ × 13½″ (43 × 34 cm).
Courtesy the artist.

Form and Proportion

Despite the fact that we are constantly observing faces as we move about and meet people, most of us have surprisingly little knowledge of the general proportions and relationships between parts of the face. Perhaps because we attend to the individuality of each person, which is the basis of portraiture, we fail to be alert to the general system of proportions that determines the placement of features. Familiarity with the general rules of proportion enable us to avoid the mistakes most commonly seen in unskilled drawings of the head.

Alanson Appleton's classically rendered portrait of David Roinski (Pl. 4, p. 88), combines a masterful knowledge of proportions and underlying anatomical structure with thoughtful observation to create a sense of solidity and individuality. Careful analysis reveals how closely the drawing adheres to the system of proportions presented in Figure 298, while at the same time concentrating on the uniqueness of the individual.

The Frontal View

Project 15.1 Study the general proportions diagrammed in Figure 298 and compare them with your own reflected image. Use a pencil as a measuring device (see pp. 36–39).

1. Hold a pencil in front of your nose to create a vertical center line. The eyebrows, eyes, base of the nose, and mouth can be seen as horizontal lines perpendicular to it. When you incline your head to the left or right, your features remain at right angles to the center line. As you tip your head forward or backward the feature lines are seen as downward or upward curves corresponding to the curvature of the skull.
2. Accurate proportion of head width to height is a critical factor in portrait drawing if the features are to assume their correct relationship.

298. Alanson Appleton
(1922–1985; American).
*General proportions of the head:
frontal and profile.*
Pen and ink, 8½ × 11″ (22 × 30 cm).
Permission Mrs. Alanson Appleton,
San Mateo, Calif.

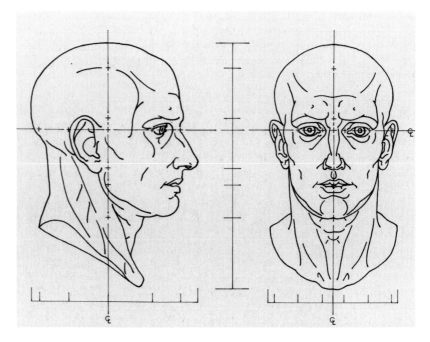

3. The line of the eyes lies about halfway between the top of the skull and the chin. It might appear to be lower depending on the fullness of your hairstyle. With infants the eyebrows mark the halfway point, with the eye line dropping approximately one-quarter into the lower half (Fig. 299).
4. The distance between the hairline and chin is divided roughly into thirds by the eyebrows and the base of the nose. The lower section may be slightly greater.
5. The center line of the lips, like a flattened letter M, falls approximately one-third of the way between the nose and chin—sometimes more than a third, but always less than half.
6. The top of the ears align with the eyebrows; the bottom of the ears fall just below the bottom of the nose.
7. The distance from the side of the head to the outer corner of the eye, the width of the eye, and the space between the eyes are all very nearly equal measurements.
8. The width of the nostrils corresponds to the distance between the eyes.

The Profile View

Project 15.2 It is possible to study your profile by using two mirrors. The frontal view of the head resembles an upright egg; in profile it appears as a tilted egg.

1. A common error in drawing the profile head is placing the eye too close to the forehead plane and the nose.
2. The ear is located in the back half of the head. The distance from the outer corner of the eye to the back edge of the ear is about equal to one half the height of the head.
3. The measurement from the earhole to the tip of the nose and the distance from the chin to the eyebrows are equal. (In the frontal view the distance between the earholes is equal to the measurement from the chin to the eyebrows.)
4. The earlobe indicates the position of the jawbone.

Project 15.3 Observe heads wherever you are. Notice how consistently the placement of features adheres to the general proportions as seen in Figure 298 and as listed, with the greatest deviation occurring in the width of heads.

A problem beginning students experience in drawing the frontal view of the head is conveying a convincing sense of structure. Too frequently, even though accurately positioned, the features appear to float on the surface of the paper rather than existing as part of a three-dimensional form. As has been noted, three-dimensional form becomes most apparent through the use of light and shadow. In a line drawing it is possible to impart a degree of three-dimensionality through overlapping shapes and lines, and to introduce light and shadow by gradations in the thickness of lines (Fig. 297). When the study of form is intended, adequate directional light is essential.

Project 15.4 A plaster head—a standard fixture in most art departments—provides an excellent means for studying general proportions of the head and relationships between its parts. A plaster cast has the virtue of remaining motionless, thus permitting leisurely and accurate observation. It can be repositioned easily so that it can be viewed above

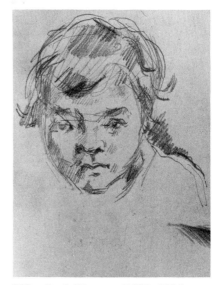

299. Paul Cézanne (1839–1906; French). *Portrait of His Son,* detail from sheet with *Self-Portrait.* Pencil on white paper, entire page 4⅞ × 8½″ (12 × 22 cm). Art Institute of Chicago.

300. Jean François Millet (1814–1875; French).
Man's Head in Three-Quarter View to the Left.
Black crayon, 6¼ × 4⅝" (16 × 12 cm). Louvre, Paris.

301. David Hardy (b. 1929; American).
Untitled. 1984. Charcoal and chalk, 11 × 8" (30 × 21 cm).
Courtesy the artist.

and below eye level, as well as in frontal, profile, and three-quarter views. Use your pencil or stick of charcoal for comparative measuring and to establish the correct alignment of features.

Project 15.5 Working from a plaster head or your own reflected image, lighted from above and to one side, do two drawings—one in line (Fig. 297); the other fully modeled in light and dark, using line only to clarify those areas where tone is insufficient (Fig. 300)—in which you develop a sense of solid, three-dimensional form. Emphasize bony structure, cheekbones, the turn of the forehead from frontal plane to side plane, bony protuberances in the nose, and so forth. Concentrate on revealing form rather than creating a likeness. Make sure that the eyes appear to sit within the socket and not on the same plane as the forehead or cheeks.

For the tonal drawing, begin by sculpting the basic form with patterns of light and dark before turning your attention to defining and detailing the features. Drawing the head is very similar to modeling it out of clay. First you create the general form, then you move to the details. Charcoal and chalk, or any combination of light and dark colors, on a middle value paper works well for portrait studies, as evidenced in David Hardy's elegantly understated drawing (Fig. 301).

The Features

Once correct relationships of form and features are firmly settled in the beginning artist's perception, achieving a likeness depends upon the accurate analysis of a set of individual features to be superimposed over the preliminary plan. *The most common errors result from failure to look at the shape of each feature, drawing instead what one thinks to be the shape of that feature.* The novice, for example, has a tendency to represent the eye as an almond shape with the upper and lower lids as matching curves meeting at points. Careful observation of the eye reveals that it is more irregular in shape—the high point of the curve of the upper lid occurs closer to the nose; the low point of the lower lid is nearer to the outer corner of the eye. At the inner corner the lids come together to form the tear duct; at the outer corner the upper lid overlaps the lower lid. Eyelids also have thickness. The iris of the eye appears to rest on the lower lid, while the upper portion is partially hidden by the upper lid. In profile the eye appears as the letter V lying on its side; the upper lid projects beyond the lower lid, overlapping it at the outer corner; the inner corner lies forwards of the outer corner (Fig. 298).

Lips also present a problem for beginners who are inclined to outline them, when the only line is that between the lips. What we think of as the upper and lower lip lines are really changes in coloration. Notice in Figure 302 that the bottom of the lower lip is defined only by the shadow centered beneath it. Moving toward the corners of the mouth, the lips tend to flatten, almost to disappear, except for the color difference.

Project 15.6 You must understand a form before you can draw it. Study your own features carefully at close range. A hand-held mirror is recommended. You are urged not to work from photographs for this assignment, since the flattened image does not adequately convey the three-dimensionality of form. Practice drawing your eyes, nose, lips, and

302. Raphael Soyer
(b. 1899; American).
Self-Portrait with the Artist's Father.
Pencil, 9¾ × 12⅛″ (25 × 31 cm).
Sotheby Parke-Bernet.

ears separately in frontal, profile, and three-quarter views. You will probably discover that your eyes are not identical in size and shape and that your mouth is not the same on both sides (Fig. 302). Making additional studies of the individual features of other persons will increase your awareness of differences that exist and the necessity for drawing exactly what you see.

Try to avoid flatness. Do not just outline shapes. A single light source above and to the side will reveal the strongest sense of form.

Project 15.7 Drawing someone with a distinctly unusual face is a good exercise in developing sensitivity to the peculiarities of likeness. Stress all departures from regularity, differences between eye shapes, and the length and structure of the nose, mouth, lips, and chin. Notice wrinkles, muscularity or flabbiness of the flesh, heaviness of eyebrows and lashes, and quality of hair and direction of its growth. Although it may not please your model, be merciless; kindness produces only a flaccid likeness.

The Self-Portrait

The self-portrait may serve either as an opportunity for serious exploration or merely as a chance to work one's technical prowess on an obliging model. A glance at the following group of drawings will suggest that self-portraits can span a considerable range of disparate styles and approaches. For the beginning student the self-portrait offers decided advantages. First, the sitter is always available and easily manipulated. Second, there is no need to worry about offending the sitter's "self-image," no need to apologize for any unflattering drawing.

Raphael Soyer's drawing (Fig. 302) reveals a most subtle study of himself accompanied by his father. The self-portrait's thoughtful expression, the slight irregularity of eye shape and size, the sensitive mouth, and furrowed brow all bespeak the introspective artist. The prominence given to his eyes and the intensity of their gaze seem to underscore the essential linkage of drawing to seeing. In spite of the almost elusive nature of the modeling, except around the eyes, the head is strongly structured. (The placement of the features and the division of the head correspond almost exactly to the general proportions diagrammed in Fig. 298.) The head of Soyer's father mimics that of the artist in structure but is less well defined in form and may well have been done from memory.

That drawing is a matter of looking and seeing is evident in James Ensor's *Self-Portrait* (Fig. 303). We are conscious that shortly Ensor will shift his gaze from the mirror before him to look through his pince-nez at his paper to add yet another line to his drawing. The eyes clearly dominate the drawing. Ensor displays skillful use of selectivity as he emphasizes some features more than others. In contrast, most beginners feel obligated to delineate every detail with equal clarity.

Marie Laurencin departs from a completely objective recording of appearances to offer an image of compelling ambiguity (Fig. 304). The largeness of the form on the small page and the cropping of the head imply physical closeness, yet the expression of the languid eyes seems withdrawn and distant. Unmodeled cheeks contrast strangely with the pronounced fullness of the lips, which are accented by the

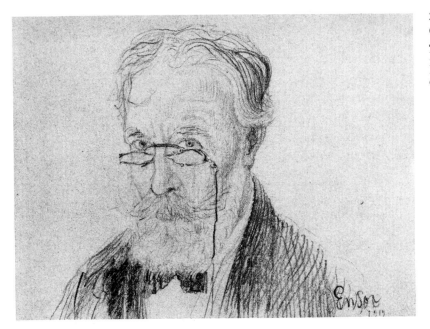

303. James Ensor
(1860–1949; Belgian).
Self-Portrait. 1919.
Pencil, 4½ × 6″ (12 × 16 cm).
Museum voor Schone Kunsten,
Ostend.

strongly defined cast shadow. The head assumes an awkward angle in relation to the neck and shoulders; the features are not at right angles to the central axis of the head. These elements have been deliberately manipulated for expressive purposes.

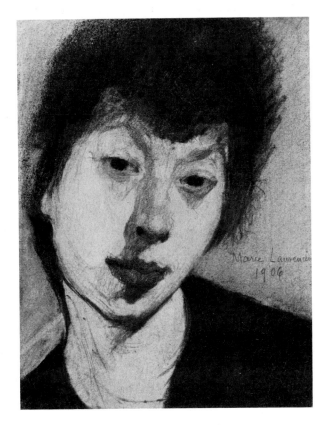

304. Marie Laurencin
(1885–1956; French).
Self-Portrait. 1906.
Charcoal and pencil,
8⅝ × 6¾″ (22 × 17 cm)
Museum of Modern Art,
New York (purchase).

A tight, "large-screen" close-up of Robert Arneson's crinkly eyes and a wry smile, playfully textured with dots, squiggles, and games of tic-tac-toe (Fig. 305), projects a self-image of relaxed warmth and good humor.

Project 15.8 Don't stop with one or two self-portraits. If you want to learn to draw heads and portraits, take advantage of your availability as a model; study and draw your own face frequently, using various media, techniques, lighting effects, and poses. Using two mirrors will allow you to draw the more interesting but difficult three-quarter view without the awkward "eyes to the side" look. Proceed from structure to features, then to expression. Decide how you can best describe your personality visually. Additional self-portraits reproduced throughout the book, among them those of Käthe Kollwitz, "who left a lifelong record of [herself] in self-portraits" (Figs. 23, 119), will suggest other approaches.

Sketchbook Activities

Careful analysis and thoughtful drawing contribute to one's effectiveness as a portrait artist. It is also important to acquire the facility to put down simply

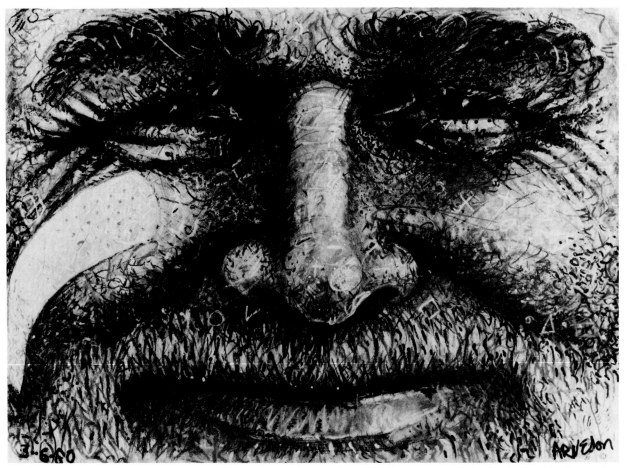

305. Robert Arneson (b. 1930; American). *Cheek*. 1980. Conté, oil pastel, and oil stick; 29 × 41⅛″ (75 × 106 cm). Fine Arts Museums of San Francisco, Achenbach Foundation for Graphic Arts (Hamilton-Wells Fund).

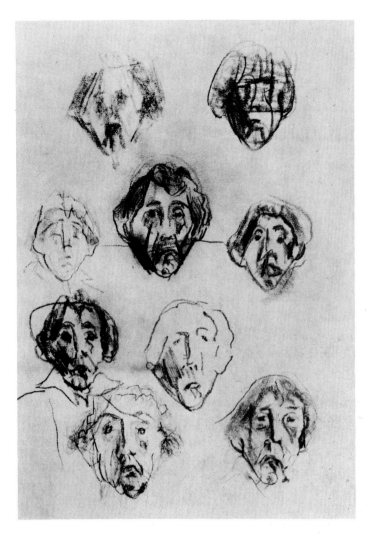

306. John Marin
(1870–1953; American).
Studies of the artist. c. 1940–50.
Pencil. Courtesy Kennedy Galleries,
Inc., New York.

and quickly the essential features that characterize people you see. John Marin's self-portrait studies (Fig. 306) illustrate a quick-sketch approach to portraiture. Add to your sketchbook routine the habit of making rapid portrait studies. Drawing quickly requires intense concentration. With continued practice you will develop the ability to suggest structure, likeness, and character with the most economical means.

The Objective Approach

One broadly accepted ideal of portraiture is pure objectivity. Since "pure" objectivity exists only as a theoretical state of mind, in terms of artistic endeavor an objective approach involves depicting exactly that which is observed, free from distortion and interpretation.

Josef Albers offers a straightforward depiction of a man, unidentified but with a strong indication of individuality (Fig. 307). Albers has used a line that matches in firmness and clarity the chiseled profile of his model. The essentially planar treatment of the hair contributes to a sculptural effect, while the lighter values lend softness to the beard.

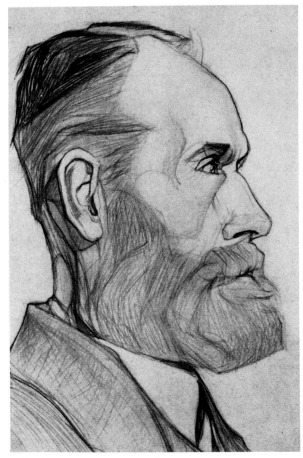

307. Josef Albers (1888–1976; German-American).
Man in Profile. 1914. Pencil, 14⅜ × 10″ (37 × 26 cm).
Collection Anni Albers and the Josef Albers
Foundation, Inc.

308. Chuck Close (b. 1940, American).
Self-Portrait/Conté Crayon. 1979. Conté crayon on paper,
29½ × 22″ (75 × 56 cm). Private collection.

William Michael Harnett's charcoal drawing *Portrait of a Young Girl* (Fig. 296) exemplifies the best qualities of 19th-century academic tradition—solidly realized form and modeling of exceptional delicacy. The nuances of texture have been rendered with amazing fidelity, the softness of skin, hair, and wool shawl contrasting with the sharply defined profile and the accented clarity of the eye. Without deviating from his intended objectivity, Harnett has created an image of haunting intensity.

We often equate pure objectivity with "photographic likeness," and indeed the meticulous realism of the Harnett drawing (Fig. 296) bears strong similarity to a photograph. Chuck Close's *Self-Portrait* (Fig. 308) appropriately can be termed a photographic likeness since it is a transcription of a photograph. Working with two grids—one superimposed over a photograph he selected to reproduce, the other an enlarged grid on a sheet of drawing paper—Close methodically analyzes and summarizes the tonal value of each square of the photograph, then duplicates it with a scribbled tone. He has created similar grid portraits with dots the size of the end of a round pastel crayon. With both methods, the resulting images bear strong resemblance to photographs as reproduced in newspapers.

The technical triumphs of each age provide special problems and special opportunities. One might think that television and photography would eliminate the need for the objective portrait sketch, but this is not entirely the case. Television news programs often rely upon courtroom artists, not only because until recently television cameras were not admitted, but also because artists skilled in portrait sketching can provide more incisive characterizations than the camera; these sharpen and add variety to the reporting.

Police artists have begun to play an increasing role in the apprehension of criminals. Relying upon visual recall and verbal descriptions of victims and witnesses, they fashion a likeness of the perpetrator of the crime, often with amazing accuracy.

Project 15.9 For an exercise in objective portraiture, you might find the "weathered" face of an older model easier to draw than the smooth features of a young person. Make your initial sketch in medium-hard pencil, measuring and checking frequently for verisimilitude. Work slowly and carefully. Gradually strengthen forms and add textures. If you do not comprehend the subtleties of some feature, examine it at close hand, perhaps making a separate study of that form. Use softer pencils for the modeling and a very soft, very sharp pencil for the dark accents in eyes, nostrils, hair, and so forth.

The Idealized Portrait

Idealization in portraiture can take many forms but in general means a structuring of features to conform to a concept of perfection and minimizing of all irregularities.

The major problem of drawing an idealized portrait involves achieving a resemblance that satisfies the sitter as a "likeness" and at the same time irons out the less ideal aspects of the face. Ingres had this amazing capacity, as evidenced in his portrait of Doctor Robin (Fig. 192), which creates the illusion of an objective likeness, exact and precise, yet careful examination reveals clear idealization—perfect symmetry of feature, smooth sculptured form, and flawless skin.

Picasso deliberately fashioned his *Portrait of Madame Georges Wildenstein* (Fig. 309) after the drawings of Ingres. He has re-created the same detailed and idealized rendering of the head, the same linear description of the subject's dress and the chair. Somewhat more casual, but no less elegant, is David Hockney's *Celia in a Black Dress with White Flowers* (Fig. 310). Although Hockney seems to place emphasis on the positive-negative aspects of the richly varied interlocking shapes of the flowers and dress, attention ultimately centers on the delicately drawn head with its blending of likeness and idealization.

Project 15.10 Draw an idealized portrait, either of yourself or a sympathetic friend (Fig. 310). Determine how best to flatter your model without loss of likeness. Anyone harboring a desire to be a professional portrait artist would be well advised to focus particular attention to this project. Be certain to use a flexible and easily erasable medium such as soft pencil, charcoal, or chalk. None of the idealized portraits discussed are large drawings, and because each includes the body, the heads are relatively small. Should you also want to include the figure, it is suggested that first you practice drawing just the head, making it large enough so that the features are not small and cramped.

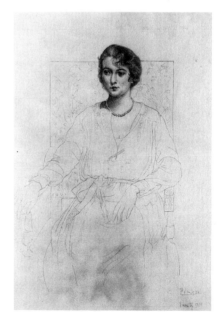

309. Pablo Picasso
(1881–1973; Spanish–French).
Portrait of Madame Georges Wildenstein.
1918. Graphite on white paper,
13¾ × 9½" (35 × 24 cm).
Private collection.

310. David Hockney
(b. 1937; English).
*Celia in a Black Dress
with White Flowers.* 1972.
Crayon, 17 × 14" (43 × 36 cm).
© David Hockney 1972.

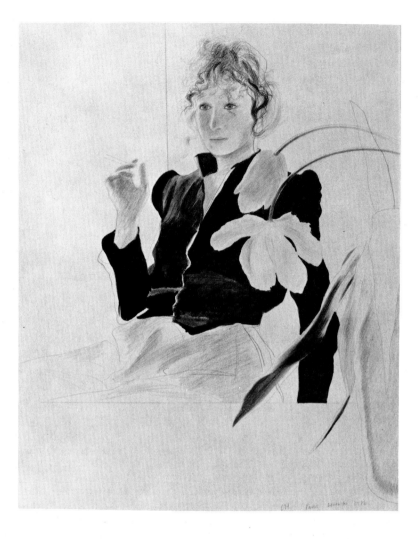

The Psychological Portrait

Some drawings seem mostly to record externals (Fig. 192), while others create the illusion of penetrating the surface to reveal inner aspects of personality—tensions, withdrawn self-sufficiency, or warmth and sociability. Many of the portraits already seen have included visual clues that explore character as well as appearance. The variety with which artists are able to reveal personality traits, their own and others', is one of the most fascinating aspects of portraiture.

Walter Sickert portrayed the famous English caricaturist Max Beerbohm as a warm, sympathetic observer of life (Fig. 311). The raised brows, heavy-lidded eyes, and slightly open mouth all seem to describe an inner life as much as they do external appearances. The raised hand adds an accent as though Beerbohm needed a gesture to give full meaning to his words.

The very turbulence of the crayon scribbles with which Oskar Kokoschka has drawn his *Portrait of Olda* (Fig. 312) creates a disturbing mood, which is intensified by the abstracted look in the eyes, the crooked mouth, and the thoughtful pose. The rather unusual combination of free execution, suggesting the artist's spontaneous approach

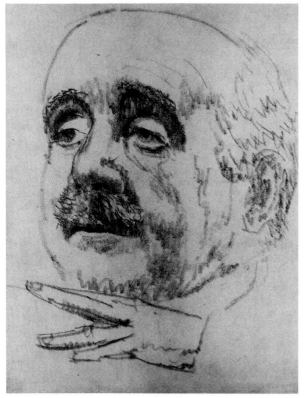

311. Walter Sickert (1860–1942; English).
Sir Max Beerbohm. Pencil on cream paper.
Sotheby Parke-Bernet.

312. Oskar Kokoschka (1886–1980; English). *Portrait of Olda.* 1938. Blue crayon, 17¼ × 13⅞″ (44 × 35 cm). Allen Memorial Art Museum, Oberlin College, Ohio (R. T. Miller, Jr., Fund).

to the act of drawing, and the sense of the subject as a tense, withdrawn personality seems paradoxical. The sensitivity of Kokoschka's perception is evidenced in his selective delineation of features, the hair and collar being drawn more emphatically than the subject's eyes. Olda's introspective nature, in contrast to Sir Max Beerbohm's outward focus, is immediately apprehended.

Alice Neel draws with power and subtlety. In her portrait of *Adrienne Rich* (Fig. 313), the bright, alert eyes and controlled smile provide a clue to the tenor of the subject's thoughts. The entire pose, reinforced by the loose, easy drawing suggests an introspective, yet relaxed bemusement.

Gwen John's study of her friend Chloe Boughton-Leigh (Fig. 314) appears to be an acute perception of character as well as an accurate description of appearance. John skillfully creates the impression of a young woman little concerned with fashion or appearance, a person who, at least as she poses, seems untouched by the world. A subtle change from the free, fresh treatment of pencil line and gray wash, so appropriate for suggesting the formless dress and the hair in unconcerned disarray, to the more controlled definition of the face combine to create a quietly fascinating image.

Project 15.11 Figures 295, 313, and 314 are similar in subject, but the character and mood of the drawings are very different and can be credited only in part to the individuality of the subjects. To a much

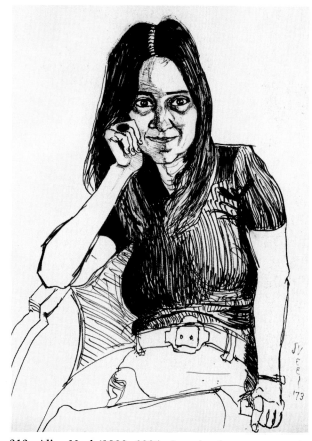

313. Alice Neel (1900–1984; American).
Adrienne Rich. 1973. Ink heightened with
Chinese white, 30 × 22″ (76 × 56 cm).
Courtesy Robert Miller Gallery, New York.

314. Gwen John (1876–1939; English). *Bust of a Woman
(Study of Chloe Boughton-Leigh)*. c. 1910. Crayon and wash,
9⅝ × 7½″ (24 × 19 cm). Albright-Knox Art Gallery,
Buffalo, N. Y. (gift of A. Conger Goodyear, 1953).

greater extent, the difference derives from the ability of each artist to
recognize the most natural pose and revealing expression, and to select
media and technique suited to subject and mood. Study the three draw-
ings, noting the total appropriateness and expressiveness of each.

As you gain confidence in your ability to render a likeness objec-
tively, begin to introduce a note of subjectivity, allowing your drawings
to reflect more than the external characteristics of your subject. Try to
find the means to respond to the personality of your model in ways
that are visually expressive.

Often the personality of an individual is revealed as much
through "body language"—posture and gestures—as with facial char-
acteristics. One knows in looking at Catherine Murphy's drawing of
Harry Roseman Working on Hoboken and Manhattan (Fig. 315) that the
model builder possesses the patience to sit for endless hours engaged
in the most detailed work. Interestingly, Murphy's drawing technique
demonstrates the same dedication and patience.

Theophilus Brown apparently found far greater visual interest
in the pose of fellow artist Mark Adams (see Fig. 295) than in the very
ordinary seated pose of the model (Fig. 316). With little more than a
simple direct contour drawing of the figure in silhouette, Brown pro-

315. Catherine Murphy
(b. 1946; American).
*Harry Roseman Working on
Hoboken and Manhattan.* 1978.
Pencil, 13¾ × 11″ (35 × 28 cm).
Courtesy Xavier Fourcade, Inc.,
New York.

316. Theophilus Brown
(b. 1919; American).
Mark Adams Drawing. 1985.
Pencil, 11½ × 14½″ (29 × 37 cm).
Courtesy the artist.

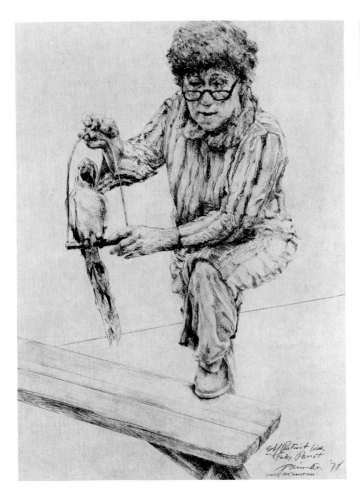

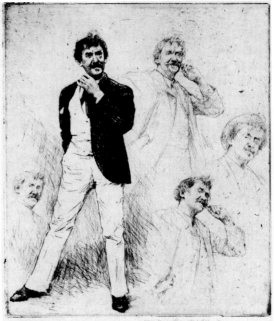

left: 317. Joyce Tremain (b. 1922; American).
Self-Portrait with Fake Parrot.
1978. Pencil, 29⅝ × 22″ (76 × 57 cm).
Art Institute of Chicago
(gift of Fairweather-Hardin Gallery, 1978).

above: 318. Mortimer Menpes
(19th century; American).
Whistler: Five Studies. Drypoint,
6¾ × 6″ (17 × 15 cm). New York Public Library
(Astor, Lenox and Tilden Foundations).

vides an immediately recognizable full-length portrait of Adams standing at his easel in a pose of unaffected naturalness and ease, but one of total concentration on the act of drawing. The drawing communicates a strong sense of individuality even to those who do not know Adams.

While posing with a fake parrot may appear to be either eccentric or contrived, in Joyce Treiman's self-portrait (Fig. 317) it seems quite natural. The quietness of the drawing is deceptive; at first glance it appears as an exercise in objective reporting. Gradually one begins to see traits of character revealed in the pose—thoughtfulness, commitment, determination, self-assurance, and vitality, well centered and supported by the foot firmly resting on the bench.

In decided contrast, the unabashed posturings of the artist J. A. M. Whistler, delightfully recorded in an etching by Mortimer Menpes (Fig. 318), are clearly those of a colorful eccentric, who was described as a man of "engaging arrogance."

Caricature

Webster's dictionary defines caricature as "a picture in which certain features or mannerisms are exaggerated for satirical effect." While in many kinds of portraiture the minor eccentricities and idiosyncratic

details of feature and expression are minimized (or almost completely eliminated as in the idealized portrait), such elements provide the essence of caricature. Caricature demands a special talent for selecting and sharpening telling details of feature, head shape, posture, and particularly expression. Many portrait artists cannot caricature; many caricaturists cannot do a "straight" portrait.

Like all satire, caricature can be humorous and kindly, mordant and biting, or almost ribald in the gusto with which it depicts its subject. Visual recognition remains the essential ingredient of successful caricature, and for that reason most caricaturists focus their attention on well-known public personalities, particularly politicians, who are often almost savagely caricatured in the printed news media.

The particular genius of the caricaturist has rarely received more brilliant expression than in the drawings of David Levine (Fig. 319). Less than a month following the 1980 presidential election, Levine's interpretation of the victorious Ronald Reagan preparing to assume the presidency beamed from the cover of a national periodical. The eyes, cheeks, and expansive crooked smile could be recognized immediately, yet there was something unfamiliar about the image. Levine, obviously responding to the repeated jokes about the true color of Reagan's hair, has depicted him white haired and wrinkled, seated before a theatrical mirror, an ample assortment of makeup containers before him. The delicacy with which the lipstick is held perhaps suggests the deftness with which the makeup is to be applied. Levine's use of cross-hatching to emphasize features and create volume has been widely imitated.

Entertainers have always provided a special attraction for artists and public alike. Toulouse-Lautrec's drawings, paintings, and posters immortalized the colorful and eccentric Parisian music hall performers who were his friends (Fig. 289). "For Heaven's sake, don't make me so atrociously ugly," pleaded the horrified cabaret singer Yvette Guilbert when she first saw Toulouse-Lautrec's sketch for her poster

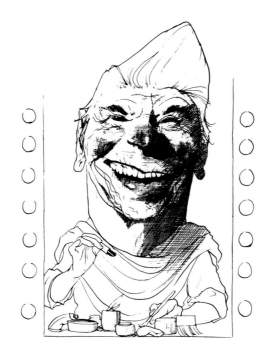

319. David Levine (b. 1926; American). *Ronald Reagan.* Reprinted with permission from *The New York Review of Books.* Copyright © 1980 Nyrev, Inc.

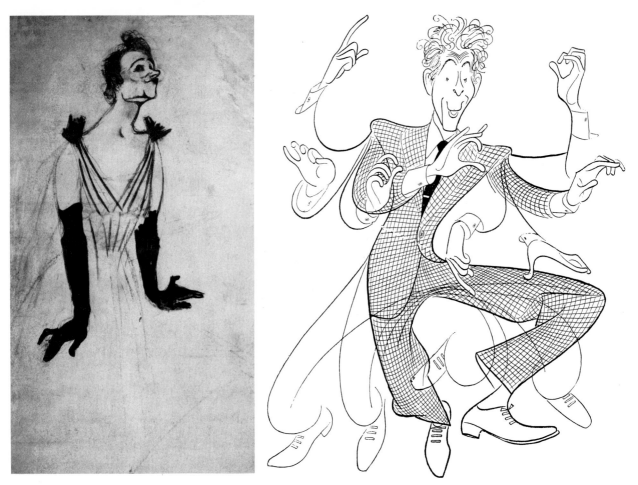

above: 320. Henri de Toulouse-Lautrec (1864–1901; French). *Yvette Guilbert,* study for a poster. 1894. Pencil and oil on paper, 7¼ × 3⅝″ (19 × 9 cm). Musée Toulouse-Lautrec, Albi.

above right: 321. Al Hirschfeld (b. 1903; American). *Danny Kaye at the Palace.* 1953. Pen and ink, 30 × 24″ (76 × 61 cm). Reproduced by special arrangement with The Margo Feiden Galleries, New York, © 1953 Al Hirschfeld.

(Fig. 320). Later, when critics praised his interpretation and she realized the value of the poster to her continued popularity, her wounded vanity was considerably healed. The sketch reveals the artist's fascination with Yvette's ugly grace as he captures every nuance of feature and gesture. One cannot but take delight in the contrast between her almost clownlike makeup and the affected elegance of her pose.

The world of Broadway theater would be incomplete without the talents of Al Hirschfeld. For the past half-century his sure, witty pen has witnessed every major, and sometimes not so major, theatrical event and has portrayed stars of major and minor magnitude. Hirschfeld explains that the essence of a performer is revealed only in performance (Fig. 321). Only by observing comedian Danny Kaye in action would it be possible to conceive of the rhythmic patterns of multiple images that convey the frenetic gracefulness of his movements—six feet, eight elegantly expressive hands, and one head drawn in such a manner that it, too, seems more than a single image.

Project 15.12 If you have not attempted a caricature, do so now. Regular features allow less potential for exaggeration than do strongly distinctive or irregular features. Distortion often serves as the basis for caricature. If you are working from life, it is best to study your subject engaged in conversation or some other activity, for it is then that traits of character and individuality are revealed.

Synthesis in Drawing

Illustration

*Illustration is as old as civilization itself,
writing having originated in easily recognized
object drawings known as pictographs.*

Perhaps the most encompassing definition that can be given for illustration is "visual language." If we accept that interpretation, any drawing or painting that communicates information, ideas, or feelings could be labelled illustration. Art that emphasizes storytelling is often described—and sometimes dismissed—as being "illustrative."

Illustration versus Fine Art

The distinction between illustration and fine art developed early in this century out of the clash between the traditional literalism of illustration and the modern art movement. For more than half a century the art of illustration developed more or less independently from fine art. The difference between the two fields was perhaps greatest during the late 1940s and 1950s, which were dominated by nonrepresentational art. Today there is little difference. Illustration reflects a full range of contemporary art styles at the same time that fine art evidences a renewed interest in figurative and representational elements. This apparent merging of the two areas seems to have started in the 1960s, when leading Pop artists began to introduce elements of illustration into their paintings and major corporations began to use works by prominent contemporary artists in their advertising. Van Howell has cleverly blended the two—fine art and illustration—in Figure 322 by allowing the head and hand of artist Mark Rothko to emerge from the familiar hovering rectangles typical of a Rothko painting.

Many drawings done as illustrations fit easily into the category of fine art and are exhibited and collected as such. Why then the notion

322. Van Howell. (b. 1948; American)
Rothko. 1980–82. Pen and ink,
9¾ × 7½" (25 × 19 cm).
Courtesy the artist.

MARK ROTHKO VAN HOWELL

that illustration and fine art must be viewed as separate, and not necessarily equal, art forms? Many major artists have worked as illustrators. Edouard Manet, a pivotal figure in the history of modern art who demanded for artists the freedom to work in the style of their own choosing, did illustrations for a French translation of Edgar Allen Poe's *The Raven*. Among Toulouse-Lautrec's best-known works are the cabaret and music hall posters he designed. A century later Jane Avril (Fig. 289), Yvette Guilbert (Fig. 320), and other such colorful, often eccentric, entertainers continue to draw capacity audiences to auction houses when original copies of his posters come up for sale, and to museum bookstores, where sales of reproductions of the posters flourish.

A technical distinction between "illustration" and "fine art" is that the former is created expressly for the purpose of commercial reproduction. Being concerned primarily with reproduction, illustrators often select media and techniques based on the way they will reproduce, rather than from any consideration of permanence. The circumstances in which the works are created also contribute to the

notion of a separation. While the fine artist works independently, choosing when, what, and how to draw, generally without having to please anyone else, the commercial illustrator works under the guidance of an art director, must be concerned about how the work will reproduce, has to meet a deadline, and is responsible for satisfying a client. Beyond that, the illustrator must create an image that will be understood by the greatest number of viewers. "You've got to please both the art editor and the public," lamented the legendary Norman Rockwell. "This makes it tough on the illustrator as compared with the fine artist, who can paint any object any way he happens to interpret it." (It seems appropriate to point out, however, that until late in the l9th century, most artists could be considered commercial artists in that they worked by commission and were responsible for satisfying their patrons.)

One additional significant difference is that most illustrations are presented in conjunction with text in some form, whether it be an article, story, or advertising copy. Although illustrations can be appreciated for imagery and technique, they cannot always stand alone when viewed out of context. Fine art, in contrast, while it might refer to something outside itself, is meant to be complete in itself.

Types of Illustration

The purpose of this chapter is to introduce students to illustration, the area of commercial art most closely related to fine art. A survey of different types of illustration, including a brief discussion of the purpose and requirements of each, will reveal that *A Guide to Drawing* offers a basic prerequisite course for illustrators as well as for fine artists. The illustrations reproduced are but a sampling of the remarkable range of drawings done in this diverse field. No attempt has been made to select only recent examples; like fine art, that which is fashionable changes from year to year. For an expanded look at the richness and variety of contemporary illustration, you will want to linger over the illustration yearbooks that are published annually and skim through all the current magazines in the school library each month to keep yourself informed about what is happening in the field.

Commercial illustration in its various forms now appears to be divided between drawing and painting on the one hand and photography on the other, with an apparent increase in the use of drawing. There are three major categories of illustration—editorial, advertising, and medical and scientific—each making its own demands on the artist. While versatility is an asset, most professional illustrators select an area of specialization.

Editorial Illustration

Editorial illustrations accompany stories and articles in books, magazines, and newspapers. Although guided by an art director, the illustrator must have an awareness of the content and structure of each story and article to ensure that the choice of imagery, style, and technique is compatible with the text and grasps the essential meaning of the piece.

Book Illustration

Nineteenth-century novels were almost always illustrated; today adult books rarely are. Illustrations are confined mostly to book jackets,

323. Edward Gorey
(20th century; American).
"The summer she was eleven,
Drusilla went abroad with her parents."
Illustration for *The Remembered Visit*
(Simon & Schuster, 1965).
Copyright © 1965 by Edward Gorey.

324. Barron Storey
(20th century; American).
Captain Ahab,
illustration for *The Great White Whale*
(Reader's Digest Association, Inc.).
1978. © 1981 Barron Storey.

special limited editions designed for book collectors, and what might be considered "children's books for adults," such as those created by Edward Gorey (Fig. 323) and David Macaulay (Fig. 154).

Book jackets, originally called "dust jackets," were intended simply to protect the covers of books. Today they are designed to attract the attention of buyers and promote sales. Some covers use only type; others add illustration, combining the talents of graphic designers and illustrators to suggest the essence of the book quickly, effectively, and truthfully.

Contemporary book illustrations often depict character and establish mood (Fig. 324) rather than portray specific episodes from the narrative. One of Barron Storey's illustrations for *The Great White Whale* forcefully captures the mood of the book, suggesting the insane obsession of Captain Ahab, who stands defiantly erect against the battering forces of the sea, his ivory leg planted firmly on deck. Storey's handling of pen-and-ink cross-hatching remains very much in the tradition of 19th-century illustrations reproduced by wood engravings. Many contemporary illustrators use similar techniques because line drawings are the easiest and most economical to reproduce.

Illustration originates with and must be true to the words of the author. Good illustration should amplify the text, but should not depend upon a caption to explain its meaning. The interdependence of text and image would seem to require that good illustrators also be good readers.

Children's Books

Children's books, by tradition, are richly illustrated. In fact, much of the success of a children's book depends upon the contribution of the illustrator, since a child's imagination is activated through the combination of verbal and visual imagery. Text and illustrations go hand in hand, the illustrations both follow and advance the story.

A survey of children's book illustrations reveals great diversity of styles. A certain literalness in representation assures visual identification, but this can be accomplished without sacrificing imagination and invention. While children's literature frequently incorporates fantasy and make-believe, successful illustrators are able to treat the commonplace with whimsy, vividness, vitality, and excitement (Figs. 325, 326).

Children are an appreciative but critical audience who expect drawings to be faithful to the text. While free to select style, the illustrator is not free to reinterpret even the most minute detail of the text, as anyone who has ever attempted to satisfy a child's questioning can attest.

Collected works of many of the best-known 19th- and early-20th-century illustrators of children's books are available in paperback editions; the illustrations of Maurice Sendak (Fig. 326) are the subject of a major study. Anyone interested in illustrating children's books should become familiar both with what has been done and what is being done.

Magazine and Newspaper Illustration

While certain book illustrators, such as Edward Gorey (Fig. 323) and Maurice Sendak (Fig. 326), develop a personal style that remains relatively constant from book to book, illustrators of stories and articles for magazines and newspapers are expected to be able to change style

325. Mercer Mayer
(b. 1943; American).
Illustration for *A Special Trick.*
Brown ball-point ink and wash
over pencil, 8½ × 9¼″ (20 × 25 cm).
Copyright © 1970 by Mercer Mayer.
Used by permission of The Dial Press.

326. Maurice Sendak
(b. 1928; American).
Illustration for "The Three Feathers"
from *The Juniper Tree and Other
Tales from Grimm,* translated by
Lore Segal and Randell Jarrell.
Pictures copyright © 1973 by Maurice
Sendak. Reprinted by permission
of Farrar, Straus & Giroux, Inc.

327. Jack Desrocher (20th century; American). *My Wasted Life*, illustration for the *San Francisco Examiner*. 1980. Pencil, width 10″ (25 cm). Courtesy the artist.

almost from one assignment to the next. Change is inherent in all aspects of contemporary life, particularly in the field of mass communication, in which capturing the largest percentage of public attention is, of necessity, the prime consideration.

The illustrator or photographer is often called on to provide a single major illustration to attract the attention of the reader and establish the character of a story or article in an effective and substantially truthful manner. Such drawings often tend to be symbolic, with the meaning immediately perceived when seen in relation to the title of the article (Fig. 327).

The range of articles printed in popular periodicals requires illustrators capable of working with a variety of subjects and versatile in employing media and techniques without allowing technique to become more important than content. A certain boldness is required for drawings to be reproduced on the newsprint used for daily papers (Fig. 327). Because magazines and newspapers focus upon topics of current interest, there is the additional demand of meeting deadlines.

Spot Drawings

Spot drawings attract the attention of readers and provide visual interest for articles and stories that do not feature a major illustration. They are often related to the subject in a general way rather than being specific, as seen in David Suter's clever anthropomorphizing of a lunch bucket and gloves to convey the effect of unemployment for a magazine article entitled "A More Severe Slump" (Fig. 328). *Prayer Feathers* (Fig. 329), drawn as an illustration for a book of poetry, represents an artist's poetic response to verbal imagery rather than being an illustration of a particular poem or lines.

Spot drawings often are used as "fillers"—that is, simply to fill unused space as well as introducing visual interest to a page. Since the need for fillers cannot be anticipated, they usually are unrelated to the

328. David Suter (b. 1949; American). Illustration for "A More Severe Slump," *Time* Magazine. 1980. Felt-tip pen, 10″ (25 cm) square. Courtesy the artist.

329. Daniel M. Mendelowitz
(1905–1980; American).
Prayer Feathers.
1978. Pencil, 8″ (20 cm) square.
Collection Mrs. Daniel Mendelowitz,
Stanford, Calif.

surrounding text and exist as a charming or whimsical bonus of no intended importance. Spot drawings also can be useful for imparting information, as evidenced in the simplified step-by-step drawings common to "how-to" books.

Sports Illustration

The ability to depict movement, excitement, and atmosphere is essential to successful sports illustration, which tends to be a highly specialized field. The sports illustrator must understand sports, and must be knowledgeable about the human figure and be able to represent it convincingly in action (Fig. 330). While the camera is able to freeze the image of figures in motion, photographs often fail to convey the quality of movement and excitement associated with sports precisely because the action has been frozen. In most instances, top sports illustrators are better able to suggest the feeling of energy and movement that fans associate with sports seen live or viewed on television. While sports illustrators frequently use photographs for reference, they have the skill to inject a sense of aliveness and vitality through clarification, simplification, and exaggeration. Robert Handville's dynamic representation of the speed and power of hockey players (Fig. 330) depends more on the energy contained in the strength of his gestural drawing than on detailed accuracy of form. Aspiring sports illustrators should avail themselves of as much life drawing as possible, with particular emphasis upon quick sketching and gesture drawing.

GO, BOBBY! GO—

330. Robert Handville
(b. 1924; American).
"Go, Bobby! Go—."
Illustration for *Sports Illustrated.*
© 1965 Time, Inc.
Reprinted by permission.

Editorial Cartoons and Caricature

There is a long and continuing tradition of political cartoons and caricatures as illustrations in popular periodicals. The brilliant, biting look at the antics of national and world leaders have won Pulitzer prizes for some of their creators.

The impact of editorial cartoons generally results from the successful combination of visual image and caption, sometimes supplemented with dialogue. Political cartoonists depend almost entirely on broadly exaggerated caricature. Since their topics must be as current as yesterday's news, editorial cartoonists work under extreme deadline pressures.

Feeding the public's insatiable appetite for information about the famous and the infamous remains a primary function of popular periodicals. In addition to the ever-present photographs of such personalities, some magazines and newspapers continue the tradition of using caricatures of familiar politicians, literary figures, and entertainers (Figs. 319, 321).

Advertising Illustration

A second major area of commercial illustration embraces everything done for advertising purposes. Fashion, product, and travel illustrations all rely upon visual flattery to arouse consumer interest. Advertising illustrations generally are integrated into a layout that includes headings, copy, and the client's name. Unless the illustrator is also

responsible for the layout, it is necessary to learn to work within a prescribed format to create a visually stimulating ad.

Fashion Illustration

Fashion drawing falls into two categories: **reporting** (Fig. 331) and **advertising drawings** (Fig. 332). Fashion reporting treats fashion as news. It is directed toward revealing new trends in fashion in drawings that convey the general characteristics of forthcoming styles rather than depicting specific garments in detail. Advertising drawings are designed to sell merchandise, and though often highly stylized, they are rendered with considerable concern for accurate detail.

Because the style of representing fashion changes as rapidly as fashion itself, illustrators must be versatile, flexible, and imaginative. Not only must they be up to date, they must also be able to anticipate and initiate change. Strictly literal representation, no matter how well drawn, lacks buyer appeal.

In the fashion field, competition between artists and photographers is keen. Artists have greater freedom to change, exaggerate,

left: 331. Steven Stipelman (20th century; American). Illustration for *Women's Wear Daily.* 1980. Pen and ink. Reproduced by permission of the Fairchild Syndicate.

below: 332. George Stavrinos (20th century; American). Armani (fashion), Descending Staircase. 1985. Pencil, 8⅞ × 12½″ (23 × 32 cm). Courtesy the artist.

dramatize, simplify, add, or eliminate. A skilled artist, working from any model, can totally transform the character of the figure at will.

Training for a fashion artist should include drawing from nude and clothed models. Knowing how the body works in motion and understanding how the figure is constructed permit effective distortion. Figures in fashion illustrations, while rarely realistic, must appear to have an underlying sense of structure, proportion, and balance. Pose, gesture, and movement, while exaggerated, must be convincing and plausible. Both structure and pose determine how a garment drapes, as does the weight and character of the fabric (Fig. 333). A garment must appear to fit; it must follow the contours of the body and appear to move with the body. Although still-life studies of pieces of draped cloth perhaps seem uninspiring, fabric is the "stuff" that fashions are made of. The ability to suggest and render different materials and textures in a variety of media and techniques is a basic requirement for fashion artists.

Fashion illustrators generally specialize in drawing women, men, or children; only rarely do drawings of one include either of the other

333. Ranaldi. Advertisement for Caumont from *Gentlemen's Quarterly*. 1985. Grinta Intntl. Corp., © Ranaldi 1985.

two. Accessories provides an additional area of specialization in fashion illustration. Hats, bags, shoes, scarves, belts, jewelry are, in effect, the province of the fashion still-life artist, who is expected to make such objects stylish and appealing without obvious falsification. This specialty requires an artist skilled at depicting detail and rendering textures and materials with a sense of flair.

Perhaps more than in any other field, one learns about fashion illustration by studying fashion drawings, fashion magazines, and window displays of fashionable stores. It is valuable to accumulate a file of outstanding fashion drawings that employ interesting techniques, as well as photographs of figures for reference.

Product Illustration

The area known as "product illustration" includes almost anything that can be manufactured and offered to the consumer. The illustra-

334. Penelope Gottlieb
(20th century; American).
"As Time Glows By," advertisement
for Brown and Gold Lighting. 1981.
Pencil, 20 × 15″ (51 × 38 cm).
Courtesy the artist.

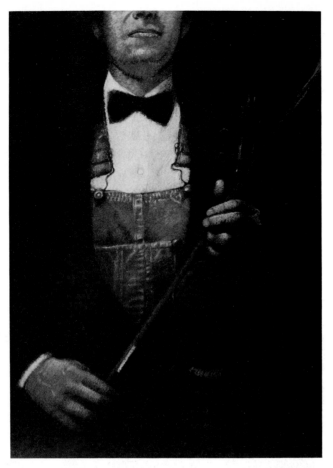

335. Gary Kelley (b. 1945; American). Promotion for Cedar Rapids Symphony. 1982. Pastel, 24 × 18″ (61 × 46 cm).

tor is expected to depict commonplace objects with style, to make them attractive to the public. While the objects cannot be falsified—truth in advertising—they can be idealized and dramatized. An unusual perspective can be introduced to intensify the form, while bold modeling in light and dark and dramatic rendering of surface and textures complete the effect. Standard still-life experiences provide the basis for product illustrations.

A well-known song title, altered by the substitution of a "sound-alike" word, provided the theme for Penelope Gottlieb's imaginative advertising drawing for a combination lighting fixture and ceiling fan (Fig. 334). The combination of the new title—"As Time Glows By"—with images of an upright piano, a smoldering cigarette, and the shadowy silhouette of a figure clad in a trench coat and fedora, was calculated to delight generations of film buffs, especially Humphrey Bogart fans, who immediately would identify the mood of intrigue, danger, and romance with the film classic *Casablanca*.

While in the most literal sense product illustration would seem restricted to depicting objects, illustrations created for record albums and to advertise movies, television programs, and other entertainment events are product related (Fig. 335). Gary Kelly's drawing for the Cedar Rapids Symphony of a symphony violinist wearing bib overalls under formal attire skillfully suggests that agriculture does not preclude culture.

Travel Illustration

The extensive advertising programs of the travel industry require illustrations ranging from elaborate full-color paintings to spot drawings. Styles and techniques are as varied as the services provided; subject matter embraces figure, landscape, and architecture.

Medical Illustration

Medical illustration is "the graphic representation of any medical subject made for the purpose of communicating medical knowledge." Medical illustrators need to have a scientific background as well as extensive art training. Since absolute accuracy is critical, the artist must possess highly trained powers of observation and meticulous draftsmanship (Fig. 199). The artist is called upon to do what a camera cannot do—clarify and simplify, select what is essential to communicate effectively and completely.

Illustrations for articles published in medical journals are prepared in collaboration with surgeons, often from sketches made on location in the operating room as the surgeon describes to the illustrator what is to be revealed. The artist must have both the knowledge and imagination to visualize what is desired and find the most effective means to communicate that information.

A number of major university medical schools offer specialized training in medical illustration, which includes learning to work with doctors in the operating room. Admission requirements include completion of a pre-med program. Interested art students can prepare by taking classes in life drawing, anatomy, still life, perspective, design, composition, rendering, watercolor, and airbrush.

Scientific Illustration

Each of the scientific disciplines has its own needs for illustrative materials. The qualities required for all scientific drawings are accuracy, clarity, and neatness (Figs. 199, 210). Details of form and surface characteristics must be carefully observed and meticulously rendered. Forms must be lighted evenly without obscuring shadows. Stippling is the most common method used for shading.

Art Directors

Illustrators need to be familiar with the traditional areas of subject matter and the art elements; they must use media and technique imaginatively and expressively. It is also necessary to know about methods of reproduction in order to prepare drawings or paintings suitable for the process to be used.

Without a firmly established reputation, an illustrator cannot expect to be granted complete independence in making creative decisions. It is the art director who has major responsibility for determining what an illustration will be. For this reason it is important that art students, especially those who might want to become illustrators, learn to follow assignments, accept criticism and suggestions made by instructors (acting as art directors), be willing to make suggested changes, and complete projects on time. Since most illustrators are required to submit preliminary sketches for approval, students are

urged to adopt the habit of making rough drawings for working out ideas before starting right in on what is to be the finished presentation piece.

Research Resources

Professional illustrators often are called upon to provide drawings for subjects that lie beyond their own personal experience. They must learn to use reference material to search for information that will provide authenticity to their work. It is of incalculable value to know how to use the resources of libraries. Particularly useful to illustrators are picture collections maintained by major libraries. Several indexes also assist in locating published illustrations (photographs, paintings, drawings) on specific subjects. *Illustration Index* (4th ed.) compiled by Marsha C. Appel (Scarecrow Press, 1980) has a cultural and historical orientation. It is of particular value because it indexes eight periodicals likely to be available in most libraries—*American Heritage*, *Ebony*, *Holiday*, *National Geographic*, *National Wildlife*, *Natural History*, *Smithsonian*, and *Sports Illustrated*.

Preparing a Portfolio

If you seek employment as an illustrator, it is essential to prepare and maintain a portfolio with samples of your best work to show agencies, art directors, and potential clients. Never include any drawing with which you are not totally satisfied; it is better to include few drawings of high quality than many of poorer quality. Be extremely selective. Put aside any sentimental attachments you have to particular drawings, and include only your best. It is also important that you keep your portfolio up to date. It is unwise to show all the same drawings if you make return visits to the same people.

Your portfolio should demonstrate both variety and consistency. Select pieces using different media and techniques, but be certain that your own sense of style is evident. If you know what type of accounts an agency or art director handles, you can select pieces that most closely meet those needs.

Include any examples of your work that have been reproduced. If you are an "unreproduced illustrator," it is possible to have some pieces commercially photographed with prints made at a slightly reduced size from the original drawings. A sample of a preliminary rough with the corresponding finished drawing provides an indication of your ability to follow through.

Concentrate on making the best possible presentation. All drawings should be clean, well matted, and easy to handle. Use mats of uniform outer dimensions with openings appropriate to the individual drawings; smaller drawings can be grouped attractively in a single mat. Attach the drawings to a backing board that is the same size as the mat and hinged to it by paper tape. Covering each drawing with acetate is less troublesome than placing protective tracing paper over the complete mat.

Put as much thought and effort into preparing your portfolio as you did into doing the drawings. While it is the art that counts, art directors are influenced by the quality and degree of imagination evident in your presentation.

Expressive Drawing

If the subjects I have wanted to express have suggested different ways of expression, I have never hesitated to adopt them . . .

—Pablo Picasso

Frequent mention has been made throughout the preceding chapters to the expressive qualities of drawing in the context of specific topics—the elements of art, media, and subject matter. The selection of most of the drawings reproduced, in fact, was prompted as much by degree of expressiveness as by topic considerations. Although some drawings fit into very specific slots, good drawings are rarely limited to a single context. Most of the drawings in the book could have been reassigned with equal effect to other chapters, and almost all could be included in this chapter, titled "Expressive Drawing."

Except for purely technical drawings in which all suggestion of individual style is deliberately avoided, a degree of expressiveness usually is evident even in what is intended as a completely objective drawing—admittedly more so in some than in others. What distinguishes drawings one from another is the degree to which viewers respond beyond mere recognition. This relates to the degree to which the artist goes beyond simple description of form or subject to reveal an attitude, perhaps an emotion, not only about the subject but also about the experience of seeing and the process of manipulating media.

Empathy

The legendary early-20th-century American painter-teacher Robert Henri pointed out to his students that "artists have been looking at Rembrandt's drawings for three hundred years," and in spite of all the "remarkable drawings" done since then, we are not yet done looking

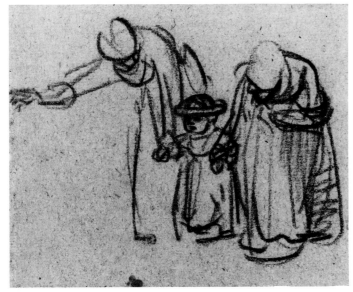

above: 336. Rembrandt (1606–1669; Dutch).
Two Women Teaching a Child to Walk. c. 1640. Red chalk,
4 × 5″ (10 × 13 cm). British Museum, London
(reproduced by courtesy of the Trustees).

right: 337. Isabel Bishop (b. 1902; American). *Conversation.*
1942. Etching, 6⅞ × 4⅞″ (18 × 12 cm).
Courtesy Associated American Artists, New York.

at them. Henri's suggestion that "the beauty of [Rembrandt's] lines
. . . rests in the fact that you do not realize them as lines, but are only
conscious of what they state of the living person," is beautifully dem-
onstrated in *Two Women Teaching a Child to Walk* (Fig. 336). The draw-
ing reveals Rembrandt's sensitivity to human gesture and the extraor-
dinary economy with which he reveals subtle and tender emotions.

Rembrandt, a dedicated observer of humanity, rarely depicted
anything that could not be found within a few hundred feet of his
doorstep, but within that microcosm existed a full spectrum of human
drama that he recorded with a sensitivity, honesty, and integrity that
transcend time and place. Rembrandt drew and painted out of **empa-
thy,** which is characterized as the capacity to identify with the subject,
to conceive and share feelings and experiences, and to project this
sympathetic attitude through the work of art.

Empathy is the ability to externalize feelings, to give meaning to
the commonplace. The warmth with which Isabel Bishop captures the
hand-on-the-shoulder familiarity of the two women in *Conversation*
(Fig. 337) allows the viewer to feel a sense of shared intimacy, casually
observed without intrusion. Empathy extends beyond the artist's re-
sponse to subject matter, whether people, places, events, or experi-
ences; it also embraces the artist's response to the media selected and
to the act of drawing. It is impossible for someone knowledgeable
about art not to respond to the fresh, unlabored quality of Bishop's
line, and delight in the process of drawing as did the artist herself.

It was pointed out in Chapter 12 that students frequently strug-
gle needlessly against the belief that what they draw must be "artistic."
They confront a corresponding dilemma with the concept of "expres-

sive," often confusing it with "emotional."

The images of Käthe Kollwitz (Figs. 338, 119), mirror the sorrow of her life and times with such intensity that one is easily tempted to say categorically: "Käthe Kollwitz *is* expressive drawing." Drawings can be expressive, however, not because they are highly charged emotional statements, but simply because they communicate an individual point of view and purpose. Lacking as it does any visible sense of drama or emotion, Giorgio Morandi's *Still Life* (Fig. 339) might not readily be accepted as "expressive." It is, in fact, difficult to convince beginning students that an expressive drawing or painting can be made from so very little, from objects of such apparent insignificance, yet Morandi, with his unique and quiet talent, has done just that. Drawing out of deep respect for and attachment to the humble objects with which he shared his creative life, Morandi produced images as free of pretention and ostentation as he was himself.

What one "feels" about a subject need not be emotion. It might be interest in the space that a subject occupies, or a response to line, movement, volume, or patterns of light and dark, whatever offers the greatest visual interest, with individual artists reacting differently to the same subject. Eduoard Vuillard, for example, saw his studio—described as ". . . a jumble of furniture, household objects, half-finished works and other paraphernalia . . ." that included a full-size cast of the Venus de Milo—with an empathy that no other person could because it was his own (Fig. 340). The open, meandering soft pencil lines, drawn ". . . with a hand that is as sure as it is light," according to one critic of the period, reveal much about the artist and his feelings. The French author André Gide said, "I know few works where one is brought more directly into communion with the [artist] . . ." and went on to describe Vuillard's style as ". . . caressingly tender, I might even say timid . . ." Equally personal and expressive, both as a drawing and as a space, is Edwin Dickinson's *Studio* (Fig. 108).

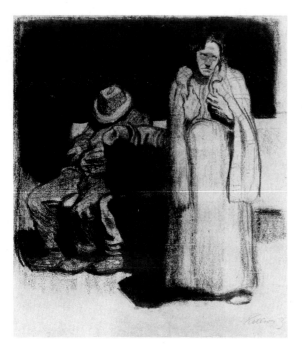

left: 338. Käthe Kollwitz (1867–1945; German). *The Homeless.* 1909. Charcoal and wash, 13¾ × 12½" (35 × 32 cm). National Gallery of Art, Washington, D. C. (Rosenwald Collection).

above: 339. Giorgio Morandi (1890–1964; Italian). *Still Life.* 1954. Pencil, 9 × 12" (23 × 31 cm). Private collection.

340. Edouard Vuillard
(1868–1940; French).
Interior of the Artist's Studio. c. 1897.
Pencil, 4½ × 7″ (11 × 18 cm).
Courtesy Richard L. Feigen & Co.,
Inc., New York.

There are some who suggest that a distinction exists between representational and expressive drawing; others, while agreeing that all representational drawings are not expressive and that all expressive drawings need not be representational, can see no reason to separate the two. Drawings can be and frequently are both.

Artist or Dilettante?

Learning to draw, learning to see size, shape, and space relationships, learning to manipulate and control media and technique, and master the basic skills of drawing as a means to achieving expressive drawing involves hard work. It requires developing an attitude about being an artist, an attitude that accepts every experience related to drawing as valuable, an attitude that respects both the tools and the process of drawing. It is important, even if you are a beginning student, to decide whether you are willing to make a commitment to being an artist or whether you are content to be a dilettante who dabbles in art. The sampling of drawings in this book represent the product of intense involvement by artists whose mastery of the means of drawing allows them freedom of expression in responding to all that they experience— visually, physically, emotionally, and imaginatively.

A critic commented that Degas seemed "continually uncertain about proportions" when he drew the human figure. The artist agreed that the criticism described exactly what he experienced as he drew. Although recognized as one of the supreme figure artists of any age, Degas knew no easy formulas for drawing the figure. Each drawing demanded total concentration on the tilt of a head, the lifting of a shoulder, the manner in which a book is held, the way in which only a portion of a figure's weight is supported by an umbrella, the silhouette of a coat (Fig. 341). Perception? Most certainly, also empathy—an empathy that in the case of Degas was rarely tendered toward the subject in a personal sense, but to the human figure as a form to be drawn.

What impresses is the amount of drawing serious artists do, much of which no one but the artist ever sees. Cézanne left over

341. Edgar Degas (1834–1917; French). *Two Studies of Mary Cassett or Ellen Andrée in the Louvre.* 1879. Charcoal and pastel on gray paper, 18¾ × 24¾″ (48 × 63 cm). Private collection.

twelve hundred drawings, Rembrandt at least fifteen hundred. It is believed that Modigliani ". . . did as many as one hundred fifty drawings in a day." We are told that Giacometti drew constantly, that drawing was a way of life for him.

When Jennifer Bartlett rented a "memorably hideous" villa in the south of France during what proved an unpleasantly cold, wet winter, it was the inner need to be creatively involved rather than external inspiration that prompted a remarkable series of drawings. After rejecting the idea of attempting to paint under such conditions, Bartlett purchased a stock of paper (each sheet approximately 20 by 26 inches, or 51 by 66 centimeters), plus a full array of wet and dry drawing media. One day she picked up a pencil and having nothing particular to draw, made a drawing of the villa's dilapidated garden, which she could see from a full-length window in the dining room. It was to be the first of almost two hundred drawings of the garden that she did during the next fifteen months. Figure 124 is #12 from the series, Plate 9 (p. 172) is #122.

Responding Subjectively

Considerable emphasis has been focused on learning to see as a fundamental aspect of learning to draw, yet it is possible for artists to become so caught up in recording what is observed that they fail to respond to the subject. Just as some people learn to play musical instruments with technical facility, but without feeling or warmth, so too do some artists develop the necessary proficiency to draw well, but their drawings lack personal expression and interpretation. Once perceptive abilities have been developed and technical proficiency with media and techniques has been gained, one is free to begin drawing subjectively rather than objectively, with the ultimate goal of responding naturally and intuitively, without consciously having to decide how to respond.

Making Choices

Whistler decried "the purposeless copying" of every detail; Matisse cautioned, "What does not add to a [drawing] detracts from it." Selection and discrimination are an important part of expressive drawing; every line, shape, form, value, color requires judgment and thought—before the pencil is put to paper, during the process of drawing, and after the work is finished.

Any creative act depends upon the making of choices. The intent of *A Guide to Drawing* is to introduce the student to a broad range of options and provide an awareness of how to exercise those options. *What choices to make, however, are decisions that belong to the artist alone, and that is something which cannot be taught.* Too frequently, students plunge into drawing without taking time to question themselves about the best viewpoint, the most appropriate media and technique, or how they feel about the subject and what they want the drawing to convey. A few minutes of thought and observation before actually beginning to make marks on the paper will greatly influence the end product, but not dictate it. It is possible to begin drawing with a fully formed concept, only to discover other ideas emerging along with the images on the paper. Mature artists remain ever alert and receptive to such impulses which call intuition and imagination into play.

Looking at how three contemporary American artists—Wayne Thiebaud, Manuel Neri, and Willem de Kooning—depict a centrally placed female figure in a standing frontal position allows us to see how different individual responses can be to the same subject, pose, and composition. Thiebaud's *Standing Figure* (Fig. 342) appears, at first glance, to be straightforward objective drawing. Thiebaud acknowledges an "academic" approach to figure drawing—his skillful use of traditional chiaroscuro creates three-dimensional solidity; the cast shadow anchors the figure firmly to the ground plane, even though the space itself remains undefined; strong dark accents isolate the figure from an almost pure white background. The drawing, however, is not "purely objective." He has made certain choices that make the drawing unique. Perhaps the most interesting is the distance at which he has positioned the woman behind the picture plane. Whether a deliberate or intuitive choice, it sets up a condition that involves the viewer in a very different way than does Manuel Neri's drawing *Mary Julia* (Fig. 343). Neri's faceless woman, thrust against the picture plane, creates an almost overwhelming sense of physical and psychological proximity, the impact made all the more emphatic by the dramatic black background. Neri explains that he draws ". . . to put down ideas for sculpture—gestures, positions, proportions . . ." It is difficult to determine whether the arms of his figure are placed behind her back, or whether, like a piece of ancient Greek sculpture, she is armless. Neri's expressionistic style permits such ambiguity, whereas Thiebaud's figure would appear incomplete without arms.

The physical presence of a model is so strongly felt in both drawings that the viewer can easily identify the combined activity of looking and drawing. The figure in Willem de Kooning's *Woman* (Fig. 89) serves only as a point of departure for his powerful, gestural calligraphy. Paul Cummings of the Whitney Museum of American Art points out that de Kooning ". . . does not produce presentation drawings, that is, refined, complete pages made for their own sake. Most of his drawings occur in the process of evolving a vocabulary of images and strokes to be used in [his] paintings." Cummings added that de

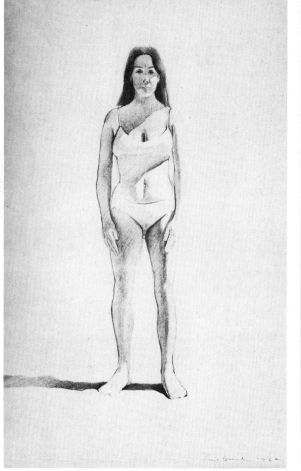

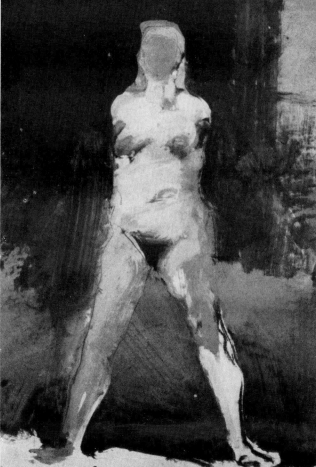

Kooning's ". . . mastery of [media] allows him to concentrate on the act of drawing."

By constantly making drawings artists gain an understanding and control of their means that allows complete freedom and certainty in their response to visual stimuli. While some people learn to draw with less effort than others, very few artists can claim to have been born knowing everything about art, as Gertrude Stein suggested of Picasso, and even those who think they were must learn to focus and discipline their natural talents. For others it requires a more conscious and systematic dedication to mastering basic skills that provide the means for expression. Matisse commented that he always wanted his work ". . . to have the lightness and joyousness of a springtime which never lets anyone know the labors it has cost." The facility to draw seemingly without effort is, in effect, the reward for those labors.

More than Technique

Mastery of media and techniques facilitates expressive drawing, but drawing is dependent on more than flashy technique, and cleverness. Choosing to adopt the style of someone else often results in self-

conscious and mannered drawing; attempting to be "artistic" often results in an equally self-conscious and contrived drawing.

It is particularly important for students to be receptive to new ways of seeing and new ways of drawing. Studying the methods of others and working as they do, as has been suggested before, is a valid learning experience that introduces new ways of seeing and thinking. Young artists are cautioned that while style and technique can be imitated quite easily, imagination, intuition, emotions, attitudes, and accumulated knowledge and experience cannot, and it is precisely from those intangible and elusive elements that individual style and expression are born. Style is more than talent, skill, and sleight of hand; it evolves from an individual's own being. Style is not dependent on complete originality, but on total individuality, manifested in a unique image that reveals a subject as it is perceived by one artist alone. As Picasso explained, he either chose or invented a style appropriate to that which he wanted to express. The diversity of his styles is suggested, at least in part, by the variety of his drawings selected for this edition.

A comparison of Eugène Delacroix's *Arab Dancer* (Fig. 344) and Willem de Kooning's *Man* (Fig. 345) reveals an almost identical handling of line, but to totally different effect—Delacroix's dancer an image of lightness, fluidity, and grace; de Kooning's man clumsy, his movements uncontrolled. Philip Guston's *Ink Drawing* (Fig. 10) shares the same character of line without any apparent reference to recognizable subject matter.

Although Van Gogh's letters to his brother Theo document the struggle he endured in learning to draw, his early pieces have an

below left: 344. Eugéne Delacroix (1798–1863; French).
Arab Dancer. c. 1832.
Pen and ink, 7½ × 6″ (19 × 15 cm).
Museum Boymans–van Beuningen, Rotterdam.

below: 345. Willem de Kooning (b. 1904; Dutch–American).
Man. 1974. Charcoal and traces of oil paint on paper mounted on canvas, 4′3¾″ × 3′5½″ (1.31 × 1.05 m)
Courtesy Xavier Fourcade, Inc., New York.

intensity of expression in spite of, or perhaps because of, their awk-
wardness and lack of facility. Van Gogh approached all subjects—
landscapes, still lifes, figures—with equal fervor, with a sense of total
identification. In a drawing dating from his early dark Dutch period,
Van Gogh describes the stark and barren *Winter Garden at Nuenen* (Fig.
346) in an essentially literal way, in contrast to the frenzied convolu-
tions of *Grove of Cypresses* (Fig. 347), which are pure invention, the
expression of his own personal torment.

Imagination and Expression

Van Gogh stated that he never drew *from* imagination, but he almost
always drew *with* imagination. Just as the external world provided the
basis for Van Gogh's imaginative interpretations of experience, so too
can the art elements—line, texture, pattern—stimulate imaginative
activity. Oskar Kokoschka, it would seem, was as interested in playing
with line as he was with capturing the likeness of poet Herwath
Walden (Fig. 348). Invention, improvisation, and imagination assume
a greater role in Joan Miró's *Self-Portrait* (Fig. 349) than does observa-
tion. Although depicting himself with serious demeanor, Miró en-
gages in imaginative play as legitimate artistic expression. Any famil-
iar shape or object can provide the subject for visual improvisation in
the same way that a simple melodic theme can initiate elaborate musi-
cal invention.

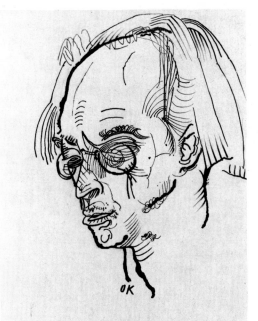

left: 348: Oskar Kokoschka (1886–1980; Austrian).
Portrait of the Poet Herwath Walden. 1910. Pen and ink.
Fogg Art Museum, Harvard University, Cambridge, Mass.
(bequest of Meta and Paul J. Sachs).

below: 349. Joan Miró (1893–1986; Spanish). *Self-Portrait*.
1938. Pencil on canvas, 4′9½″ × 3′2¼″ (1.46 × .97 m).
Museum of Modern Art, New York (James Thrall Soby bequest).

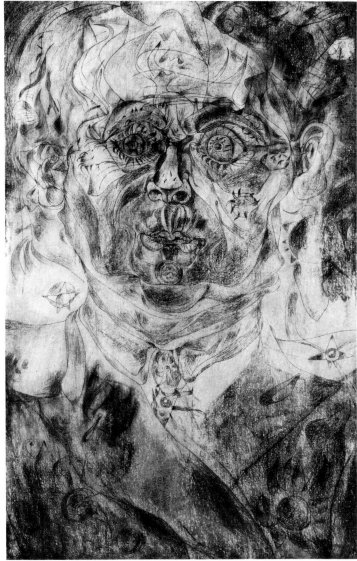

Imagination and expression are manifested not only in *how* and *what* one draws, but also *with what* one draws. Artists have been encouraged to explore new uses and combinations of materials by the great expansion of media resulting from modern technological developments. All challenge artists' inventive powers, but the abundance of new materials and the inventive attitude toward techniques so characteristic of today is not an unmixed blessing. An undue concern with invention, with new materials and techniques, can distract one from more profound expressive concerns. It is easy to become enamored of surface qualities without giving sufficient thought to the deeper levels of interpretation and meaning that constitute the major significance of works of art. It is also possible to flit from one fascinating material to the next without ever fully exploring the potential of any one. A period of exploration and experimentation is necessary, however, for every artist, because only by such a process does one find the materials best suited to one's individual temperament.

Mastery of Craft

Imagination and invention are of little value to artists if they have not mastered their craft sufficiently to provide visual realization for their concepts. If Picasso was not born knowing how to draw, he very early acquired the requisite technical skills that allowed him to give form to all the inventions of his fertile imagination.

This final chapter has reiterated, as was stated near the beginning of the book, that expressive drawing requires more than an accurate rendering and skillful manipulation of media and technique. There are, unfortunately, no foolproof formulas or successful mechanical approaches to drawing with expression. You must decide what works for you. Nor are there predetermined standards by which to judge when a drawing is finished other than to consider it complete when it conveys exactly what was intended and when "it can no longer be developed for the better."

The degree of detachment necessary in determining whether a drawing is successful is difficult to maintain while engaged in the process of drawing. It calls for the artist, in effect, to become another person in order to judge whether what was intended has actually been communicated, to decide whether technique and composition fully support the idea. The most difficult but most important question to ask is the by-now-familiar "Would the drawing be interesting if it had been done by someone else?" Failing an honest positive answer, the artist should be willing to do the drawing over. Complacency contributes very little to expressive drawing.

Self-portraits offer endless possibilities for exploring various avenues leading to expressive drawing. Lacking the availability of other subject matter, one has only to look into a mirror. Fantin-Latour found in himself ". . . a model who is always ready, offering all the advantages; he comes on time, he does what you tell him, and you already know him before you start to [draw] him." As a student, after he returned from copying at the Louvre, Fantin would sit before a mirror and draw self-portraits from five until eight in the evening. Figures 350 and 184 provide a sampling of that concentrated activity. Fantin favored black chalk or charcoal, which allowed him to build the dense rich black tones that contribute significantly to the dramatic and expressive impact of his studies. He experimented with the placement

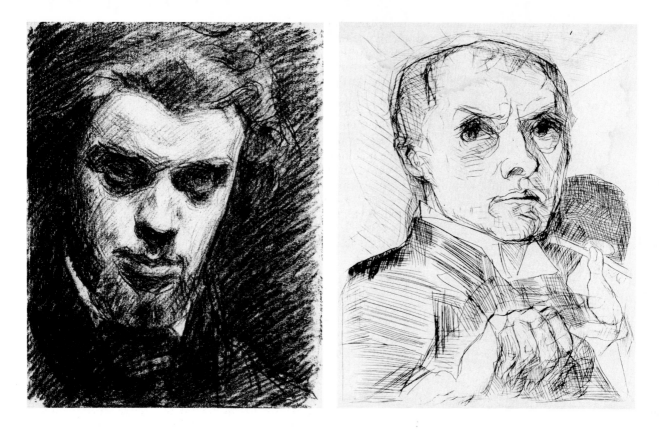

of the source of light for heightened theatricality. Positioned directly overhead in Figure 350, the lamp creates deep pools of darkness from which his eyes burn with hypnotic intensity.

Lighter in tone, but similar in effect, is Max Beckmann's *Self-Portrait with Burin* (Fig. 351). Beckmann's drawing style is much the same, the difference being choice of medium—the crisp lines made by an engraving point on a metal plate in contrast to the broader strokes of Fantin's chalk.

William Beckman's *Self-Portrait* (Fig. 352), drawn under a less harsh overhead light and with softer modeling, appears to project from the picture plane like a piece of low relief sculpture. The head is firm, yet not fully three dimensional because of the flattening effect of the emphatic dark outline. The strict frontality and calculated symmetry of the pose are broken only by the shape of the hair and the points of the shirt collar. The overall effect is both compelling and disquieting.

The self-portrait of Lovis Corinth (Fig. 353) conveys a similarly disturbing impression; the pose also frontal, but not rigidly so. The decided lack of symmetry, rather than being expressive distortion, acknowledges physical changes that occurred when Corinth suffered a stroke. What first appears to be a casual sketch is a remarkable drawing by a man unwilling to relinquish the means of creative expression.

While most people by nature are inclined to repeat what they can do successfully, a willingness to experiment leads to development and growth. That does not mean that every drawing must be different; it merely suggests that you should avoid prolonged repetition of only those things that you are comfortable doing. In your quest for

above left: 350: Henri Fantin-Latour (1836–1904; French).
Self-Portrait.
c. 1854–56. Black chalk and stump, 11¾ × 9½″ (30 × 24 cm).
Detroit Institute of Arts (gift of Abris Silberman).

above: 351. Max Beckmann (1884–1950; German).
Self-Portrait with Burin. 1916.
Drypoint, 11¾ × 9⅜″ (30 × 24 cm).
Museum of Modern Art, New York (gifts of Edgar Kaufmann, Jr.).

352. William Beckman
(b. 1942; American).
Self-Portrait. 1983.
Charcoal on paper,
29⅛ × 24¾″ (74 × 62 cm).
Courtesy Allan Frumkin Gallery,
New York.

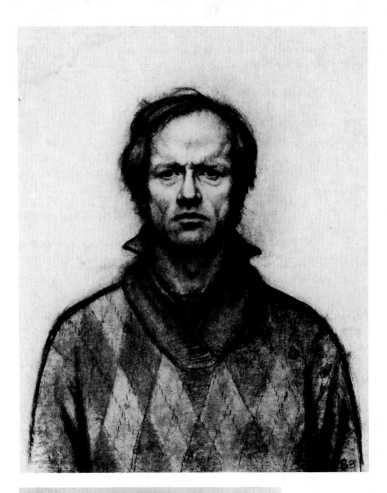

353. Lovis Corinth (1858–1925;
German). *Self-Portrait.* 1924.
Crayon. 12½ × 9⅞″ (32 × 25 cm).
Fogg Art Museum,
Harvard University, Cambridge, Mass.
(bequest of Beta and Paul J. Sachs).

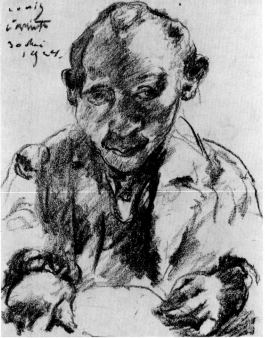

creative growth, remember that neither imagination nor style demand complete originality. When pursued for its own sake, originality quickly exhausts itself. Imagination and originality, as we have seen, need be nothing more than your own unique interpretation and expression of feeling and seeing.

Expanding Awareness

It is not uncommon to hear students say, "All I want to do is draw" (or paint or sculpt or throw pots). If one chooses to be an artist, commitment is important, even imperative. Commitment is reflected in the eagerness, willingness, and persistence to do more than settle for the easiest and most obvious solution to a project. At the same time, however, art students are responsible for more than mastering the craft of drawing (or painting, and so on). They must be willing to expand their awareness to include other areas of learning and experience beyond the studio to stimulate creative growth.

The noted science fiction author Ray Bradbury, when asked, said that he had never experienced "writer's block," because he had spent his life "feeding the muse." Looking, seeing, reading, and being aware of and sensitive to life are essential to all creative people; they are as necessary to an artist as learning to draw. To say that you have no ideas means that you have stopped experiencing.

Ben Shahn (Figs. 37, 237) writing about the education of an artist, states, "There is no content of knowledge that is not pertinent [to the artist]." He advises the student to learn everything possible about art by taking classes, working independently, looking at art, going to museums and galleries, and reading about art. Beyond that, he stresses the importance of studying all other subjects, both in the humanities and science. He urges the student to read, to be knowledgeable about literature, religion, history, and philosophy. Other recommended learning experiences include getting a job, observing people, listening to people, talking to people—and perhaps most important, thinking about and integrating the accumulated experiences so that they might feed the imagination and become part of the identity of an artist. As Shahn points out, "Such an art education has no beginning and no end."

Index